LANGUAGES OF SURREALISM

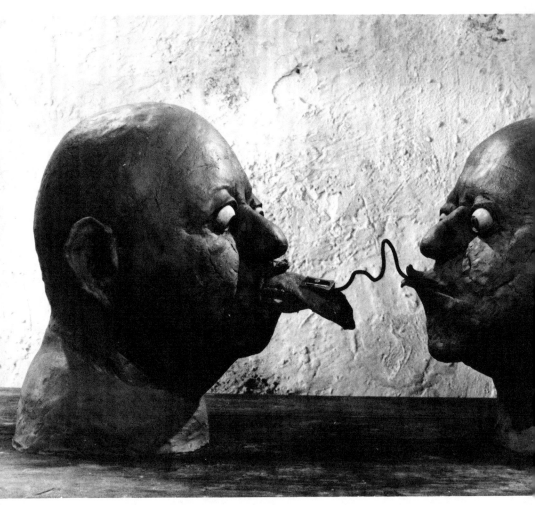

Jan Švankmajer, still from *Possibilities of Dialogue* (1982).

LANGUAGES OF
SURREALISM

J. H. MATTHEWS

UNIVERSITY OF MISSOURI PRESS
COLUMBIA, 1986

Copyright © 1986 by
The Curators of the University of Missouri
University of Missouri Press, Columbia, Missouri 65211
Printed and bound in the United States of America

Library of Congress Cataloging in Publication Data

Matthews, J. H.
 Languages of surrealism.

 Bibliography: p.
 Includes index.
 1. Surrealism. 2. Arts, Modern—20th century.
I. Title.
NX600.S9M37 1985 700'.9'04 85–2771
 ISBN 0–8262–0482–1

∞™ This paper meets the minimum requirements of the
American National Standard for Permanence of Paper for
Printed Library Materials, Z39.48, 1984.

To the memory of Herbert S. Gershman
University of Missouri, 1956–1970

PREFACE

Of the material gathered here, the section on Jean-Pierre Duprey has the longest history. In 1967, fascination with the fate of a contemporary who had committed suicide before either of us had reached the age of thirty had induced me to write for *Phases* a brief "Jean-Pierre Duprey vu de loin," to which I was to find myself returning nearly fifteen years later. Other parts of this book owe their existence to a variety of circumstances: a presentation at the Cleveland Institute of Art, on the occasion of a so-called festival celebrating "The Persistence of Surrealism" in 1979; a Gertrude Force Weathers Memorial Lecture in the Department of French and Italian, Indiana University; a talk in the cinema department of another state university (a sixty-minute causerie followed by ninety minutes of questions—the mere twinkling of an eye compared with the time it took the institution to release the very modest honorarium it had offered). These sections bear the marks, not to say the stigma, of oral delivery. Although expanded for the present occasion, they have not been rewritten with a view to concealing their origin.

Two chapters have a less exotic provenance. They were written independently of one another and several years apart for journal publication. "Grammar, prosody, and French surrealist poetry" appeared originally in *Dada/Surrealism*. "André Breton and Joan Miró: *Constellations*" was included in a special number of *Symposium* devoted to "Poetry and Painting." Both texts appear here by permission.

The remaining parts of this essay collection followed upon my discovery that I had much to learn from continuing examination of the languages of surrealism. The presence of these chapters next to comments already shared with one kind of audience or another is not to be inter-

preted as a sign that I imagine I have exhausted my topic. Reproduction of essays that have come to rest in earlier books of mine might have had some attraction for their author. The reappearance of all or some of this material would scarcely foster the illusion that I have treated the languages of surrealism with unimpeachable thoroughness. Readers more curious to see what this book leaves out than what it includes will notice without delay that, although it speaks of verbal poetry, painting, film, and surrealist objects, it offers only the briefest mention of sculpture and does not discuss the language of surrealist photography at all. Nor, for that matter, does it provide an evaluation of the life-style of Afro-American surrealist Ted Joans, qualified by Joans himself as "spontaneous automatic" and of greater appeal than his publications or collages to surrealism's leader in France, André Breton, who found, similarly, the man more enlightening than the storyteller in Achim von Arnim.

Thoroughness is not the goal of this volume. I wish merely to demonstrate that surrealism authorizes and encourages use of a number of languages in addition to verbal expression. Hence, one hears the surrealist message most clearly, responding to it most quickly and fully, when attentive and receptive to a variety of complementary expressive modes through which surrealists have sought and discovered ways to communicate with their audience.

ACKNOWLEDGMENTS

Thanks are due Mary Ann Caws for permission to reproduce from *Dada/Surrealism* an article entitled "Grammar, prosody, and French surrealist poetry" and to HELDREF Publications for "André Breton and Joan Miró: *Constellations*," from *Symposium*. For permission to reproduce Joan Miró's *Woman with Blonde Armpit Setting Her Hair by Starlight* I am indebted to the Cleveland Museum of Art; for his *The Escape Ladder*, to Pierre Matisse Gallery Corp., New York. René Magritte's *The Unexpected Response* is reproduced by gracious permission of the family of Cornelia Sage Walcott Mackin. Mr. and Mrs. Jerome L. Stern have kindly authorized use of Yves Tanguy's *I'm Waiting for You [Expecting You]*. Suzanne and Edouard Jaguer have granted permission to reproduce two of Jean-Pierre Duprey's drawings from their collection. For permission to use a *cadavre exquis* belonging to me I am grateful to Conroy Maddox. Mrs. Kurt Seligmann has approved inclusion of her husband's *Will o' the Wisp*. From a private collection, Max Ernst's *Airplane Gobbling Garden* (1935)—first of a series of paintings bearing that name—appears by permission.

Karol Baron, Jean-Louis Bédouin, Jorge Camacho, Mário Cesariny, Frantisék Dryse, Anne Ethuin, Chas Krider, Juhani Linnovaara, Eva Medrová, Gordon Onslow Ford, and Martin Stejskal all have granted permission for their works to appear. Stills from their films, indicated parenthetically, appear by permission of Jan Švankmajer *(Possibilities of Dialogue)*, Wilhelm Freddie *(Eaten Horizons)*, Marcel Mariën *(Imitation of the Cinema)*, and Dr. Ludvig Šváb *(L'Autre Chien)*.

For assistance in locating photographic material, my gratitude to Ian Breakwell (London), Mário Cesariny (Lisbon), Jean-Jacques Dauben

(Hilliard, Ohio), Ragnar von Holten (Stockholm), Edouard Jaguer (Paris), Stephen R. Miller (Cohasset, Massachusetts), and Tony Pusey (Orkelljunga). I apologize to these individuals for having been able to use too little of what they made available to me.

J.H.M.
August 1985

CONTENTS

1
INTRODUCTION

A collection of short articles, reviews, and essays spanning several years, André Breton's *Les Pas perdus* affords us the opportunity to retrace its author's advance to the position from which he wrote his first surrealist manifesto. Published in February 1924, *Les Pas perdus* made clear that, being a word poet, Breton was preoccupied above all with verbal language. When the *Manifeste du surréalisme* appeared in October of the same year, it offered an explanation of automatic writing and spoke of numerous writers but mentioned few painters, and then only in a modest footnote. Even in the *Second Manifeste du surréalisme*, first made public at the end of 1929, Breton continued to give *language* the narrow meaning that most of us do not hesitate to assign it. Referring to a general problem raised by surrealism as *"that of human expression in all its forms,"* Breton nevertheless remained quite specific: "Whoever says expression says, to begin with, language."[1] He left no doubt as to the sense in which he took *language* when he alluded to "the hordes of literally unleashed words to which Dada and surrealism have been bent on opening the door." If one were inclined to question the emphasis present in this text, Breton's undisguised contempt for "the logical mechanism of the sentence" surely would dispose of any uncertainty.

Insistence on language as the use of words is noteworthy in the *Second Manifeste* for two reasons. First, it seems to leave no place for a language of painting, despite the fact that, the year before the second manifesto's appearance, Breton had gathered as *Le Surréalisme et la peinture* a series of essays on surrealism and painting, inaugurated no later than 1925. Even more striking is that restrictions placed on the significance of the

1

word *language* can be read as conflicting with the declaration that opens Breton's 1929 text. Affirming that surrealism tends to "provoke, from the intellectual and moral point of view, a *crisis of consciousness* of the most general and most serious kind" (p. 153), Breton contended that success or failure in obtaining this result can alone decide whether, historically speaking, surrealism succeeds or fails. Surely, it would be a distortion of surrealism's program to conclude that the famous "certain point of the mind" from which contradictions appear resolved—the point, Breton emphasized, all surrealists hope to establish—can be attained only by writers, only by individuals whose language is verbal.

Judicious commentators have noted that, while the constitution of the surrealist group in France certainly changed over the years, sometimes quite dramatically, at any given moment the spirit of surrealism was kept alive by remarkably few individuals. Thus, the continuity of surrealism was assured by the creative energy of a core membership defending and at the same time demonstrating the vitality of surrealist principles. We can think of nobody but André Breton and Benjamin Péret who maintained unswerving lifelong devotion to the surrealist cause. All the same, no one can argue that, at this moment or that, those wholeheartedly dedicated to surrealism, its most loyal and combative defenders, were exclusively writers. More than this, review of surrealism's history brings to light the folly of believing that, in order to support the ideas underlying surrealism and to apply them creatively, every surrealist must express himself or herself of necessity in written language, deeming words the only fitting medium of surrealist communication.

True, the seeds of surrealism were sown in verbal language as a protest against traditional literary theories concerning ways to achieve poetic effect, against an inherited concept of the poetic in which Breton and his companions had lost faith completely. But once surrealism began to gather momentum, just as the idea of poetry underwent expansion to embrace more than the use of words only, so application of the term *language* ceased to respect limitations no longer judged applicable, yielding to a broader definition. The latter demanded acceptance as it testified to the capacity of modes of language other than the verbal to communicate surrealist poetry, to effect poetic discoveries and bring them to light. Meanwhile, as the word *poetry* expanded in meaning in surrealist usage, so *language*, too, eluded the strict confinement of conventional use.

When Tristan Tzara has described poetry in one of the surrealists' own magazines as "an ill-defined lively flame,"[2] we may well fear the worst as he and his friends go on to talk of poetic language. Luckily,

though, things do not turn out so badly as they seem likely to do: "It is certainly admitted today that one can be a poet without ever having written a line of verse." This assertion provides us with a point of departure for a study of the languages of surrealism, even though Tristan Tzara looks upon *poet* as "a bad term, so true is it that already for us the terminology is no longer adequate to the new content" (p. 21).

It is beyond question—and, more significantly, beyond truism—that all who deserve to be called surrealists identify the use of language with a special magic. This has been a feature of their most vigorous and fruitful thinking ever since Breton proclaimed in his first manifesto that poetry is "the perfect compensation for the miseries we endure." Any serious consideration of surrealism as an energizing force, as a productive means for coming to terms optimistically with the world about us and for redeeming mundane reality through awareness of the surreal, must lead us eventually to a study of its language. The essays brought together below all build on this premise, developing out of it in one way or another. Moreover, the material offered here rests upon acknowledgment of one centrally important fact, all too often ignored.

Coping with surrealist language calls for more than a sustained effort to deal honestly with the surrealists' use of words. It requires examination, on a level where complete parity is assured, not only of how surrealists write creatively but also of how they communicate by way of pictorial art, for instance. It demands consideration of the language of surrealist painting or cinema or sculpture, not as an accessory mode of expression, second to and dependent for its impact on the language of surrealist word poets, but as a complementary and equally valid and vital mode of exploration by which the surreal may be attained and findings in the realm of surreality may be recorded and imparted.

In all that follows, language is understood as the means by which the artist seeks to embrace the surreal and to communicate with his or her fellows. Thus, verbal language is not ranked higher than any other here. Instead, the complementarity of modes of communication favored in surrealism is, everywhere, the central issue. Among those communicative modes, historical circumstances (recounted with sufficient detail and clarity for our needs in Breton's 1924 *Manifeste du surréalisme*) have granted the language of words chronological precedence over other surrealist languages. However, no long search need detain us before we can demonstrate one important basic fact. Sometimes, words are less than fully equal to rendering things that the language of painting or cinema is better able to share with its audience. When this happens, though, the surrealist sees no reason to judge the cinematic or pictorial superior to the verbal, to elevate the one at the expense of the other.

In surrealism, the question of relative worth is dismissed as immaterial because it proves to be quite unproductive. Among surrealists, it is never a matter of asking why, at times, words are perfectly adequate to meeting the purposes assigned them, while, at some moments, verbal language proves to be less successful than its sculptural and pictorial counterparts, or can be suppressed altogether in cinema. Nor is it ever considered fitting to wonder why, on other occasions, words appear to achieve more than pictures do, or less than a surrealist object does. Surrealist artists are not in competition with one another, each trying to outdo his neighbor, each writer (painter, photographer, sculptor) determined to prove to his companions that they are going about things the wrong way. What counts for everyone is reaching ends designated by ambitions common to all. The viability of surrealist language, therefore, is to be assessed strictly in the light of its capacity to further progress toward surrealist goals.

During the critical years when, in Paris, Joan Miró was beginning to feel the attraction of themes and techniques that would lead him to align himself gladly with the surrealists, he felt more influence and stimulation from authors than from pictorial artists of his acquaintance. Still, this fact did not have the effect of tempting him to give up painting for writing. Meanwhile, although Breton never openly confessed to feeling challenged, a reading of *Le Surréalisme et la peinture*, from its first edition on, suggests one thing quite persuasively. Contemplation of work executed by surrealist painters discussed in his book was a source of continually fruitful inspiration to the man whose original manifesto was, by his own avowal, devoted to "poetic surrealism." There can be no doubt that, observing how painters faced the obligation to advance exploration of the surreal, Breton was brought back repeatedly to review his own investigations as a writer, to evaluate their efficacy in relation to the task set by surrealism for everybody truly committed to its doctrine and practice.

That surrealists do not vie with one another is a signal benefit of participation in a movement deeply suspicious of the world at large, a movement that displays no regard at all for widespread public recognition. Indeed, amply documented over the years (in the careers of Max Ernst, Louis Aragon, and others), one danger faced by each and every surrealist is that acceptance outside the group carries a serious penalty. Adjustment to society's requirements leads to compromise, then to estrangement from surrealism, and finally even to total surrender of surrealist values and to antipathy for them.

Success in approaching the surreal by way of fruitful exploration of the domain of surreality calls for demonstration of qualities radically

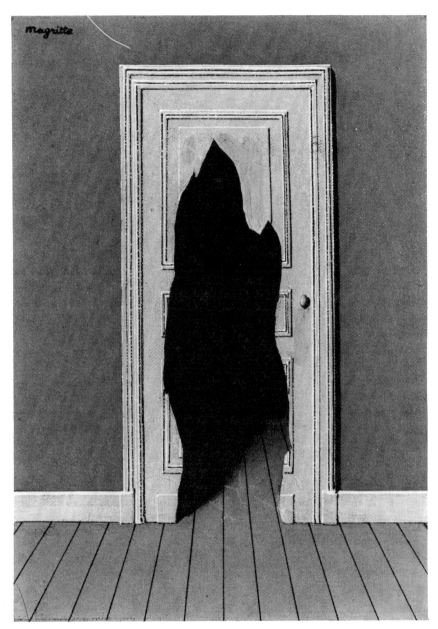

René Magritte, *The Unexpected Response* (1934), oil on canvas. Coll. the Estate of Cornelia Sage Walcott Mackin. Photo courtesy of the Portland Museum of Art, Portland, Maine, where it is currently on loan.

different from the mere ability to record aspects of the real skillfully enough to furnish a recognizable image of the known. Paul Eluard highlighted the problem confronting any persistent investigator of the surreal when he pointed out, "There exists no model for someone looking for what he has never seen."[3] No convenient acceptable model stands before such a person, either in the world about us or in the work of some other writer or painter, sculptor, filmmaker, or photographer.

It does not follow, though, that Eluard denied surrealist artists as a group any hope of being really productive. He was all the more ready, in fact, to question the possibility of the existence of a model meriting imitation because he placed the fullest confidence in imagination. Thus, the consistency of his thinking in this area is illustrated in his careful identification of a centrally important advantage enjoyed by all surrealists. He stressed in *Donner à voir* that imagination has "no instinct for imitation" (p. 81): "It is the universe without association, the universe without a god, since it never lies, since it never confuses what will be with what has been." The surreal extends enticingly before the surrealist's imagination as unquestionably "what will be," not as "what has been." Indeed, its appeal lies in its sometimes violent departure from the norms by which we customarily accept certain things as real and reject others as lying outside the world of reality. Its dynamism, meanwhile, is a consequence of the surrealists' eagerness to turn every new discovery to account in order to make it, if possible, a starting point for further investigation or, at the very least, a marker along an as yet unmapped road to surreality.

Breton's position of unchallenged prominence among surrealists in France earned his ideas on art special attention. It helped prompt and then keep alive discussion of the role to be assigned to pictorial artists in the surrealist movement. Which painters, for example, deserved to be accorded most trust? Which could be expected to contribute to surrealism most profitably? Answers to these and related questions were not formulated in advance in *Les Pas perdus*, which appeared eight months ahead of the *Manifeste du surréalisme*. All the same, one essay reprinted in that February 1924 volume did outline some basic postulations, never contested by those who remained with Breton after following him out of Dada into surrealism or by any who joined his group later: "I persist in believing that a picture or sculpture can be envisaged only secondarily with regard to taste and stands up only so far as it is liable to make our abstract knowledge, properly so called, take a step forward."[4]

Reading these words in conjunction with those in which Eluard highlighted the essential role of imagination in surrealism helps reveal how

painting and sculpture earn their undisputed place beside writing in the effort to advance surrealist goals. Breton's sentence is clumsy, betraying excitement far more than the assurance that will characterize his mature prose style. Nevertheless, its essential point is not to be mistaken. Nor is this central fact: by requiring the work of painters to be judged in relation to its cognitive value, Breton placed all surrealist pictorial artists on an equal footing with surrealism's writers, imposing on every one of them exactly the same obligations while also implicitly granting them the same privileges.

Nothing to which a surrealist finds cause to attach the slightest importance is gained by borrowing the jargon common to some forms of art criticism, with their vague references to the grammar and syntax of this or that painter's work. Meanwhile, everything slips confusingly out of focus if we make the error of supposing that, in discussion of surrealist aims and methods, extension of the word *language* so as to include painterly no less than verbal creative action is a mere figure of speech. Certainly, only by approaching the language of painting in the manner recommended by surrealism's theoreticians can we expect to understand why in *Les Pas perdus* Breton dismissed "the non-values" by which the painter's *métier* is increasingly evaluated in critical circles. Only from this direction can we hope to appreciate "what clears the ground"—*la part du feu*, as Breton calls it when referring to painting, "one of the most admirable modes of expression I know" (p. 175).

The shift in emphasis that permits Breton to equate painting with means of expression is not calculated to reduce the importance of pictorial technique or to limit its significance. On the contrary, by outlawing the "non-values" that, as a surrealist, he saw undermining painting, Breton aimed to raise pictorial art to the level at which it could really serve the purposes of surrealism.

The variety encountered in surrealist creative works, the broad span of subject matter as well as technique, the ever-shifting perspective—all stand as evidence of the difficult problems surrealists face persistently and with tenacity. A token of the elusiveness displayed by the surreal at times, variety brings to light the predicament faced by artists who feel sure that the less they know in advance of where they are going, the more chance they have of getting there. The final thrill of arrival remains unforeseeable and perhaps will prove to be a reward earned only very rarely and by comparatively few. Yet the excitement of departure never ceases to spark creative effort, justifying continued investigation into the potential of language for forcing access to the surreal.

The surrealist application of language does not make a prime virtue

of ignorance, of course. However, it does accept ignorance as the zero point from which entirely new measurements may be taken. In practice, this means that surrealists discount knowledge gained through experience in the familiar world and acquired by dutiful acquiescence to an educative process common to western societies advocating empirical deductions as well as scientific ones. All forms of knowledge gathered by traditional methods—those overseen by rational logic, notably—must be set aside, surrealists maintain. Then, having cleared the ground, the artist can expect to be free to start from zero and ready himself to calibrate a new scale of cognition.

For the very reason that achievement cannot be measured according to a scale laid down a priori—because progress sets it own calibrations, which it invests with meaning—surrealist language is never recapitulative but always tentative. Its prime virtue is that, whatever form it assumes, it remains above all speculative in nature as it fulfills its assigned investigative function. Here, basically, lies its appeal for those employing some form of language in order to penetrate the surreal. Language is a vitally necessary instrument for exploring surreality so long as it takes a surrealist beyond the anticipated into the unpredictable or, even better, the totally unprecedented.

Any departure, intentional or accidental, from the path to which surrealists are committed brings them to a halt, making further progress unlikely or even quite impossible. In fact, there is a serious conflict between surrealism and deviative use of language—being content, that is, to require of it no more than satisfaction of the artist's ego, sense of aesthetic pleasure, and so on. This can lead to unwelcome results quite unlike those faithfully pursued by authentic surrealists. Once an artist succumbs to the temptation to value his medium exclusively or even primarily as the vehicle for externalizing his sense of *métier*, he no longer deserves a place in surrealism.

The basic disagreement separating surrealism from literary or artistic expression (in the sense that these phrases commonly assume) finds its source, meaning, and vitality here. A surrealist gauges the worth of his endeavors and evaluates their significance against the unknown, not the known. For this reason, he sets no store by past accomplishments. Complacency is ruled out along with the temptation to self-indulgence derived from assured command of a proven technique, of a well-tried formula having demonstrated worth. Nothing is more foreign to surrealism than the spectacle of an artist working comfortably within his capabilities, sure of what he can do, and careful to avoid attempting the slightest bit more. Nothing could be truer to the spirit of surrealism,

meanwhile, than an honest attempt to expand capabilities and to extend knowledge beyond past achievement, even if, on occasion, the price should happen to be failure.

We gain some idea of the originality of surrealist language when, paradoxical as it sounds, we think of surrealism as an art of risk. The creator's accomplishment rests on his willingness and ability to incur risks, to take nothing for granted, and to refuse all accommodation, ever alert to the dangers of a weakness that Breton dismissed grandly as self-kleptomania. The first step—one having to be taken over and over again, surrealists warn—is to avoid developing a style, clichés, mannerisms, and fixed forms of expression such as every surrealist ascribes contemptuously to "schools" of literature and art.

Surely, in all this we are struck first and foremost by the arrogance surrealists appear to betray when setting themselves apart the way they do. To gain correct perspective, one needs to acknowledge their condemnation of preoccupation with the acquisition of a distinctive style as being, in their estimation, fundamental to artistic integrity, as keeping creative energy flowing in channels to which surrealist ambitions grant value. To be sure, one must accept the fact that Péret—whose automatic writing places him, beyond dispute, at the very forefront of surrealist word poets—never recognized his own unique poems when his friends read them back to him. One also has to appreciate that Péret's response is paradoxical in appearance only. His surprise at hearing his own automatic texts shows most clearly where an important difference lies between surrealism and romanticism.

The romantic writer treasured his sense of identity, the *moi* that he took to be the vortex of his creative energy. He communed narcissistically with it, looking upon it as the vital source of his poetic inspiration. Péret, in sharp contrast, wondered at the release of images by automatism. They were as revealing to him, the "modest recording machine" by which they reach an audience, as they were to anyone else.

A celebrated maxim in which Breton laid the foundation for surrealism runs, "Language has been given man so that he can make surrealist use of it." This confines language to a narrow role that firmly excludes all others, denying them significance as well as measurable value. In the poetic venture, the famous lapidary phrase seems to limit the application of language. But it only *appears* to restrict the term *language* in the surrealist's vocabulary.

Making surrealist use of language means returning it to the magic function that Breton, Péret, and Pierre Mabille sought to bring to their

Eva Medrová, *Cry* (1978), photograph.

readers' notice, the first in his anthology of black humor, the second in his *Anthologie des Mythes, légendes et contes populaires d'Amérique*, the third in an anthology devoted to the marvelous. Contending that language must never cease to be employed magically, all three—and their fellow surrealists also—made it plain that the demands placed upon language in the name of surrealism are strict, leaving neither time nor place for language used in the pursuit of beauty according to the inherited criteria of aesthetics. However, among surrealists, elimination of concerns dismissed as extraneous never resulted in anything but the certainty that, used surrealistically, language gains a freedom, when employed within the confines of aesthetic theory, it inevitably must sacrifice.

Never, perhaps, has a group of artists destined to leave an indelible mark on a period to which they belong conceived their place in history with more self-assurance. Never, either, have poetry, painting, sculpture, photography, and cinema been more closely united as means for pursuing specific ends and for dismissing, along the way, all types of

literary and artistic activity either falling short of or interfering with stated goals. This is a salient feature of surrealist action. Surrealism stands alone as a phenomenon defined just as accurately by its militant opposition to consecrated ideas, in literature and art, as by its efforts to outline and adhere to ideals of its own and to work assiduously toward their eventual realization.

Ideally, the surrealists' motivation owes nothing to either envy or the upstart's impulse to attract attention by self-publicity. Their attitude toward other people as much as toward themselves is dictated at all times by their shared concept of the place of art in life—art in all its varied forms and life in its most profoundly serious relationships. In question is the individual's relation to society at large and to other individuals. So is his or her position with respect to moral and ethical issues. Hence, surrealist art is unalterably marked by concerns no surrealist would hesitate to define as humanistic. Art would lose its distinctive character and all its meaning if it could be separated from the problems of modern-day living, to which surrealists are sensitive and which they try to resolve.

Stress on affiliation with a group, rather than with a school, and on participation in a movement (with the attendant idea of progress toward something) fosters among surrealists devotion to common ideals without ever imposing blind adherence to aesthetic values. Critics who speak from outside the surrealist circle of a "surrealist aesthetic" begin by missing essentials and, from then on, really never make up for their error. In addition, they betray an inclination—a compulsion, sometimes—to imagine surrealism restricted within a framework familiar to them. They hope to be able to handle it through mechanical application of evaluative criteria that they themselves are indisposed to set aside. Surrealism, though, refuses to fit the pattern taken for granted by such observers. This is why it provokes resentment and antagonism among many accustomed to claiming the right to judge literary or artistic accomplishment.

In the surrealist movement there can be no occasion for the imposition of confining regulations. The writer, for instance, is no more obligated than any other artist to practice automatism, shall we say. Hence, the language authorized and approved by surrealism takes diversified forms, which do not find justification in aesthetic principles reassuring to critics, persuading them that they have at their disposal reliable standards to be applied and checked when they assume their evaluative role. In fact, it is the obligation to evaluate achievement by strictly extra-aesthetic standards that unifies surrealist effort in a variety of media.

Thus, the modes of surrealist language complement one another, advancing from more than one direction toward the same common goal.

The special nature of surrealism's aspirations confers vital unity on surrealist language. Still, it releases linguistic forms from monotony and even, for that matter, from uniformity of style. Basically, fidelity to surrealism imperiously demands an unambiguous and purposeful answer to the most direct of questions: why use language? It does not ask, we notice, how language is to be used.

Obviously, the *how* ought to depend on the *why*, whoever is using language, whether language is narrowly or liberally defined, and for whatever consciously held reason. All the same, giving the *why* precedence as rigorously as they do, surrealists knowingly assign language a thoroughly functional role. This role must receive consideration while we review in areas where surrealism conducts its explorations the uses to which language is put. Far from restricting the productive exercise of language, surrealist functionality has far-reaching consequences. It sets criteria and imposes standards from which language in surrealism derives its distinctive qualities as an instrument of investigation and revelation. The standards evolved in the name of surrealism are intended to refine an instrument of inquiry and discovery and to engender a distinctive conception of language indicative of the surrealists' determination to use words and pictures responsibly.

The confusion often encountered among people outside the group about why exactly surrealists are creative artists comes from this fact. And it is easy to appreciate where misunderstanding lies, so long as phrases like *instrument of inquiry* and adverbs like *responsibly* remain undefined in their application to surrealist creative activity. Noticing, as they cannot fail to do, how far short surrealism falls of the idea of "art" and "literature" with which they themselves are familiar, uninformed and hence misleading commentators attribute to weakness or even incompetence the surrealists' departure from norms that criticism acknowledges no reason to modify, adjust, or abandon.

What we know of the circumstances under which Miró progressed toward a pictorial language appropriate to surrealist inquiry and what we sense of Breton's anxiety about the efficacy of verbal language in the context of the same inquiry combine to direct our attention to the underlying drama of surrealist investigation and to give it sharper outline. If we concentrate only on cases evidencing anguished sensitivity to the problem of communication as posed in surrealism, we deny ourselves a properly balanced view of the atmosphere in which vigorous attempts have been made to prospect the surreal. Nonetheless, we do appreciate

a little better, this way, how seriously all genuine surrealists take their responsibilities. Reflection on the conduct of Jean-Pierre Duprey, painter, sculptor, maker of concrete reliefs, as well as writer, compels us to recognize that "an art of risk" is not an empty phrase when applied to surrealism. Surrealism is no refuge for the Sunday painter or for the individual who self-indulgently writes poems "on the side." Urinating on the eternal flame beneath the Arc de Triomphe—no translation is needed for defiant surrealist language of this sort—earned Duprey first-hand experience of the third degree in a Paris police station as well as three weeks in a psychiatric ward.

The gravity of the step any person takes when enlisting in surrealism and accepting the consequences cannot be overestimated. The commitment demanded of somebody who shoulders obligations prescribed by surrealism may be gauged from the acrimonious recriminations uttered by defectors and renegades (a sampling appears after the 1930 version of Breton's *Second Manifeste*) who angrily assert that the air in the surrealist camp is unbreathable. From another angle, it can be measured, and far more accurately, through consideration of evidence of futility in people whom rejection from the group either has reduced to sterility—and, in the case of Roger Vitrac, to alcoholism also—or to painful awareness of irremediable loss, like that mentioned in a private letter never meant for publication, by one individual after his formal exclusion.

The sense of privilege shared by everyone admitted to the surrealist circle does not come from pleasure at being allowed to speak a language impenetrable to outsiders. Surrealism has never been esoteric in that snobbishly exclusive way. Belonging to its membership imposes, rather, acceptance of the duty acknowledged in a maxim borrowed enthusiastically from Arthur Rimbaud: "To find a language." At the same time, it demands recognition of the urgent need facing each surrealist: to find a language for himself.

What kind of language? Neither Péret nor Yves Tanguy—no more inclined, the one than the other, to explain how admirers might imitate the language in which he expresses himself—can help furnish an answer to this question. Indeed, the more attentively we scrutinize remarks by these two impeccable surrealist artists the better we understand that commentary is superfluous. Explanation is not only irrelevant but impossible once a surrealist has mastered a language of his own.

Taken in its surrealist acceptation, language is not *given* but an object of conquest. Its merits are to be weighed, therefore, against what it promises to reveal, instead of against its demonstrable capacity for recording the already familiar and for making us see again what we have

seen before, even if perhaps not quite in the same way as formerly. No one had emphasized better than Eluard the prospective and anticipative nature peculiar to surrealist language. Examination of remarks consigned to his *Donner à voir* on the virtue of words lets us see that Eluard's comments take on a deeper as well as a broader meaning when their application is extended, as surrealism permits, to the language of the sculptor or painter, filmmaker or photographer. The drama underlying surrealist linguistic practice denotes, in Alain Jouffroy's phrase, "the *tension* of thought when it discovers what it is: grasping a poetic continuum in propagation."[5]

Jouffroy's own initiation into surrealist creative action was most unusual. It happened that one evening in December 1947 he underwent a strange visual hallucination. As the vision began to fade, he found himself responding, not by attempting to sketch what he had seen but with an outpouring of words. "In the total darkness illuminated by what I believed I had seen, the images evoked in me by words sketched themselves with almost photographic distinctness in my brain," although they were to leave him, later, with no memory of what he was saying. "An even more remarkable thing was that these images engendered one another, after the manner of those unicellular creatures that reproduce by a process of breaking down, repeated indefinitely. They organized themselves on their own, and it was as though my thought was divided up into hundreds, thousands of drops of mercury so that it, too, resembled the phenomenon I had witnessed" (p. 119).

There is no exaggeration in saying that Jouffroy's subsequent writing in *Aube à l'antipode* (which he began the very next day and would describe, when dedicating a presentation copy, as "These first signs of an uninterrupted book") represents an effort to recapture the vision that had induced in him the first flow of poetic verbal language. In this respect, then, it is exceptional in surrealism. In late 1929 Breton referred to surrealism in his *Second Manifeste du surréalisme* as the "ever so *prehensile*" tail of romanticism. Yet, surrealists in general—Breton among them—have devoted less energy than the romantics did to searching for paradise lost. Customarily locating paradise ahead of them, not behind, the surrealists aspire to fashion language into an instrument that will penetrate the future rather than reconquer the past.

It is commonly agreed that aping one's elders and predecessors is scarcely a rewarding activity in any notable literary or artistic school. Given the ambitions shared by members of the surrealist group, it would be nothing short of fatal in surrealism. Here imitation could do no more than borrow, in the absence of a creative spark, the external form of poetry, its empty shell, in other words. The thought of an artist,

whatever his accustomed medium, living in a patently self-serving manner off what others have done is abhorrent to surrealists, who see such conduct as unpardonably exploitive in the worst sense of the term. Anything less than condemnation of an individual who thinks he can turn other people's moments of inspiration to his own account is a betrayal of surrealism. Surrealists cannot condone, therefore, polishing a technique, on the excuse that attention to form may be expected to result in some sort of improvement.

Substance, the germinating core that endows form with the only value it can have as a communicative vehicle, in surrealism, eludes the imitative gesture. Because surrealism is not a pastime, it requires total dedication, a plunge—at whatever cost—in search of the new such as Charles Baudelaire sought to make. Without this, painting, sculpture, and writing are like meaningless scribblings or pointless ornamentation.

Not one surrealist worth his salt has time to spare for developing a style, for laboriously acquiring a "manner" of his own. Among other things, disregard for such pursuits, so dear to many other writers and painters, is a sign of the surrealists' firm refusal to be judged by the public at large. It explains Breton's easily misread injunction that members of the surrealist circle take care to "prevent the public from entering." More than this, it signals their determination to look persistently inward, rather than outward, and to dedicate themselves to self-exploration above all else. Its effect on surrealist inquiry, as a consequence, is to demand that language function as an implosive agent, not for decoration or for the complacent self-advertisement of the person using it.

Commonly esteemed as marks of distinction, elegance and beauty of expression are judged by the surrealist to be entirely extraneous to poetic effect. Surrealists are more disposed to treat these qualities as distracting, decorative elements than as essential to the fruitful search for poetry. Experience has taught them mistrust of any artist whose appeal to his admirers is proportionate to his proven command of techniques expressly adopted for aesthetic purposes. Everything, in fact, hinges on the definition of beauty found to be consonant with surrealist aspirations.

Breton led the way, when speaking of beauty as "convulsive." The meaning ascribed to *"convulsive"* in his *L'Amour fou* (1937) has far-reaching consequences that we cannot hope to summarize here. All the same, it is permissible to begin by applying the adjective in a narrowly restrictive sense (at which surrealists would be entitled to protest) long enough for us to be sure to grasp one prime feature of surrealism. Surrealist language is poetic to the extent, precisely, that it is disruptive

of inherited values, not only aesthetic ones but moral and ethical ones, too. The first stage to be passed by the surrealist artist calls for self-examination. *beauty elegance standardization*

There was nothing fanciful or whimsical about Roberto Matta Echaurren's decision to eschew landscape painting and to paint, instead, pictures called "inscapes." It is noteworthy that, discussing Matta's work in a July 1947 catalog preface reproduced in *Le Surréalisme et la peinture*, Breton quoted French poet Pierre Reverdy—"Creation is a movement from inside outward"—implicitly drawing a parallel between the painter's task and and the word poet's. The same parallel is suggested by another surrealist, Vincent Bounoure, when he describes Yves Laloy's paintings as possessing "the aggressiveness by which alone the inner vision is attained. Each is the signal of victory over the opacity of the perceptible decor, the sovereign result of a new and perilous adventure."[6] Evaluation of any surrealist artist's achievement, by this criterion, can never be the natural right of society at large. It remains the prerogative of the artist alone. Meanwhile, evaluation takes shape and direction from his or her dedication to the goal of self-discovery, born of the realization voiced when Breton declared the great enemy of man to be opacity, within himself as well as outside.

The orientation of surrealist thought and action leads to emphasis upon ends, not means. It demands that attention to the latter be controlled by devotion to the former. For this reason, methods are never sanctified in surrealism, never accepted and applied routinely without question. On the contrary, their suitability to continued pursuit of surrealist objectives is under constant review. Hence, surrealists must be ready, willing, and able to abandon a technique or general approach that has ceased promising to make a vital contribution to advancing ends shared with companions. A particularly revealing instance is provided by the history of automatic writing in surrealism.

Automatic writing is presented as the essential discovery of surrealism in Breton's *Manifeste*, where it is identified as the point of departure for all surrealist activity. Among the forms of surrealist language, it has consistently held the public's attention most widely, becoming in fact the peculiarity for which surrealists are known best. By the 1930s, however, Breton was admitting quite openly that automatism—often the subject of misguided and even malicious commentary by critics—had become a mixed blessing to surrealism. Not until he wrote his *Ode à Charles Fourier* (begun in 1945 and published in 1947) was Breton willing, though, to depart altogether from automatic practice.[7] Finally, however, when asked in 1962 if he still wrote automatically, he responded without prevarication: "What is the good? I have explained myself on that point.

Automatic writing could not be an end in itself. Everything lies in having obtained it in as pure a form as possible for, from then on, it is easy to reconstitute and reproduce the series of mental operations it implies to begin with."[8]

Those who claim to have discovered in automatic writing the Achilles' heel of surrealism reveal nothing better than their incomprehension of the working principles that led Breton and his earliest associates to adopt automatic writing in the first place. Surrealists have been dedicated all along to "systematizing confusion," in Breton's phrase, not to systematizing automatism, which they consider a working method and no more. Like all other techniques found worthy of application to surrealism's advantage, automatic writing commands respect only so long as it promises results. To be judged profitable in surrealism, results must offer tangible evidence that poetic sources inaccessible to reflective thought can be reached and tapped. They are, essentially, revelations of a kind that cannot be brought to light by way of mental processes governed by rational deduction and association. Thus, the sense of privilege underlying the first surrealist manifesto originated in Breton's enthusiasm when he discovered evidence that poetry could be revitalized through a new image-making procedure, to which the key was automatism.

All the same, to channel creative practice exclusively into automatism and to impose the latter on painters no less than on writers would have been quite contrary to the spirit of free inquiry from which surrealism took impetus. It is an indication of Breton's alertness to the danger of consecrating any technique and of making it the be-all and end-all of surrealist action that, at the close of his October 1924 manifesto, he announced, "I do not believe in the early establishment of a surrealist stereotype" (p. 54) and, even more firmly, "I hasten to add that future surrealist *techniques* do not interest me" (p. 60). On the same occasion, he described surrealism as a declaration of "our absolute *non-conformism*" (p. 63), so indicating that surrealists are disposed to be attentive to all forms of language that deny conformity and affirm its opposite.

The surrealist's refusal to commit themselves blindly, once and for all, to automatism and the consequent variety evidenced in vital forms of surrealist language from the mid-1920s onward—these aspects of surrealist activity are not to be interpreted by any means as proof of the irresistibly powerful influence exercised by André Breton through his manifestos. It is, far more significantly, a token of the surrealists' common dedication to a persistent search for ways to penetrate to the surreal, by whatever techniques sustain the hope that their cherished ambitions can be realized through implementation of expressive means

available to the individual. Jean Schuster draws attention to what is important here when explaining, "The driving belt between the individual and the collective—and this is perhaps at the same time a vital gearwheel in surrealist activity, its most original characteristic—has been stretched, neither too tight nor too slack, once and for all. This being so, the means of ensuring the development of surrealism depends, in large part, upon the determination of each of us to force his own locks."[9] Because they do not all stand in front of the same closed doors, the surrealists do not all have to deal with the same locks. But whatever way they find of forcing entry, they share one common purpose: to pass beyond the door facing them and to gain admittance to the surreal.

2
SURREALIST IMAGE-MAKING

To many people, perhaps to most, making a surrealist image may not have quite the attraction that making money has. Nevertheless, both activities share several revealing characteristics. The latter begin to come into focus when we place ourselves in the position of an individual who, never having made either, has reached a stage in his life at which he wonders, albeit idly, what it would be like to make the one or the other. He casts about for a sure-fire method—at once reliable, productive, and (since time is money) not too time-consuming—that surely will bring results. Although magnetically drawn neither to surrealist imagery nor to wealth, he would like to assure himself that there is indeed a method he might follow if he were like those held by an attraction to which, he flatters himself, he remains safely immune. Things become clearer still if we adopt the outlook of an individual who, really wanting to enrich himself, unfortunately finds he can lay hands on no guaranteed formula for making a fortune. When, seeking consolation, he takes it into his head to try making surrealist images instead (we all look for consolation where we can), he soon discovers that supposedly tested recipes are actually not quite what he expected them to be.

It seems advisable to begin with a simple comparison, mundane enough not to pass for a poetic image, that underscores something without which the title above could be misconstrued easily. Surrealist image-making is not at all like cabinet-making, for example. A prospective surrealist does not start out as an apprentice under an expert who, if sufficiently well disposed, is able to impart necessary knowledge and share the precious benefits of experience, thus efficiently training a

19

surrealist craftsman the way a carpenter might train an eventual card-carrying union member.

One might interject that, however it may have been for painters at one time in the past, poets have never learned their trade somewhat the way plumbers do. The point needing emphasis, therefore, is the following. When referring to image-making by surrealists, we risk suggesting a deliberate procedure of fabrication that, not being patented or protected in any manner, can be imitated or pirated with impunity and also measurable profit.

I am reminded at this point of a French poet, Jean Malrieu, who told me how a respectful group of aspirant versifiers once converged on his home with the express purpose of sitting as disciples at his feet. He happened to be white-washing his house at the time and energetically chased them off the property, brandishing his paintbrush. I recall, too, that more than twenty-five years ago a student of mine, having heard talk of surrealist automatic writing, decided to try his hand at it. At first he was enthused. But soon he came to grumble at not having been able to progress beyond the stage reached with his very first attempt. Was there something he had missed? Had he begun by "doing it right," only to lose the knack unaccountably? Was I in a position to redeem automatic writing and to renew his faith in a procedure rewarding only the first time around? Evidently, this young man, in all sincerity, was giving André Breton and me a last chance. Just as obviously, we failed to rise to the occasion. Eventually, the student opted for seeking money, not surrealist images, and went to work for a major oil company.

That student must have felt he had a real grievance. For in one respect, as principal spokesman for surrealism, André Breton supposedly resembled Dada's chief spokesman, Tristan Tzara. Each of them appears to have been entirely willing to tell anyone interested exactly how to go about writing poetry. Each, in fact, seems to have taken pains to outline at least one tried and true formula. Tzara's most famous recommendation to the would-be Dada poet advises snipping words from a newspaper article, dropping them into a bag where they can be thoroughly mixed, and then pulling them out one by one. Equally well known is a section in Breton's first manifesto. It bears the eye-catching title "Secrets of Surrealist Magic Art" and opens, "Have writing materials brought you, after settling yourself in a place as favorable as possible to your mind's concentration upon itself" (p. 44). The trouble is, though, that Tzara's instructions conclude with the laconic affirmation that the poem produced according to the method outlined will assuredly "resemble" its author. Meanwhile, instructions regarding the practice of automatic writing are set forth in the *Manifeste du surréalisme* beneath the subhead-

ing "Written surrealist composition, or first and last draft." It all sounds perfectly serious until one takes into account two other subheadings in the same text: "So as not to be bored any longer in company" and, especially, "How really to be seen by a woman in the street." In the latter instance, the method of achieving desired results is left to the imagination, a blank space opening up invitingly on the printed page.

André Breton could never be mistaken for one of the world's great humorists. Nor was his sense of humor unusually subtle. Still, one might ask whether the touch of ponderous humor to be felt in the *Manifeste du surréalisme* is not enough to forewarn all readers against naive incredulity or misplaced earnestness. However, the situation is not quite as simple as a casual glance might suggest. The fact remains, after all, that the way to practice automatic writing as surrealists understand the term is indeed the one described in the first surrealist manifesto, even if, before we begin, we have to fetch our own writing materials. Max Ernst's proposals for "forcing inspiration" are just what he said they are: means by which he believed the pictorial artist may force inspiration, the very way he himself tried to do at one time. Yet André Breton and Jean Schuster have stated bluntly, "You force locks, not images."[1]

There seems to be a serious lack of unity here, supposedly attributable to the inept mixing, above, of apples and pears. Ernst's contribution to surrealism is largely confined to art. Hence, his determination to force images relates to the production of pictorial imagery. Breton and Schuster, however, will be remembered as surrealist writers. Presumably, to them, imagery is, first and foremost, verbal. But if we separate painters from poets in order to resolve an apparent contradiction between forcing images and not forcing them, we surround ourselves with confusion from which no escape is possible until we have returned to first principles. We must start out by noting that a surrealist acknowledges no real distinction as separating images according to the media through which they happen to be communicated.

There are no radical, insurmountable differences between pictorial surrealist image-making and creating surrealist word images. In fact, the technical considerations that have to be met by each artist in his or her chosen medium merely open up the pathway to exploration of the very same world of images. So why did Ernst seem to be attempting something that Breton and Schuster believed could not be done?

We are likely to find ourselves going around in frustrating circles if we commence by inquiring how, precisely, images are to be created. Far more informative is an investigation asking, to begin with, what exactly surrealists are trying to do, concentrating on what they deem an image to be.

The logical starting place for such an investigation would appear to be the dictionary definition of *image*. At once, however, we face a difficulty. A consistent pattern links all meanings that apply in accepted usage of the word. An image, we are told, is "a representation of a person or thing, drawn, painted, etc." It is, no less, "the visual impression of something produced by reflection in a mirror, refraction through a lens, etc." Alternatively, it is "a person or thing much like another, a copy; counterpart; likeness." Of course, image is also "conception; idea; impression," "a mental picture," and "a vivid representation." All the same, that mental picture represents something known, something given. Thus, the example of vivid representation offered by Webster reads, "this play is the *image* of life." Meanwhile, *The Shorter Oxford English Dictionary* employs the words "artificial imitation," "likeness" again, "semblance," "counterpart," and "mental representation of something." Both reference works agree, therefore, in authorizing us to speak of an image as having to do with something already existing. This is something that, coming before both impression and representation— to limit attention for the moment to verbal language—dictates the mental picture captured in figurative speech, in simile or metaphor.

The problem we face with surrealism now stands out better. Far from meeting expectations to which standard dictionaries inform us we are fully entitled, the authentic surrealist image runs counter to familiar definition, even to the point of seeming not to be an image at all. The distance setting surrealist imagery off all by itself turns surrealist image-making into a uniquely unpredictable venture, in which charlatans and imitators end up no better off than individuals who go bankrupt while vigorously trying to amass a fortune.

A warning issued by one of the first surrealists, Louis Aragon, still carries all the force it had when uttered during the 1920s. Inanities, Aragon declared, are no less inane for having come about through use of automatic means. Automatic writing, for instance, guarantees nothing and sanctifies less. There is no great mystery about this.

The man who fails to make money still retains positive knowledge of what has eluded him. In contrast—and now we encounter a major difference where, at first, we saw only shared characteristics—someone actually failing to produce surrealist images nevertheless may persuade himself (and lots of other, too) that he has been eminently successful. This is because his fundamental error is common to many of us. He presumes a surrealist image to be as recognizable as a dollar bill. He believes he can be as certain of having put the one on paper or canvas

as of having put the other in his pocket. This is far from the case. Counterfeiters, however, who pass imitation money run more risk of detection by the public at large than those who offer imitation surrealist images.

The error a pseudosurrealist shares with the general public submits him to preconditioned, simplified notions about the nature of surrealist imagery. These prompt him to try to put together images—pictorial ones or verbal ones—conforming to the set pattern lodged in his mind. Hence, having come into being as the "mental representation of something," the end product of his efforts is indeed no more than a "copy" of a surrealist image, even when it is enough of a "likeness" to be taken for the real thing. At best, therefore, he has contrived to present us with an image of a surrealist image, possibly authentic-looking to the uninformed, but spurious nonetheless.

There are a number of ways to explain what has occurred. The most charitable of these discounts crude opportunism and admits the unfortunate intervention of involuntary confusion. This is the only excuse possible for the existence of the popular adjective *surrealistic*, for which no support comes from surrealist theory. Far from bearing a positive and productive relation to surrealist goals, the word *surrealistic* breeds confusion and misunderstanding and encourages the identification of the surreal with flights of fancy and with oddity. If, then, we exonerate the pseudosurrealist of charges of opportunism or deliberate falsification and ask where he has gone wrong, we see that, so much like the parodist's—though in the absence of the kind of awareness that is essential to successful parody—his operating procedure cannot be really fruitful. It puts the cart (the image) before the horse (the making process). More than this, it rests on the thoroughly misleading assumption that the cart is hitched to a different horse altogether. And why should this be? Quite simply, because of a fundamental misconception about the sort of cart needing to be pulled, from where it is being drawn, and how.

Basic to all dictionary definitions of *image* is the unchallenged supposition that image-making aspires to capture or render a preexistent model, something against which success or failure of the whole undertaking can be measured with perfect accuracy. This explains why consulting a dictionary actually sends us off in the wrong direction, during our search for surrealist images and in our endeavor to establish how images are made. We have only to listen to Paul Eluard to realize how far out of our way we shall go if we neglect to seek guidance from the surrealists themselves.

Commentary by surrealists about poetic expression in any form, however, offers little practical guidance to the would-be creative artist. We observe here a sharp contrast with Symbolist commentary. The surrealists devote little or no space to discussing how images are born and why imagery affects the sensibility in ways that promote attainment of surrealist goals. In part, surrealists reject the precedent from which, in their youth, some of them (Breton and Benjamin Péret notably) used to draw inspiration, because they are determined to separate the phenomenon of poetry from the application of aesthetic theories. In addition, though, practical considerations play an important role in their neglect of the theory of image-making. Eluard brings these out when stating categorically in *Donner à voir*, "There is no model for someone looking for what he has never seen" (p. 131).

Here is the essential point. An authentic surrealist image does not render a preselected model and is not intended to reflect one. It brings before us something never seen before, even by the image-maker himself. Hence, Eluard's claim, also put forward in *Donner à voir*, that the principal quality of poems is to inspire, not evoke (p. 81). Without unfair distortion, one may simplify in the following manner the procedure leading to the creation of surrealist imagery. Rather than inviting the image-maker to look back to a known, preselected model, it requires him to move forward, always in the direction of the unknown.

In his first manifesto, Breton bids readers note how closely surrealist images resemble those conjured up by opium. One does not voluntarily evoke them, he asserts. Instead, continues Breton (quoting Charles Baudelaire now), images "offer themselves . . . spontaneously, despotically." Questioning whether images are ever really evoked, Breton expresses the doubt that any poet actually can apply Pierre Reverdy's celebrated formula for making images by bringing more or less distant realities together. It is Breton's contention that two unrelated realities either come together on their own or do not. Intentionality in the poet should not be credited with having influenced what takes place.

The original surrealists in France agreed with Breton in denying emphatically that deliberate intent can assume a positive and constructive role during the manifestation of an image. Hence, the techniques by which they began seeking to capture images of their own were designed to facilitate a *rapprochement* (Reverdy's word) that, so they argued, cannot be effected by conscious means. According to the *Manifeste du surréalisme*, premeditation played no part in the making of certain of Reverdy's images. Taken at face value, this statement is a surprisingly bold one. We understand it better after reviewing Breton's later practice as a poet. Then we glimpse in his denial of premeditation the very basis

of his theory of poetry and find ourselves led to the crux of his surrealist methodology, so far as it promotes image-making.

In the perspective proper to surrealist creative activity in Paris, remarks by two artists working in different media complement one another in a manner quite enlightening. The first of these artists is Yves Tanguy, who once explained, "I found that if I planned a picture beforehand, it never surprised me, and surprises are my pleasure in painting."[2] The other is Breton, who tells us that to him *therefore* is the most hateful of words. Breton implies a useful working definition of the surrealist image, when talking of "the only *evidence* in the world" as "governed by the spontaneous, extra-lucid, insolent relationship established, in certain conditions, between this thing and that, which common sense would hold us back from bringing face to face."[3] Expanding these comments, he goes on to observe in the same context, "Poetic analogy has this in common with mystic analogy that it transgresses the laws of deduction to make the mind apprehend the interdependence of two objects of thought situated on different planes, between which the logical functioning of the mind is not qualified to erect a bridge and is opposed *a priori* to the erection of any sort of bridge" (p. 113). However, just like two of his associates in surrealism, Tanguy and Eluard, Breton takes care to stress his opposition to the idea that a prior model exists for poetic imagery to reflect: "Poetic analogy differs fundamentally from mystic analogy in that it does not presuppose in the least, through the thread of the visible world, an invisible world tending to manifest itself." The message is unambiguous and highlights the originality of the surrealist concept of the image. Alogical surrealist imagery, we gather, is investigative and revelatory, not merely recapitulative or interpretive.

The distinction made here is important enough to warrant a moment's consideration. Surrealist imagery does not recapture the already seen. Nor does it depend for acceptance on our ability to perceive that the image-maker has offered an acceptable likeness of the known. Nor, again, is imagery of the kind surrealists value meant to command respect for its success in revivifying the known by presenting it in a novel or otherwise impressive light. It is by departing from the norms of perception and representation that the surrealist image makes its audience see. Denying and casting off the limitations that map the accustomed, it draws us beyond these. Reference to past experience is of no avail, except as we attempt to estimate the distance traveled into a world beyond the familiar, into a zone where the habitual has given way to the surreal. All this is a game, certainly, but one that finds its basic rules in

the conviction that revelation is more stimulating to the imagination than recapitulation.

Accepting that a surrealist work "qualifies," to borrow Breton's term,[4] by "the spirit in which it has been conceived," we have to address ourselves, next, to a central question. How is a surrealist image conceived and how is it executed? Answers escape us until we acknowledge the special virtue in imagery to which surrealists attach value.

Typically, the surrealist image is not initially worked out in the artist's head and then carefully rendered as it is externalized. Rather, it is recorded in the act of execution. In essence, this means that the viable image does not precede its expression, leaving the artist free to devote attention, subsequently, to aesthetic preoccupations as he seeks a mode of communication for what he has conceived. On the contrary, to the surrealist execution—conventionally the manner in which conception is given form so that it can be shared with others—is not simply formulation but the exciting cause of a revelation that takes shape in an image derived from no model. When we place Eluard's idea of the image based on no previous model next to Ernst's essay called "Inspiration to Order," we arrive at a clearer understanding of the meaning behind Ernst's ambition of forcing inspiration.[5] Ernst was a long way from believing images must or even can be made to yield to external pressure like a lock that, once forced, is of no further use. He was alluding to prodding inspiration into action by means that force it, if truly productive, to precipitate an image not only imaginatively stimulating but also entirely unforeseen.

Such means are valid, obviously, only so long as they really work. Yet they are no less worthy of esteem, surrealists maintain, because they do not work every time to the immediate advantage of anyone and everyone who cares to resort to them. It is obvious that André Masson ended up unable to go on accepting the rules of the game invoked somewhat obliquely by Aragon. One of the pioneers of pictorial automatism, who in the 1930s entitled a public lecture "Painting is a Wager," Masson eventually turned away from surrealism, firmly rejecting its tenets. Nearly three decades later he was to utter the complaint that automatism in painting is much like fishing: you never know when you will hook a fish or an old boot.[6] Of course, that is precisely the point. A painter who longs to exercise faultless control and aspires to a guaranteed method for acquiring it needs a technique that will bring home a catch after every fishing expedition. Such an individual is going to steer clear of surrealism, just as surrealists are going to ignore him and his work.

We face, here, something other than a restatement of the old dispute between inspiration and technique. Surrealists do not place their faith

in methods calculated to refine the raw material furnished by inspiration. Nor do they trust inspiration alone to supply fully satisfying images. They turn to techniques with proven ability to release surprises. They look to working methods capable of bringing to light imagery that experience has taught them cannot be obtained by other means. Surrealists, in fact, do not employ a technique so much as place themselves gladly at its disposal, eager to witness its power to precipitate a new image.

People skeptical about the 1924 *Manifeste du surréalisme* usually agree in protesting that the description it offers of the method of automatic writing is unconvincing. In so doing, they tend to lose sight of what really matters. Breton and those for whom he spoke in his manifesto were not persuaded they held at last the key to instant success at image-making. Breton was simply anxious to share with others the discovery that certain alternatives were accessible to individuals disenchanted with inherited procedures consecrated by literature and even (as a tentative footnote makes plain) by painting, too.[7] Since the first manifesto came out, the automatic method has been subject to abuse and ridicule. However, no amount of scoffing can invalidate one basic fact. The principle underlying automatic writing has ushered in a variety of methods for bringing out images that, but for those techniques, would never have existed at all.

An individual can go on being completely ignorant of those methods, be no less in the dark about how to practice automatic writing, even have not the haziest idea of what that kind of writing is, and still feel confident in raising one objection. If all the techniques I seem singularly disinclined to describe or even to identify are so reliable, then why cannot anybody at all use one or other of them to make authentic surrealist images of his or her own? Why cannot respectable results—exciting ones, even—be achieved by someone who, although not committed to surrealism, happens to feel in the mood to experiment, or merely is vaguely curious? After all, Ernst confessed to having come upon one such technique—frottage, a mechanical procedure of rubbing—and to having discovered its merits one day when rain confined him to his hotel room during a summer vacation.

These two questions sound perfectly fair. Really, though, they divert attention dangerously from essentials. It is as impertinent to ask why surrealism does not yield its secrets to the first comer as it is to ask why Péret kept writing poems that he never recognized afterward as his own but that nobody acquainted with his writing could mistake for anybody else's. It is no less impertinent than to ask why, if Tanguy was so eager to be surprised, he virtually always managed to make pictures we have

Max Ernst, *Airplane Gobbling Garden*, (1935–1936), oil on canvas. Private Collection. Photo Einson.

no trouble at all identifying as Tanguy's. We have some intimation of just how inapplicable those questions are when we go on to wonder why you or I could not write a Péret poem or a Breton poem, or why one of us could not paint a Tanguy canvas (what a way, incidentally, to make a surrealist image and money at the same time!). The most any of us could hope for is to manage to fabricate something that sounds rather like the one or looks quite like the other. We have already ascertained what kind of an image that process brings before the public.

One could fall into no greater error with surrealism than to suppose its practitioners earnestly devote both energy and ingenuity to devising modes of image-making expressly to compensate for lack of natural talent. The techniques promoted by surrealists are not favored as proven substitutes for native ability. This is to say that the purpose behind such methods is far from being to turn new recruits—or anyone off the street, for that matter—into instantly productive surrealist artists. Thus, the most serious mistake readers or spectators can make is to imagine they could do as well as the genuine surrealist artist, even better, if they only bothered to set about writing or painting in the same way or, to use the word, *style*. Attempting to do so would not leave the intelligent among us deluded for very long.

If we are to give surrealism the attention it deserves, we must comprehend what really is at issue here. Confusing surrealism with an effort to find shortcuts to artistic success, however dubious that success may appear to surrealism's opponents, has the effect of displacing its center of gravity, bringing the whole structure of surrealist thought tumbling down and causing the collapse of creative works through which surrealist thinking is externalized. Surrealists know well enough that their exploratory methods do not compensate for what an artist may lack. A technique proves itself, in their estimation, when it puts the artist in contact with creative sources hitherto concealed from sight or when it allows the artist to tap other sources previously out of range. In short, it all amounts to circumventing certain obstacles that surrealists find standing between them and the kinds of imagery to which their goals lend significance.

Among the largest and most threatening obstacles surrealists have to surmount is so-called common sense, which Breton saw as a negative element intruding between us and "the only *evidence* in the world."

Two elements demand attention before we can proceed further. Breton speaks of *evidence* and locates it "in the world," not outside reality. When a surrealist talks in this fashion, do we not sense a conflict beyond resolution? This may indeed appear so, as in the *prière d'insérer* written

Yves Tanguy, *I'm Waiting for You* [*Expecting You*] (1934), oil on canvas. Coll. Mr. and Mrs. Jerome L. Stern, New York.

Surrealist Image-Making 29

by Eluard for Péret's *De derrière les fagots* (1934). Here Eluard praises his fellow surrealist's poetry as characterized by "extra-lucid" images, "evident as *the strident cry of red eggs.*" It takes no major effort to identify the words underlined by Eluard as an image borrowed from Péret's collection. But what about seeing such an image as *evident*? The difficulty is that it does not seem to have its source "in the world."

Eluard's brief text promoting *De derrière les fagots* is a mini-manifesto of surrealist poetics. It opens with a statement of principle: "One of the principal properties of poetry is to inspire in frauds a grimace that unmasks them and lets them be judged." What better way to catch the attention of readers' who may not have grimaced but who have been betrayed by a slight moue of puzzlement upon their first encounter with the strident cry of red eggs? Next, Eluard explains why he once admitted Péret to be a greater poet than himself and also why Péret's reputation in surrealist circles is, and appears likely to continue to be, unrivaled: "Like no other, the poetry of Benjamin Péret encourages this reaction, as inevitable as it is useful." Why, exactly? Because "it is endowed with that major accent, eternal and modern, which detonates and makes a hole in a world of prudently ordered necessities and of babbling old refrains. For it tends, with its extra-lucid images . . . toward a perfect comprehension of the inhabitual and toward its use against the ravages of malignant exploitation by stupidity and a certain form of good sense."

Reluctance or, worse, open refusal to acknowledge the kind of evidence in which surrealists take an interest invariably fosters an inclination to treat surrealist images as defying lucidity, as extra-lucid because they stand outside it. Surrealist imagery cannot be grasped as extra-lucid so long as "a certain form of good sense," firmly based in the routinely familiar, is permitted to curtail audience response.

In opposing what is commonsensical, surrealists resist the ravages of that good sense condemned by Eluard. Hence, the special regard they share for the poetry of Péret: "For it militates insolently in favor of a new *régime*," Eluard contends, "that of logic linked with life not like a shadow but like a star." Logic is not the precipitate of past experience, the agreed process by which one advances commonsensically from the habitual toward the as yet unfamiliar, soon to prove itself acceptable to reason. Surrealist logic extends ahead, a star to guide the poet forward into the unknown that has no need of approval by reason in order to gain acceptance. Hence, the surrealist's preoccupation with evidence obtainable through "insolent" relationships, set up in the act of surrealist image-making. Such relationships are insolent to the degree that they betray disrespect for "a certain form of good sense." Yet they have not

been painstakingly put together in deliberate defiance of reason but have come into existence where reason's supervision of associative thought has been evaded. So far as it operates against common sense to generate images embodying insolent relationships, surrealist methodology functions positively by efficiently neutralizing the retarding influence of rational opposition to the development of imaginatively challenging relationships between words or pictorial forms in which unprecedented poetic analogies take root.

Whether articulated or not, commonsense objections convey to surrealists the indisputably negative effects of rationalism inhibiting or even completely undermining surrealist imagery. When a person declares under provocation, "You can't say that," he actually means common sense does not approve something that, already having been said, demonstrably *can* be. One potent reason surrealism first gathered momentum in the field of spoken and written language is that its earliest adherents had made a discovery of fundamental importance. They had come to realize they could say anything at all, provided they broke out of the confinement imposed by the commonly held supposition that language is and must always be the medium of rational communication. Reviewing the definition of surrealism furnished in the first *Manifeste*, we are reminded that it "rests on the belief in the higher reality of certain forms of association" neglected in the past (p. 40). These associative forms are higher, we are to infer, because they surpass any condoned by reason. Hence, this accompanying belief: "Language has been given man so that he can make surrealist use of it" (p. 48).

Having made their capital discovery about the liberative capacity of words, the surrealists did not throw themselves self-consciously or self-indulgently into verbal incoherence. From the start, their concern was not simply to destroy language but to place it on a new footing where it would be unencumbered by the weight with which rational discourse limits its ability to serve as a vehicle for communication. Communication was to remain the justifying cause of all forms of poetic activity. Not for a moment did surrealists fail to be aware that the artist addresses an audience with whom he must make contact through his work. What had changed—necessarily, in their estimation—was the manner in which communication was to be effected and the nature of the contact achieved through works created by new means in which their ideals and ambitions led them to place trust. Their viewpoint fostered the fundamental and broadly influential conviction that rational comprehension is neither the key to assimilation nor the pathway to communication.

In his *Manifeste du surréalisme* Breton confided, "I am in no hurry to understand myself." And why was this? Because he looked, as he said,

to "a miraculous compensation" to intervene when he used words—"and it does intervene" (p. 48). So long as the function of language is assumed to be to hold itself at the disposal of reason, surrealists were quick to conclude, the purposes of poetry are defeated. This deduction at once became the proposition in which all forms of surrealist investigation—and not only through words—found their source.

There is a centrally important fact to be taken into account by anyone seeking correct measurement of the significance surrealism has had for the twentieth century. A discovery leading to the drafting and publication of Breton's 1924 manifesto certainly inspired, initially, renewed confidence in the capacity still possessed by words to meet needs left unsatisfied by verbal poetry during and after the First World War. Had the consequences of that discovery been limited to modifying use of verbal language, the influence of surrealism on the century that witnessed its birth would have been much narrower than it has proved to be in the areas of theoretical discussion and creative action. It is folly to regard surrealism as a literary school mainly influential in the domain of verse expression; it is nothing short of betrayal to represent pictorial surrealism as "literary," that is, as a clumsy adaptation to art of criteria designed for and best suited to literature. In fact, as the surrealist movement gathered strength, it became increasingly evident that rejection of literature had become the indispensable prelude to the first step taken in a direction pointed out by surrealism. From the outset, literature was synonymous in the surrealists' vocabulary with everything that weighs the artist down, chaining his work in content and form to outworn traditions from which no participant in the surrealist venture can expect anything of value.

On the one side is understanding. Here artist and public have no difficulty meeting on common ground. This is, however, ground on which surrealists are persuaded that no discoveries of any value can be made. On the other side is revelation, successfully resisting anticipation and defying evaluation by previously established criteria based on familiar experience. Revelation, surrealists believe, follows upon the application of image-making techniques of a special kind. These warrant esteem because they compensate miraculously for our incapacity to assimilate them on reason's terms and, in fact, preclude rational assimilation.

By excluding understanding, as we customarily speak of it, by releasing the image-maker from any obligation to present his work for reason's approval, does not surrealism plead for acceptance and approval of anyone whose claim to being an artist rests on nothing more than the public's inability to comprehend what he or she has accomplished? Must

not surrealism find room for such an artist in its ranks, strictly on the grounds that no one knows what he or she is about? We can begin to answer these questions only if we remember that, as Breton indicated, the first manifesto deals with poetic surrealism (p. 50). The important thing to bear in mind when we are considering the movement launched in October 1924 is that poetic surrealism is not restricted by any means to the exercise of verbal language. Hence, the benefits of "miraculous compensation" can materialize in other modes of creative expression just as well.

The advantages of escaping reason's jurisdiction, as enjoyed by the word poet on the plane of written or spoken language, are similar to those that came Ernst's way when he first tried out the technique of frottage, which he was to describe in "Inspiration to Order" as resting on "nothing other than the *intensification of the mind's powers of irritability*." The answers we seek are implied in Ernst's comment on the viability of frottage as a surrealist technique.

From the very beginning, the last thing surrealists aimed to do was set themselves outside criticism, safely beyond reproach in a zone where the creative artist need feel answerable to no one. Nothing is more alien to surrealism than granting artists such freedom of action as to leave them without any other goal than self-indulgence. There is something else to note, also. Any fool can take rubbings with black lead from floor boards on which repeated scrubbing has brought out patterns originating in the wood grain. But it takes someone better equipped than a fool to create with such rubbings a collection of graphic images like Ernst's *Histoire naturelle*. Ernst, it is well worth observing, alluded to intensifying the powers of the creative mind. He said nothing about infusing power into a mind that has none at all to begin with. It is fruitless to try forcing inspiration when and where inspiration is totally absent; it is no more profitable to deny reason, however vigorously, however earnestly, in the misplaced hope that this action in itself suffices to make surrealist poets of us all.

A leading practitioner of early surrealist pictorial collage, Ernst once coined the admonitory phrase, "It isn't the paste that makes the collage,"—which sounds so much better in French than in English or German: "Ce n'est pas la colle qui fait le collage." Blind dependence on surrealist techniques, Ernst wished to emphasize, cannot guarantee the miraculous compensations for which a true surrealist creative artist may look with confidence.

This brings us to another equally significant aspect of the fallacy that inevitably distorts the outsider's impression of the role images play in surrealist creative practice and of the mechanism of surrealist image-

making. What one must not forget is that the methods by which surrealists embark on making their images would be quite pointless, not merely evidence of fastidiousness, if the end result simply gave shape to a concept already implicit in thought or even worked out in advance. We lose track of an essential feature of surrealist creative practice if we fail to appreciate that the surrealist who knew beforehand where he or she was going would not even bother to set off. In this respect, surrealist image-making gives new meaning to the Baudelairian dictum, "Happy are those who leave in order to leave." The spirit of surrealist endeavor does not encourage either laziness, idle curiosity, or vanity. Instead, it demands rigorous elimination of such forms of self-indulgence and insists on total devotion to the pursuit of unprecedented discovery.

We must bear in mind that there was nothing unique about the floor boards from which Ernst took his first rubbings. He found in planks placed before him by chance nothing at all to grant him an enviable advantage over someone who might decide later on to follow his example and even to aim at putting together a sequel to *Histoire naturelle*. The special element giving Ernst an unequalled advantage was located in his sensibility, upon which the rubbings he collected acted as a welcome stimulant or, as he himself preferred to put it, as an irritant.

Practice varies considerably among surrealists. Eluard, we know, liked to treat the fruits of automatic writing as material to be placed, later, in poems he was writing. Péret was exclusively an automatist. Ernst, acknowledging the intervention of his "meditative and hallucinatory powers," found frottage most productive when he voluntarily restricted his own "active participation" (that is, we may assume, his conscious and deliberate participation), leaving the creative process to those powers and, hence, gladly remaining a passive witness to the birth of pictorial imagery. For Esteban Frances, meanwhile, the technique of grattage—scratching with a sharp instrument on a surface prepared with several layers of color—was an intermediary stage, beyond which an artist will progress as he or she explores the implications of an emerging virtual image.

Two things are particularly noteworthy in the use of characteristic surrealist techniques such as frottage and grattage. The first is the strictly mechanical nature of the methods in question, an aspect of surrealist image-making that easily persuades uninformed observers they could make surrealist images, too, if the need were pressing enough. More elusive, the second thing to note is the role reserved in the surrealist creative process for cooperation between technique and the artist's sensibility. In some cases, the artist's conscious contribution is minimal; in others it is quite considerable. And the degree to which

an artist shares actively in developing or bringing out the image to which technique has led may fluctuate not only from artist to artist but also from work to work, according to the degree of irritability displayed, by the sensibility at one moment or another.

It is a matter of opinion whether the image emerging while the artist remains a simple spectator is of greater validity than one in which his or her voluntary participation is pronounced. However, it is certain that surrealists delight in the sharp contrast between the simplicity of the method employed and the surprising results that can follow upon its application. This phenomenon is especially gratifying to them in view of their profound mistrust of and contempt for painterly values, rules of prosody, and all other considerations of an aesthetic order which they regard as inimical to true creative accomplishment in image-making.

It is tempting to read into the surrealists' scorn for aesthetic values handed down by the nineteenth century nothing more significant than a sign of iconoclasm directed against tradition's inheritance. Breton, for one, discovered that after the 1914–1918 war he no longer could look upon the mold of French Symbolism as suitable for giving form to poetic expression. It is just as true that artists other than he experienced no less keenly the need to reject tradition or to go beyond it without, for all that, identifying with the cause of surrealism or adopting its special attitudes and characteristic techniques. Appreciation of one fundamental fact, then, is crucial to understanding the surrealists' reasons for working the way they do: According to inherited values, respect for traditional modes of operation brings a modicum of assurance of competent performance and of achieving a decent minimum. In contrast, surrealist methods do not generate in people utilizing them the false hope that this or that technique invariably will guarantee quality, however this term is understood. Their operating procedures find support in the conviction, common to all surrealists, that certain techniques offer the promise of results incapable of being produced by traditional creative modes and channels, even though the promise is by no means a firm guarantee. In this very important respect, therefore, surrealist methods are by definition initiative.

When surrealists assert that images cannot be forced, they intend to bring to our notice two crucial features without which their imagery would lose its identifiable character as well as its purpose. First, a surrealist image cannot be obliged or forced to manifest itself so that, conveniently and with reassuring promptness, it will answer the artist's need for something new and exciting. However beneficent chance looks, from the vantage point of surrealist theory, no one must expect to exercise proprietary control over its operation and intervention in human

affairs. "Chance for fun and profit" is hardly the surrealists' rallying cry. Surrealist artists are resigned to being unable to bend chance to private will or desire. Many of them, in fact, see their primary role as placing themselves humbly and gratefully at the service of chance. If truly devoted to the cause of surrealism, not one hopes to exploit chance for personal gain, unless gain be interpreted as pleasure before the spectacle of an emerging unforeseen image. The popularity of group activities in which surrealists collectively invite chance to intervene in the framework of a pictorial or verbal game testifies amply to this. Second, common sense has no right to question what chance reveals. In surrealism, the impulse to domesticate imagery by way of rational explanation—viewed as entirely groundless and as, in any case, irrelevant—is consistently denied.

Considered within the framework of surrealist theory, inspiration to order is a particularly interesting concept. It conjures up ideal conditions under which the surreal manifests itself excitingly. For this very reason, perhaps, it alludes to results that outsiders find very easy to misinterpret. Ernst's idea was not to turn the artist's studio or his ivory tower, for that matter, into a factory designed to supply inspired works on demand, filling orders as they come in, effortlessly and with production-line efficiency. It is a mistake to begin with the assumption that Ernst imagined it possible to attain the level of fruitful inspiration by breaking down barriers separating the creative artist from access to the magic realm where inspiration can be enjoyed more as a right than as a privilege.

The obstacles Ernst aimed to overthrow exist in the individual artist, not in the world around him. Hence, means that render it possible to force inspiration are those that will allow each artist to take inspiration from within himself. The inspirational resources on which he is now at liberty to draw are his alone. So long as he remains honest with himself and with his public, his techniques afford him no occasion or temptation to plunder resources belonging to any of his companions in surrealism. "The bars," Breton once commented, "are on the inside of the cage."

Presenting the surrealist image-making process as an expression of the surrealists' antirational posture and of their abiding faith in chance has serious disadvantages. It limits the scope of surrealism and offers an incomplete picture of surrealist image-making. While there is more to be said—some of it in the pages that follow—one essential fact justifying the narrow focus imposed above is plain already: the arrival of the image—the goal of surrealist image-making activity—is not a purely gratuitous phenomenon in which the artist has no occasion to take

pride. As the image breaks forth, so the artist concurrently breaks in upon himself. Eruption is fruitfully balanced by irruption. The surrealist breaks out of confinement, reaching creative imaginative freedom in a moment of discovery that authenticates surrealist language, whatever form it takes.

3

GRAMMAR, PROSODY, AND FRENCH SURREALIST POETRY

The ambition was grandiose indeed that André Breton summarized in an article called "Les Mots sans rides" (Words without Wrinkles), published for the first time in a magazine he co-founded (*Littérature*, n.s. 1, 1 December 1922) and taken up in his volume *Les Pas perdus*, which appeared barely eight months before his first surrealist manifesto. He spoke, apropos of words without wrinkles, of "giving language back its full destination" (p. 167). For some people, among whom he included himself, this meant "making cognition take a big step forward." That is to say, no comprehension of the surrealists' ceaseless preoccupation with language is possible until we start from the realization that language fascinates surrealists because they demand that it serve cognitive purposes.

At once we become aware of a problem underlying the surrealist approach to verbal language. From the moment when surrealism first presented itself as a means of vitalizing poetic content and so of giving new significance to the vocation of poet, those in France who rallied to its cause were placed in a distinctly paradoxical situation. They were keenly sensitive to the inherent weaknesses of words as means of communication limited in use by the demands reason imposes on verbal expression. At the same time, they were excited by the limitless potential for poetic discovery they felt entitled to attribute to language. Their aspirations generated the tantalizing hope of all-power, agonizingly counterbalanced by awareness of the imminent threat of powerlessness.

This state of affairs would not have been important and, indeed, would have had an insignificant influence on surrealist theory and practice, had surrealism been originally, like Fauvism, a movement in painting. The confinement imposed by certain traditions of language usage was critical for surrealists in Paris because the young men who first joined Breton had already experimented with poetry. Thus, they had indulged in writing verse according to the custom of an established school of word poets, the Symbolists. The latter, while advocating certain forms of liberation, had denied the possibility of others, leaving some of their disenchanted, discontented disciples frustrated and aware more of what they now wished to do than of how to set about achieving their goals.

Reviewing the immediate consequences of the dilemma facing these impatient young writers, we are sure to find our attention drawn to several among them who revolted against accepted forms of poetic expression, especially as sanctioned by late-nineteenth-century usage. Prominent among these were Louis Aragon, Jean Arp, Michel Leiris,

Gordon Onslow Ford, *The Transparent Woman* (1940–1941), oil on canvas.

Grammar, Prosody, and French Poetry 39

and Benjamin Péret, whose work elicited from Breton this confession in *Les Pas perdus*: "I go sometimes as far as envying him his remarkable lack of 'composition' and that perpetual running with the current [*à vau l'eau*]."[1]

In Breton's text, the phrase *à vau l'eau* clearly is not given pejorative force, the sense of "going to rack and ruin." It is a reminder that the French surrealist leader admired the writings of J.-K. Huysmans, author of, in his own phrase, "a brief fancy, in the form of a bizarre *novella*" called *A vau l'eau* (1882).[2] Hence, we are afforded an opportunity to note that surrealists are far from disposed to reject everything written in the nineteenth century. Their opposition goes consistently to the rigid formalism that still straitjacketed almost all French poets during the century prior to their own. In the 1920s, the writers mentioned above stood at the forefront of surrealist poets, almost all of them in Paris, devoted to experimenting with words in ways that, in some instances, Dadaist iconoclasm may have helped foster but did not manage to channel into the negativity to which Dada was dedicated.

A moment's thought suffices, though, to make us aware that a substantial number of writers entitled to call themselves surrealists did not engage or did not persevere for long, anyway, in exploding poetic forms in the same ruthless manner. Reading their publications tempts us to wonder whether we should not be leveling at such writers the criticism outlined in Breton's article "Lâcher tout" (Drop Everything) (*Littérature*, n.s. 2, 1 April 1922), reprinted with "Les Mots sans rides" in *Les Pas perdus*: "Dadaism, like so many other things, has not been for certain people anything but a way of sitting down" (p. 131). Are we to find numerous older surrealist poets, Breton among them, guilty of "sitting down"?

Was it lack of ability or, rather, a sense of their function as writers that led several first-generation surrealists in France—as though they retained greater respect for tradition than their fellows did—to approach the language of poetry from a more familiar angle than the one chosen by Aragon, Arp, Leiris, or Péret? When we raise this question, placing it against the background of hope and doubt providing the setting for surrealist poetic endeavor in the period immediately after the 1924 manifesto was published, a few remarks by Aragon catch the eye.

With the self-absorption that, whether he was speaking of poetry or of cinema, generally characterized his published *chroniques* during the second decade of the twentieth century, Aragon referred in the seventh issue of *La Révolution surréaliste* (15 June 1926), the first surrealist magazine, to a recently published verse collection by Philippe Soupault:

"Georgia, I am speaking only for myself. I who, as no one else does, believe in the strength of words. This is a book that has made me think of their weakness." Here is a departure point for discussion, but little more. Although Aragon's notice goes on to confide, "I thought I was suddenly touching the weakness of words," it betrays some reluctance to face essential issues head-on. Declaring quite abruptly (and, it seems, somewhat inconsequentially) that Soupault's *Georgia* is "like the premonitory signs of the storm," it fails nonetheless to explain exactly what Aragon's compliment means. In fact, it does not even lead up to a complete sentence. Instead, it ushers in these few indecisive words: "When each blade of grass has become conscious of the sky." With all the good will we can muster, one can hardly affirm that Aragon has provided a firm conclusion from which fruitful deductions may be made. What comes quickest to mind is the article entitled "Philippe Soupault" in *Littérature* (n.s. 10, 1 May 1923) signed by Breton and consisting of four enigmatically blank pages. Could it be that the problem has nothing to do with Aragon's unwillingness to speak out, not to mention Breton's, but stems from the peculiarities, even the inadequacies of Soupault's poetry?

This question might be read as an introduction to a point-by-point contrast between the work of Aragon, a bold innovator in surrealist poetic form, and of Soupault, a cautious participant in surrealism who was born in the same year (1897). Yet one fact beyond dispute has the greatest historical significance for surrealism. The five-year period of experimentation from which Breton crystallized his *Manifeste du surréalisme* was inaugurated in 1919 with an investigation into the possibilities of automatic writing as a poetic tool, conducted in conjunction by Breton and Soupault, who published their results, *Les Champs magnétiques,* in 1920. In spite of his later tendencies, Soupault was not a reluctant recruit to the surrealist movement any more than he was an unwilling participant during the few years that he remained affiliated.

Still, one has only to place *Georgia* (1926) next to *Le Mouvement perpétuel*—the volume of poems Aragon published the same year—to observe some marked dissimilarities touching content and form. In the circumstances, it is particularly regrettable that Aragon's penchant for an ostentatiously telegraphic style appears to have precluded a forthrightness to which his readers surely are entitled, especially on the subject of the impending "storm" and on *Georgia's* precise role in announcing the latter's arrival. As things stand, one cannot but wonder whether Aragon really did intend to praise Soupault's work or whether he wished, rather, to hint at reservations that, for reasons of his own, he declined to state openly.

Actually, speculation about friction between Aragon and Soupault is

distractive.[3] The striking feature about Aragon's notice in *La Révolution surréaliste* is, after all, that its author should have undertaken (consented?) to review a book in which his own idea of poetry predisposed him to discover little merit.

Looking at *Georgia* brings to light something far more interesting than the mere possibility of disagreement between Aragon and Soupault on the nature of poetry. Soupault's collection presents certain stylistic features that, when we broaden our inquiry, we find him sharing with other first-generation surrealist poets. Even if, in Soupault's case, we pass over the evident influence of Guillaume Apollinaire, to whom the first poem in *Rose des vents* (1920) is dedicated, there is something decidedly familiar to a student of nineteenth-century French poetry about the sound of the opening lines of "Fleuve" in *Georgia*, despite their irregularity of form:

> Couloir longitudinal des grands bâtiments souterrains
> tendance obscure des lions parasites
> ô lune affreuse qui court comme une grande lueur
> fleuve
> les sillages des bateaux sont tes cheveux
> la nuit est ton manteau
> les reflets qui dormets sur toi sont tes écailles[4]

In the writings of other surrealists, too, there is evidence of a rhythm that we recognize as part of the heritage of nineteenth-century French verse. We are on familiar ground so long as we give our attention to syntactic patterns recurring in the work of several of the older French surrealists. Among these is Breton, whose contribution to *Les Champs magnétiques* includes "Usine," which tells us, "A égale distance des ateliers de fabrication et de décor le prisme de surveillance joue malignement avec l'étoile d'embauchage." The contrast could scarcely be more marked between the reassuring rhythmic symmetry of this phrase, on the one hand, and, on the other, the antirational vision Breton's words evoke: that of a surveillance prism playing mischievously (or is it spitefully?) with a hiring or recruiting star.

In his 1924 surrealist manifesto, Breton delighted in the feeling of imaginative liberation he had experienced through automatic writing. Yet, so far as grammar goes, his automatic texts (exemplified not only in *Les Champs magnétiques* but also in *Poisson soluble*, appended to the *Manifeste du surréalisme*) are indisputably conventional, to the point of being pedestrian. Breton's return to regular sentence structure and a certain stateliness of language as soon as he began practicing the verbal automatism in which surrealism took root thus repudiated the freedom manifest in the self-consciously experimental poems of his *Mont de Piété*

(1919). Observing that Breton appears to have taken a step backward, by Aragon's standards, anyway, confronts us with a question of primary importance. Addressing ourselves to the traditionalist form in which so many surrealist poetic statements are cast, should we be speaking of some kind of weakness on the author's part, or must we be prepared, on the contrary, to give credit for strength?

Born in 1896, the same year as Breton and Antonin Artaud, Gui Rosey published in 1933 his *Drapeau Nègre*. This long poem came out under the unambiguous imprint "Editions surréalistes," that is, at the surrealists' expense. No outside pressure, then, can be assumed to have been brought to bear on what the poet had to say or on how he expressed himself. Even so, despite its irregular form and revolutionary content, this poem looks quite traditional in regard to sentence structure. Its rhythms are not the least unconventional:

> Voici venir par les sentiers battus de fièvre lente
> le temps des grandes mues nocturnes
> de velours et des lucides incantations
> où l'homme
> briseur de morts et de mots
> gravit l'or escarpé
> plein de bruits
> comme une forêt vierge.[5]

In his "poème épique," *André Breton*, written in 1933 but not published until four years later, Rosey apostrophized Breton:

> Je hais comme toi un poétique effort qui finit en beauté
> Fausses manières de perle agité de frissons
> Je hais surtout l'art barbare d'écrire
> Le mot propre régnant comme un nombre
> A la place d'une étoile filante.

Rosey may well express hate—and ascribe it also to Breton—for "a poetic effort ending in beauty." He may declare his detestation of "the barbarous art of writing" and reject "the right word" in favor of "a shooting star." He nevertheless expresses his views in a creakingly old-fashioned manner: "I hate like you." Furthermore, it is no exaggeration to say that there is a rhetorical strain present in his epic poem, as in other texts of his. Not only that, the same rhetoric marks the poems of Breton's *Clair de terre* (1923), dedicated under an eye-catching title (Earth Light) to Saint-Pol-Roux. Here "Amour parcheminé" ends: "Parmi les freins et les edelweiss sombres se reposent des formes souterraines semblables à des bouchons de parfumeurs." So frequent are effects of the kind we meet here that it is fair to say that one of the distinguishing features of verse

by certain surrealists is inner contradiction. It brings together conventional (antiquated, some might say) rhetoric and adventurous images, as in Breton's aligning of unidentified subterranean forms and perfumer's bottle-stoppers.

The evolution of Breton's poetry is especially revelatory. It shows that his first collection, *Mont de Piété*, brought together texts experimental enough to warrant the designation "laboratory material." However, once he had become persuaded of the virtues of automatic writing, Breton returned—naturally and apparently without misgivings—to the strict grammatical form of Symbolist verse, at which, as a youth, he had tried his hand, just as Roger Vitrac (born 1899) had done in *Le Faune noir* (1919), dedicated to Henri de Régnier. From then on in Breton's writings, the poetic spark no longer would be struck either by ellipsis or by unprecedented extra-grammatical confrontations such as stand out in *Mont de Piété*. It seems that, once he had decided to place his trust in verbal automatism, Breton became quite proud of the ability obviously possessed by his subconscious to embrace the complexities of French grammar confidently and without a trace of reluctance when liberating images through automatic writing. "Entrée des médiums" (Entrance of the Mediums), an essay written for *Littérature* (n.s. 6, 1 November 1922) and reprinted in *Les Pas perdus*, speaks of certain phrases that welled up in his mind as he was falling asleep. In spite of the scorn he heaped in "Les Mots sans rides" upon "an only middling useful syntax," Breton stressed in "Entrée des médiums" that the phrases he heard just before he dozed off were not only "poetic elements of the first order" but also "in perfectly correct syntax." Something he did not acknowledge, though, was that his automatic texts usually took on a rhythm that would surprise a reader of Victor Hugo no more than it would a devotee, like himself, of the Comte de Lautréamont's *Les Chants de Maldoror*. One thing is clear, whether we infer that Breton was displaying inexplicable discretion on a point meriting frank discussion or whether we conclude that he had no comment to make because he was unaware of how his poems sounded. In his verse, we detect a traditional tone just as noticeable in the surrealist poems of Robert Desnos, for example.

In Barcelona on 17 November 1922 Breton praised Desnos as being "in this plain . . . at the present moment the rider farthest ahead" and as "a man free of all ties" (p. 211). Yet in the surrealist poetry of Desnos, as well as in that of Breton, instances of extreme linguistic adventurousness—*Rrose Sélavy* (1922–1923), *L'Aumonyme* (1923), and *Langage cuit* (1923)—are outweighed by far less innovative pieces such as "Vie d'ébène," from *Les Ténèbres* (1927):

Un calme effrayant marquera ce jour
Et l'ombre des réverbères et des avertisseurs d'incendie fatiguera la
 lumière
Tout se taira les plus silencieux et les plus bavards
Enfin mourront les nourrissons braillards
Les remorqueurs les locomotives le vent

(A terrifying calm will mark that day
And the shadows of lamp standards and fire alarms will fatigue the
 light
Everything will become quiet the most silent and the most talkative
At last will die the bawling infants
The tugboats the locomotives the wind)

Who can fail to notice the stilted inversion of subject and verb (by which, as children, we used to recognize that we were reading 'poems') in the last couplet? In texts of this sort, the instrument of language is used in a manner that appears to beg the question, when structural renewal in the field of poetic communication is under discussion. The pieces assembled in Desnos's 1926 collection *C'est les bottes de sept lieues, cette phrase 'Je me vois'* (It's seven-mile boots, that phrase "I see myself") come as an anticlimax after the volume's title.

Turning to the opening poem, "Georgia," of Soupault's *Georgia*, we may find ourselves responding to an incantatory quality that could have appealed to Artaud. In some verses, too, we have the opportunity to reflect on "Georgia night," "Georgia snow," "Georgia shadow," and so on. Nevertheless, this does not compensate substantially for the banality that faces every reader once the terminal word is dropped from each verse. This text comes nowhere near Péret's tribute to another woman, Rosa, in "Clin d'œil," from *Je sublime* (1936):

Je ne dors pas Georgia
je lance des flèches dans la nuit Georgia
j'attends Georgia
je pense Georgia
Le feu est comme la neige Georgia

True, lopping off the name *Georgia* mutilates the poem, but attributing adjectival value to that same word is a concession that the French language does not readily condone. At the risk of injustice—for these lines are typical neither of surrealist poets in general nor of Soupault in particular—one might say that the opening poem of *Georgia* gives the game of contrivance away. It brings to mind Artaud's sharp comment in *Le Pèse-nerfs* (1925): "The whole literary tribe are a lot of pigs, and particularly those of today."

It seems imprudent to suppose that Artaud would have condemned

Soupault for the most heinous crime against poetry known to surrealists: literature. It is surely a coincidence that Soupault's name (like Breton's) is absent from the third number of *La Révolution surréaliste* (15 April 1925), edited by Artaud, who could hardly have meant to condemn every writer known to him. Doing such a thing would have entailed attacking Leiris, whose "Glossaire: j'y serre mes gloses" appears over an important footnote signed by Artaud himself in the third and fourth issues of *La Révolution surréaliste* before being taken up and expanded in *Bagatelles végétales* (1956).

Wherever the truth lies, "Georgia" progresses in a manner that warns us to be cautious about granting it the status of experimental poem on the same footing as Leiris's "Glossaire," which provoked from Artaud the enthusiastic declaration: "Yes, here now is the only use to which language can be put henceforth, a means for madness, for eliminating thought, for making a break, the maze of unreason and not a DICTIONARY in which certain ill-bred pedants from around the Seine canalize their spiritual contraction." While accurate and fair, the argument that Soupault makes no great claims for "Georgia" only diverts attention from a central concern, somewhat less easy to identify in other surrealist poems that are far more representative.

Next to the stated purpose in Aragon's *Le Mouvement perpétuel*, which brings together texts written between 1920 and 1924—"I dedicate this book to poetry and shit on those who read it"—the aims of other contemporary surrealists sound relatively modest, less arrogant in some respects, more acceptable by the standards set by the French poetic tradition. Breton, to whom *Le Mouvement perpétuel* is dedicated, surely would never have felt at ease writing a poem like "La Route de la révolte":

Ni les couteaux ni la salière
Ni les couchants ni le matin
Ni la famille familière
Ni j'accepte soldat ni Dieu
Ni le soleil attendre ou vivre
Les larmes danseuses du rire
N-I ni tout est fini

(Neither the knives nor the saltshaker
Nor the sunsets nor the morning
Nor the familiar families
Nor I accept soldier nor God
Nor the sun to wait or live
The dancing tears of laughter
N-E-I-T-H-E-R neither all is finished)

With the possible exception of Desnos (at his most daring), not one of the writers named so far, we can feel certain, would have signed without hesitation the "Art poétique" in Aragon's *La Grande Gaîté* (1929):

Oh me demande avec insistance
Pourquoi de temps en temps je vais à
La ligne
C'est pour une raison
Véritablement indigne
D'être cou
Ché par écrit

(People ask me insistently
Why from time to time I start a
New line
It's for a reason
Truly unworthy
of being pu
T down in writing)

Neither "La Route de la révolte" nor Aragon's "Art poétique" appears in any anthology of surrealist poetry edited by a participant in the surrealist movement, be it Péret's, Pellegrini's, Bédouin's, or the *Petite Anthologie poétique de surréalisme* prefaced by Georges Hugnet in 1934. Still, only the *Petite Anthologie,* appearing soon after Aragon's defection to Stalinism, excluded him altogether. In both Péret's *La poesia surréalista francese* (1959) and Jean-Louis Bédouin's *La Poésie surréaliste* (1964), Arp (born 1887) is represented by, among other things, "L'éléphant est amoureux du millimètre" (The Elephant Is in Love with the Millimeter) from his *Poèmes sans prénoms* (1941), which explores language in the same direction as Aragon's surrealist poems: "Le papillon empaillé devient un papapillon empapaillé / le papapillon empapaillé devient un grandpapapillon grandempapaillé."[6]

The important thing, then, is that surrealists in France have saluted "the fabulous regiments of the plague" with Rosey, whose *Drapeau Nègre* declares that the spoken word "makes a fine poem tear out eyes and not provoke tears." They have undertaken, with Bédouin, to follow "the pure star of subversion." They have remained in full agreement with Breton's condemnation in *Les Pas perdus* of "the predilection, marked for a long time, for fixed forms in literary subject matter" and with his argument, "It is at the price of constant renewal, having to do notably with methods, that an artist can avoid becoming prisoner of a genre that he has or has not created himself." All the same, one feature goes unchanged in surrealists' handling of poetic language. In general, they have been averse to joining in the kind of iconoclasm that underlies

Arp's surrealist verse and some of Aragon's poems. They seem to lack the destructive playfulness of the former and the disrespect shown for words by the latter. By and large, the older surrealist writers in France have fallen short of demonstrating the boldness one would have expected in devoted admirers of Apollinaire, who once wrote these sadly prosaic verses:

> O bouches l'homme est à la recherche d'un nouveau langage
> Auquel le grammairien d'aucune langue n'aura rien à dire
> Et ces vieilles langues sont tellement près de mourir
> Que c'est vraiment par habitude et manque d'audace
> Qu'on les fait encore servir à la poésie

> (Oh mouths man is in search of a new tongue
> About which the grammarian of no language will have anything to say
> And these old languages are so near to death
> That it is really from habit and lack of boldness
> That people still use them for poetry)

All too many French surrealists, in short, appear to have succumbed to a timidity in contradiction with their well-publicized opposition to the poetic tradition handed down by French literature from the seventeenth century onward.

Over the years, there have been exceptions to the common tendency among surrealist poets to conform in their use of prescribed linguistic structures. These exceptions have been of such importance that they cannot be ignored. Nor can one dismiss them as aberrant departures from the norms of surrealist poetic expression. Surrealist poetry would be impoverished if we were to exclude the contribution of *Dialogues de mes lampes* (1941), *Tabou* (1941), and *Déchu* (1956), all by Clément Magloire-Saint-Aude (born 1912), of *Sens magique* (1957) and *Poèmes* (1968) by Malcolm de Chazal (born 1902), of *Odeurs d'amour* (1969) by Guy Cabanel (born 1926), and of *Mon Sommeil est un verger d'embruns* (1961) and *Le Poème commencé* (1969) by Pierre Dhainaut, who was not born until 1935. In works such as these we find vindication of an assertion Breton made as early as 1922, in "Les Mots sans rides": "What matters is that the alarm has been sounded and that henceforth it seems imprudent to speculate on the innocence of words. They are now known to have by and large a very complex sonority; in addition, they tempt the paint brush and people are not going to be slow becoming preoccupied with their architectural side" (p. 168). Who, after all, can ignore the "architectural side" of this couplet from "Reflets," in *Dialogues de mes lampes*: "L'extase le deuil la luxure / Au gras des glas des râles"?

The longer we extend this list of exceptional surrealist poets, however,

the more obvious it becomes that we have ceased to confine our attention to surrealist poetry in France, when we speak of Chazal (lifelong resident of his native Mauritius) and of Magloire-Saint-Aude (who never left his native island of Haiti and whose poems were not published in Europe until 1970). More than this, we are dealing with younger and younger poets who do not belong to the generation that concerns us primarily. Aragon, Desnos, Leiris, Soupault, and Vitrac all had parted company with surrealism before Dhainaut's birth. So had Jacques Baron, Georges Limbour, and a half-dozen others. Nevertheless, the very richness of the contribution made to surrealist poetry by a number of writers born after 1900 causes us to wonder why so few of the earliest surrealists in France did not attempt to investigate certain possibilities that they patently neglected or ignored.

Most of the poets for whom Breton made himself spokesman when he brought out his *Manifeste du surréalisme* declined to carry revolt to the very core of verbal language. For some of them at least, it was not simply a matter of continuing to abide by the basic rules of syntax commonly thought to be an indispensable prerequisite for meaningful communication. The rhetorical strain easy to detect in the writings of Desnos (all the more noticeable next to the daring manifest in his *Rrose Sélavy*, brilliant demonstrations of the "architectural" possibilities of poetic inquiry), Limbour, Rosey, and so on led to grandiloquence in some instances. As a result, the work of certain writers—among them several of the best-known poets—leaves the impression that they were content to disseminate surrealism's message of revolution within a framework of expressive language elaborated by and inherited from the poetic tradition to which, nonetheless, these authors had formally declared their unrelenting opposition.

However, no deliberate choice dictated the course of action that was to lead most surrealists into prolonging nineteenth-century practice in some noteworthy respects. The whole picture looks quite distorted if, from the outset, we do not admit the spontaneity with which prominent and influential surrealists of the first generation advanced along paths where other poets of quite different persuasion had gone before. Failure to acknowledge this basic fact and to give it full weight introduces an impression of artificiality and contrivance that entirely contradicts the truth and falsifies the situation.

To be able to set everything in correct perspective, we have to bear in mind that, before anything else, surrealists place their trust in "a particular light, *the light of the image*" to which Breton's 1924 manifesto says they are "infinitely sensitive." Nowhere in surrealist theory is there any foundation for the misleading supposition that becoming an authentic

surrealist word poet or remaining one calls for the ability to follow Aragon's example, shall we say, or to engage in the kind of disruptive word play with which Leiris experimented when he defined *épaules* (shoulders) as "pôles des ailes disparus" (poles of disappeared wings) and said of *poussière* (dust), "elle pousse entre les serres de la lumière" (it grows between the greenhouses [*or* talons] of light). On the other hand, in his first surrealist manifesto, Breton attempted not so much to classify surrealist images as, he explained, to "take account, essentially, of their common virtue." Appreciation of the achievement of the majority of writers who pioneered surrealist word poetry in France (and, in this respect, in Belgium also) rests on full acknowledgment of the "virtue" of surrealism's imagery as conveyed within the established framework of conventional language structure.

Examining what might be termed the mechanism of the surrealist verbal image, we observe that its efficiency depends usually on the conjunction of a number of essential factors all helping invest surrealist word poems with their special quality. It cannot escape our attention that every one of the categories specified in the *Manifeste du surréalisme* is illustrated, in Breton's text, by examples showing the image-making process operating inside the bounds of regular grammatical form. This fact tells us something worthy of note. Whether published or not, Desnos's *L'Aumonyme* and *Langage cuit* as well as a number of poems gathered in Aragon's *Le Mouvement perpétuel* all antedated the redaction of the October 1924 surrealist manifesto. Including some examples from these sources would have presented Breton with no problem. Yet he evidently chose to exclude anything that was not impeccably grammatical, cast in unimpeachable syntax, meanwhile offering samples from Lautréamont and Pierre Reverdy to keep himself, so to speak, on the right track.

Aiming to divert language from everyday usage within the scope of commonsense communication, surrealists were wary, from the first, of the dangers of incoherence that go with the unregulated technique of leaving "words in liberty," advocated by Tristan Tzara. Review of Breton's evolution out of Symbolism into surrealism indicates that, for him, Dada was only an interlude offering him the chance to rid himself of retarding influences. Dada never really shook his faith in poetry, in the sacred nature of poetic expression. As a result, when he finally reached the conclusion that the poetic impulse had been renewed by way of his 1919 experiments in automatic writing, the intervening years of Dada militancy counted for nothing. Surely, rejection of Dada had at least a little to do with Breton's return to conventional form, preferred finally over *les mots en liberté* as a vehicle for poetry. The original surrealists

(most of whom shared Breton's disenchantment with Dada, in which they, too, had participated) seem to have accepted as their point of departure that the underlying laws of grammar are meant to serve the cause of communicability in language and so cannot be set aside without heavy penalty.

Surrealist poets, after all, do not want to isolate themselves in the unintelligible, even though they vehemently protest against the limitations present in rational thought and expression. They see far more advantage, it would appear, in enticing their audience along familiar paths of traditional and conventionally organized language, toward unforeseen surprises and revelations recorded and reported through words. Breton hints broadly at this in his first manifesto. Instead of associating surrealist language with obscurantism, he speaks with wonder and satisfaction of "an extraordinary lucidity, and in the sphere where I expected least of it" (p. 49).

Of course, surrealist poets would be singularly lacking in boldness if they were to abide by grammatical rules only out of fear of not being understood, of not reaching a public. Breton's contemptuous dismissal of *une syntaxe médiocrement utilitaire* (a middling useful syntax) proves that he was fully aware of and alert to the limitations to which a surrealist easily can find himself sacrificing all that really counts in his writing. In surrealism, grammar is not sacrosanct, something to be respected for itself or because it customarily receives respect from everyone else. If value is to be granted, it is for contributing actively to poetic revelation, as surrealists understand the term. We gain some idea of what is involved if we listen to Breton offering in the *Manifeste du surréalisme* a few representative examples of the imagery that impresses him most, "the kind that presents the highest degree of arbitrariness . . . the kind one takes longest to translate into practical language" (p. 53).

At the top of Breton's list are images embodying "an enormous dose of contradiction." These are exemplified in a number of "Textes surréalistes" that he himself published for the first time in the sixth number of *La Révolution surréaliste* (1 March 1926), among them this one: "Les rideaux qui n'ont jamais été levés / Flottent aux fenêtres des maisons qu'on construira" (The drapes that have never been hung / Flutter at the windows of houses that will be constructed). As a poetic statement, this affirmation draws strength, that is to say, it finds its challenge to habitual thinking—as communicated by *le langage pratique* (practical language), from which surrealists expect nothing valuable—from the conflicting time sequence it brings into juxtaposition, thanks to flagrant tense contrast based on firm, unambiguous grammatical structure. No reader can protest that he is incapable of comprehending what has been

said, on the grounds that the writer has failed to make grammatical sense. The poet has violated his audience's presuppositions about time and about the order it logically imposes on events, but he has done so without breaking any of the rules of syntax.

This is what is interesting in Breton's image and in so many that follow the same linguistic pattern. The contradiction from which it derives its capacity to dispute preconceptions in the rational mind is not merely condoned by grammatical structure but actually highlighted by grammar rendering meaning unequivocal. The image presented by Breton, then, represents not one but two of the categories cited in his first surrealist manifesto. It brings us face-to-face with a rationally inexplicable contradiction and also, as Breton himself bids us notice, "draws from itself a *laughable* formal justification." Functioning at the expense of commonsense thinking, syntactic form derides good sense. In so doing, it conducts us into the domain of surrealist poetry.

The regulatory effect of syntactical usage is actively solicited under the rules governing the game *Si . . . Quand* (If . . . When). Samples of this word game first appeared publicly on 1 June 1929, in a special issue of the Belgian magazine *Variétés* devoted to surrealism:

JP S'il n'y avait pas de guillotine
SM Les guêpes enlèveraient leur corset.

(JP If there were no guillotine
SM Wasps would take their corsets off.)

BP Quand les lacets pousseront dans les jardins ouvriers
SM Les cheminots se moucheront avec des pinces à sucre.

(BP When laces [or winding railroad tracks, or hairpin-bends, or snares] grow in workmen's gardens
SM Railwaymen will wipe their noses with sugar tongs.)

In the second of these examples, the images of the garden and the one involving railwaymen have already been provided by the two players (with due concern for grammatical exactitude, we notice). Therefore, the role of the relationships routinely assigned by grammar between main clause and subordinate clause (we note the appropriate use of the future tense in each case) is not, strictly speaking, to elicit unforeseeable images. Instead, grammatical linkage serves to connect two given images in sequential order, syntactically unexceptionable on a rationally unjustifiable cause-and-effect basis. Because the rules of the game deny the author of the second phrase knowledge of the content of the subordinate clause for which he has to supply a main clause, this relationship is established entirely by syntax. Thus, syntax not only creates the link

that grammar requires but also becomes the factor introducing a welcome (because fruitful) quality into the sentence: arbitrariness.

So far as intention is discernible in the game of *Si . . . Quand*, it lies implicit in the appeal (made a priori) to linguistic structure to impose a connection that grammarians will be unable to deny. Grammatical reconciliation is guaranteed in advance and—functioning as an open invitation to imaginative speculation—will stand up to whatever objections common sense may make. Instead of appeasing reason, the intervention of grammar prompts reason to formulate, though quite ineffectually, even more objections than when the two phrases existed independently and quite apart from one another.

In the second of the two sequences quoted above, interpretation of *lacets* in its primary sense puzzles the reasoning mind, unable to assimilate the idea of laces growing in a garden of whatever kind. Mention of *cheminots* in the main clause seems to urge substitution of another interpretation of *lacets*: winding railroad tracks. This associative process—traditionally considered the key by which an apparently obscure image may be unlocked—causes only more confusion to reason, instead of satisfaction. We are still left wondering how to make tracks grow, where the seeds come from, which is the best fertilizer to use, and so on. The same holds true of the following:

SM Si les bottes de paille dissimulaient leur envie de flamber
BP Les moissons seraient bien belles

(SM If *Les bottes de paille* were to hide their *envie de flamber*
BP The harvest would be very fine)

Two phrases have been left untranslated in this example because the reassurance that grammatical form appears to promise rational thinking—if *this* is so, then *that* follows—turns out, in the end, to be quite illusory. When reason attempts to render a poetic image as a prosaic statement of fact, linking *bottes de paille* to harvest time by interpreting it as "trusses of straw," it is thwarted by the disconcerting intrusion of a noun, *envie*, which helps reinforce the personification introduced earlier by the verb alluding to dissimulation in the subordinate clause. "Leur envie de flamber"—their wish to catch fire—we now discover, makes no more sense if *bottes de paille* is taken to denote "boots of straw." However, it does not make any less sense, either. To reason's logic surrealists prefer the logic of unreason:

AB Si les objets pleins étaient remplacés par l'intervalle qu'il y a entre
 ces objets, cet intervalle seul étant plein, les anciens objets servant
 d'intervalle
EP Personne n'arriverait à prendre quoi que ce soit

> (AB If full objects were replaced by the space that there is between these
> objects, that space alone being full, old objects serving as space
> EP Nobody would manage to catch anything at all)

It is significant that a word game popular among surrealists (who speak in *Variétés* of *Si . . . Quand* as an "activity that is not without charm") rests squarely on rules that demand unswerving fidelity to regular grammatical structure. For one thing, the prescribed rules guarantee in advance that the end product will assume a linguistic sequence that no reader or listener will have cause to reject as unintelligible. For another, abiding by these rules promises to create noteworthy tension between the conventionality of form and the unconventionality of substance. Voluntarily submitting as they do to the exigencies of French grammar (never open to accusations of laxity), the surrealists provoke an unexpected and profitable interplay between form and content.

If we examine *Le Mouvement perpétual* and *La Grande Gaîté* page by page, we discover that, on balance, Aragon's surrealist poetry is less structurally innovative than poems of his cited earlier. Moreover, the bolder the confrontation arranged between words in his poetic texts, the less likelihood there is of startling images such as Breton takes pleasure in transcribing in his *Manifeste du surréalisme*, in which Aragon is represented by two extracts:

> During an interruption in the game, while the players were gathered around a bowl of flaming punch, I asked the tree if he still had his red ribbon [i.e., the ribbon of the French Legion of Honor].

and

> A little to the left, in my guessed-at firmament, I perceive—but no doubt it is only a haze of blood and murder—the frosted brilliance of the perturbations of liberty.

Indeed, a later publication, *La Grande Gaîté*, in which Aragon advances further than ever before in experimentation with unconventional word juxtapositions, offers only one memorable image, in the poem called "Transfiguration de Paris":

> Mais le plus beau moment ce fut lorsqu'entre
> Ses jambes de fer écartées
> La Tour Eiffel fit voir un sexe féminin
> Qu'on ne lui soupçonnait guère

> (But the finest moment was when from between
> Its parted iron legs
> The Eiffel Tower let us see a female sex organ
> We scarcely suspected it had)

To say the very least, this image compares favorably with the preceding one as an example of imagery implying "the negation of some elementary physical property." Had "Transfiguration de Paris" appeared before the first manifesto, it certainly would have merited citation as a better instance than any of the lines appearing there as imagery that "sets off laughter."

In Aragon's earlier verse collection, where word play is less frequent and sentences are more uniformly traditionalist, we encounter many more images. "Un Air embaumé" begins:

> Les fruits à la saveur de sable
> Les oiseaux qui n'ont pas de nom
> Les chevaux peints comme un pennon
> Et l'Amour nu mais incassable
>
> (Fruits with the savor of sand
> Birds that have no name
> Horses painted like a pennon
> And Love naked but unbreakable)

Sometimes, we notice, Aragon's writing is not very different from Soupault's or Desnos's. In fact, at moments, it sounds even more conventional.

The poem entitled "Le Ciel brûlé" in *Le Mouvement perpétuel* has a highly irregular structure. Yet it introduces a curious anomaly: two successive verses modeled so perfectly on the alexandrine that each has a caesura placed according to the convention of French Classicism:

> Sous les grands rideaux cernés de cruauté
> Nous perdons lentement nos visages de plâtre
>
> (Beneath the great drapes circled with cruelty
> We slowly lose our visages of plaster)

Obviously, there is a world of difference between these lines and those making up Aragon's "La Route de la révolte" or "Art poétique." Attentive to structural differences here, we are in danger of finding them somewhat bewildering. This is especially the case if we open Péret's *Le Déshonneur des poètes* (1945) to the page attacking the poets—Aragon among them—anthologized in a recent publication assembling wartime patriotic verse, *L'Honneur des poètes*. Péret, who contends, "Not one of these 'poems' rises above the lyrical level of pharmaceutical publicity," argues that "it is no accident if their authors have felt they should, the immense majority of them, return to rhyme and the classical alexandrine."[7] Does Aragon's surrealist verse manage somehow to escape stricture according to these standards, even though, during the 1920s, he was not above writing in alexandrines or arranging his lines in *rime embrassée*? Or are we to believe that his earlier display of traditional skills

invalidated the poems he wrote while affiliated with surrealism, including, incidentally, the rhymed verses of a text from *Le Mouvement perpétuel* called "Aux Prunes," dedicated to one B. Péret?

Le Déshonneur des poètes positively identifies formal convention with decadence in poetry: "Form and content necessarily retain a most narrow relationship and, in these 'verses,' react upon one another in a headlong canter toward what is most reactionary." If Péret's basic hypothesis is to be treated as unassailable, then it appears that we must credit Aragon with writing revolutionary poetry only when he eschewed rhyme and inherited verse patterns, the stigmata of the reactionary poet.

Péret's profound mistrust of fixed forms—shared by surrealists in general, and not only in France—rested on the supposition that form inevitably limits content while disciplining it and so directs poetic expression into reactionary channels. Péret looked upon the relationship between form and substance as necessarily unproductive because he believed it impedes poetic freedom. However, a rereading of Aragon's two verses from "Le Ciel brûlé" does not support this theory. Nor does examination of the following line from "La Faim de l'homme," in *Le Mouvement perpétuel*: "Mon ombre se dénatte et tout se dénature" (My shadow unbraids itself and everything is distorted [*or* changes its nature]).

Whether or not parody of a famous verse in the nineteenth-century poet Alphonse de Lamartine's "L'Isolement" is intentional ("Un seul être vous manque et tout est dépeuplé"), it is evident that we are facing the kind of play upon words in which Arp indulged with such pleasure and that Desnos reserved for *Rrose Sélavy* and *L'Aumonyme*. In "La Faim de l'homme," word play is submitted to no restrictions at all by the classical alexandrine form in which it is cast. Placing "Mon ombre se dénatte et tout se dénature" beside the two alexandrines culled from "Le Ciel brûlé," we observe that in each case the caesura has a dramatizing role to play. It engineers a pause before the surprise arriving with the second hemistich. In each case, the full impact of surprise (which Breton was to contend must be sought "*unconditionally*") comes only in the last tetrameter. Thus, the rhythmic pattern laid down by verse structure throws into prominence that part of the line most resistant to assimilation by rational thought and to translation into what Breton termed "practical language": *cernés de cruauté, de plâtre*, and *se dénature*. In short, the rhythmic pattern of a highly respectable verse structure with a long pedigree accentuates, every time, a superstructure of antirational imagery.

It would be a serious error to suppose that when a surrealist happ
to follow rhetorical patterns consecrated by the venerable traditions
French prosody, he inevitably weakens his poetry. Conventional enoug
in form to sound classical, Aragon's alexandrines are aggressively revo-
lutionary in substance, their enigmatic content successfully evading rea-
son's jurisdiction and actively soliciting imaginative speculation. What
is more, the principle does not change when, examining how a surreal-
ist formulates what he has to say, we turn from rules of prosody and
consider the contribution made by the fundamental requirements of
grammatical communication.

For most of the first-generation surrealist writers in France (and this
is equally true of Goemans, Lecomte, and Nougé, counterparts in Bel-
gium), following grammatical rules was not simply the most appealing,
most promising, or least offensive option, preferred over several alter-
natives. Fidelity to traditional prosody was intermittent and, no doubt,
accidental more often than it was intentional (though we have to remem-
ber that Aragon, for one, and Breton, for another—"Hugo is surrealist
when he is not stupid"[8]—admired Victor Hugo). Yet regard for the basic
customs of the French language appears to have been instinctive on the
surrealists' part. All the same, it brought them a discovery they could
have neither foreseen nor planned. They found that, far from blunting
the poetic image, conventional linguistic structure could sharpen it;
instead of lending support to *le langage pratique*, it subverted it. Thus,
whatever Péret may have felt entitled or obligated to say in opposition
to fixed poetic forms, it takes no more than a cursory glance at his
poems to reveal one thing. While no surrealist has practiced automatic
writing so consistently and with such brilliant success as he, none has
demonstrated more respect for the rules of sentence structure or turned
them to better account in drawing upon conventional reality to the
benefit of surreality.

It would be foolhardy to ignore the element of play that contributes
significantly to the verse of Aragon and Arp, for example. It would be
simply foolish to ignore the fact that these poets—just like Desnos in
Rrose Sélavy and Leiris in his glossary—experimented self-consciously
with words as sounds more than prescribed sense. All the same, a few
questions remain. Answers to one or two of them suggest themselves
more readily than responses to others.

Did Aragon just happen to parody a verse by Lamartine, known to
every French high-school graduate and dropout? Did a taste for parody
dictate his occasional (and, hence, mocking) use of the classic French
verse form, the alexandrine? Did the surrealist principle of seeking

surprise—not only for itself but, as Breton emphasized, *unconditionally*—impose upon surrealist word poets of the first generation certain conditions, knowingly respected? And did these entail deliberate choice, in some instances, rather than pursuit or acceptance of a "gratuitous encounter," admired by the original surrealist group in France and by their successors too? In earliest surrealist writing, was the contrast between the surprising image and the conventional form in which it was conveyed invariably accidental?

Some of these questions will go unanswered, continuing to elude solution, however much evidence we care to examine. Nevertheless, the confidence with which we can respond to others already indicates something worthy of remark. When the surrealist movement began, the poets who enlisted made a discovery from which they were not slow to profit. Gaining access to the surreal and putting one's hands on the means for reporting what is to be found in the domain of the surreal do not require setting aside all the basic tools of traditional French poetic expression. They demand only that some of these tools be honed differently, be turned to uses for which they were not designed but to which they prove to be adaptable. Not every surrealist word poet, especially among those of the first generation, took the fullest liberty with the language and form of poetry. Even so, there is not one among the surrealist poets whose work fails to back up Breton's statement in the *Manifeste du surréalisme*, "Language has been given man so that he can make surrealist use of it" (p. 48).

By whom has language been given? Surrealist theory invariably skirts this issue, just as Breton avoids discussion of the origin of man in *Nadja*.[9] Theoreticians of surrealism have shown themselves more than reluctant to admit that human aspirations can have any source outside man, that there can be any extrahuman measure for his achievements. It is surely a sign that Bretonian thought was still at an early stage of evolution that Breton speaks in his first manifesto of language as *given*. Time brought greater sophistication, certainly, and also a bolder ambition. Surrealists came to look upon poetically expressive language as the *object of conquest* that it surely was for Jean-Pierre Duprey.

4

JEAN-PIERRE DUPREY

Among discoveries of a kind enthusiastically hailed as annunciatory by the surrealists in continental Europe was that of English nonsense verse. Despite André Breton's preference for German models over English ones, Louis Aragon's translation of *The Hunting of the Snark* (illustrated by Max Ernst) in 1929 and, exactly three decades later, Robert Benayoun's translation of Edward Lear, *Bonjour Mr. Lear*—to be followed a year after by his *Anthologie du Nonsense*—constitute firm evidence of appreciation among surrealists in France for the conquest of rational logic by disruptive playfulness. This defeat was all the more appealing to them for being without equivalent in either French or German literature.

When not simply arch or whimsical, nonsense asserted itself as consistent with the spirit of surrealism. It demonstrated, among other things, that attentiveness to rhyme in disregard of reason could produce pleasure such as was offered by the work of none of the English writers generally acknowledged as major poets of the period into which Lewis Carroll and Edward Lear had been born.

The celebrated *Anthologie de l'Humour noir* makes a case for humor, manifesting itself in certain very distinctive forms, as a critical commentary on life.[1] Nevertheless, the surrealists' admiration for a number of authors represented in Breton's volume lends itself quite easily to negative interpretation. Like the affection shown by surrealists for nonsense verse, it helps raise doubts in more than a few readers about the seriousness of an investigation into the poetic virtues of the written word formally launched by the 1924 *Manifeste du surréalisme*. This is especially

the case among English readers, who tend to treat nonsense verse with the placid indulgence its dismissive though amiable designation suggests.

If one were challenged to cite no more than a single writer's name in opposition to the argument that the surrealist approach to language is frivolous, a number of fitting candidates might be mentioned, Breton at the head of the list. None, though, holds our attention more compellingly than Jean-Pierre Duprey, the last and youngest author to have his name added to the *Anthologie de l'Humour noir*. This was a man whose early suicide confirmed the gravity of his poetic undertaking in its various directions, setting a seal upon his work as nothing else might have done.

The essential feature of nonsense is that it never lets us lose sight of the norms from which it departs. Unless aware of these, at the moment of reading and reflection we are in no position to measure the nonsensical with any degree of accuracy. Enjoyment of nonsense verse presupposes full realization by its audience of the distance separating it from the familiar, the customary, and the accepted, its defiance of usual modes of thought and conduct. Only with knowledge of the scale set by habitual experience can we judge how inventive this or that nonsense writer is. Thus, there remains an unbroken bond between author and audience. Between Duprey and his readers, in contrast, no bond of a comparable nature can be detected easily. Fancy is absent from Duprey's work, ousted by anguish, aptly described by Alain Jouffroy as "the cement that makes his poems blocks of indissoluble enigma."[2] This is an anguish to which he finally appears to have succumbed, presumably unable in the end to exorcise it through the act of writing. During a telephone conversation a few days before he died at the age of twenty-nine, Duprey remarked to a friend, "I am somewhat allergic to the planet."

The experience upon which Duprey drew in his poetry was intensely personal. His effort to deal with it through verbal language does not read like an attempt to communicate, even with the "happy few" whom the romantics self-consciously distinguished from crass, insensitive society. Instead, it stands as the record of an obsession, testimony to the poet's inability to reach his goal with certainty, let alone to share with his audience knowledge that they could comprehend and assimilate readily. *Derrière son double* (Behind One's Double), which Breton received through the mail (without forewarning and from a man he did not know) is an antirational discursion on life, in which Duprey's reflections center upon the elusiveness of a meaning he is trying to embrace.

Jean-Pierre Duprey, two untitled drawings on paper prepared with plaster (ca. 1958). Coll. Suzanne and Edouard Jaguer, Paris. Photos Marcel Lannoy.

The last poem of his to be published before his death closes enigmatically with the words, "But the mirrors are overpopulated, for I no longer can see anything in them."[3]

It is striving rather than accomplishment that the poet lets us witness from one end of *Derrière son double* to the other. The focal point of attention is "the Nothing place where Nobody lives." Duprey, then, has nothing to report, but everything to discover. The locus of poetic action is found within. The role of language, consequently, is to come to terms in some way with the uninhabited point that is Nothing. At the core of this writer's experience we do not sense anything so grand as a monument to the human sensibility, something we can pride ourselves in having attained and now many contemplate with admiration or complacency. Instead, we reach the ultimate confrontation with the void for

which a key image—in spite of appearances, more literal than metaphorical—is *le trou* (the hole).

We are a long way from being able to detect in *Derrière son double* even a faint echo of Gustave Flaubert's axiom, "The whole art consists in making something out of nothing." In fact, one could not be led further from Flaubertian aesthetics than in Duprey's strange disquisition, concerned with the presence of an absence signaled in his text by capitalization of its initial letter. *Derrière son double* is not an exercise intended to illustrate the adaptability of language to aesthetic purposes. Indeed, aesthetics would violate the integrity of Duprey's poetic venture.

Far from seeking to impose shape on recalcitrant subject matter, Duprey's first published book was meant to face the problem of dealing with ineffable formlessness, without distortion through an effort to reduce it to formal proportions. In this fundamental respect, therefore, the aim sustaining *Derrière son double* differed radically from Benjamin Péret's more easily grasped surrealist ambition: "the rectification of the universe."

Duprey's hope was not, like Flaubert's, to resolve on the level of art the conflict between the sensibility and the objective world. Nor was it, like Péret's, to correct nature by dominating outer reality during imaginative play, seen by the author of *Le Grand Jeu* as "the grand game" permitting the surreal to usurp the place of the real. Each in his own way and on his own terms, Flaubert and Péret felt confident that their chosen methods were sure to succeed. Duprey, on the other hand, approached very tentatively indeed the task he had set himself, conscious of its immensity and by no means certain that, when it was over, he would have arrived at his goal or even have brought it within range.

After examining the manuscript of *Derrière son double* on 17 January 1949, Breton wrote its author a more than polite letter, concluding, "You are certainly a great poet who has as his double [*doublé de*] someone else who intrigues me. Your lighting is extraordinary."[4] Breton was not too blinded by enthusiasm to recognize that Duprey's writings were scarcely free of external influence. First in his 1949 letter and later in the prefatory note to the Duprey selection (part of the second act of a play, *La Forêt sacrilège*, eventually published in 1970) in his anthology of black humor, Breton alluded to Alfred Jarry, after whose novel *La Dragonne* was named the bookstore-gallery where he had received *Derrière son double*. On the latter occasion, Breton correctly observed that the opening parodic phrase of Jarry's *L'Amour absolu*—"Let there be darkness"— appears as the core around which the work of Duprey crystallizes (p. 575). One cannot read *Derrière son double* without being reminded of the following passage in *L'Amour absolu*:

The place is empty, like the seat of a
ghost of theatre,
The throne where Nobody has sat.
Nobody.
One of the Persons.

In Duprey's writing, too, nobody *(personne)* becomes one of the characters, one of the persons *(personnes)* we encounter.

In his *Anthologie* Breton expressed the view that the preeminence usually granted light over darkness is "a remainder of oppressive Greek philosophy" (pp. 575–76). Meanwhile, Péret condemned the "philosophy of lights" that was the pride of the Enlightenment in France (an age that, according to him, produced only one poet: the Marquis de Sade).[5] Given this position, there is no cause to wonder at the French surrealists' predisposition to receive Duprey cordially and to read his work attentively. Duprey, for his part, would attend gatherings of the surrealist group, sitting in silence as though withdrawn into himself, an absent smile on his lips. Asked on one occasion how he enjoyed such meetings, he winked and grinned, "We don't have much fun, eh?"

Part 1 of *Derrière son double* proceeds "From the invisible of the eye to the glance of the mouth." The movement it follows is physically impossible, hence rationally unacceptable. The privilege of sight is withdrawn from the eye and conferred instead upon the mouth. Investigation is separated from contemplation of evidence perceptible to sight. Concurrently, exploration is attributed to speech: the mouth will see what the eye cannot.

The first and only act of a dramatic sequence (to put it more carefully, of a sequence cast in dialogue form[6]) has for its setting "the earth, the sky, the air, the sea, the void (sometimes filled with air) or nothing" *(Derrière son double,* p. 21). Against this imprecise background someone identified with unusual care as L'Homme au bonnet (The Man with the Cap) declares, "I've seen them all, with long crows' beaks fitted with false noses; they didn't catch me, but, closing my eyes, I recognized them alright because of their hollow orbits astride a long beak… This signifies no doubt that I've been dreaming."

We start at a disadvantage if we suppose that reference to dreaming comes as some form of excuse at the beginning of *Derrière son double.* Closing his eyes and withdrawing into dreams have earned L'Homme au bonnet the gift of vision. Discoveries do not accompany observation of whatever exists already for all to see. They follow upon an action shutting out things objectively present, in favor of others that are the fruits of language. In addition, they result from inner need. L'Homme

au bonnet tells us he has slept within the space "between the two lips of an abyss," specifying that this is "an abyss whose dizziness I have within me!" (p. 22). In short, he is prepared for his meeting with Monsieur H, who confides, the moment he speaks, "I count the days that have never been, the nights that will never be, the keys missing from the nights for opening the day and everything lacking to make something that lacks nothing."

Monsieur H's conduct is not to be taken for a simple inversion of normal behavior, a quixotic or clever way of arriving by the pathway of paradox at familiar ends. He is not slow to confess, "But my calculations are always incorrect... because of the zeros that demolish everything, you understand!" How to understand zeros said to be flat balls and circles, all "without contours in space"? Monsieur H's solution is to place his trust in holes, which he makes everywhere—in walls, in precipices, in drafts, even in his own head. "A hole," he declares, "is a very good thing, you understand! It makes a very good telescope for seeing all black at the end; one uses it as a magnifying glass to look in detail at the Nothing place where Nobody lives."

To Monsieur H, holes are "swellings of the void." More particularly, he looks upon them as "keyholes." But, as he himself asks, where are the corresponding keys? "That's the point to find. And that's that!" (p. 23). The homage to Péret, whose "Un Point c'est tout" (And That's That) dates from 1942, is discreet. It is present all the same throughout *Derrière son double* in word pictures like the one depicting a cat's head ending in woman's hair. Still, mere imitation is not Duprey's purpose. His imagery, we soon notice, has a violent quality that is without parallel in Péret's writing.

The second of two bodies identified simply by the first letters of the alphabet announces that they both take life from "the joys of the abyss." Even so, we do not know whether Body A is in fact dead or alive, while his companion asks, "But what if our death catches up with us and covers us with dry, drier, drier sand?" When Body A throws himself "onto the angle of thunder," it runs him through. The gleam of his blood, changed into blue flames, dances with lice all around the others present. The latter fade away, eaten up by the flames like figures drawn in chalk, quickly erased. Only one of them will be seen again.

The figures assembled on stage barely qualify as persons, have no recognizable characteristics to speak of, and can be erased at will, leaving no trace. Their fragility discourages belief in their existence as "real." Imaginatively created and nurtured, they can be allowed or made to disappear when the imagination ceases to be interested in them. Was Jean–Pierre Duprey ever truly interested in such creatures,

though? The way he begins orchestrating the themes of *Derrière son double* suggests otherwise. His dramatis personae merely supply the occasion for bringing those themes into focus.

Associated with that of illumination by way of darkness, the theme of plunging into the void recurs in the second scene. Here cask hoops become "the spectacles of the void," replacing the eyes, and "giving a glimpse behind the head of a little window" (p. 26). The window still remains "despairingly closed," however. Meanwhile, a new personage, L'Esprit-du-Dedans (The Spirit-of-Within) offers the sun "a subterranean key" that locks "the eyes of the sky's mummy." All the same, the question, "Spirit, where are you?" continues to go unanswered. In the third scene, sight has actually become "leprous," and we read of "the reality of a void." This is a propitious moment, we are informed, for L'Esprit-de-Dieu (The Spirit-of-God) and Monsieur H's "multiple bodies" to arrive on stage. The gesture of erasure emphasized earlier is, presumably, reversible.

The unity of the opening section of *Derrière son double* is thematic, not narrative. The interweaving of themes provides something quite different from evidence of technical command. It is a sign of inescapable preoccupations, welling up through language that is Duprey's chosen means of plumbing the depths of his own anxiety. It would be fruitless, therefore, to search for logical connections between the images presenting themselves. Pointless, also, would be seeking to explain why, exactly, Duprey likens cask hoops to "the spectacles of the void." Preciousness is not the key to his treatment of words. He links the latter by association, not design, the associative spark originating in inner compulsion, not concern for artistic effect. We notice, in this connection, that mental pictures normally generative of hope or fulfillment fail to bring release from anxiety. Like the "little window" of which a glimpse is offered, they remain "despairingly closed." Thus, images normally optimistic in nature surrender their potency to "the reality of the void."

Images here in general reinforce the impression of a closed world, distant from common experience and distinguished by qualities more negative than positive, peculiar to the universe into which Duprey advances. The sea is said to resemble "lower down, the hair of a tree" rolling endlessly branches that a wind, come from very far, propagates "in the direction of depth." Meanwhile, illumination assumes curiously negative features. When in scene 4 Monsieur H mentions "blinding lightning," he refers to it as "making a hole in the head and blocked face" of someone born blind. The adjective "blocked" leaves no prospect of alleviating the state of blindness, so emphasizing that darkness con-

quers light by rendering it ineffectual. In the Dupreyan universe, air is "dried water." Gravitational pull holds everything so tightly that upward motion is impossible. His double speaks of Monsieur H's head as weighing him down. He cannot carry it, yet cannot throw it off. It weighs "like a swamp anchoring in sand its tentacles scored with plunging weeds" (pp. 28–29).

References to the downward pull of gravity take on a premonitory ring, as do statements like the Double's claim that days and nights are "a rope that leads us to the end" (p. 29). Meanwhile, the compression of verbal language heightens the enigma, as Monsieur H alludes to "the midnight weight of a cellar laugh falling from a sky and pulling it after it into a cellar prolonged to behind the last world" (p. 30).

Logically, if not quite predictably, Part 2 of *Derrière son double* is headed "La Nuit prise comme profoundeur" (Night Taken as Depth). As a prologue it carries a letter in which Monsieur H tells Personage Y of a project he has conceived: a journey into "that country newly discovered or, if you prefer, invented by us" (p. 33). It is a country not to be named or situated geographically. Nor can its mores be described, for reasons of which the most important is that Monsieur H knows nothing of such things. The least he can say about this country is, "I strongly suspect it lies nowhere, which is sufficient." An account of his journey through the unidentified region is provided in a journal from which extracts now follow. Wishing to remain anonymous, Monsieur H declines to name and characterize "a personage of mine who, in fact, does not exist" and whom one might imagine under the name of Other or Everybody. Monsieur H's own preference goes to Nobody, "or better still and more simply: Monsieur H."

Monsieur H's journal, needless to say, is the diary of an imaginary journey beginning with the vision of the universe as "the swelling of an empty bowl" turned upside-down on (we are reminded of Ernst's 1929 collage-novel *La Femme 100 têtes*) "the skull of a headless woman" (p. 34).[7] Monsieur H (or perhaps his double, Monsieur H) is embarked on a voyage during which imaginative invention takes the place of discovery or, more precisely, becomes the only discovery deemed worth recording. In addition, positing the absence of any foreseen or preestablished meaning in events or behavior, Duprey is more than content to situate nowhere a voyage conducted "upside-down" or, indeed, not at all. Nowhere is a locale he presents as not existing, yet as a place one can still point out.

Monsieur H alludes in his journal to "that place where I was nothing, where Nothing was nothing, where we were nobody and where the

absent was ourselves deep inside me" (p. 36). He tells of wandering under "that canopy of which the center was a hollow inside the full void," and of pursuing himself. He recounts how from his right hand, torn in three, emerged silent birds "which pierced my face, digging down to the H point of my body where I did not know myself yet" (p. 37). Clearly, the imaginative voyage of discovery is an expedition into self-discovery in which Monsieur H, "sorcerer (I am introducing myself!)," is engaged. "I lost my body from the inside" (p. 39), confides this "sorcerer from habit" (p. 40). "Solitary in himself," he has seen "an abyss open up under the feet of ANYONE trying to climb," and now informs his readers, "And so it is that, pursuing our course upside-down, we arrived at the point of encounter with the beginning of time and with its end" (p. 41). In the postscript of a letter addressed to himself, Monsieur H admits that "what I had taken for my right eye was in reality only a green door opening in a circle onto the sea" (p. 44). He explains, "It was underneath that I dived," to find a way out, he specifies, "by the bottom."—"At that moment the color of my eyes passed the Cape of Great Night."

These extracts from Monsieur H's diary show it to be nothing at all like the fictional journals that have such a long tradition in France and elsewhere. Nor, of course, does it resemble in the least the self-consciously literary private journals (often meant for publication) that have no less respectable a pedigree. Nothing could be further than the second section of *Derrière son double* from Alfred de Vigny's *Journal d'un Poète*. Indeed, comparison of the texts demonstrates beyond dispute the radical difference between Vigny's romantic idea of "the Poet" (and consequently of the poet's role in society) and the commitment Duprey made as a writer.

"Celestial captain of the mystery-vessel," navigating "in a film without an actor," Monsieur H reports, "My glance made my eyes lose their breath" (p. 44). He projects the journal of his voyage on the luminous screen of the imaginary, in order to let us observe "the schematic vision of a globe bedecked with the capital scene" against the background of countryside "that comes to you from underneath." For Jean–Pierre Duprey, everything comes from underneath, from the hole, from the void. And everything returns there, "to a colorless hole, gentlemen, on the surface of the void." This is a hole that, "one day, gentlemen, you will have to measure in order to give triple proof of the exact dimensions of your nothingness," states a letter attributed at the end of Monsieur H's diary to a man who has died in a little distant town in "a country with no way out" (p. 46).

Stressing the absence of one or another element of reality normally assumed to be essential, Duprey makes us feel—often as a concrete presence—the universe of the void. Monsieur H's journal refers to the Place of Thickness (or is it of Density?) that has the form of a pyramid without a lateral face, of a hollow inside a full void, and of a dead man's flag "the color of colorless." It outlines projects that would produce truly surrealist objects, like fitting a guillotine with an ashtray, covering a thoroughbred horse with the bodywork of an automobile, and transforming a wild boar into a potato. The world finishes in chaos as, speaking through the mouth of his double, Jean-Pierre Duprey deprives it of habitual significance, so transforming the universe, seen at "the illegible hour" marking "one second after the end of infinities" (p. 48).

This is the point reached at the end of the second Part of *Derrière son double*. Its eighteen-year-old author seems persuaded of purely negative solutions, from which it is easy to comprehend why he suspended writing in December 1948. However, he returned to his text in 1949 to append a third section, written in February and headed "Solution H ou du second voyage imaginé de Monsieur H." There one senses, initially, a less pessimistic view of things.

Chalked on "a cube of air solidified in contact with the eyes" is an inscription: "HERE LIES, in the same place as a bone transformed into a bell clapper, the body—of Monsieur H—rolled indefinitely around itself like a whirlwind that will see its own end only when it knows itself to be changed into a powerful, though invisible, mass of a sphere full inside and void of its contours: which is only a supposition" (p. 51). We face no more than a supposition, perhaps, but one that begins less passively and more positively than before.

Behind "the windowpane of appearances-suppositions" hangs a thread, said to represent Monsieur H's mind, stretched—with a weight at the end—through the space "between the void and its hollow appearance." The location? "Somewhere, there was a star and it was there, there only, that things happened" (p. 51). We learn that, in choosing to disappear into the hundredth night ("then called matter-night"), Monsieur H chose wisely. Without a sound, we are told, he advanced inside himself. "I spent there an eternity calculated with a watch that did not run well; then I arrived at me. But my appearance remained unknown to me" (p. 53). Nevertheless, searching in his skull, he concluded that it was "no doubt J.-P. Duprey's."

The poet's double has at last reached the stage of recognizing his double in the poet. The revelation has an apocalyptic aspect, we are indirectly invited to acknowledge, as Monsieur H's account brings to

mind the Book of Revelation, while yet showing us something only Duprey has seen:

> And I heard:
> ... "There is no more sky, no more sun, no more night," said a voice, "no more light and the windows resemble sewn-up mouths, black but toothless . . ."

Now day goes back into the earth "as into a station," while the wheels of rumbling trains imitate "the incoherent accent of a phrase repeated a hundred times by the buffeting of the wind and brought to light in the lingerie of a fire" (p. 54). Incoherent though the phrase may sound, it has one word that stands out audibly. Out of chaos, instability, and uncertainty has come the redemptive logos: "ETERNITY." Duprey intimates that the conquest of eternity comes with elaboration of an inner vision, authenticated by the eye of the spectator-creator who, in *Dierrière son double*, bears the name Monsieur de l'éternel, "called Eternal-Father."

It is as though, early in 1949, Duprey had succeeded in making sense of his journey to "the other side of the eye" (the example set by Péret in his story "La Maladie du N° 9" was not to be ignored, evidently). Progress comes not with looking but with interruption of normal vision. This is why we read in this book a fragment "revealed from elsewhere," in which the poet speaks of sticking his finger in his own eyes and of recognizing there the color of his double. Suppression of the external world sheds light on the color of the double, seen in a night that is "a bright door." Here language effects the dialectical union of all that we have taken to be irreconcilable, a magical shift by which subjectivity triumphs over the elements present in the material world.

The third section of *Derrière son double* is followed by a passage headed "Entre Parenthèses" (In Parenthesis). Here, reversing the effect of the self-blinding gesture, the Eternal-Father waits for "the imaginary members of the brain's family" to emerge one by one from "the inner folds of his Eye" (p. 55). As for Monsieur H, he projects a few circus scenes on an imaginary screen that is nothing other than a decapitated general's kepi. His voyage "taking place in reverse or not taking place at all," we witness only the final scene of the last act. Monsieur H sees fit to reduce it to its minimum, a single word that, incidentally, does not occur in the dream he has let us read: "END." Action indeed has been reduced to "Mystery in its embryonic state" (p. 61). Upon invention of "an unknown language," Monsieur H announces that he will abstain from defining a more and more confused situation. He merely reminds us of his name—"Monsieur H or Nobody"—and reports, "The Journey, begun

at the period of the beginning of time, finished well before the first hour of time, but I continue it still..."(p. 62).

Duprey did not close *Derrière son double* with "Solution H," but followed it with three more sections. The part called "Trois Feux et une tour" (Three Fires and a Tower), written in January 1949, is a dialogue set in a field of thistles at the bottom of the sea. One of the two unidentified speakers reveals that he has let the other grow in order to deliver himself of the overflow of his "phantasmal thoughts" (p. 66). These are complementary figures, in other words, "the unity of water and fire, of crime and its proof, of death and its name, of rape and the void"—"We form a double chain with my nights of anguish and your days of sleep" (p. 67). One takes away the other's head, his teeth, and his body. Both "empty themselves." Then their voices do likewise.

In scene 2 the figures met in scene 1 now have names and are situated "outside time." When Talamède reminds him that, because he is in eternity, there is no way out, Quicri-Kirat asks, "But what is Me?" (p. 71) and muses about disappearing at once, leaving behind only "an occupied place."

The third scene takes the form of a "Conversation entre les dormeurs moribonds" (Conversation between the Moribund Sleepers). We are informed, here, that death is "A button I have in my navel, and, if I press it, the cadaver-hour will be announced" (p. 75). Meanwhile the beyond is "death seen from above, front face and in profile, seeing from the side." Talamède's interlocutor, Philîme, confides, "It is midnight on the torn clock face and I feel as though I am inside a hole." By the epilogue, Philîme has become Salex, whose companions, he declares, "will be suicides, hanged men, who will cry to me to go further" (p. 77). As for the poet, he "blows out the candle that casts light on us the one and the other," while Salex, Talamède, and Quicri-Kirat become "the inheritors of the estates of Death."

The ongoing collapse of the stable universe is documented further in "Dans l'Œil de miroir" (In the Mirror Eye), dating from January 1949: "SOMETIMES a voice rises, coming from no throat, to recall that the sea is everywhere. INDEED, it is everywhere, mixed with the air in such a manner that we see it fly, and the sun of that moment is a nightlight seeking the night to *enlighten itself*" (p. 81). Meanwhile the mystery of new relationships continues to impress itself upon us: "A great solitude and, in this solitude, a tree lights its fruit from the fire of the shadows." There is a corridor cut into the depth of the eye. "They say it links a pearl mine, oyster colored, with the gold but hollow teeth of the corpse left on account."

As before, strange creatures result from arbitrary word combinations to which logical connection and sequence are no hindrance. Hizal-Rex describes himself as follows:

> my eyeless face is, less the defect of the nose, a talking belly staring at uncombed hair inside the wheel of shadow-trapping silk. My hands and feet, similar in color, hang on the ceiling or defend the framework of a black skylight in which the glass is a pane of sunshine. My sex sweeps away the vestiges of man.—And so I belong to myself and I dream of an impossible spider's web folded upon a heart that beats in mine. (pp. 82–83)

As before, strange, quite inexplicable events occur, "an omelette of stars bursts somewhere like a tire" (p. 84). As usual, visions appear that have no counterpart in day-to-day experience. Born of night, darkness, and the unknown, they provide glimpses of horror and fascination linked with death, not life. A snake, for instance, says,

> Lower down than the roots, a corridor, starting from the golden interior of the corpse's mouth, in the form of a tomb, gives access to a white swimming pool of water, black and hard, a new theatre, in which the backdrop is hollowed out in incandescent coal—burnt blood. At the bottom of the hard water I found myself once more in a cold room, but, on the ground, a carpet of octopuses, which were sewn together, imprisoned my feet which now hurt me so much. Inside, leaning over the sky, a man of black visage was making stars flow into the black of his three eyes which then seemed hernias of the night.

Duprey was not content to cast his images in the worn mold of anthropomorphism. A brutal metaphor like "hernias of the night" is not meant to bring the inanimate to life after the fashion set by literary convention. Instead, it confronts us with the impossible, assembling terms we take to be irreconcilable, and bringing us face to face with the rationally inadmissible. *Derrière son double* does not submit us to the random alignment of unrelated words, such as apparently is legitimized by surrealist precepts. On the contrary, we are introduced to a relationship between man and his environment that has no precedent in literature. Born of tortured existential awareness, Duprey's verbal imagery has no literary pretensions and, in its author's view, no literary value either. The contrast could not be sharper, in *Derrière son double*, than between literature and poetry conceived and practiced as an exploratory venture from which all aesthetic concerns are banned.

The closing section of *Derrière son double* bears the date March 1949. It confirms that doubling, in Duprey's text, is a direct expression of desire and therefore betokens resistance to death:

However. Nothing is a windowpane that exists.
—I have pressed my eye to it and the transparency of that pane, become universal, has revealed to me the inside of the Inside!!... (p. 105)

Now eternity "opens wide, like an essential book to the page marked" (p. 106). Soon we read, "My book, oh my great book in which I learn to know the warmth of a double body, I open you at the missing page" (p. 112). Life has become "eternity sickness," with death an "eternized fall" or "Ex-termination by externity." Waking from oneself is, then, waking from death "posed as an enigma," while one's mouth is "a lighthouse overlooking esternity" (p. 113).

As for the existence of the double, it inspires the statement, "I can tell you again that the word END can be written anywhere and that it is no more than the diminutive of the Infinite... Blended with me, you are my beginning and I begin you over again endlessly (with the end)" (p. 114). We observe once more the role of the dialectical principle in *Derrière son double*. Duprey's sorcerer-double, Monsieur H—in his way an alchemist searching for the *supreme point*—discovers that each step toward the abyss seems to bring him closer to the "soul point." Hence, he aspires to "learn" his own soul. It is in this sense that the poet places himself behind his double, who will have managed to penetrate beyond the world of appearances and who will be, consequently, closer to that comprehension from which each of us is separated by death. One can grasp in this proposition the shadow of the enigma that descended on Duprey's work on 2 October 1959, the day he threw himself finally into the void. But it would be an error, apparently, to conclude in favor of anguish despairingly seeking a last way out through suicide. The poet who speaks in *Spectreuses* (written after *Derrière son double*, in June and July 1949) of "forms still outsideform" in the end succeeded in imposing a meaning on the void: "I am what I am and what precedes me.—This said, because I double myself and split in two." Without *Derrière son double*, we should have greater difficulty understanding why Jean-Pierre Duprey felt entitled to assure readers of *Spectreuses*, "We are walking toward ourselves!"

Duprey did not share Victor Hugo's faith in the divinatory power of verbal language. There is an obvious contrast between Hugo's pontifical "Ce que dit la bouche d'ombre" (what the mouth of the shadow says) and Duprey's reference to "la bouche d'ombre, celle qui bâille souvent" (the mouth of the shadow, the one that yawns often). All the same, it would be foolish to ignore the fact that Duprey worked all the last afternoon of his life on the poems of *La Fin et la manière* (The End and the Manner), before hanging himself from a rafter in his studio while his

wife was out carrying them to the mailbox. For him, the act of writing was never the acceptance of defeat. It was testimony to the inevitability of a confrontation of which the poet's self-elimination marked the climax. Moreover, Duprey—whom more than one observer has sought to represent as estranged by then from the surrealist group—wished his last poems to be read by someone whose opinion he respected. It was to Breton that he addressed his final texts, delivered posthumously.

Before voluntarily meeting death, Duprey had one more statement to make. It proved that *Derrière son double* is the very core of his written work. In *La Fin et la manière* the poem "Santé noire" (Black Health), for example, takes up the theme of the hole and affirms its author's conviction that sight and hearing, as we know them, are as inefficacious now as when he wrote at the close of the first act of *La Forêt sacrilège* (completed in August 1949), "APART FROM THAT, once again, I warn the spectators that what they will be able to see bears only a fairly distant relation to what passes in truth behind our eyes..."[8] This warning is of special import, not only to the hypothetical audience assembled to watch Duprey's theater, but also to anyone standing in front of his painting or sculpture.

Duprey turned to sculpting during the period of his life when it seemed he had abandoned written expression once and for all. After deciding in 1951 to devote himself to working in metal, he became an apprentice ironworker, until 1952 sharing his time among several foundries in Paris and Pantin. From 1953 through 1958 he participated in exhibitions of both painting and sculpture, before resuming writing the following year with his last book, *La Fin et la manière*.

The existence of sculptures and paintings side by side with texts of which virtually only *Derrière son double* had found an audience before his death proves the folly of separating verbal language from other forms of expression in Duprey's case. When Edouard Jaguer—with whose group *Phases* Duprey more than once exhibited—spoke of his post-1951 work as "a challenge offered poetry, brutally called upon by its creator himself to materialize before his eyes," he quite rightly identified Duprey's undertaking in sculpture as being poetic in character. More than this, Jaguer underscored the continuity between writing and sculpture in Duprey's work. As a sculptor, Duprey sought to continue, on a new plane, the investigation he had begun earlier as a word poet, extending exploration further, yet in the same direction. It was not that, after completing half of his texts in only a few months, he had given in to disillusionment or disappointment. Rather, looking at his sculpture, we are entitled to consider his previous writings as necessary to explain

why he aimed through sculpted forms to materialize themes always central to his poetic meditation.

Duprey's sculptures are generally metallic forms resembling armatures. One would suppose that, if made by a more conventional artist, they would have been used eventually as the framework for a shape to be modeled in clay before casting. Duprey, however, has not left behind pieces that look patently unfinished. His are figures stripped of flesh and muscle, caught in postures starkly indicated by bone structure alone. This is why the eye can look through them as well as at them. The resistant outlines of sculpted forms can be appreciated only as one observes at the same time the space embraced by the creatures Duprey has fashioned. Persistent reminder of the void, space is an integral part of his message, imposing its presence by keeping us aware of an absence to which our attention is drawn by the "holes" in his creations.

Duprey once explained in a text called "Réincrudation" (its title borrowed from the language of alchemy), written at the request of the *Cahiers du Musée de poche*, which needed a theoretical statement to accompany reproductions of some of his drawings and sculptures, "I must wait, tame my dream, render it docile, familiarize myself with That which wishes to burst forth, into the night in which I dream I let That come down as far as me, despite its dreadful smile, wait until That solidifies and becomes a statue." There is no chance here of claiming great originality for the procedure to which Duprey referred. He revealed the special nature of his endeavor only in the next sentence, with which he brought "Réincrudation" to an end, "Then the statue holds out to me a white stone, too white, too smooth, and I know it is the matrix of the void." The artist's role, waiting for the work to manifest itself in consciousness, is classic. However, with Duprey, the function of sculpture is not simply to body forth an image first nourished and then cherished within; its manifestation testifies to a meeting with the void.

Duprey faced a time-honored question: why write, sculpt, or paint? For him, though, the question was removed from the field of elective choice, ending up irresistibly in the zone of compulsion. Hence, it would be pointless for us to ask what he hoped to achieve. More pertinent is establishing what he found himself driven to attempt. In short, the continuity to be noticed between the poetry of *Derrière son double* and the sculptures Duprey made after he suspended writing at the end of 1950 is not assured simply by the fact that both texts and sculpted shapes express the same creative sensibility. Far more significant is that both represent obsessive preoccupation with the invisible, with things lurking in the void and menacing the known. Thus, each expressive mode sinks its roots productively into the same anguish.

Dupreyan sculpture finds its origin in the conflict between light and darkness and concurrently in the implied contrast between form and the formless. To sculpt is a method of immobilization that signifies the last stage of one kind of creative experience. Duprey acknowledged as much in "Réincrudation": "The period of dreams is my nocturnal cycle, I am not uncomfortably installed in it, for my phantasms are in the image of the black of my soul and, everything being as it should be, I find in them a sort of peace." Still, the objectification of phantasms does not come about without effort or altogether spontaneously. "However, at the beginning, I always struggle furiously against torpor, fearing final immobility." Resisting the finality of definitive form by delaying as long as possible the immobilization process, Duprey succeeded in endowing his metal figures with an anguished expressiveness that remains their most distinctive feature. His aim, then, was not merely to fix an inner revelation, but to arrive at a form somehow allusive to the previously unformed. The formless, meanwhile, remained the image of night, to which sculpture had the capacity to attempt a diurnal counterpart.

Readers who have had time to notice how, in *Derrière son double*, Jean-Pierre Duprey evoked strange animal forms born of word alignments over which rational predisposition exercised no restraint are better equipped than most, no doubt, to respond to the figures he sculpted. Forms appear before us as disturbing phenomena beyond our ken, not as copies of the familiar. Their strangeness makes them alien intruders, offering no concessions to our expectations. In fact, it is their uncompromising nature that impresses most. Their arrival destroys presuppositions, intimating that a different world exists somewhere, with relationships other than those we are accustomed to take for granted. There is no "front," "back," or "side" view from which we can hope to look at them. We do not know from which angle to approach, for their attitude is no more conciliatory from one than from another. Just as we do not know how to come at them, so we are at a loss to decide how to make contact with them, on their terms any more readily than on our own.

Without diminishing his stature, we can say Duprey as a sculptor was more an artisan than an artist. He was a fabricator, making for himself rather than to impress those around him with the display of his skill. Technical knowledge he had acquired in the foundry was applied to an effort at self-exploration through externalization of inner perception. Like so many before him, Duprey asked the fundamental question, why create? His answer suggests neither exorcism of fear—comforting through creative activity—nor an attempt to reassure his fellow men. His sculpture often gives substance to fear, without concurrently ex-

tending the consolation of disciplined form. Indeed, it brutally denies the mitigating value of art. The completed object stands as evidence of struggle, not of conquest. One is never impressed with the imposition of order and form so much as with the tension that breathes vitality into all of Duprey's work and invests it with meaning.

First sight of a Duprey sculpture may give rise to the impression that we are face-to-face with an aggressive form belligerently challenging a public that cannot know how to deal with it. Longer acquaintance encourages the belief that its aggressiveness is not directed against the spectator after all. Whatever is going on, the latter's role continues to be external, that of witness only. The figure we observe is engaged in confrontation—perhaps in combat, but certainly never in friendly encounter—with some other creature or creatures, at all times invisible to us. In other words, Duprey used sculpture as a medium in which, as earlier in *Derrière son double*, he could bring to his audience's attention the threatening presence of the unknown and the unseen in the void.

As a result, we detect an enlightening parallel between the sculpted forms and the unique nonfigurative reliefs Duprey made in concrete. The shadows filling the depressed areas of the reliefs vitalize them by releasing tension through contrast with the raised surfaces that catch the light. The interplay of light and shade, like the interrelationship of the visible and the invisible, provides Duprey's work with its dynamism. In every instance, we meet signs of necessity, not of contrivance or artistic ploy. Furthermore, exactly the same characteristics mark Duprey's painting. The inviolable, utterly remote quality possessed by his imagined figures comes from their undisguised disinterest in us and from their involvement with something or someone we cannot see most of the time.

"Je dois attendre." When, in "Réincrudation," he announced what he had to do in order to create, Duprey surely gave *attendre* the sense of "waiting." However, his work in metal and concrete does not persuade us that, for him, the verb carried at the same time the force of "expecting" it would convey normally. Thus, in his comments on sculpture he openly drew attention to the distance between himself and most of those with whom he consorted in the surrealist group. The difference between him and them was a radical one, lying not so much in the nature of customary methodology—though his concrete reliefs are certainly unique—as in self-definition in the role of artist. We cannot appreciate the special character of Duprey's contribution to surrealism without taking account of the basic fact that, artistically, he never ceased to function in full, unclouded awareness of his ignorance about what

concerned him most deeply. Accepted as a condition of creative action from which release could come only when life was over or had been terminated, ignorance set the seal of integrity on Duprey's work by ruling out comforting but unsupported hypotheses centered on anticipated discoveries. So did the firm conviction that waiting is worthwhile, even where confident expectation would be no more than self-deception. It was not the presumption of eventual rewards that sustained the artist in Duprey. It was the obligation—one he could never shirk—to probe the unknown regardless of the cost in self-esteem and peace of mind.

With Duprey, waiting signified something quite different from calm assurance that a revelation destined to manifest itself in creative consciousness would find its way, eventually, to fully satisfying expression. The essence of his activity as an artist lay in doubt, from which were born conclusions purely tentative in nature, signs of struggle more often than evidence of complete success. In sculpture, as in the written text, Duprey's effort was concentrated on making a foray into the unknown. What he had to tell or show, thereafter, testified to the important fact that an encounter had taken place. It did not prove the unknown must become any less mysterious because the artist has dared to face it.

However expressed, Duprey's poetry bears witness to the risk that surrealists generally regard as fundamental to poetic investigation. Still, it is noteworthy that he explored the unknown without hope of finding rewards such as persuade other surrealists to believe implicitly in the cognitive function of poetic inquiry. In consequence, his work is validated less often by the revelations it succeeds in sharing with its audience than by the honesty with which it respects the limitations of ignorance, while continuing the effort to know more than can be known and to communicate more than the medium permits.

Seen from the perspective such an interpretation of his achievement invites us to adopt, Duprey's suicide is not an act of desperation, a miserable admission of failure. It is the extension of his investigation as initiated through art, the next step taken in approaching the unknown, through a jump into the void that cannot leave us indifferent to the manner in which the artist chose to take his own life.

From up close, Jean-Pierre Duprey's death by suicide represented a painful loss for which many of his friends had difficulty accepting the necessity. From a distance, this act takes on, at times, the appearance of a logical conclusion to the poet's gesture. And this is anything but a tragic conclusion for the individual who took the main role in the drama replayed in *Derrière son double*. It is as though Duprey had foreseen his

own death—might one go so far as to say even in its circumstantial details?—when, in *Specteuses,* he announced, "But I Know and the Habbyss sends me back to myself." From a distance, Duprey's double—the shadow his books, painting, and sculpture cast on the future—becomes daily more familiar to us.

5

ANDRÉ BRETON AND JOAN MIRÓ: *CONSTELLATIONS*

There is no reason to doubt the sincerity of Paul Eluard's admiration for certain painters to whom he dedicated poems at various times during the 1920s and 1930s. True, one may challenge his taste on discovering poems for Dora Maar, Leonor Fini, S. W. Hayter, Valentine Hugo, Humphrey Jennings, and Roland Penrose next to others for Jean Arp, Georges Braque, Salvador Dalí, Paul Delvaux, Giorgio de Chirico, Max Ernst, Paul Klee, André Masson, Joan Miró, Pablo Picasso, Man Ray, and Yves Tanguy. Still, that is not the central issue here. What matters is that nobody can deny one fact. The best of intentions have scarcely engendered poems for painters that must count among the memorable writings surviving from Eluard's period of association with surrealism. In fact, his decision to bring together a selection of texts under the heading "Peintres," at the end of his *Donner à voir*, has had only one really noteworthy consequence. It leaves readers with no alternative but to conclude that, individual lines aside, Eluard found himself while writing those verses unable to communicate adequately the excitement he himself felt when looking at the work of this painter or that. Meanwhile, his efforts to capture in words the atmosphere peculiar to the work of one painter or another often took him no further than itemization of characteristic features (in de Chirico's pictorial universe, for instance, or Delvaux's) such as might be offered by art critics.

Eluard's case is worth citing in the present context because the quality of his writing when he was paying tribute to artists whom he respected

and valued as friends contrasts strongly with the surrealist and post-surrealist poetry he wrote under impetus from his dominant inspiration, love. Moreover, it deserves mention because the discrepancy between *vers de circonstance* (occasional verse), prompted by admiration or affection, and the poems that gave Eluard indisputable stature as a surrealist is anything but unique. The very same undeniable impoverishment is a feature of André Breton's verses entitled "La Maison d'Yves Tanguy," written in 1939. Like Eluard's, Breton's earnest intent is unquestionable. Yet "La Maison d'Yves Tanguy" does less to illuminate Tanguy's painting or explain Tanguy's attraction for its author than do the short prose pieces (extending over a period from 1928 through 1942) gathered with it in a bilingual volume published in 1946.[1]

Other examples only confirm the conclusions to which *Donner à voir* and *Yves Tanguy* both point. It seems that, heartfelt though they surely are, verse tributes to painters signed by surrealist poets of proven worth read like dutiful exercises, stilted or quite lifeless.[2] In the final analysis, they contribute little or nothing to our appreciation of the artists in question, and even less to their authors' reputation. Indeed, such exercises reflect negatively on those who engage in them. This happens regularly enough to give special prominence to texts by André Breton, written as an accompaniment to Joan Miró's *Constellations*. Modestly labeled *proses parallèles,* these texts certainly do not take verse form. All the same, they stand apart from Claude Tarnaud's perceptive analysis of E. F. Granell's art as the fruit of an experiment in poetic communication unique in surrealist writing.[3]

The *proses parallèles* published with *Constellations* do not derive their distinctive quality from their author's wish to extol the virtues of Miró's art. Nor, for that matter, do they claim our attention as an interpretive or evaluative commentary that sends us back repeatedly to Miró's graphics for its justification, its raison d'être. They could be read in isolation and treated—especially by those ignorant of their origin—as belonging to the tradition of the prose poem.[4] However, they take on their full significance and resonance only when examined in conjunction with the pictures that were their inspiration.

We are far from the *transposition d'art* in which Théophile Gautier placed trust. Breton's *proses parallèles* are fundamentally different in character from Gautier's lines "A Zurbaran," for instance, as they are too from the poems Eluard dedicated to Picasso, from the texts he provided to go with Man Ray's drawings in *Les Mains libres,* or again from those he set down in celebration of Hans Bellmer's doll.[5] Simplifying, one can identify the profoundly original nature of Breton's undertaking in the following way. Looking back at the Miró graphics with which

they belong does not so much help us understand how Breton came to write what we have been reading as it leaves us marveling.

Bent on demonstrating an evolution in Breton's poetic method—"Poetic composition finds its closest ally in harmonic composition" in the poems for *Constellations* (p. 57)—Anna Balakian analyzes these texts (the very last that Breton published) as proof of "the progress of his poetic craft" (p. 58). Without actually saying so, she implies that there exists no necessary connection between Miró's gouaches and Breton's parallel texts. The temptation to follow this lead is very real, since it makes dealing with Breton's *proses parallèles* appear somewhat less of a challenge, especially when disregarding Miró, so as to concentrate on Breton, actually appears entirely defensible. The fact is that, unlike the collection called *Talismans*, [6] *Constellations* was not executed or even conceived as a collaborative work. Miró completed his gouaches between 21 January 1940 and 12 September 1941, while living in Europe, first at Varengeville-sur-Mer, on the Normandy coast, then in Palma, on the island of Majorca, and finally at his birthplace in Montroig, Spain. During the early part of that same period, Breton was still serving as medical officer at the military flying school in Poitiers. Demobilized in the Free Zone in May, he made his way by August to Marseilles, from where he sailed to Martinique the following May. By way of Santo Domingo, he reached the United States by midsummer to make New York his base until his return to Paris in May 1946. It seems likely that Breton was without knowledge of Miró's undertaking, and it appears certain that, even if informed, he was quite unable to follow, let alone influence, its progress.

All in all, one's first inference is that there is no reason to criticize Anna Balakian, whose interest in proving Breton's defection from the cause of verbal automatism led her to disregard Miró's part in *Constellations*. Her selectivity has its counterpart in that of Jacques Dupin. Preparing his major study of Miró's art, Dupin evidently saw no cause even to allude to the existence of the *proses parallèles* when he discussed *Constellations*. Yet, especially when read in succession, these commentators' remarks leave us a little uncomfortable, wondering at the presupposition in which they take root. Can words and pictures be separated in *Constellations*, when Miró and Breton clearly indicated that they should be taken together, by agreeing to make them public at the same moment, within the covers of the same book?

Facing this question, we should feel more at ease if we could persuade ourselves, and others, too, that *Constellations* is a book in which pictures appear as an adjunct (however welcome) to a text that must be granted

priority. Alternatively, one might advance with greater confidence on the assumption (supported by the circumstances of composition) that *Constellations* reverses the idea of the illustrated book, to become a volume in which words illustrate pictures by paying tribute to them. Given the precedence of pictorial composition over parallel text, in this instance, one has no trouble admitting that such is the case. The difficulty lies in defining the nature of Breton's homage to Miró, in identifying the relationship of text to picture.

One detail that appears to have never drawn the attention it merits is that there were originally twenty-three gouaches in Miró's 1940–1941 suite, although the collection put out in New York in 1959 omitted the thirteenth in the series, a picture called "Nocturne," completed in Palma on 2 November 1940. Exclusion of "Nocturne" clearly had nothing to do with its quality, which was in no way inferior to that of the gouaches reproduced by Jacomet, *en phototypie et au pochoir*, for the deluxe volume issued by Pierre Matisse in a limited edition of three hundred and fifty numbered and signed copies. It would appear that "Nocturne" had been left out only because Miró had given it to his wife as a present. The noteworthy point is, then, that its omission (about which Breton knew nothing, by the way[7]) had reduced the total of gouaches for publication to twenty-two. And, more important still, this was a fact hardly likely to displease Breton.

Evidence of Breton's fascination with the number twenty-two appeared a half-dozen years before *Constellations* in his preface, "Fronton virage," to Jean Ferry's *Une Etude sur Raymond Roussel*. Discussing *La Poussière de soleils*, Ferry had made an elementary slip in arithmetic which had brought him to the conclusion that twenty-two scene changes occur in Raymond Roussel's second play. Not bothering to check Ferry's figure, Breton showed himself only too eager to accept it when he wrote, "Let us observe first that staging *La Poussière de Soleils* presupposed twenty-two set changes (22: that is, the number of signs in the Hebrew alphabet, or of 'paths' linking the Sephiroth of the Cabala, or of the major arcana of the tarot)."[8] He followed his statement with a number of notations suggesting that Roussel's work can be interpreted in light of alchemical lore. Breton's direct allusion to the twenty-two *arcanes majeurs* of the tarot pack (derived from the esoteric tradition) is enlightening, coming as it does from the author of *Arcane 17* (1945). Composed in 1944, not very long after Miró completed his *Constellations*, *Arcane 17* is a book placed under the sign of the star (just like Roussel's first play, *L'Etoile au front*). It has prompted one commentator to remark, "The occult network linking the various directions in which the poet

pushes his inquiry is indeed that of High Magic," and to add, "Each time his confidence in the order of a world where nothing is produced fortuitously gathers new strength."[9]

Reviewing the tendency in Breton's thinking that developed through *Arcane 17* under the stress of current historical circumstances, one is struck at first by a marked contrast with the way Miró worked a little earlier, at the time of the fall of France. *Arcane 17* would be incomprehensible if we were to ignore its author's situation as an exile from an occupied country. As for Miró, he confided later to James Johnson Sweeney, "I felt a deep desire to escape. I closed myself within myself purposely. The night, music, and the stars began to play a major role in all my paintings." Speaking of *Constellations*, Dupin has reported, "It would seem as though nothing disturbed completion of so perfect a sequence of works of art. And yet, this was a crucial period, full of world-shattering events. According to the artist's friends in Varengeville, he was so caught up in his work that he seemed completely unaffected by what was going on around him. He executed the first ten gouaches in a state of such mental concentration that those closest to him might have been pardoned for supposing he didn't know what was going on."[10] Yet beneath this surface dissimilarity ran preoccupations common to both artists that explain Breton's eventual wish to parallel Miró's graphics in words. Hence, his declaration in his essay devoted to *Constellations*, soon after taken up in the volume published by Matisse and finally absorbed into the definitive edition of his *Le Surréalisme et la peinture*:

> Art, in a manner at first latent, then manifest, has never felt itself threatened to its very principle. It would gain nothing from braving the interdict and repression which, behind them, have left not a living blade of grass. So far as it is still possible, art comes to the point of attending to its own enigma, of trying as a last resort to grasp its own essence: what is it that consecrates fire when everything indicates that oil is going to be lacking in the lamp?

It is no exaggeration to say that both Miró's *Constellations* and Breton's verbal parallels face this question and offer complementary answers to it.

Discussing art in connection with *Constellations*, the author of *Arcane 17* highlighted "the promise of an order over which the calamities of the outer world could not *in the end* prevail." On the same occasion he alluded to "a mysterious exigency, which seemed to have a hold over destiny." Referring to elements that "passed by at first as though in disarray," he acknowledged with pleasure and gratitude "a power of mutual attraction that made them combine in building an emergency

raft," concluding, "These sentient figures, linked very closely with us, of which the sudden brilliancy is going to exorcise the tearing wind and the black night, are our own constellations."

Breton's 1958 article in *L'Œil* demonstrated that he was acutely sensitive to the contribution made by Miró to proving that art can establish order in the face of chaos. There he described Miró's gouaches as forming "a *series* in the most privileged sense of the term":

> We are speaking, in fact, of a deliberate succession of works having the same material means of execution. They participate in and differ from one another after the fashion of bodies in the aromatic or cyclic series of chemistry; considered at the same time in their progression and their totality, each of them takes on also the necessity and value of each component in a mathematical series; finally the feeling of an uninterrupted exemplary success that they afford us, here, retains, for the word *série* [break], the force it has in games of skill and chance.

The last meaning in which Breton invites us to understand *série* is particularly applicable, especially in view of Gérard Legrand's assertion that "one could not propose, either, a better term to signify these texts," the *proses parallèles*.[11]

Two remarks are worth adding at this stage. First, the attraction of the numeral twenty-two calls for emphasis. Referring to the *arcanes majeurs*, "those singular twenty-two figures," Béatrice de la Sablière points out, "one finds once more in them the great forces of nature and the cosmos, the sources of knowledge."[12] Second, when explaining how he worked on *Constellations*, Miró once said, "I would set out with no preconceived idea. A few forms suggested here and there would call for other forms elsewhere to balance them. These in turn demanded others." He recalled that he would return to a single gouache day after day "to paint in other spots, stars, washes, infinitesimal dots of color in order to achieve a full and complete equilibrium."[13] In *Constellations*, the unpremeditated gesture culminates in harmony, as Miró demonstrates how right Breton is to place faith in "the order of a world where nothing is produced fortuitously"—even when and where chance is invoked.

Breton was to find the appeal of *Constellations* compelling, although he did not see Miró's gouaches until after the war that, in his estimation, had threatened to lead to the extinction of art. Without hesitation, he recognized the value of Miró's graphics, which happened to be the first artistic works from Europe to reach New York (by diplomatic pouch, incidentally) at the end of the Second World War: "If only one thinks about it, from the relationship of such a work to the circumstances that saw its birth emanates the same pathos as the desperate denial of the

hunger in the cry of the grouse." In the realm of art, Breton was particularly well equipped to notice, the Philosopher's Stone finds its equivalent in an *"exigence mystérieuse"* capable of exerting a hold over destiny, of resisting and even reversing the baleful effects of history. Hence, he was quick to appreciate that Miró's word *constellation* "is then indeed the most charged with the idea of passage and transmission at any cost valid, at the same time, for nature and for myth."

We know that from the 1940s onward Breton saw the principal task of surrealism as elaborating a myth appropriate to our time. The last international surrealist exhibition organized under his supervision, *L'Ecart absolu* (1965), testifies amply to the myth-making role of postwar surrealism. It is well known also that, from the moment surrealism was launched, Breton emphasized the cognitive function of poetic language. Almost as early, he came to stress that, in surrealism, poetry extends its boundaries beyond the limits of verbal communication to embrace modes of artistic expression endowed with significance by surrealist aspirations. We understand these modes better after referring to *Ajours,* the 1947 text appended to the edition of *Arcane 17* published in France: "The act of love, on the same score as the painting or poem, is disqualified if, on the part of the person giving himself over to it, it does not presuppose *l'entrée en transe (entry into a trance)"* (p. 206).

Reading these words may lead us to question whether "trance" can be used in complete fairness, when one is considering works as meticulously elaborated as Miró's *Constellations.* Yet, just as the painter himself saw fit to draw attention to the controlling need for harmony, in the creation of *Constellations,* so, too, he spoke quite openly of communing with his pictorial universe, indifferent to contingent circumstance.

Insofar as Miró's graphics elicited verbal responses from Breton—solicited them, he might have said—they provide us with a point of departure far less dubious when we are dealing with the poet than when we address ourselves to the painter's creation. Still, the process by which the *proses parallèles* came into being is not very far removed from that which resulted in *Constellations.* In fact, the painter's deliberate withdrawal into himself is close to Breton's deliberate concentration (repeating the experiment twenty-two times rules out the possibility of total spontaneity) on Miró's graphics. Both artists, in short, can be said to have experienced a voluntary *entrée en transe.*

Thus, although in 1958 Breton was to place the *"résistance"* exemplified in Miró's creative act on the same plane as the Resistance in Occupied France about which *Arcane 17* shows him to have been wary, if not altogether skeptical, it is to Miró's mode of resistance through art that his confidence really goes: "In an hour of extreme disturbance, the one

that covers his 'Constellations' from first to last, it seems that, by a reflex reaching out for the most pure and the unalterable, Miró has wished to open up, in the fan of all seductions, the full register of his voice." The important thing is, therefore, that Breton goes on to invoke the migratory instinct of birds: "The warbler possesses innately the sense of a relationship with the firmament such that it has the power to make its way, without prior apprenticeship, by the constellations."

The myth that brings Breton's *proses parallèles* to life derives, we may infer, from the spectacle of Miró's initiative self-immersion in art, which magically gives direction and purpose to a pictorial inquiry conducted so successfully as to bring to mind an analogy with the word poet, similarly finding, although without seeing, *"le plein registre de sa voix"* *("the full register of his voice")*. Perhaps, then, on balance, André Breton's departure from verbal automatism—which, after all, dates back to his *Ode à Charles Fourier* (1947)—is less significant in his *proses parallèles* to *Constellations* than is the evidence of his continuing fidelity to an article of faith laid down very early in his career as a poet, "We know now that poetry must lead somewhere."[14]

Miró's observations about *Constellations* intimate that, during the composition of his series, he enjoyed the impression of being led, of engaging in a succession of exploratory experiments, upon which he had launched compulsively. Yet throughout the venture he found himself participating actively, aiming to attain harmony of the kind for which magic suggested a fitting analogy. As for Breton, although he never once commented on how he came to write his accompanying texts, his term *proses parallèles* tells us something about his motivation. It indicates that he acknowledged the precedence of a poetic inquiry of a nonverbal kind, carried out according to Miró's dictum, "Thus poetry, expressed through the plastic arts, speaks its own language."[15] In addition, it shows that Breton aimed to conduct verbal investigations of a closely related nature.

Written between October and December 1958, Breton's *proses parallèles* are presented each with the gouache that inspired its composition. Arrangement in the *Constellations* volume respects the order in which Miró's graphics were executed. Having no information on Breton's working method, we are sure of only one thing. Writing took Breton far less time than Miró had spent painting.[16] Another fact becomes clear just as soon as we open *Constellations*. The first *prose parallèle*, accompanying Miró's "Le Lever du soleil" (The Sunrise), gives fair warning. It indicates most clearly that Breton has no intention of simply describing the content of Miró's pictures. If he is to accomplish something corresponding to what Legrand has called "the enchantment afforded us by

Miró's sigla and asterisms," it will not be by referring to that enchantment the way he has spoken of Tanguy's work in "La Maison d'Yves Tanguy," with no better results than Eluard achieved in his poems for painters.

Since, like Eluard, Breton had fallen short of communicating a sense of the magic of Tanguy's painting ("With the fulgurant furnishings of the desert"), one can only commend his prudence—to call it that, for now—in refraining from attempting to do the same in his verbal parallels to *Constellations*. For Miró has never demonstrated with less ambiguity than on this occasion that he explores through his painting a sign language no less complex than when it appears to culminate in rudimentary formal simplification. Any attempt to translate Miró's signs into the code of spoken language is destined to fail. The most one could hope to achieve is at best tautology. At worst, it is mere verbosity.

Next to the majority of graphics in *Constellations*, "Le Lever du soleil" stands out as markedly simple. It assembles four animate figures and three circular shapes, two of these overlapping. One of the figures is obviously a bird, the remainder are human. The text belonging with this picture is relatively short, though not quite the briefest in the series. Considered as a verbal description of "Le Lever du soleil," the *prose parallèle* would have to be judged a failure, or at least as putting forward an interpretation of its content too fanciful to be convincing: "It was said that horse-play must come to a bad end. It was all over, once and for all the silk-weaver and the cobbler have settled accounts; we have been let off with a peat not meant to unravel wax-end's silk. So much for the outer spectacle. . . ." Puzzlement yields to the realization that, responsive to the magical character of Miró's gouache, to the magical event that it captures (one of the figures, evidently female, is suspended or passing through the air on a level with the sun), Breton is sensitive to what lies behind *"le spectacle extérieur."* This is why, closing his text, he brings to our attention a child, "alone in being able to show, in the tassel of the curtain stirred by the spasms of the nightlight, the heraldic paw, raised high, of the very young lion coming forward and playing."

To grasp the nature of Breton's undertaking and to measure how successful he is in his *proses parallèles,* we have to appreciate that he has no interest in competing with Miró or in trying to convince his readers that words can exhaust the power of the pictorial image. Looking at the painter's work impels him to look into himself. The image before his eyes liberates images within, and it is the latter that he seeks to capture in acknowledgment of the former's evocative quality.

Of all Miró's *Constellations,* the first displays human forms most directly. In "Le Lever du soleil" they stand out clearly against an unclut-

tered background, shaded here and there, that never distracts the eye from the figures commanding our attention. With the second gouache, the emphasis changes. Humanoid and animal shapes are still present, but they take their place now in a formal design, disposed about the motif that gives the picture its title: "L'Echelle de l'évasion" (The Escape Ladder). With the escape ladder Miró returned to one of the themes he had been developing ever since the 1920s.[17] Background and foreground become one in "L'Echelle de L'évasion" without the reassurance that perspective could have been expected to bring. Drawn into the picture, the eye is so disoriented by ambiguous planes that Breton's first sentence seems to capture an impression we all share: "Everything is still puckered like the bud of a poppy, but the air yawns with traps."

Breton's second sentence, too, is faithful to the mood of Miró's gouache. However, it is palpably less derivative, more independently creative: "One has only to stick one's nose outside to move about in surprise boxes of every size from which the head of Spiky-Haired-Peter, grown up and spreading his beard of wood cinders, asks only to burst forth from its annelid's body." So much more typical of the workings of Breton's imagination than of Miró's, the verb *burst forth* in particular is proof that slavish imitation is far from the writer's goal. It prepares us for the discovery that, bringing his *prose parallèle* to a close, Breton makes no reference to the escape ladder, and does not need to: "In possession of the tools of their trade in full strength, the chimney-sweeps exchange their longest 'Ooooh-Ooooh' though the chimney-flue."

The dramatizing element in "L'Echelle de l'évasion" is the shading that helps integrate foreground and background. The following gouache lets the background withdraw discreetly so that our attention is concentrated on line—not only the distorted shapes of the *"personnages"* evoked, but also those marking *"les traces phosphorescentes des escargots"* that guide them. With "Personnages dans la nuit guidés par les traces phosphorescentes des escargots" (Personages in the Night Guided by the Phosphorescent Trails of Snails), Breton responds to the theme of magic guidance. Associatively, he invokes the names of Gérard de Nerval, Xavier Forneret, and Arthur Rimbaud. Thus, the night is taken as a symbol of ignorance, erroneously assumed to be daylight: "Rare are those who have not experienced the need for such help in broad daylight—the broad daylight in which the common herd have the agreeable pretension of seeing their way. They are called Gérard, Xavier, Arthur... the ones who have known that, in comparison with what could be reached, the beaten tracks, so proud of their signposts and leaving nothing to be desired by way of tangible foot-support good, lead strictly nowhere." As a consequence, revelatory on the theoretical plane and in

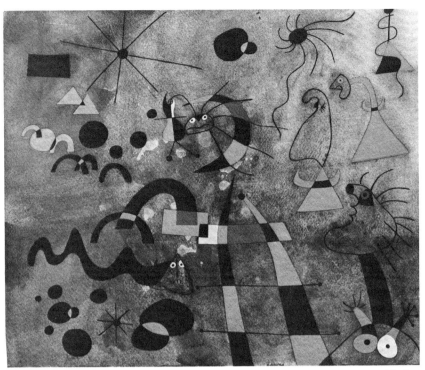

Joan Miró, *Constellations: The Escape Ladder* (1940), gouache and oil. Pierre Matisse Gallery, New York.

fact important to our understanding of Breton's position as a poet, this *prose parallèle* is the most prosaic of the whole series: "I say that the others, who flatter themselves they have their eyes wide open, are, without knowing it, lost in the woods." It is only by inference that we grasp which qualities the writer finds admirable in Miró's picture: "Upon awakening, everything hangs on denying fallacious clarity the sacrifice of this Labrador stone glimmer which takes away from us so fast and so much in vain the premonitions and the incitements of night dreams when it is all we possess in our own right to guide us without striking a blow through the labyrinth of the street."

Next to "Personnages dans la nuit . . . ," the following title, "Femmes sur la plage" (Women on the Beach), promises less. It corresponds to a gouache of far greater simplicity assembling female shapes against an unaccentuated background where no *"traces phosphorescentes"* are discernible. Breton's accompanying text is cast in the form of a brief dialogue between sand and cork. It reminds us that, over the years, Miró

has succeeded in fashioning a language, distinctively his own, that evokes human forms in poetically suggestive attitudes. In his *prose parallèle*, Breton avoids mistakes made in his "La Maison d'Yves Tanguy" by eschewing analysis. Instead, he offers an account of a creative process that imaginatively transposes Miró's, "I take her like the ball on the bounce, and stretch her out on a thread, I evaporate her lingerie to the last bubble and, of her discarded members, I have her make the wheel of the sheer intoxication of existing." The lyricism is Breton's; its source lies in Miró.

The following picture bears a title in which erotic suggestiveness balances a mundane daily gesture. It is to the former that Breton's attention goes at first in "Femme à la blonde aisselle coiffant sa chevelure à la lueur des étoiles" (Woman with Blonde Armpit Setting Her Hair by Starlight): "What is there between this cavity without depth, so gentle is its slope that one might believe that upon it the kiss was molded, what is there between it and that savannah imperturbably unrolling above us its spheres of fireflies?" Initially, the liberative suggestiveness of the "blond armpit" stimulates his imagination. Before Breton has finished his text, however, the banal routine of hair-brushing at bedtime has become equally suggestive, as "the lover luges quite gently toward ecstasy": "Perhaps under the power of the comb this fluid mass, with mature deliberation braced with buckwheat and oats, pinned all along with electrical discharges, is not baffling any longer in its fall the torrent running the color of rust in every twist and turn of the grounds of Fern Castle with its thirteen towers by the favor of the gesture covering and uncovering the nest skillfully woven from tendrils of clematis." At first one's impression is that, set in motion by Miró's title rather than by the content of his gouache, Breton's imagination has found impetus largely in Charles Baudelaire. By the end of this *prose parallèle*, though, it is evident that Miró's fetishism—in this respect so different from Baudelaire's—which brings stars and a crescent moon into his picture, has directed Breton's attention to the mysterious union between man and the universe from which Miró's work draws so much of its potency.

Three of Miró's titles so far—"Le Lever du soleil," "L'Echelle de l'évasion," and "Personnages dans la nuit . . . "—convey a sense of promise. So does "L'Etoile matinale" (The Morning Star). Yet the gouache with which it belongs attains neither the eloquent simplicity of "Femmes sur la plage" nor the tantalizing complexity of line to be found in "Femme à la blonde aisselle. . . ." By comparison, Breton's *prose parallèle* displays greater inventiveness. The writer indisputably appears to have surpassed the painter, as though bringing to his text more than is to be found in the artist's work:

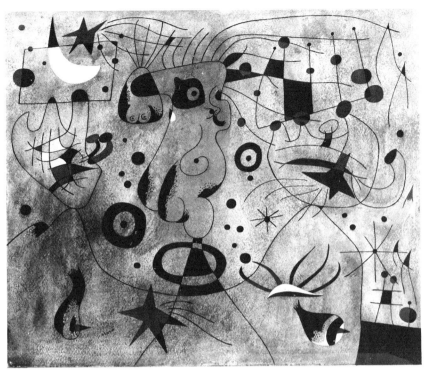

Joan Miró, *Constellations: Woman with Blonde Armpit Setting Her Hair by Starlight* (1940), gouache and oil. Contemporary Coll. Cleveland Museum of Art.

She says to the shepherd, "Approach. It was I who drew you as a child toward those deep caves in which the sea as it pulls back garners the eggs of the storms that the seaweed glazes, with myriads of downcast eyes. Only in the skimming light, as one lays hand on the superb fossils along the road seeking its way through the dynamited mountain, you were consumed with desire to see burst forth the edge of a coffer of very old workmanship which contained (it was not even worth while to force it open) everything blinding that can stream into the world . . . "

"Personnage blessé" (Wounded Personage), which follows "L'Etoile matinale," displays a poetic intensity lacking in the preceding gouache. Background shading once again contributes a dramatic quality that enhances figurative design, as fanciful inventiveness becomes more purposeful than in "L'Etoile matinale," where it retreats into formal elegance. Breton's text, meanwhile, draws inspiration from Miró's dramatization of the human condition in "Personnage blessé." Avoiding the

didacticism that made his *prose parallèle* to "Personnage dans la nuit . . . " earnest but not exciting, Breton wrote:

> Man all his life prowls around a little padlocked wood of which he can discern only the black tree trunks from which rises a pink mist. His childhood memories make him stealthily pass an old woman whom the very first time he has seen come out with a very thin faggot of incandescent thornwood. . . . This distant initiation bends him in spite of himself over the edge of the daggers and makes him caress obsessively that silver ball which Count Potocki is said to have polished for seasons on end with the purpose of storing his head in it.

It is not of the victim of blind fate that Breton makes us think but of Amfortas, whose wound is both a sign of distinction and of confrontation with the mystery of life: "Without knowing how he has possibly been able to get in, at every moment man can awake inside the wood made of the soft free fall of an elevator at the Palace of Mirages between the trees lit from within on which he will try in vain to push aside a crimson leaf."

The disposition of graphic elements making up Miró's "Femme et oiseau" (Woman and Bird) does not quite attain the simplicity of "Le Lever du soleil" or "Femmes sur la plage." Its most prominent feature is a rhythmic unity to which the structure of Breton's text pays tribute. At the same time, the *prose parallèle* achieves poetic density with remarkable economy of means, marshalled in three sentences of increasing length and momentum: "The cat dreams and purrs in the brown stringed-instrument trade. He scrutinizes the bottom of ebony and from a distance laps the living mahogany tree in a roundabout way. It is the hour when the sphinx of madder releases his horn by the thousands around the Vaucluse fountain and when everywhere woman is no longer anything other than a calyx overflowing with vowels in liaison with the illimitable magnolia of the night."

Usually unresponsive to the appeal of music, which he regarded as anti-surrealist, Breton appears to have sensed, for once, the role it played in the harmonic composition of Miró's *Constellations*. At the same time, however, the musical allusion in his first sentence occurs within the frame of an image that defies reason too actively for us to interpret "stringed-instrument trade" (*la lutherie*) and its unforeseeable qualifying adjective as having anything more to do with a pedestrian critical judgment than "the sphinx of madder" (*la sphinx de la garance*). For Breton, Miró's woman is Petrarch's Laura, his reference to Vaucluse suggests, a wonderful "calyx overflowing" (*calice débordant*), a precious link with the universe, typified in "the illimitable magnolia of the night" (*la magnolia illimitable de la nuit*).

In "Femme dans la nuit" (Woman in the Night) the light, optimistic tones of "Femme et oiseau" yield to darker hues. Reminiscent of those predominating in "Personnage blessé," the darker colors are offset, however, by reds, yellows, and especially blues that reduce the menace of night. To Breton, we may guess from his *prose parallèle*, these suggest fruitful metamorphosis. Thus, his text is an optimistic celebration of beneficent encounter ("At ten in the evening all women in one run to the rendezvous in the open country, at sea, in the towns"), invokes a lucky *break* such as is mentioned in his prefatory notice, and lastly points to the vital principle, manifested in protoplasmic life and germination: "A profuse protoplasmic life cuts itself from the Milky Way, at sigh height, a germinating almond. Of the daytime sky remains an accentor's nest." In keeping with his reassuring faith in art's capacity to withstand and finally to overcome negative repressive forces, Breton stresses at the end something other than the terrors and dangers commonly associated with nighttime. He refers now to the songbird's nest, from which one can anticipate, with the seasonal renewal of life, the resurgence of creativity in song, as nature reasserts its harmonious irreversible principles.

In "Danseuses acrobates" (Acrobatic Dancers), painted after "Femme dans la nuit," line communicates rhythmic flow, as curves and parabolas render movement highlighted (but not threatened) by patches of bold color taking forms that Miró's *Constellations* has rendered familiar—notably, the star, the sun, the crescent moon. In the opening sentence of the parallel text, impressions commingle yet bring to mind quite distinctly the contortions induced in hysterical patients said to be possessed: "Speak to me of those women whose double cock-of-the-walk crest spreads at will the semi-circular arc that links their nostrils to their heels, the nape of their neck to their pubis and who in an always harrowing muffled sound choose to be engulfed at ground level." Breton's words remind us, too, of a sensitive description by Benjamin Péret of the game of *capoeira* (part dance, part wrestling match, executed to berimbau music) played by the natives of Bahia: "It goes without saying that the dancers have no awareness of the prolongation of their gesture or of what their attitudes express. They play like young cats, but, being men, they cannot but allow the thousands of intimate links that enclose them in nature to show through."[18] It is apparent that union between nature and human gesture has fired Breton's imagination in "Danseuses acrobates": "Nothing, either, will be governed in the mind without a distracted person's trait at the expiration of which the highest period of suppling commands abandonment to the radar that infallibly sets encounter on track and, doubt rejected, from tropism to giration, must always permit us to *grasp once again by the hand*."

The title of the next gouache, "Le Chant du ressignol à minuit et la pluie matinale" (The Song of the Nightingale at Midnight and the Morning Rain), aligns two elements that obviously call for different treatment in graphic terms. Morning rain and the song of a nightingale do not permit the same form of representation, any more than midnight and morning go together. Miró made no more attempt to show rain than he could have done to show a bird's song. Instead, against a light gray background delicately shaded near the center of the picture, he arranged, together with the nightingale, shapes that recur often in *Constellations*—circles, zigzag lines, blue stars, crescent moon. He limited his palette to red, black, blue, and white, creating a pattern that appears haphazard yet is delicately balanced. Rain and song, midnight and morning become harmonious elements in pictorial equilibrium.

Oddly enough, harmony is not achieved in Breton's text. If the two middle sentences may be taken as connected by a stylistic device (the *et de mouvement*), the first, second, and last all stand alone, suggestive but isolated. Moreover, the complexity of Breton's word images (in the first sentence, especially) and the extravagance of his vocabulary (*criocère* and *emparadise* stand out particularly) seem to create a barrier between the *prose parallèle* and Miró's picture. This is the passage that comes closest to appearing gratuitous, in the context of *Constellations*:

> The treble clef bestrides the moon. The crioceris sets in a bezel the point of the sword of consecration. A sailing ship borne by the trade winds opens up a pass in the woods. And the twelve drops from the philter extravasate in a wave of sap that emparadises hearts and pretends to bring out that marvel (it can only be glimpsed) which, on the side of happiness, would counterbalance sobbing. The dear old quavers all afire lay down the cover of their cooking pot.

The tonality of Miró's "Le 13 l'échelle a frôlé le firmanent" (On the 13th the Ladder Lightly Touched the Firmament) is more subdued than in "Le Chant du rossignol . . . ," thanks to a more somber background, the substitution of maroon for red, the introduction of orange, and reduction of white. The ladder motif is repeated, but does not dominate the design in which astral bodies (star, crescent moon, and sun) have pride of place. Breton's text, meanwhile, reflects responsiveness to the balance achieved pictorially by Miró, as well as to the sense of unity between earth and firmament captured in his title.

The *prose parallèle* to "Le 13 . . . " is the longest in the series. Its linguistic constituents are more simple than is the case with most. However, word combinations remain typical in their exploration of imaginative fields beyond the range of rational projection. We read of a staircase that "snaps and bristles with ever more obstacles as it rises, a vertical

labyrinth of a murex cut fallen into ruin." Breton speaks furthermore of "the temptations of below, innumerable mole-cricket-headed dulcimer players." The investigative line bringing discovery in Miró's work has its equivalent in the linguistic exploration (taking advantage of the adaptability of conjunctions, especially *à* and *de*) by which Breton, too, in his way, penetrates a universe that he is imaginatively equipped to explore for himself and for us.

Thanks to the unexplained suppression of the gouache and oil wash on paper called "Nocturne," there occurred after "Le 13 . . . " an interruption in the sequence of Miró's *Constellations*. Since Breton knew nothing of this when putting together his comments, his laudatory remarks sound less than authoritative as he points to "une *série* au sens le plus privilégié du terme." All the same, with or without knowledge that Breton lacked, one fails to detect a hiatus, adversely affecting Miró's graphic suite. There is no occasion to look for any when the *prose parallèle* to "La Poétesse" (The Poetess) succeeds that going with "Le 13. . . . "

Miró's technique stands out with better clarity if one places "La Poétesse" beside "Le 13. . . . " Comparison of the figurative elements arranged in these two pictures shows immediately that they reflect an approach and a methodology that establish common ground on which identifiably similar pictorial patterns are erected. Nevertheless, the titles selected by Miró are totally unrelated. They impose themselves upon our consciousness in such a way as to rule out expectation of appreciable affinity of content. Taking each title with the graphic design to which it has been assigned leaves us placated in one instance, but bemused in the other. The ladder motif justifies calling the twelfth gouache by a name in which the noun *l'échelle* figures. It is by no means as easy, though, to comprehend why the fourteenth picture, which differs so little iconographically (except that the ladder forms are absent, now), should warrant so dissimilar a title. Confronted by our inability to grasp why two pictures obviously procured by like means bear such divergent names, we are reminded of an observation by Miró made in the course of a 1961 conversation with Camila José Cela: "Understanding entails the risk of deforming the initial force."[19]

Nothing in the text Breton wrote for "La Poétesse" implies that he was disconcerted by a painting in which, however much good will we muster, we cannot be sure we discern a poet of either sex. But then nothing in his *prose parallèle* indicates how Miró's poetess has become "the Beautiful Ropemaker of our day" whose mission it is to "make the salt of the earth sputter." Nor, of course, does Breton explain how the poetess has brought her *Belle Cordière* to the point where she "aims at

the instant when the sun must become 'black like a sack made of hair' and the wind must strew the earth with green figs." What matters, really, is not understanding—that limiting process by which, Miró and Breton agree, creative poetic thoughts can only be inhibited—but welcoming imaginative release: "The games of love and death are going on under the peristyle with detonations of firearms. From the coppices where the bewitching song is brewing, the belladonna's nipple is breaking through in lightning flashes and undulating. Lamiel, the fire-brand in his fingers, is preparing to burn down the Law Courts."

Following the three crowded gouaches executed after "Danseuses acrobates," Miró's "Le Réveil au petit jour" (Awakening at First Light) returns to the boldness of line that characterized "Le Lever du soleil," "Femmes sur la plage," and "L'Etoile matinale." Miró employs here a rigorous reduction of form, producing shapes evocative of those in the woodcuts and sculpture of Arp. Meanwhile, red, blue, green, yellow, and white easily counter the menace of black, just as the pink tones in the background compensate for gray. The final effect is one of joyfulness, a promising new beginning. This is captured, too, in Breton's *prose parallèle*, with its "miller's wife's bonnet" making off "on the wing," flying over the belfrey, "pushing aside the night kites, like the others in the shape of hearts and cages." Breton introduces us to "the lark-headed plow," and "a last flame throws out its chest in the center of the unmade bed." Moreover, "In counterpoint, in the murmur becoming louder, soars a barcarole from which bursts forth, tintinnabulating, our great friend Oberon, who reigns over the watercress. . . . Indeed the magic horn gives voice as a chandelier in the distance," not to forget "the four molars and the moustaches at the price of which we have Esclaramonde and the daily sacrifice is accomplished." The allusions are unambiguous and to the point.

The graphic layout is more supple and more subtle in "Vers l'arc-en-ciel" (Toward the Rainbow), where optimism continues to be the prevailing mood. As for the accompanying text by Breton, it is less penetrable, more challenging to the mind, and, therefore, more imaginatively inviting because unrestrained by the limitations of observable reality. "From a wheat melting more than snow the pink monster of rope-jumping flairs out in the dear gray courtyard rid at last of its cheeping windows. From among the scrolls of the sandy flower a child's heart springs ever higher until it breaks away, a diabolo, toward the fuschia of the mansard roof." As in "Le Réveil" with its lark-headed plow, through unwonted word combinations the poetic phrase juxtaposes elements taken from the familiar world and, in "Vers l'arc-en-ciel," fuses them into entities—like the woman's hair "by jerks with waves of black-

birds' wings" rising from a cauldron giving off "the strong scent of slipping-away and of feinting"—that come to life in the imagination even though day-to-day existence denies us the occasion to see them.

The title "Femmes encerclées par le vol d'un oiseau" (Women Encircled by the Flight of a Bird) warns that we may expect to find more than one woman here, but not a bird. Although absent (or possibly so), the latter influences the picture profoundly. Its flight is graphically transposed so that the women become part of the design, not the center of attention. Naturally, "Femmes encerclees . . . " resembles "Le Chant du rossignol" more than it does "Le Réveil. . . . " But it also recalls "La Poétesse" in its utilization of sign language, as opposed to line, that fills the whole picture in disregard of figuration.

The dominant effect—perhaps one that Miró set out consciously to render—is that of encirclement, in which people are depicted as being absorbed in a situation over which they exercise no control. Hence, it seems, the relationship evoked in Breton's *prose parallèle:* "He is at my heels, he bears a grudge against each of my curls, he treats me like a violin being tuned, he forgets me in his labyrinth where the winged agate goes around!" Hence, too, the overlapping impressions, drawn from different areas of experience, recorded in the words, "Where have I seen that feather of slingshot in maidenhair fern spin vermilion in the lightning of a fencing doll?" Meanwhile, Breton directs attention to domination, which, in Miró's pictures, maintains subjection in equilibrium: "Every evening what does the nightjar do, he returns, with me on his crupper, to his post as switchman, from which he is the ruling spirit of the cones, horns, lanterns, beacons, flags, and flames."

Predictably, with "Femme au bord d'un lac à la surface irisée par le passage d'un cygne" (Woman on the Edge of a Lake with Its Surface Made Iridescent by the Passage of a Swan) the background corresponding to the lake's surface stands out, in a variety of delicately shaded tones, more than in "Femmes encerclées. . . . " In the top left of the picture a woman raises her arms in a lyrical gesture—"the arm," notes the poet, "which reflects, so that you cannot tell them apart, the neck of a swan, springs up absently on the honey's angle." This human form is distinguished only by three strands of hair, rudimentary breasts, and an exaggerated vulva, decoratively rendered according to an iconography that Miró has made his own. At the bottom of the picture, underlining the union of the human and animal kingdoms in nature, a swan with a head and a neck distinctly resembling those of the woman raises its wings in a similar gesture. Meanwhile, on the swan's head is balanced a white shape which could be a broken eggshell, allusive at once to Leda and to alchemy.

Breton's interest in myth and the esoteric tradition is discernible in his *prose parallèle* with its references to the Cyclopean eye, *"le terrible héraut du Retour Eternal,"* the flying carpet, alembics, and the Lady of the Lake. All these elements are woven into a text in which language is submitted to alchemical change:

> Their reverie takes on the velvety appearance of the flesh of a thought proportioned to the dimensions of the Cyclopean eye opened by lakes, of which the fixed stare fascinated the person who was to serve as the terrible herald of Eternal Return. The fine wake left by the heart innervates the three base petals of the immense floating flower endlessly wasting away to be born again in a blaze of stained-glass windows.

Breton shows no interest in elucidating Miró's gouache, being more concerned with "the marvelous cloud of incognizance" where "the steam from the alembics makes a hive."

In "L'Oiseau migrateur" (The Migratory Bird), the escape ladder motif recurs, as two grotesque human forms gaze up at a distorted bird flying away from a dark cloud. Breton's response—"On the walls of the little towns, of the out-of-the-way hamlets, these fine signs in chalk and charcoal are the *alphabet of vagabonds* unrolling"—emphasizes liberation through language, in the face of menace: "watch out for the mastiff that can jump the hedge." It invokes a "little nude man, who holds the key to the rebuses" and who, teaching the rare individuals ready to hear him *"the language of birds,"* holds out the assurance, "Whoever encounters the truth of letters, words and so on can never, when expressing himself, fall below his conception." Breton's *prose parallèle* is testimony to the surrealist faith in the mysterious liberative ceremony of poetic communication; "And each of us passes back and forth, tirelessly tracking his chimera, his head a calabash at the end of his big bell."

Mention of *"la clé des rébus"* ("the key to rebuses") comes in Breton's text just before Miró gives attention to ciphers and to deciphering, when *Constellations* offers in succession "Chiffres et constellations amoureux d'une femme" (Numbers and Constellations in Love with a Woman) and "Le Bel Oiseau déchiffrant l'inconnu au couple d'amoureux" (The Beautiful Bird Deciphering the Unknown to the Loving Couple). Considered side by side, these two gouaches offer a curious contrast. The first has the stranger title, yet it is the second that is the more complex, graphically, less easy to decipher in fact. The relevant texts by Breton are about the same length, nevertheless. In the first, the key phrase is the closing one: "In the center, original beauty, babbling with vowels, served by numbers, with a supreme fingering." The second text ends with a reference to "those myriads of egrets bearing achenes. . . . Between their soaring and return to earth according to the endless curve

of desire are inscribed in harmony all the signs embraced in the celestial musical score."

Harmony is an essential feature of both *proses parallèles*. Deciphering is the theme that becomes progressively dominant, as once again Breton takes up an image hardly characteristic of his work. Music is explicitly invoked in "Le Bel Oiseau" when he refers to a score, a point of departure for music making. Music, numbers, and those essential ingredients of spoken and written language, vowels, are brought together by fingering—the key to felicitous execution—in which some cosmic mystery involving the sun's rays has a part to play. This, he makes quite plain, is a mystery in which love permits men and women to participate, as though by granting them sureness and subtlety of touch.

The union of cosmos and mankind is brought to the fore in Miró's next title, "Le crépuscule rose caresse les femmes et les oiseaux" (Pink Dusk Caresses Women and Birds). Women and birds have ceased to be readily distinguishable in the relevant gouache, as indeed is the case, too, in other of the *Constellations* series where the human and bird kingdoms commingle. It is the blending into one unified design that Miró evidently intends to bring to our attention, their separateness yielding to unifying graphic patterns. The same kind of intermingling is present in the first sentence of Breton's parallel text, "The sorb enters the lyre or else the lyre enters the sorb," and later in "It really was worthwhile, your bosom is a wave of bullfinches."

The final gouache in Miró's series is a salute to "Le Passage de l'oiseau divin" (The Passage of the Divine Bird). It betrays no sign of fatigue or of weakening inspiration. Nor is there any indication of restlessness, of a desire to be finished with *Constellations* so that new directions in painting can be investigated. The magical act of exorcism through graphic invention continues. So does celebration of the transposition of sublimation. Meanwhile, Breton alludes to the sublimation of which the alchemists spoke, when referring to biological metamorphosis and talking of "*le subtil du devenir*" in which the caterpillar leaves itself open to victimization by the bird. On balance, in the picture, the title, and the accompanying text, the mood is positive and optimistic. Breton's concluding lines run, "Butterflies are very high-minded; they play with children; the butterfly knows this and is amused at it; he escapes always, even when they catch him and kill him."

In some instances, the links binding Breton's *proses parallèles* to Miró's gouaches in *Constellations* are easier to detect and to accept than in others. It is no problem, in fact, to classify these texts so that those most obviously inspired by the graphics with which they belong precede

those in which rational thought finds more tenuous the connection between word and picture. Arranging Breton's contribution in this fashion reveals, however, factors that are not to be denied and cannot be ignored, if we are to approach accurate evaluation of *Constellations* as evidence of collaboration on the poetic plane. As we advance in our classification, so it becomes increasingly difficult to establish exactly how Breton's contribution relates to Miró's. The links seem more elusive and thus more debatable. Breton's parallels are most prosaic, we notice, when on the surface their author reveals most directly the nature of his indebtedness to Miró. Hence, as they move further from prose, increasing therefore in poetic intensity, it becomes harder to explain how they relate to the pictures they accompany. Is this to say that the adjective *parallel*, selected by Breton himself, is of questionable relevance, applying appropriately only so long as his texts are confined to the level of prose?

There is no easily detectable evidence that will persuade the skeptical—especially those sensitive neither to Miró's poetry nor to Breton's—that, within the framework of the published *Constellations*, an organic unity of word and picture is manifest. Anyone still unconvinced might contend that, since Breton's contribution followed Miró's, the burden of proof rests with the writer rather than with the painter. Yet anybody acquainted with Breton's attitude toward poetry, as it embraces the obligations of the poet and of his public, too, knows that neither supportive nor explicative evidence is to be expected in this instance.

Within six months of the completion of his *proses parallèles*, Breton signed jointly with Jean Schuster an "Art poétique,"[20] the first such text to appear over his signature since he and Éluard published their "Notes sur la poésie" in 1929. A brief prelude warns that "the poet has no need to exculpate himself before any judge." Then come twenty-three numbered statements (not twenty-two, as one might have anticipated). Among these the following are especially pertinent to our appreciation of *Constellations*:

III

I have banished the clear, divested of all value. Working in the dark, I have found lightning. I have disconcerted. I have called for a riot, braved monsters and prodigies, made everything blaze that exasperates the needy and the good soul.

V

I have extolled the feelings one experiences blindly, and which one would ruin by trying to identify. Thanks to me, everyone now surrenders to them with closed eyes. Everyone feels a new intimacy with them. Everyone is more at ease in his soul when what he held too well escapes him.

My verses recall at each word that they are the negation of prose ("What I say is oracle"). Each vain effort to reduce their enigma, to escape the trap they set, calls for a new gloss. One cannot penetrate their secret. Wishing desperately to do so, one renders their beauty more unfathomable.

Above all, the eighth passage in "Art poétique" sheds light on *Constellations*, illuminating Miró's contribution just as much as Breton's. There one finds a declaration that brings us to the threshold of appreciation: "One forces locks, not images."

6

PAINTING, POETRY, AND SURREALISM'S "UNDERLYING AMBITION"

Altogether too little notice has been taken of one central fact in the history of surrealism. The excitingly enigmatic phrase that first led to sustained investigation of the potential of language for surrealist inquiry recorded a *visual* impression. It ran, we are informed in the *Manifeste du surréalisme,* something like "There is a man cut in two by the window." André Breton's expository text assures us there could be no misunderstanding, because the phrase that came into his head while he was falling asleep was accompanied by "the weak visual representation of a man walking and sliced halfway up by a window perpendicular to the axis of his body" (p. 35).

Breton attributes to his being a writer, not a painter, his inclination to concern himself with the way in which the inexplicable yet insistent phrase *"rapped at the windowpane"* (p. 34), rather than with the visualization accompanying it. Still, a footnote in the first manifesto emphasizes that, later, concentration on similar "apparitions" convinced the French surrealist leader that they were not inferior in clarity to the auditory phenomena so fascinating to him. One thing is amply demonstrated by writing surrealists produce after relaxation of reason's regulatory control over verbal expression. Images similar to the original "bizarre phrase," stimulating Breton's interest and suggesting an exciting approach to language generative of surrealist word poems, establish their

claim on attention by way of the "apparitions" they liberate in our imagination.

This feature of verbal imagery in surrealism relates to an essential characteristic of surrealist creative energy which, in whatever medium we find its manifestation, thwarts any attempt to understand exactly why it operates quite as it does. At its best, surrealism does not have any prescribed aim beyond exploration of the surreal.

Even then close definition is elusive. As Louis Aragon once pointed out, like the horizon line, surreality withdraws before the advancing explorer. Thus, when we are dealing with surrealism, rational understanding not only escapes us but proves to be at odds with the artist's endeavor. We are left, therefore, facing the necessity to come to terms with discoveries made in surrealism's domain. If we cannot understand, can we nevertheless respond in a way that does not betray the surrealist's purpose or demean his creative activity?

Taking this question with us into a reading of a 1935 lecture delivered by Breton in Prague, we note one categorical statement in particular: "There exists, at the present time, no difference in underlying ambition between a poem by Paul Eluard, by Benjamin Péret and a canvas by Max Ernst, by Miró, by Tanguy."[1] Breton's words are more than a little puzzling. They call for alignment of poems and pictures, for mixing apples and pears that look quite remarkably dissimilar.

As Eluard humbly acknowledged, he was no Péret. A good Ernst looks nothing like a good Miró, which could scarcely be confused with a Tanguy (and Tanguy's canvases, everyone will agree, are singularly free of fluctuation in quality). Our first reaction, therefore, is likely to be one of perplexity. We have difficulty enough putting our finger on a common element uniting Eluard and Péret. In the circumstances, it seems close to folly to try to establish what links of ambition connect the two prominent surrealist writers mentioned by Breton and three ranking surrealist painters of the same generation, as well. All the same, surrealists consider them to be of fundamental significance. Reference to published statements by Breton does more than furnish a theoretical basis on which one can argue with confidence for the unity of surrealist painting and writing. It suggests at the same time that there may be a method for tackling the problem of identifying the underlying ambition shared by surrealists. To test this hypothesis, we may ask whether looking at surrealist pictures can help readers respond to surrealist poems in a more fruitful manner.

Such an approach to surrealist expressive modes must appear a willful violation of customary critical habits. We are committed, apparently,

VII. La bague de l'ombre te regarde

Sommeille la manche rouge de ta
 langueur
A l'automne trépané
Dans la joie brune et ta moue
Au bal hélait des ludions calmes

Ton doigt passé au dé redonné à la
 lointaine action
Vers les viandes guéries sous la soie des
 loupes
Et le miel des mots volés aux litières
Cingle vers les bords floches de la peur
Qui tendit belle sur ta noce un œil
 funèbre
Cave attrapé en houppelande

Et nous
Dérobant le tulle et le tesson
Comme si folle la mare aux brèmes
 s'amusait
Des courses et du bol et des lampes
Et que lourde elle exhale aux tympans
 mourants ses nards.

Bottom, Martin Stejskal, interpreted poem (1975). Top, *The Shadow's Ring Is Looking at You*, from *Maisons* (1976), lithographs by Martin Stejskal, texts by Vincent Bounoure. Coll. J. H. and Jeanne Matthews.

to a hazardous venture. A trap set by a truism of critical commentary that brands surrealist painting as literary immediately opens up before us. Implicitly granting the spoken word priority over the pictorial image in surrealism, the adjective *literary* presupposes that surrealist painters aspire to imitate surrealism's writers, if not actually to compete with them—presumably to their own disadvantage. This trap is fortunately easy to sidestep and so is no real threat. One does not have to pause for long before realizing that pictorial surrealism could not be expected to illuminate surrealist writing, if all it did was grant the latter precedence in everything.

Surrealist painting would be of limited significance, indeed, if its only purpose were to facilitate comprehension by furnishing a pictorial illustrative adjunct to written language. Breton gladly admitted to the prejudice born of his vocation as a writer when he confessed to having thought more about the strange phrase heard one night in bed than about the mental picture going with it. There is certainly no basis for the belief that, in surrealism, pictorial imagery is more accessible—to take that word in its commonly accepted sense of readily comprehensible—than its verbal counterpart. After all, as the work of Salvador Dalí proves beyond dispute, the imagery of surrealist painting is weakest when it shows least resistance to the interpreter's efforts.

No less indicative of the true nature of surrealist pictorial language is the discovery one makes when examining a succession of texts in which writers affiliated with surrealism, Eluard among them, pay heartfelt tribute to the poetic imagery of certain painters. Uniformly, the results are lamentably prosaic, revealing inadequate attempts to render the magic that has prompted comment. Such is the case with the writing of Hugh Sykes Davies, guilty of imitating Dalinian imagery in his *Petron* (1935), a book dismissed, it is well worth noting, as "orthodox surrealism" by one self-assured but misinformed commentator.[2]

There can be no doubt that familiarity with the iconography of Giorgio de Chirico's painting during the period 1910–1917 (the dates carefully specified in Breton's *Le Surréalisme et la peinture*[3]) and acquaintance with the atmosphere peculiar to it provide the best possible introduction to his novel *Hebdomeros* (1929). Recognition of this fact does not take us very far, however. All one has learned, in the final analysis, is that de Chirico's pictures and his writing draw upon the very same imaginative resources—hardly a surprise, after all. In order to make progress we must search for more than proof of the obvious as we ask whether the kind of imagery at which a surrealist arrives by way of painting can advance appreciation of surrealist word images. It is not a matter of simply taking note of the self-evident. Nor, again, is it a question of just

paying attention to signs of transposition from one medium to another in which, so far as it is present to a significant degree, parallelism reflects some measure of premeditation on the writer's part. We only falsify evidence if we confine attention to indications that this or that surrealist poet has followed the example set by one surrealist painter or another.

Once we have reached the stage where it seems prudent to pause and take stock, we find we have entered a curiously indeterminate zone. Here it looks as if we should do better to proceed in the opposite direction from the one we really wish to follow. The definition offered by Breton in *Le Surréalisme et la peinture* of "the essential discovery of surrealism" runs, "Without preconceived intention, the pen that moves to write, or the pencil that moves to draw, *spins* an infinitely precious substance not all of which is perhaps material for immediate exchange but which, at least, appears charged with everything emotional the poet or painter has within him at that time" (p. 68). Breton, we see, placed words and pictures on the same footing as means of surrealist investigation. Even so, the history of surrealism in France during the months immediately following publication of his *Manifeste du surréalisme* suggests that, initially, among surrealists, the writers enjoyed a real advantage over the painters. The ability of painters to apply the automatic principle seemed problematical and became the subject of debate throughout the winter of 1924–1925. Meanwhile, the writer's capacity to do so not only was uncontested but had been documented as early as *Les Champs magnétiques*, written in collaboration by Breton and Philippe Soupault as far back as the summer of 1919.

In the 1920s and later on, a complicating factor appeared: increasing signs that surrealist writing might fall victim to at least one of the unspecified *poncifs* (stereotypes) against which Breton had warned his companions in his manifesto. Few commentators seem likely to quarrel with Edward Germain's remark, "The 'surrealist image' which Breton had defined in 1924 as 'the juxtaposition of two distant realities'—'the chance meeting of a sewing-machine and an umbrella on a dissecting table,' to use the famous phrase from Lautréamont—soon became reduceable to a formula: 'the ------ of the ------.'"[4] But something more needs to be added.

The versatility of *de*, its capacity to carry the sense of "belonging to" and also "made of," taken with the even greater versatility of *à*, at once permitted the French language to open up unforeseen perspectives, as soon as automatic writing—the revelation of the first surrealist manifesto—had liberated those prepositions from the confinement imposed

by rational discourse. In contrast, surrealist painters could not avail themselves of similarly convenient structuring devices that are just as universally available in their chosen medium and no less productive in effect. For the surrealist painter there existed nothing comparable to the commonplace preposition for combating tradition and opposing conventional modes of thought, perception, and communication.

If the painter had reason from the first to envy fellow surrealists who wrote, the latter, it seems, faced a serious risk growing out of the availability of prepositions for their investigation of the surreal. Objecting to the recurrence of a predictable verbal structure, critics have felt justified in deploring the monotony of surrealist formulaic phrases structured about *de*. They have disregarded consistently, however, the essential factor that, in surrealism, it is content and not form that really matters.

Two examples display the external features of monotony with which some critics voice displeasure, "the lids of her windows" (Dylan Thomas) and "the snakes of her hair" (Nicholas Moore).[5] Confusing content with container, Germain has not hesitated to cite both of them as instances of surrealist imagery. His basis for classifying them among surrealist images rests unsteadily on the surface resemblance that each of these metaphors bears to a *rapprochement* of words frequently encountered in surrealist writing. When we turn to Breton's praise of Francis Picabia as being "the first to understand that any *rapprochement* of words without exception was permissible and that its poetic virtue was all the greater because it appeared gratuitous or exasperating at first sight,"[6] we appreciate where the difference lies and how great it is. In Thomas's image and Moore's, resemblance amounts to nothing more noteworthy than arrangement of words according to a recurrent pattern in which the preposition *of* occupies a pivotal position. Neither of these phrases qualifies as surreal by the standards to which Breton refers. No surrealist would condone the triteness of the resulting metaphorical figure just because the latter happens to have been cast in a linguistic mold rendered familiar by numerous surrealist texts of impeccable quality.

Images such as those selected for quotation by Germain can make a claim upon attention only at the level of elucidation. Even there, they are of strictly limited value, for they do no more, finally, than restate the banal. Rehearsing a literary commonplace (Moore's unself-conscious plagiarism of the Medusa myth, for example) means nothing at all to the surrealists. Their main concern is illumination, not elucidation. In other words, the function of the image in surrealism is not to show the

familiar in new or unusual perspective, but to reveal the previously unseen.

In the field of surrealist creative action, the form employed by the writer is no more than a mechanical aid, a procedure, to the extent that it is a method of bringing words together (the meaning of *rapprochement*) in a manner that allows an image to appear. This is to say—and the point is fundamentally important in surrealism—that form, here, is not just the means by which the writer has elected to address others (the way Thomas, for example, loved word-juggling—as in his variation on a stock phrase, "His awful wedded wife" [*Under Milk Wood*][7]). It is quite simply the linguistic framework within which the image wells up in consciousness and succeeds in communicating itself through the channel of language. In short, its worth lies in providing a serviceable vehicle for articulating something not only previously unstated but also previously unthought.

Ersatz sub-surrealism, which almost comes close to justifying use of the popular adjective *surrealistic,* borrows the container without addressing itself to the content. It respects the form, or passes for doing so. Nonetheless, it fails to capture the spirit of surrealism. The reason for this is obvious, but in need of reiteration all the same. By itself, the mere linkage of words with the help of prepositions is a guarantee of nothing at all, in the surrealists' eyes. In fact, being elementary components of grammatical expression, far from ensuring poetry, as surrealists speak of it, prepositions most often serve quite antipoetic ends. Thus, the phrase "the lids of her windows" is merely precious in the worst sense of the term. Surrealists see such an affected and uninspiring circumlocution as failing to bring about an association of words capable of operating positively upon the imagination.

Whether or not "the lids of her windows" records spontaneous word association and, hence, can be accepted as a genuine product of verbal automatism within the surrealists' definition of the phrase, it does no more, really, than bring to light the poverty of the creative sensibility in which it has its origin. It bears out Aragon's contention that inanities are no less inane for being the result of surrealist technique. Essentially, under surrealist scrutiny, the poetic nature of a phrase is not validated through word arrangement but in the imaginative leap beyond banality. Going a little further, we can say that verbal structure is only as liberative as its potential for imaginative stimulus enables it to be. This is why, in the two phrases isolated by Germain, what impresses most is the confinement imposed upon imaginative play by the utterly pedestrian use of the preposition *of.* Structural monotony is not the source of dis-

satisfaction so much as of disappointment at finding in the celebrated "formula" nothing that really provokes lasting enthusiasm.

Now we find ourselves confronted with the question of the nature of the enthusiasm generated by the surrealist image. It comes into sharp focus as soon as we notice that pronouncing surrealist imagery nonsequential, as people often do, brings to bear evaluative criteria rejected by the surrealists as entirely impertinent. Evidence offered by surrealist poetic writing reveals that the surrealist image is vital where it proves to be sequential *in a new way*. Thus, it leads us along paths of perception and response divergent from those taken by everyday language. It activates a receptivity that ceases to find its bearings in the commonplace and the commonsensical. This is why trying to paraphrase—on the false premise that the image is explicable according to standards reason approves, and that it is, in Breton's damning phrase, "material for immediate exchange"—leads to an impasse of thought, to use a thoroughly anti-surrealist metaphor.

Surrealism had not existed for long as a coherent movement when Breton took issue violently with someone who had the temerity to furnish "explanations" of a few images by a poet the young surrealists in Paris admired. Undertaking to tell his readers what Saint-Pol-Roux had "meant to say," the unfortunate commentator infuriated Breton. It was not that the author of the first manifesto of surrealism—soon to write a second one—categorically denied or begrudged critics the right to interpret. His objection was to the presumption behind one interpreter's statements: that poetic images are merely figures of speech, fashioned with care and attention by an individual bent on sharing ideas or feelings with his readers. Breton's protest was directed against the presupposition that all poetic images necessarily lend themselves to explication. He would return to it many years later when he prefaced Jean Markale's anthology of Welsh bardic poetry, *Les Grands Bardes gallois* (1956), with a text entitled "Braises au trépied de Keridwen."

As reaffirmed in "Braises," Breton's condemnation of any attempt at reducing poetry to prose is centrally important to understanding the surrealist concept of imagery. It brings to the fore the vital question of precedence in surrealist creative action. In surrealist verbal imagery of the highest order, words precede images, not vice versa. Words, therefore, reach out, so to speak, for the image, finally "fixed" in language (the comparison is not uncommon in surrealist-inspired remarks on image-making) only when they succeed in reaching their unforeseeable goal. This is to say that words are not preselected and then artfully

arranged so as to record a picture already in the poet's mind. This is why it is helpful to approach certain of the images appearing in surrealist writing by way of surrealist pictorial imagery.

It would be an error to infer, at this stage, that imagery in surrealist painting is somewhat more direct in its effect than the images offered by surrealist writers. In fact, "Braises" insists that the virtue of painting depends as little on what it "represents" as the virtue of poetry depends on what it "signifies" literally. There can be no question of attaining something Breton calls pointedly "a banal and illusory clarity" and of comprehending surrealist writing any better by way of surrealist painting. All the same, we may hope to appreciate some aspects of writing more fully when coming to it via painting.

Now we begin to perceive a little better the nature of the role assigned the reader/spectator in surrealism. The surrealist's audience is not faced with the task of reading and looking in such a manner as to penetrate meaning efficiently, the way ahead conveniently lit by what Breton terms contemptuously "the precarious gleaming of elucidation." To proceed in this fashion—and in this direction—would be tantamount to striving to reduce surrealism to realism; in other words, trying to domesticate the surrealist image.

To the "precarious gleaming of elucidation" Breton openly preferred the "gleam of a siphonophore."[8] There is no ambiguity about the contrast between these two phrases, both hinging on the possessive *of*. On the one hand, reason finds it fitting to link *gleaming* with elucidation, on the grounds that, according to a hackneyed metaphor, the latter sheds light on obscurity. On the other hand, linking *gleaming* with an organism known best to marine biologists is very different indeed. The siphonophora are small swimming or floating sea hydrozoans, some adapted for nutrition, others for reproduction, but none having the property of emitting light. Yet, conditioned by surrealism, Breton's imagination can find illumination where nature has not granted even its possibility. Guided by the siphonophore's gleam, he sets out in his *Yves Tanguy* to join a surrealist painter in "that place he has discovered."

Receptivity of a special kind, developed in a direction reason sees no excuse for taking, goes in the surrealist's imagination with sensitivity to illumination emanating from a radiated sea animal that science tells us gives off no light at all. What then is to be seen "by the light of a passing glue factory"?[9] Posing this question, Spike Milligan takes his listeners to the heart of the surrealist experience. Now the things we may anticipate by rational projection and those we are enabled to see by way of surrealist imagery are poles apart.

Milligan's phrase is doubly disconcerting. It presents a glue factory in

movement, passing a spectator by. It offers a factory the mind naturally associates with its smell as being actually a source of light. By its gleam or effulgence—we cannot be sure which—one character in a radio play tells us he can discern another. The latter wears only one boot, on his head, incidentally. "Why? It fits, dat's why—what a silly question." Rational questions that aim to challenge the logic of unreason are dismissed as foolish. If the boot fits where the cap should, why not wear it instead?

Language is blessed with the capacity to say more than reason authorizes or condones. Because of this, it becomes an appropriate instrument for surrealist investigation, a reliable means by which to penetrate to the surreal. Language best fulfills the function surrealism reserves for it when it is allowed to lead the imagination and to generate images in complete freedom, with total disregard for reason's edicts and interdictions. Hence, it would be inconsistent to require the audience to submit the image captured by verbal language to evaluative review by common sense. It would be inconsistent for the audience to mete out approval or disapprobation only after invoking rules, regulations, customs, and assumptions of reasonable origin. Such rigidity is bound to infringe upon the liberty exercised in the surrealist use of language. Still, as sketched here, the situation is ideally simple, the alternatives transparently clear. Making the choice demanded of us by surrealism between the reasonable and the anti-reasonable may not be every time as easy as it sounds. Resistance of a kind that rational deduction pronounces entirely appropriate stands between us and full enjoyment of certain images running afoul of predispositions in thought we find difficult to reject. The impulse has been developed and has grown strong in us to try to assess the potency of verbal images, surrealist ones like any others, by their ability to meet reason's requirements. Therefore, we incline—naturally, it seems—to disallow any images failing to do so. Inculcated values invite application of an admissibility test devised and administered by reason, which alone tallies the score. In no small measure, the predicament in which we are placed by an encounter with surrealist word imagery is a direct consequence of the fact that, thanks to the way we have been educated, we are accustomed to weigh knowledge only after submitting what we hear and read to rational analysis. Because our response finally depends on the latter, wherever analysis turns out to be unproductive, response is sure to be less than positive.

The special virtue of sight, surrealists argue, is that it is not subject to restraints such as usually limit thought. Breton emphasized that virtue quite succinctly in the very first sentence of his *Le Surréalisme et la pein-*

ture: "The eye exists in an untamed state." This assertion seems open to question, when one considers how the eye, in fact, may be trained to react more sympathetically to some things seen than to others. But this is exactly the point. In an important text on the theme of "Le Message automatique" Breton noted in his *Point du jour* (1934) that physical perception and mental representation seem to the ordinary adult to be radically opposed to one another. He went on to assert—and later to repeat in his *La Clé des champs* (1953)—that both should be considered "the products of dissociation of a *single original faculty* of which traces are to be found in primitive man and children." As a simple camera, the eye remains an impartial mechanism for recording visual impressions. To those writers identified as surrealists in the first manifesto and said there to have made of themselves "modest *recording instruments*" (p. 42), the advantages of that mechanism appeared positive indeed.

The 1944 essay "Silence d'or," where "Le Message automatique" is quoted, presents one of the paradoxes of early surrealist activities in France. Breton declares in this essay that the painter fails in his "human mission" if he continues to let representation be separated from perception "instead of working for their conciliation and synthesis."[10] Even so, when the surrealist movement was launched, painters by and large found it less easy than writers to enter the world of the surreal. Yet surrealists whose medium was verbal language judged the purity of the eye, to which the painter appeals, to be unequaled in the mind, where word images come under examination. The eye seemed relatively pure because it is conditioned less thoroughly than the mind to evaluate through a process of acceptance and refusal, by which reason admits information of one kind while rejecting information of another sort.

Sight provides the standard by which the poetic use of language is to be measured, as Breton refers in "Silence d'or" to an aim acknowledged as ambitious, "we must want to *unify, re-unify hearing*, to the same degree as we must want to *unify, re-unify sight*" (p. 78). In addition, affirming that the process of reunification must be essentially the same with the one sense as with the other, he cites the visual field—"in which it can already be grasped"—as offering a precedent to be followed on the auditory plane.

In spite of all this, however, twenty years after the *Manifeste du surréalisme*, Breton denounced in "Silence d'or" those who qualify poets as visionaries. He declared that, on the contrary, the great poets have been "auditives" (p. 80). The stress he placed in 1944—and not for the first time, by any means—on the poet as hearing rather than seeing is in harmony with his conviction that poetic vision, or "illumination" (he

used the word) is not the cause of poetry, but its effect. To put it another way, Breton regarded the surrealist poet as impressed with the capacity of words to "assemble themselves in singular sequences [literally *chains*] in order to shine forth, and at the moment when one looks for them least" (p. 79). Illumination, then, brings revelation of the surreal as words slip the harness by which reason would keep them under control. All the same, while the surrealist poet is not painstakingly setting down a record of an inner vision, he does share sights with his readers. His major function is to *show*, as Eluard indicated by selecting the title *Donner à voir* for a book of essays.

Breton affirmed in "Silence d'or," "Never so much as in surrealist poetic writing has confidence been placed in the *tonal* value of words" (p. 79). He aimed, then, to direct attention to the frequency with which the sound of a word accounts for its appearance next to other words connected tonally, though not in ways reason can justify. He was alluding to the contribution made by phonic association in leading the poetic phrase toward an image. Thus, he wished to point out how often sound association replaces sense sequence in the evolution of surrealist verbal imagery. In short, Breton was explaining obliquely how in his anonymously published poem *L'Union libre* (1931) he arrived at verses like "my wife with calves of elder pith," which reads in French, "Ma femme aux mollets de mœlle de sureau."

Breton has not placed in our hands a guaranteed but strictly mechanical method for creating images that will have the ring of surrealist authenticity. Even though we can track the progression by way of sound from *mollets* to *mœlle*, we cannot *explain* how Breton the "auditive" came to hear the word *sureau*. Nor, of course, can we explicate the image completed by that word in terms tolerable to reason. The same holds true when we examine one of the images from Breton's "Au beau demi-jour de 1934" (In the Fine Early Morning of 1934) in his collection *L'Air de l'eau* (1934): "Et la forêt quand je me preparais à y entrer / Commencait par un arbre à feuilles de papiers à cigarettes" (And the forest when I prepared to enter it / Began with a tree with cigarette paper leaves). This proves how necessary it is to accept what a surrealist actually says, instead of falling into the illusion of believing one must seek banal clarity in his words.

It is obvious that the arrangement of words in this last image fails to satisfy our need for explicable meaning. Nevertheless, even without comprehending French, a reader can appreciate that the disposition of the words on the page provides an instance of the "musical sequence" mentioned in "Silence d'or" as distributing words according to "inhabitual but very much more profound affinities" than those required by

"immediate meaning," for which Breton expresses nothing but scorn. Everything rests, in fact, on a sequence dependent for its unity on the "inner music" of repeated sounds, notably f, p, $ç$, r, and a.

An interesting feature of Breton's argument in "Silence d'or" is that it speaks of the "inner word" of poetic surrealism as absolutely inseparable from the "inner music" carrying and conditioning it. Thus, for the poets, "inner music" plays a role analogous to that of the "inner model" for the surrealist painter.[11] In automatic writing especially, "inner thought" excludes "reflective thought," in the very measure that the sole obligation binding the surrealist writer is to let thought accord with "inner music." It is noteworthy that Breton's position remains remarkably consistent. Indeed, he makes a point of quoting in "Silence d'or" a section from "Le Message automatique" that adds one final important detail: "Always in poetry verbo-auditory automatism has seemed to me upon reading to be creative of the most exciting images." Focusing on this observation, we can return to the image borrowed a moment ago from "Au beau demi-jour." Visibly, Breton's image is cast in a thoroughly familiar structural pattern. However, it is evident that a radical difference exists between the image conveyed in his prepositional phrase and the metaphors cited by Germain. Whereas the lines by Thomas and Moore invite explication, Breton's do not, even indirectly. They do not imply comparison, either, the way Moore's and Thomas' patently are meant to do. Breton does not liken the leaves on a forest tree to the papers with which smokers sometimes roll their own cigarettes. Instead, using both *à* and *de*, he asserts that those leaves actually *are* cigarette papers. In total consistency with his conviction that images are really not evocative, his verses do not confine themselves to evoking the texture of the leaves, shall we say, or perhaps their fragility. On the contrary, they face us with a visual impression having no precedent in common experience. And that impression does not come before us in order to allude to something, to shed light on it, or to make us see it afresh. The poetic impression *is*, bringing to mind Breton's early prediction that surrealism "is what *will be*."

The state of receptivity demanded by surrealism of its public encourages imaginative fermentation outside reason's control, beyond reason's limited range. Contradictory interpretations of a surrealist image are to be entertained concurrently, and no mental strain induced by conflict in thought should inhibit enjoyment or curtail enthusiasm.

Prepositions—to confine ourselves to our customary example—link things never seen connected before, while what is shown denies priority to the previously seen.[12] Only with this knowledge can the surreal be

accepted without misgivings and without reservations as a higher sense of reality, rather than a crudely hostile denial of the real.

On the plane of theoretical discussion, it is easy enough to grasp that the underlying ambition shared by surrealists in all media of expression is to foster acceptance of the surreal by bearing witness to its presence. The difficulty comes when we ask how that ambition is to be attained on the practical level of creative action appropriate to the individual artist's working method. Because intentionality is inimical to fruitful investigation of the surreal, it is in the nature of surrealism to remain unpredictable in its results, to lie significantly beyond mental projection, to stand outside the range of deliberation. Breton made this absolutely clear from the first, when he advocated a method for opening up the sensibility to intimations of the surreal without prejudging the nature of surrealist revelation or prescribing a format in which it must present itself.

Another significant feature of Breton's remarks from the 1924 manifesto onward is the following. They avoid offering practical recommendations that can be followed by a reader seeking to make contact and to come to terms with the surreal by way of surrealist writing. Indeed, it is plain that Breton's theory takes for granted our readiness—eagerness, even—to throw off restraints that the majority of us accept without any objection at all. Most people do not feel the necessity to avoid the consequences of customary thought processes. Few, certainly, are persuaded that it lies in our power to escape them successfully and with real profit.

The barrier erected by the nonrational to block progress by reason marks the boundary beyond which surrealist word images are located. It delimits the areas where comprehension no longer should be the reader's goal. At the same time, it indicates the crucial point at which reflective thought ceases to be the instrument of image-making by the poet or of assimilation by his audience. Small wonder that readers find themselves at a loss sometimes, shut off by the barrier excluding reasoned response from access to the world explored in surrealist imagery. At such moments it is beneficial to look outside the field of verbal language and to seek assistance from surrealists whose medium is not words at all.

If we look for an analogy outside writing, capable of shedding light on the dynamism of the verbal image of "the tree with cigarette paper leaves," we find an illuminating point of comparison in the practice of surrealist pictorial collage. Collage pictures present a true visual equivalent, in which juxtaposition (or again, more correctly, *rapprochement*) of materials taken from everyday reality plays an active part.

A distinguishing feature of pictorial collage in surrealism is that the elements it brings together remain identifiable for what they are. The spectator rarely fails to be able to recognize their origin. At the same time, the *rapprochement* unifying them in the collage endows familiar elements with new value and heightens their significance as it incorporates them in an image of the artist's creation. The parallel with verbal images like Breton's is enlightening. It allows us to grasp, for example, that we should be mistaken in believing we ought to be seeing in the mind's eye anything but a tree sprouting leaves that really *are* cigarette papers.

The effect at the beginning of "Au beau demi-jour" is very close indeed to that produced in *Hier ist noch alles in der schwebe*, a 1920 collage made in collaboration by Ernst and another artist thought to be Hans Arp. In this *fatagaga*, the keel of a ship is the carapace of an insect laid on its back. Meanwhile, the insect's legs supply the vessel's masts. In each case, the force of the image comes from the presence of features recognizable in two ways at once—both as what they are in the world of daily experience and as what they have become in the domain of the surreal. The pictorial artist assembles within the frame of his picture elements we have never seen before in proximity or united in such a relationship. In *Hier ist noch alles in der schwebe* the insect-vessel sails beneath fish that swim (or fly) overhead. We are confronted with the same rationally inadmissible encounter as Breton achieves when letting the preposition *of* play its grammatically assigned role outside reason's supervision.

Reality is subsumed in surreality to the extent that the surreal borrows from the real in order to acquaint us with something more than reality normally seems to provide. Therefore, it is in the nature of certain surrealist images to bring before us more than we are accustomed to find in reality, while at the same time demonstrating the surrealists' belief that the real has no value unless it opens up a path to the surreal. A sense of wonder is released in us by our discovery that reality is capable of ushering in surreality and that the latter is not its opposite, by any means, but rather a sharpened sense of reality's potential.

In this connection, it is essential that surrealism's audience be alerted to the part reality can assume—and must in fact play—in bringing intimations of surreality. Thus, the dominant feature of the ship seen in *Hier ist noch alles in der schwebe* is that its hull is concurrently an insect's hard shell, and that looking at the latter lets us perceive the former at the same time. Sacrifice of the one to the other—making sure, for example, that spectators do not mistake the carapace for the ship's keel—would diminish the vitality of the image, its power to set off mental

activity in a way surrealists regard as fruitful. Similarly, presenting a tree with leaves that are cigarette papers is very different from likening foliage to the slips of paper some smokers use. Preciousness is ruled out in Breton's lines, as is the fanciful. There is no ambiguity in this image that might provide the reasoning mind with a welcome choice, the opportunity to think of leaves while ignoring the presence of cigarette papers. Instead, seeing the foliage is conditional upon visualization of small oblongs of thin paper, gummed along one edge—possibly (but not necessarily) the edge by which they adhere to the tree's branches. As it opens, Breton's poem places us on the outskirts of the forest he is about to enter. There stands visual evidence that he is on the point of moving into a privileged locale where the marvelous reigns, "Parce que je t'attendais" (because I was waiting for [expecting] you).

In surrealism, waiting is expectation, anticipation is already confidence in realization, and aspiration is the conviction that attainability is assured. Images occurring in surrealist texts and pictures frequently reflect this optimistic view that human desire stands on the brink of fulfillment, rearranging the familiar in ways that satisfy imagination's needs beyond the scope of reason. In marked contradistinction to reflective thought, speculative thought explores the surreal through multivalent visual impressions, causing us to see *(donner à voir)* the unseen. The strong bond linking verbal and pictorial imagery in surrealism can be detected here. For it is in the nature of the word image to demand of its audience something far distant from proof that they have been taught to elucidate efficiently. By appealing to inner sight through his sensitivity to inner music, the surrealist poet calls for resistance to the reasoning faculty which, from his perspective, cannot but look harmful. Meanwhile, we are challenged to demonstrate an ability to see, unencumbered by rational presuppositions and unhindered by reason's predictable objections.

With elements of language heard while writing at the dictate of the inner voice, the poet arrives at images which derive their power from their capacity to give us something to see that, otherwise, would remain hidden from us. Sight having priority over comprehension, efforts on the reader's part to understand reasonably can only raise an obstacle that effectively separates him from productive response, from participation in the surrealist poetic process. These efforts lead nowhere so much as to frustration. When understanding has ceased to be a positive factor for someone sharing in the poetic experience, enjoyment deepens proportionately to his or her capacity to see what the words of the poet (in this instance, Breton) have to show: trees on which cigarette papers

grow as leaves, a woman's calves of elder pith, a white-haired revolver, and even—though we must make haste to look while we still have time—a soluble fish.

It is a matter of historical record that expansion of surrealist inquiry to embrace pictorial art as well as verbal poetry found its earliest and most persistently energetic advocate in Breton. At the end of the 1920s— and in subsequent expanding editions—his *Le Surréalisme et la peinture* appeared as an act of faith. However, we can be sure that it was never Breton's intention or hope to draw painters into the surrealist circle in order to assist outsiders in coming to terms more easily with surrealist word poems. Throughout his life he was to remain true to the conviction that, as he once put it, the public absolutely must be prevented from "entering." Nevertheless, by encouraging pictorial artists to explore the surreal, Breton contributed significantly to making it less difficult for the public to situate all forms of surrealist experimentation, including those finding expression through verbal language, in relation to an "underlying ambition."

7

LANGUAGE AND PLAY:
LE CADAVRE EXQUIS

"Poetry must be made by all. Not by one." The popularity among surrealists in France of these words from the Comte de Lautréamont's *Poésies* is beyond dispute. All the same, it bears comment.

The credit is André Breton's for taking time to transcribe Lautréamont's text from the only known copy, deposited in the French national library, and for publishing it in the second issue (April 1919) of *Littérature*, a magazine he coedited. Yet, although *Poésies* was available in Paris even before the *Manifeste du surréalisme* had been drafted, only several years later did Lautréamont's pronouncement come to be quoted frequently by the surrealists, virtually every time being invoked as one of their guiding principles. Paul Eluard cited it at least three times in a succession of essays collected as *Donner à voir*—the first occasion being the transcript of a June 1936 lecture delivered during the International Surrealist Exhibition held in London—and he was far from being alone in his enthusiasm. Even so, it was not until Georges Goldfayn and Gérard Legrand prepared an *édition commentée* of *Poésies*[1] almost a quarter of a century later that members of the surrealist group in France attempted to evaluate Lautréamont's declaration against the background of his thought, as this found expression in *Poésies*.

Looking over indications that have come down to us of the reception given Lautréamont's statement among surrealists, we notice three things especially. First, not one of the Paris circle saw reason to accord Lautréamont's words prominence from the very beginning of surrealist activity in the French capital. Second, surrealists began quoting his

dictum only after they had reached the conclusion that Lautréamont had anticipated their ambitions to some extent. Furthermore, not for a moment did they pause at that stage to ask themselves whether they might be distorting his views when interpreting them as they did.

French surrealists had always respected Lautréamont as the author of *Les Chants de Maldoror*, from which they took pleasure in extracting from the fourth canto an image they considered exemplary: "Beautiful as the chance encounter on a dissecting table of a sewing machine and an umbrella." But they started leaning heavily on his ideas—and even then usually without indicating that they were borrowing from *Poésies*, not *Maldoror*—only after poetry, in their eyes, had begun to take vitality from their own investigation of the benefits of group activity. The exploration of dream experience and of mediumistic trance was essentially the province of the individual surrealist writer making forays into the surreal all by himself. However, a few games (of which they set about publishing records from 1927 onward) persuaded those in the French surrealist camp of the existence of benefits to be earned through group action but denied anyone persisting in working strictly alone. As a consequence, before long, the name of Lautréamont was invoked by surrealists, who were convinced already that *Poésies* helped lend significance to a mode of collaborative activity for which they had begun to feel the greatest enthusiasm.

Surrealists continued to show themselves more than willing to read Lautréamont's statement as support for their belief that poetry is a participative venture. In this venture, the poet—to borrow from *Donner à voir*—acts "contagiously" (p. 110), while the principal quality of poems is to "inspire" rather than to "evoke" (p. 74). The author becomes, according to Eluard's 1936 lecture in London, "the one who inspires much more than the one who is inspired" (p. 81). Additionally, however, surrealists isolated in *Poésies* an injunction which they read as bidding poets act in common, just as they themselves were now doing with so much profit.

A mode of group action which seemed to the early surrealists particularly rewarding is mentioned in *Donner à voir*:

> How many evenings spent creating lovingly a whole nation of exquisite corpses. It was a matter of seeing who would find most allurement, most unity, most boldness in this poetry brought about collectively. No more cares, no more memory of misery, of boredom, of habit. We would play with images and there were no losers. Each of us wanted his neighbor to win and always to win more in order to give everything to his neighbor. The marvelous no longer went hungry. Its face disfigured by passion appeared to us infinitely more handsome than all that passion can say to us when we are alone—for then we do not know how to respond. (p. 165)

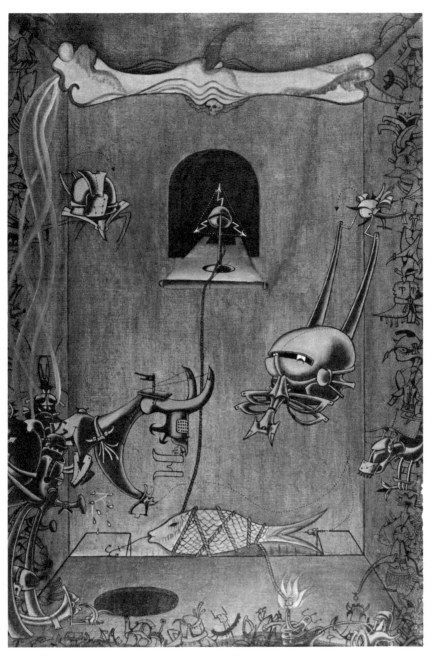

Jorge Camacho and Martin Stejskal, collective painting (1974).

Eluard's remarks are not very easy to follow. Yet they reflect his excitement at joining in an activity that has come to be known as *le cadavre exquis*. We find more explicit details in the definition of *le cadavre exquis* offered in the 1938 *Dictionnaire abrégé du surréalisme*, compiled by Breton and Eluard: "Paper-folding game which consists in having a sentence or drawing composed by several persons, without any of them being able to take account of the preceding contribution(s)." The example, now classic, that has given its name to the game, lies in the first sentence obtained by this method: "The exquisite corpse will drink the new wine." Information on the procedure of the game furnished in "Recipe for written exquisite corpses" by Tristan Tzara adds only that at the end of the game the sheet of paper—originally folded so that no participant adding a word or phrase can see what will accompany it, what verb with what noun, for instance—is to be read aloud only after grammatical agreements have been checked and adjusted where necessary.[2]

The goal in view becomes clear when we refer to Breton's 1948 essay titled "Le Cadavre exquis: son exaltation," reprinted in *Le Surréalisme et la peinture*. Seven sentences reproduced "as a reminder" have been chosen for the essay, we are told, "from among those that have given us the greatest impression of disorientation and the never seen, in which we have appreciated the *jolting* value most" (p. 289). Noting that "ill-intentioned criticism" during the years 1925–1930 treated *le cadavre exquis* as a childish pastime, Breton stresses the feature appealing to his fellow surrealists in its practice: "the certainty that, for better or worse," *cadavres exquis* "bear the mark of what cannot be engendered by a single mind," because they are endowed, "to a much higher degree, with the power of *drift* of which poetry could not make too much" (p. 290). In other words, contends Breton, with *le cadavre exquis* "we have at our disposal—at last—an infallible means of sending the critical mind on vacation and of fully liberating the mind's metaphoric activity." Moreover, he emphasizes, "Everything said here is valid as much on the graphic plane as on the verbal" (p. 290).

Recounting how the *cadavre exquis* method originated, Breton makes two comments. He reports that, around 1925, *le cadavre exquis* was born as a surrealist word game, devised "so that the elements of discourse confront one another in as paradoxical a manner as possible and so that human communication, from the outset diverted in this way, takes the mind registering it through the greatest adventure" (p. 288). First, then, he underscores the attraction *le cadavre exquis* held for surrealists, indicating that it conforms very closely to a mode of verbal communication

by which they set great store. Then he adds a one-sentence statement, all the more interesting because he does not elaborate upon it: "Nothing surely was easier than transposing this method to drawing, using the same system of folding and concealing" (p. 289).

If we turn back to Eluard's remarks in *Donner à voir* and to the *Dictionnaire abrégé* as well, we find that, just as in Breton's essay, in these texts, substitution of graphic means for verbal ones is assumed to present no difficulty and to merit no special comment. The same is true in the recollections set down by Simone Collinet, Breton's first wife: "One evening, somebody suggested we practice the same game with drawing instead of words. The technique of transmission was quickly found. We would fold the paper over the first drawing, letting three or four lines project beyond the fold. The next person had to prolong them, give them form, without having seen the beginning."[3] In Collinet's estimation, the real discovery was "participation by those who had no talent" and "the aptitude to create" that the game offered those individuals by "opening the door permanently on the unknown."

According to Simone Collinet, the only modification needed to render *le cadavre exquis* adaptable to the graphic mode was prolongation beyond the fold of a few lines that would provide the next player with a point of departure, eventually unifying two drawn segments. Tristan Tzara evidently shared Collinet's opinion. In "Recipe for graphic exquisite corpse," he specified that each participant must leave his successor with a starting point for his or her contribution.[4] Understandably, we find that neither Tzara nor Collinet proposed anything comparable to the check for grammatical correctness marking the final phase of verbal *cadavre exquis*.

Tzara's second "recipe" makes one thing plain. The text recommends participation by three players only, executing their drawings on one sheet of paper folded horizontally into three areas. Then it requires the first player to start at the top with "the upper part of a body or with attributes capable of taking its place." The second player is to supply "the middle section of the personage," while the third is left to furnish elements for completing the figure. What is noteworthy about the rules of the game so confidently laid down by Tzara is that they channel pictorial *cadavres exquis* in one direction, excluding all alternatives. The presumption is that all who join in will know, before they start, that they are going to share in creating a more or less human figure, standing (thanks to the horizontal folds made on the paper they are to use) erect. Hence, although varied possibilities still exist, graphic *cadavre exquis*, as Tzara foresees it taking shape, is much more limited in range than its

verbal equivalent, in which no preordained controls at all govern the choice of substantive, qualifying adjective (or adjectival phrase), verb, and modifying adverb (or adverbial phrase).

Had Tzara been the only person to say anything about drawing *cavadres exquis*, it would seem reasonable to suppose that all who play the game must submit to requirements more confining than those having to be met by participants in verbal *cadavre exquis*. But the conclusion over which Tzara's recipe allows no room for discussion looks debatable, when placed next to remarks by Breton.

A sizable number of drawings produced by the *cadavre exquis* process present the general outline of a human figure, even where facial traits and so on are replaced by quite fanciful elements. Differing in his approach from Tzara, Breton reads the evidence as testimony to "the preexistent will to *compose in personages*." According to Breton, this will is to be found in the drawings themselves, certainly not in the minds of those who devised the rules of the game. In fact, he speaks of the finished drawings as having, "by definition, the effect of taking anthropomorphism to its highest pitch and of prodigiously accentuating the life of relationships uniting the outer and inner worlds" (*Le Surréalisme et la peinture*, p. 290). It is clear that such figures are "the wild negation of the laughable activity of imitating physical aspects." Yet, from where Breton stands, the frequency with which creatures resembling people are produced does not appear accidental by any means.

The most striking feature of the Bretonian viewpoint is that it does not situate the union of the inner and outer worlds in one individual alone but in a sensibility common to several people, to all whose participation in *cadavre exquis* activity leads them to share in anthropomorphic interpretation. Discussing the years when he and some Czech companions tried their hand at pictorial *cadavre exquis*, Jindřich Chalupecký has made a parallel observation apropos of results obtained in Prague during the early 1930s. Strict application of the rules brought about, to the players' astonishment, drawings that "had organized themselves into continuous figures, creating fantastic forms and objects," notes Chalupecký. "In the end we discovered we had all drawn on the same piece of paper the same object, simply set out differently on the page. We had reached the stage of perfect telepathy."[5]

There is no reason to question the enthusiasm for *le cadavre exquis* present as much in Chalupecký's notes as in Breton's essay and Simone Collinet's memoir. Still, in the twenty years and more separating initial experimentation with *cadavre exquis* techniques and the accounts to which reference has been made, memory in all three witnesses had time

Roberto Matta, Estaban Frances, Gordon Onslow Ford, exquisite corpse (1940). Coll. Conroy Maddox, London.

to isolate benefits and push weaknesses into the background. Implicit in Breton's selection of seven exemplary sentences is the admission that others might have come to mind in which the very advantages we are asked to admire are patently less obvious. Only Collinet, though, openly acknowledges limitations in a method that invokes chance directly, but without complete assurance of equal success every time. On occasion, sentences produced by throwing words into unforeseeable proximity, she confesses, "fell into excessive absurdity," presumably even after basic grammatical adjustments had been made. At such times, she confides, "the waste basket played its part." Is it not fair to suppose that, now and again, the results of graphic *cadavre exquis* merited and were subjected to the same fate?

Nevertheless, Breton wishes to impress upon his readers that the exercise of *cadavre exquis* methods presents "a considerable enigma." He highlights an enigma "posed by the very frequent encounter of elements emerging from the same sphere in the course of production by several people of the same phrase or drawing" (p. 290). We underestimate the excitement released in surrealists by *le cadavre exquis*, unless we pay attention when Breton goes on to attribute this "encounter" to "a tacit communication" between participants which, even if one takes into consideration the law of probability, "tends, we think, to prove to be positive in the end."

The sentence "Le Dortoir de petites filles friables rectifie la boîte odieuse" (The dormitory of friable little girls sets the odious box right) is an enlightening example of how *le cadavre exquis* may produce more than those playing could possibly be aware of contributing. The individual who gave the noun phrase *le dortoir de petites filles* did not know that the next player was going to provide *friables*. Placed beside the first person's contribution, this adjective attaches itself to the preceding phrase by repeating the *r* and *l* sounds, even though reason would be reluctant (that is the least one can say) to condone placement of *friables* beside *le dortoir de petites filles*. There is no way to determine whether the terminal *s* of *friables*—making that adjective agree with "little girls," not with their "dormitory"—represents deliberate choice made by players in unanimous accord or by majority vote when they checked the grammar of the completed phrase. However, it is indisputable that linkage by sound came about by chance.

Chance intervened just as inexplicably and no less positively when it was somebody's turn to supply the object for a verb *(rectifie)* concealed from sight. This person's choice—*boîte*—is invested with ambiguity, not only by the *dortoir de petites filles* used earlier but also by the concluding adjective, *odieuse*, furnished by yet another player.

Review of this *cadavre exquis* as a whole suggests another reading, too. *Boîte* takes on a slang meaning of "school" (especially "boarding school"): "The dormitory of friable little girls sets the odious school right." Needless to say, reason is ill-equipped to arbitrate here. We are free to make our own choice or even, if we prefer, to entertain both possible meanings simultaneously. However we understand this *cadavre exquis*, we are left to speculate imaginatively on what the dormitory *does*, exactly, to bring about productive change.

Writing in one of the later surrealist magazines (the second issue of the new series of *Médium*, dated February 1954), Breton admitted that, although he and his associates in surrealism had been in the habit of defending themselves against attack by classifying their games as "experimental," they had turned to play as a form of diversion. This aspect of game-playing, however, does not detract from the valued bonus that amusement offered: "enrichment under the heading of knowledge." One early participant in surrealist games, Marcel Duhamel, has described *le cadavre exquis* as intended to "track down" and "create the fantastic or at the very least the unwonted," adding, "Needless to say, seriousness was banished from these almost always improvised sessions," and stressing the good-humored atmosphere typical of those occasions.[6] Regardless of Duhamel's insistence that "it was above all a question of play," we should be mistaken when evaluating surrealist games if we passed over Breton's last phrase, more suggestive in French than in English. Where Breton alludes to *"le rapport de la connaissance,"* he uses the second noun in two senses as at once "knowledge" and "the acquisition of knowledge."

In surrealism, word games derive their importance from the faith surrealists are sure one may place in the capacity of words to advance knowledge. Games bring relaxation, of course, but they also take on an active role in furthering a central aim of surrealist endeavor. Breton referred to that aim in *Les Pas perdus*. There we read of an ambition that will be shared by all surrealists: the ambition to make knowledge "take a step forward." *Les Pas perdus* does not explain what sort of knowledge surrealists had in mind. Nor does it indicate the direction in which they seek to advance while pursuing it. Clarification will come later, when enthusiasm for games reveals certain aspirations in sharper focus. Game-playing does not have the exclusive prerogative of bringing these aspirations to light. Still, it is regarded as making a vital contribution to the acquisition of knowledge. But what kind of knowledge does it help surrealists gain? To this question, left unanswered by Breton and Duhamel, Philippe Audoin offers the elements of an answer.

Reconsidering the history of surrealist games in relation to their ca-

pacity to "enrich," Audoin seems to feel guilty of no exaggeration when stating that the surrealist game is conducted "outside the causal chains of daily life," so "instituting, by rules that solicit and at the same time conjure chance, a different causality."[7] Evidently, *le cadavre exquis* typifies most forms of surrealist play, in which Audoin sees "the world of appearances and taken-for-granted relationships" as "entirely brought under review once again." What is more, *le cadavre exquis* does so in its graphic mode no less than in its verbal form.

Behind Audoin's words and, just as important, behind the "experiment" known as *le cadavre exquis*, runs an instinct that infuses every aspect of surrealist inquiry: to "go beyond, while denying, rational verification which external causality opposes to desire" (p. 479). Beneath the lucid features of surrealist games, therefore, can be detected the will to define desire through its fulfillment in repudiation of external causality. Rationally verifiable external causality is defeated by inner causality, the causality of desire, impenetrable to reason yet affirmed *in common* by every player involved.

It is not simply that surrealists find approaching poetry in conjunction with a few friends with whom they share hopes and beliefs to be useful in breaching the resistance offered by reason, ever respectful of external causality. Their abiding interest in games is a sign of continuing trust in a force outside reason, gathering strength and taking direction from the participation of several persons at once. In games of chance like *le cadavre exquis* the "nice shot" admired by players and spectators in games of skill gives way to a *find*. Audoin identifies the latter with revelation, "in the measure that it contributes to the poetic knowledge of the world and of life" (p. 479).

Audoin is not indulging in aphorisms that take us unproductively in a circle: knowledge is poetry because poetry is knowledge is poetry. The key to his comments on surrealist games is confidence in causality at odds with the one recognized by rational thought. He concentrates on knowledge gained in a manner that has succeeded in circumventing reason. He and his surrealist companions reserve the designation *poetic* for knowledge acquired by means that reason neither embraces nor approves. Hence their excitement over discoveries brought within reach by *le cadavre exquis*. As surrealists speak of it, revelation is in essence confirmation of the soundness of their views, justification of their trust in a causality hidden from the reasoning mind. Otherwise, we can be sure, they would never have retained—quoting them subsequently with pleasure and pride—certain of their verbal *cadavres exquis*, while tossing into the wastebasket others that pleased them less. Seen from the posi-

tion surrealists choose to defend, revelation is poetic because it brings to light things they wish to see, blotting out things they no longer tolerate looking at. Evidence of one form of causality that surrealism opposes now gives way to evidence of another in which surrealists are eager to place their confidence. The poetic knowledge to which they refer transcends the mundane. Cognition via poetry means, then, gaining acceptable proof—and *le cadavre exquis* demonstrates that such proof may be graphic as well as verbal—that the world need not remain the way it appears.

From the perspective shared by surrealists like Audoin, the significance of *le cadavre exquis* is that it takes surrealism's investigative procedure of automatism at least one step further away from thought supervised by reasonable postulation and deduction. Automatic writing lets conscious associations have full play and results in *"des images introuvables,"* to employ Audoin's term. These are to be understood as images such as no one is able to find by deliberately setting out to look for them. *Le cadavre exquis* carries the process further still. Because ignorance of the other participants' contribution is a condition of playing the game, *le cadavre exquis* is not an associative activity at all. Rather, it opens up perspectives on poetry by simultaneously involving several sensibilities in the same creative act.

The crux of *le cadavre exquis* is located at the point where a game some outsiders would brush aside as a mere pastime leads players to form images that strike the surrealist as revelatory. The *find*, now, is an unforeseen discovery to which participants have been led mysteriously after joining in an apparently frivolous parlor game. They have traveled a greater distance in one another's company than they could have done each on his or her own. The unpredictability of the outcome, the supposedly haphazard nature of the exercise, would discourage surrealists from participating, if it were not for their faith in chance as a beneficent force in harmony with human desire. Each player has the opportunity to collaborate with chance by sharing as much as any other player in an experiment undertaken in common.

"Never an error," wrote Eluard in one of the poems of his *L'Amour la poésie* (1929), "words do not lie." Persons sharing in making verbal *cadavres exquis* may take encouragement from Eluard's assertion. Meanwhile, someone engaged in the pictorial version of the same game need not fear his or her lack of artistic talent will hinder manifestation of a revelatory image. The fact that surrealists have never felt it necessary to trace a dividing line between the two forms of *cadavre exquis* with which they have experimented makes one thing plain. They look upon the

cadavre exquis technique as uniformly revelatory, as equally illuminating, whether discoveries come through words or pictures. Situating the expansion of knowledge on the poetic plane, they make no distinction between the means by which poetic results can be achieved during group activities.

The mystique of collective action as liberative of poetry—linked with the surrealists' reading of Lautréamont—underlies *le cadavre exquis*, as much in its pictorial mode as in its verbal form. In one sense, the varieties of *cadavre exquis* expression harmonize because both are employed to the same purpose. We comprehend this better when noticing that, although verbal *cadavre exquis* respects grammar in the interest of clarity, its aims are not simply rhetorical. However one sees it practiced, *le cadavre exquis* is directed at precipitating images that are unforeseeable *(introuvables)*.

In the course of his discussion of graphic *cadavres exquis*, Audoin builds on Tzara's recipe, referring exclusively to the making of monstrous figures in three parts. Moreover, he states, "It is to be noted that the best hybrids obtained by this procedure are those to which authentic painters have not contributed, the *clumsiness* of nonpainters ensuring, finally, a relative unity of style among the parts" (p. 484–85). It is easy enough to imagine that a contribution by Joan Miró next to one by Yves Tanguy would catch the eye. Looking at a pictorial *cadavre exquis* in which both those two highly individual painters have had a hand could become a game of identification, sure to end almost before it began. But this is not the issue. Audoin raises problems without furnishing answers to them. He implies standards left unspecified. How can we know which products of graphic *cadavre exquis* are to be classified among the best hybrids? Although there is room for confusion here, we stand to learn something useful from what Audoin has to say. He leaves us facing the question of meaningful unity within a product of *cadavre exquis* methodology.

Because a *cadavre exquis* assembles words in a prescribed order, some measure of unity is assured by the underlying demands of grammatical structure. In the context of verbal language, fruitful unity means, essentially, expressive coherence. When we turn to a pictorial *cadavres exquis*, no equivalent predetermined order or form exists which must be respected before satisfaction of the basic requirements of communication can be guaranteed. All the same, unity of style obviously takes a significant place in Audoin's thinking. Even if inclined to doubt that unification on the stylistic level is necessary or advisable, we can still see what

is on Audoin's mind. He believes there has to be a unifying factor discernible in pictorial *cadavre exquis* when, flattening out the folded paper, one comes to judge "the viability of the monster" (p. 484).

In spite of the argument put forward as much by Tzara as by Audoin and despite, also, Breton's testimony that pictorial *cadavres exquis* do indeed very frequently produce human figures, there is evidence that the practice of graphic *cadavre exquis* is capable of leading, as well, to pictures not the least figurative. Examining these, one wonders how the surrealists could have been so casual about the links between verbal and pictorial *cadavre exquis*. It is by no means clear that *le cadavre exquis* always speaks to us in quite the same language, whether it manifests itself as an arrangement of words or of pictorial elements.

In an evaluation of the fruits of graphic *cadavre exquis*, consideration of stylistic cohesion is distracting. We may suppose that a contribution readily identifiable with the graphic manner of André Masson during the 1920s, next to another that could have come only from Yves Tanguy, must detract from the stylistic unity of *cadavres exquis* in which both these artists have participated. This supposition is acceptable, but only on the theoretical plane, where it makes a point. When we turn to some of the *cadavres exquis* in question (they were executed in 1925) we discover Tanguy and Masson had a habit of signing their parts of *cadavre exquis*, even dating them at times, making guesswork or informed deduction by the spectator quite superfluous. Indeed, it would be interesting to learn how Masson would have reconciled this practice—which is quite exceptional among surrealists making pictorial *cadavres exquis*—with his statement, "One rule, although tacit, was to agree that drawing or coloring your contribution would have—so far as possible—an impersonal character."[8] Unfortunately, these words receive no development in Masson's text.

At all events, Audoin does not plead for the predominance of any one player's characteristic style over that of all the other participants in a *cadavre exquis*. Being responsive to the *"clumsiness"* typical of players who are not accomplished painters, he really has in mind "a relative unity." This is traceable to the absence of identifiable style—the consequence of participation by individuals incapable of communicating to any *cadavre exquis* they have helped draw a distinctive quality marking it in a fashion peculiarly their own.

Interestingly, the tacit rule cited by Masson was observed both by Tanguy and by Masson himself in the 1925 *cadavres exquis* in which they shared. Without the signatures, we could not point out the section of

the drawing completed by the one artist or the other. In fact, their effort to remain "impersonal" produced results best described in Audoin's word *clumsiness*. As a consequence, here and in the majority of the *cadavres exquis* in which Tanguy was involved during the 1930s, the absence of a signature makes it impossible to distinguish his contribution from that of individuals who, next to him, do not even rank as talented amateur draftsmen.

It is not difficult to see how people totally lacking in experience as pictorial artists might mark a *cadavre exquis* with signs of their ineptitude rather than with a memorable style or manner. One can understand that there is some excuse for equating the results of such participants' efforts with the products of verbal *cadavre exquis*. The latter are put together according to rules that make stylistic elegance just as unlikely as surrealists deem it fundamentally irrelevant to the release of images in which they find illumination.

Something more becomes visible when verbal and graphic *cadavres exquis* are placed side by side. Anybody unhindered by a language barrier is capable of contributing a word or phrase to a *cadavre exquis*, even though not a writer by profession or avocation. The possibility is remote of finding that a *cadavre exquis* made with words has been modified significantly by the intervention of some player who is not a writer. One may consider it disadvantageous to be a graphic artist joining in a pictorial *cadavre exquis*, or one may look upon some degree of skill in drawing as an asset. But whether regarded as a strength or a weakness in someone playing graphic *cadavre exquis*, inexperience has no measurable influence upon a participant's contribution to the verbal form of the game. Taken on their own, the words aligned in the best-known *cadavre exquis* do not present any remarkable features. There is no occasion to suppose that a person with a working knowledge of the French language would have found it too challenging to supply one or other of those words. Examined individually, each impresses by nothing so much as its banality. The surprising image they produce when arranged in conventional grammatical relationship results not from a wish, consciously acted upon, to astonish but from the *rapprochement* of words which, considered separately, really offer no surprises.

Recognizing that excitement is generated by the intervention of chance, actively solicited under the rules of the game, we realize something else at the same time. When drawings are substituted for words, the results obtained do not elicit response in exactly the same manner. True, everyone faces the surprise of witnessing the coming together (*rapprochement*) of unrelated graphic elements. In addition, everyone is likely to be attentive to the constituent parts of the drawing, whether or

not these actually form a "monster." The banality of the substantives "corpse" and "wine," of the verb "drink," as of the adjectives "exquisite" and "new," does not take from our surprise as we visualize an exquisite corpse drinking new wine. However, we cannot observe how in a drawing the component parts come together to make a monster (or a strange composite nonfigurative picture, for that matter) without noticing concurrently how well or clumsily one or another part has been executed.

Negative judgment may not enter into the matter, for we may marvel, as Audoin does, at seeing how successfully a component fits in, even though crudely sketched. The fact remains that we continue to be aware of the quality of contributions to a graphic *cadavre exquis* in a way that we are not attentive to the quality of words in verbal *cadavres exquis*. The only possible exception, in fact, entails borrowing from a vocabulary upon which we do not call frequently in everyday conversation, as, for example, in "Pear-shaped chlorine makes the atrocious seneschals speak." Even here, of course, the standard by which verbal quality is measured is that of familiarity. Hence, we have to admit that our standard is not universally applicable. A substantive like "seneschal" may not strike everybody reading or hearing it as equally unusual. Agreement is sure to be much more predictable—that is, less open to question—when we are judging the quality of drawing that reflects no skill with pen, pencil, or brush. Discrepancies attributable to differences in professional and cultural background are likely to have less influence on people's assessment of the technical sophistication displayed in this or that area of a composite drawing than upon their appraisal of the constituent elements of a verbal *cadavre exquis*.

So long as legibility presents no difficulty, reader response to words is unaffected by the handwriting of those using them. One concentrates on what the words say. When we face a pictorial *cadavre exquis*, though, our reaction to what constituent parts of the drawing have to show is very likely to be influenced by our impression of how presentation is made. This is particularly true of graphic elements in which execution is marked by awkwardness. The latter draws attention to itself much as words would do in a *cadavre exquis* read aloud by someone with a pronounced foreign accent. Even here, the parallel is not quite exact. For a verbal *cadavre exquis* that sounds odd, recited by a foreigner, loses the strangeness contributed by his or her voice when uttered by a person whose accent is unexceptionable. Because the strangeness of which we have been made aware is external to the phrase, it can be removed with no difficulty and with no substantive modification. In contrast, the clumsiness appealing to Audoin in certain graphic *cadavres exquis* is

intrinsic to some or all of the pictorial elements present. There is no way to remove or even minimize awkwardness here. Thus, *how* we see remains inseparable from our reception of *what* we see.

In *cadavres exquis* assembled from words, the unifying element of grammatical structure is not merely a safeguard against incoherent or even meaningless expression. It works positively wherever it succeeds in bringing a phrase, inadmissible by reason's standards, into existence as a linguistically communicable entity. Now language has retained its ability to reach an audience even when game-playing has made it the vehicle for a thought, idea, or image with which reason is not disposed to deal sympathetically. Pictorial *cadavres exquis* do not benefit from a comparable structural unification, prescribed in advance by the rules of the game and therefore unassailable on the level of form. Thus, a basic difference between the verbal and pictorial modes is evidenced in the ability possessed by graphic *cadavre exquis* to create its own form. Even where experimentation is limited to provoking the manifestation of some "monster" by way of a three-handed game of paper-folding, the form that finally results is unique to the pictorial image with which application of the *cadavre exquis* method has succeeded in confronting spectators and players, too.

Automatic drawing by one individual—a case in point is the graphic experimentation undertaken by Victor Brauner[9]—may give the impression of déjà vu if practiced repeatedly. But there is little or no danger of monotony where several persons help in creating numerous monstrous figures by using the technique typical of pictorial *cadavre exquis*. This fact seems to contradict Chalupecký's claim that "perfect telepathy" was a feature of the *cadavres exquis* done by himself and some friends in Czechoslovakia. It is borne out, however, in examples of those same Czech *cadavres exquis* surviving from the 1930s.

No doubt, the essential contrast is that, whichever words end up in a given verbal *cadavre exquis*, their arrangement will follow a preordained pattern. Any departure from the order required by grammatical usage would carry a penalty too high to pay, since it would endanger the communicability of some valued poetic insight. On the other hand, every graphic *cadavre exquis* marks a new departure. This is to say that each starts from nothing, in the sense that it does not have to conform to a set pattern such as grammar prescribes for its verbal counterpart. So far as a pictorial *cadavre exquis* achieves unity—the unity of a semi-human figure, for instance—it does this on its own terms, within a framework that it unaccountably manages to establish for itself. The inner cohesion of the graphic elements coming together in the completed

drawing is of such obscure origin that no one—and this is as true of the players as of those examining the results that playing the game has brought to light—can explain after the event the drawing's success in attaining internal unity. Nor could anybody have foreseen success. Internal unity is no more controllable here than it is predictable.

Even those who follow Tzara's "recipe"—aware, in other words, that all contributions are supposed to come together to form a monster for which each player is provided head, torso, or lower limbs—have no way of anticipating how their contributions will integrate. Ignorance is not simply a condition of participation. It becomes a sine qua non of the speculative venture on which surrealists are launched once they have committed themselves by direct appeal to chance.

For surrealists, *le cadavre exquis* represents a mysterious confrontation. It allows one individual to profit from joint participation with others in a game both amusing and enlightening. The game goes on under conditions that preclude taking advantage deliberately, knowingly, of what others have to bring to a creative process that can be completed only with each individual's help. This means that playing assures the satisfaction of knowing that—for better or for worse—a *cadavre exquis* would be different without the share each individual has had in its making.

Le cadavre exquis is an experience at once confining and liberative. Respect for all the restrictions dictated by the rules of the game becomes a narrow gateway opening upon affranchisement. Denial of one form of knowledge (brought about through enforced ignorance of the contribution made by any of the other players) brings in its wake knowledge of a different sort. Hence, surrealists prize in the opportunity to play at *le cadavre exquis* the privilege of advancing toward (though, we should notice, of never quite reaching) the center of the mystery of collective creative action. The latter is no less fascinating to them—the contrary is true, in fact—because it keeps players from mastering a formula by which results can be anticipated, from grasping the key to the door behind which the marvelous is to be attained.

Whatever thoughts come to mind that allow us to weigh the benefits of *le cadavre exquis* as a means of communication, verbal or pictorial, we must not lose sight of an essential feature of the game. The primary factor is not whether this or that *cadavre exquis* will prove to have something welcome to share with people who did not participate in its creation. What counts for surrealists playing the game is that *le cadavre exquis* serves immediately as an instrument of self-exploration and sometimes of self-discovery. They play for fun, certainly. However, they expect the game to do something in addition to helping them kill time. They also aim beyond provoking amusement in nonparticipants.

The first concern of *cadavre exquis* players is to let beneficent chance be their only guide into the region of self-exploration through which they hope to advance farther because they move forward together. Revelations coming by way of *cadavre exquis* activity are not prized for their capacity to invest a simple parlor game (apparently so unsophisticated that a child could join in) with weightily serious value. Of itself, gravity is no virtue in a surrealist's eyes. Those revelations prove to surrealists that *le cadavre exquis* can be a tool for facilitating a task absolutely central to surrealism: progressing from the known into the as yet unknown. Employment of this tool, under rules set for its use, is fully consistent with the surrealist belief that advancing along any exploratory path would lose its significance if one were to be able to guess exactly where the path was to lead.

Whether taking the form of amusement or of pleasure, the response released in players and other surrealists by *finds* originating in *cadavre exquis* activity should not be judged only against the known, the commonly accepted, the customary. Tentatively, yet excitingly, response is to be measured also against all that, having escaped us so far, remains to be found. Departure along the path of exploration down which surrealists are headed when they practice *le cadavre exquis* could be accurately labeled escapism and nothing more, but for one thing. Surrealists never cease to be confident that, as Breton asserted in *Les Pas perdus*, exploration undertaken through poetry leads "somewhere." Charles Baudelaire's assurance that those who leave for the sake of leaving are "happy" finds an echo in the surrealists, who feel sure that leaving offers a strong chance indeed of arriving "somewhere" other than at the point from which we started out.

To surrealists, the major attraction of *le cadavre exquis* is that it offers everybody engaged in it, regardless of natural talent or training, the prospect of arriving one cannot predict where, in return for willingness to abide by certain rules. The latter seem constrictive only until we have become aware of the positive contribution of ignorance in the game of *le cadavre exquis*. Ignorance of what other players are going to be writing or drawing releases the mind of each participant from limiting consequences of respect for a confining associative principle that is but a projection of reason.

What is wrong with rational projection, so far as a surrealist is concerned? Association, analogy, and deduction based in reason appear to surrealists inadequate, incapable of permitting the mind to escape a confinement in which the poetic spirit cannot flourish. Therefore, any method that insulates the mind against rational logic is sure to appeal to Breton's followers, especially when—as is the case with *le cadavre*

exquis—its application brings to light an associative principle quite different from the one grounded in reason.

No published discussion of *le cadavre exquis* has ever reported how the surrealists in Paris first came to play a game they could scarcely pretend to have invented. The *Dictionnaire abrégé* tells us the technique turned out to be instantly successful in generating the kind of imaginative shock—jolting the mind onto a track divergent from that followed by rational deduction—which *cadavre exquis* seemed particularly well suited to producing in those who played the game far more often than the evidence accessible to us would lead one to suppose. A valuable method had been discovered, immediately recognized as perfectly adapted to the pursuit of a number of cherished surrealist aspirations. It made no difference how often, thereafter, players obtained results in which they could see little or no merit and for which the wastebasket rather than a surrealist magazine or collective publication of some kind was deemed the best repository. Surrealists have never wavered on one point of considerable importance to their concept of their own role in society. An investigative method likely to bring the surreal to light, or into clearer focus, should be measured in relation to the degree of success obtained, not according to the percentage of successes over failures. A surrealist technique—one approved by surrealists, or one adapted to their purpose—is not evaluated within the group according to the frequency with which it leads to revelation. Most important of all to surrealists is the quality of its revelations, the intensity of the light that a given technique sheds on a world where new relationships are established to the benefit of surrealist aspirations.

Surrealists find a particular charm in any method that breaks down the barrier erected by reason to separate the real from the surreal, by implementing a technique of unquestionable simplicity. Such a method helps disarm critics of surrealism. Among these people's objections is the argument that an attack on habitual modes of cognition such as surrealists demand can be mounted only by individuals addicted to an involuted, consciously distortive approach to language in one form or another. A simple exploratory technique such as *le cadavre exquis* demonstrates how close the mind really is to contact with a mode of thought over which rational associative processes are powerless to exercise control.

The weakness surrealists perceive in conventional thinking shows up most quickly when words are arranged into sentences that meet with reason's approval. They are equally present, though it may take longer to notice them, in the logic with which pictorial imagery bears witness to the controlling purpose of a given artist's intention. *Le cadavre exquis*

presents evidence to demonstrate how grammar, an expression of reason, may become the servant of the surreal.

Verbal *cadavres exquis* teach us to read with better understanding a statement that occurs in Breton's 1922 essay "Les Mots sans rides," reprinted in his *Les Pas perdus:*

> Words anyway have finished playing.
> Words are making love. (p. 171)

Word play meant to do no more than leave the reader or listener admiring some writer's wit or verbal dexterity is without meaning to a surrealist. The latter has two interconnected reasons for believing words have ceased to play the way they have been called upon to do in the past. Firmly opposed to the cult of the personality, he judges that nothing will be gained—and he more than suspects that something important will be lost—through any procedure drawing attention primarily to an artist like Oscar Wilde, shall we say. Certainly, surrealists do not wish to end up merely getting to know more about a writer or a painter as their acquaintance with his or her work broadens. Surrealists look to the created work to show them something about themselves without imposing on its audience the distracting and fruitless obligation to remain incessantly aware of the individual behind it. Unwillingness to approach a work through its author or, for that matter, to approach the author by way of the work, has a serious motivation in surrealism. In a created work surrealists hope to see something to which Breton alludes when he speaks of the generative coupling of words.

What is it that the surrealists ask of the artist? A definite answer would compromise their demands. These cannot be formulated with accuracy because it is in their nature to lack precise outline. The liberative quality of verbal language may be gauged, then, in relation to our inability to foresee how, as they come together, words will generate revealing images over which anticipation can exercise no more control than past experience, the already seen, the already thought, the commonly accepted. Moreover, if words can make love this way, *le cadavre exquis* demonstrates, so can pictures.

8
COLLAGE

Although it is permissible to argue that verbal *cadavre exquis* exhibits a few of the distinguishing characteristics of collage,[1] by and large, collage has been a pictorial language to surrealists. In surrealism, the essential feature of collage is application of an operational procedure without exact equivalent in the medium of words, one that the substantive "collage" (from the French verb *coller*, "to stick") leaves us no excuse for ignoring. The noun obviously refers to the physical act necessary for the collage to come into being, the gesture of sticking together a variety of elements that—such, in any case, is the nature of surrealist collage—would never be found next to one another in pictures faithful to objective reality.

Basic to our reaction to a conventional woodcut or an old engraving is the knowledge that what we are viewing is a picture inspired by an event or situation antedating its pictorial representation. Pictures such as these carry their own justification: they are meant to promote visualization. When accompanied by a written text, they are intended to help readers see what the text recounts or describes. Where no prior text explains the existence of the picture, the latter still lends itself to descriptive labeling that tells us why it was made. Thus, we have been told all we need to know once we have read beneath an engraving representing a domestic scene showing a man and three young women, "Milton dictating 'Paradise Lost' to his daughters, from the painting by Michael Munkácsy."

Surrealist collages that build upon such materials divert them from their preordained purpose. By introducing through collage features

139

which no text or context demands or authorizes, the surrealist gives his or her image an orientation for which neither the written word nor prescribed use (in the case of illustrative matter borrowed from catalogs) can offer justification or explanation. What such a collage does, in effect, is tamper with narrative context. This is what happens when Ronald D. Collier interferes with the engraving cited above.

Collier places on the table where one of the daughters is earnestly writing down verses (Munkácsy evidently subscribed to the mistaken opinion that John Milton's children were his amanuenses) a woman wearing only high-heeled shoes and black bikini panties, which she seems about to remove. Gazing at their father, the daughters appear unaware of the stripper's presence, unless they are ignoring it, tactfully. As for Milton, although the seminude figure is facing him, he is absorbed in creative thought, his head bowed. Even if not preoccupied with his poem, of course, he would have missed the strip show, having been blind since 1652, years before he wrote *Paradise Lost*. The narrative content making sense of the original picture is destroyed. Displaced and confronted with elements drawn from a context far distant from their own, the figurative elements are liberated and take on a new value.

It is at this stage that technique has its part to play in turning collage to surrealism's account. To make their full effect in confounding common sense (or, in the case of Collier's collage picture, apocryphal literary history), contradictions in the real, brought before us by collage, must appear to be an organic feature of the image. In other words, the elements defying reason's passive acceptance make their contribution most productively when they are introduced in such a way as to leave the spectator unable to ignore them. Collier has obviously taken care to select a black and white photograph of a woman whose height is proportionate to that of the people in the original engraving. In addition, he has chosen a photograph in which the play of light and shade over the unclad body tones perfectly with the engraving. Moreover, he has situated the woman on the table so that her head, at the top of the picture, forms the apex of a triangle continued downward, on one side, through two of Milton's daughters (one standing, the other sitting) and through the seated figure of the poet, on the other side. In this way he has produced a collage picture marked by a structural unity that Munkácsy himself would have had no cause to contest.

Employed in the spirit of surrealism, an apparently unsophisticated method—looking simple enough to fall within a child's capabilities— serves as at once a protest and an affirmation. The resulting picture externalizes a point of view and invites the spectator to share that view-

point. We see not what the surrealist collagist has in mind to show, in fact, so much as what the collage method has made it possible for him to perceive (the distinction is an important one to surrealists). In consequence, examining surrealist collages offers an excellent opportunity for us to appreciate how surrealists utilize a method in which they detect great promise. Surrealist collagists, we observe, are not just devoted to developing and polishing a pictorial technique. They avail themselves of collage as a means for projecting a state of receptivity in which all the expressive languages of surrealism find their origin and validation.

At the methodological level, collage presents no mystery at all. For this reason, the surrealist collagist can concentrate (and expects his public to do likewise) on the virtues of collage as an image-making procedure. With collage, there is no place for one surrealist to try to display greater skill than another. Superiority owes nothing of any import to technique, which entails wielding scissors and dabbing on paste. It rests on the quality of the image captured by a method which, it goes without saying, one does not need to be an accredited surrealist in order to put to use.

Collage differs from a mechanical process like *le cadavre exquis*. All the same, it can prove to be a remarkably pure expression of surrealism. And so reviewing how the collage image comes into being affords art critics little satisfaction. Meanwhile, the surrealist would find assembling a collage unproductive, if the resulting image lacked potency. It is as image, indeed, that the surrealist pictorial collage speaks to a perceptive audience. Any compromise with "art" is irrelevant. In other words, the decision to make a collage faces the surrealist with but one alternative: arrive at a picture that will stand as an illuminating image or else admit complete failure.

Phrased in this manner, the alternative open to the surrealist seems to present an ultimatum. In reality, it simply reduces to forthright terms two choices of which only one is acceptable. A practitioner of collage wishing to demonstrate how cleverly or elegantly he or she works in the medium would soon be distracted from the task surrealism sets its adherents. There would be small likelihood of his or her understanding, quite the way surrealists do, the significance of Max Ernst's remark that the paste does not make the collage.

Collage shares with several procedures popular among surrealists a feature that can mislead an observer busy inventorying surrealist techniques. Its tools are accessible to anyone wishing to use them. Further-

more, since the materials introduced into a collage picture are often cut out of illustrated books, catalogs, and so on, their presence need owe nothing at all to the collagist's gift for draftsmanship. Hence, to the nonsurrealist the main advantage of collage appears to be that it is a method ideally suited to surrealists deficient in certain talents.

Surrealists would hardly contest that such an interpretation is defensible. However, they would not accept the implicit criticism that, as a result, collage is merely a technique which helps compensate for weakness in individuals with no natural ability to draw. Surrealists do not look upon collage as a practical compromise, available to those among them who would like to create pictures even though lacking the necessary skills to do so. Evidence suggests that the purity of surrealist collage may be preserved best when the image-making process owes nothing to the kind of ability that critics are accustomed to demand.

Collage took on special value for Ernst, who first gave its practice a direction it would follow in surrealism. Already a painter (he had begun drawing in 1896 at the age of five), Ernst turned to altered engravings and collage in 1919. Thereafter, he painted a succession of canvases that present images profoundly influenced by collage technique in their arrangement of pictorial forms. These pictures are among his most important contributions to surrealism.[2] It would be an error, though, to suppose that Ernst experimented with collage because he sought a means to revitalize his painting. Nevertheless, the effect of collage imagery on *L'Eléphant Célèbes* (1921), *Oedipus Rex* (1922), *Pietá ou la Révolution la nuit* (1923), and *2 Enfants sont menacés par un rossignol* (1924) is incontestable.

In surrealism, the language of collage aims to capture revelation through encounters such as one does not make in the everyday world. Hence, the benefit of listening to Jacques B. Brunius, a practitioner of surrealist collage, when he declares that we should not be talking about collage at all, but of *rencontre* (encounter).[3] The word *collage* emphasizes the method by which collage pictures have been made. *Rencontre*, however, highlights better the effect of collage technique. The stress Brunius gives reminds us that, for surrealists, collage as a means of expression takes its value from the encounter the collagist has managed to bring before his public. After all, it is not on the methodological plane that Ernst's collages are better than those executed by numerous imitators, some of whom delayed thirty or forty years before paying attention to his novels in collage form, *La Femme 100 têtes* (1929), *Rêve d'une petite fille qui voulut entrer au Carmel* (1930), and *Une Semaine de bonté* (1934). The difference lies, essentially, in the atmosphere of Ernst's work, a token of

his capacity to arrange encounters such as his imitators are not capable of offering.

It is no easy matter, accounting for the special quality that sets Ernst's collages far above those by people who sometimes not only use an identical technique but also practice it on the very same primary material—notably engravings from turn-of-the-century books and illustrations from scientific publications of that time. The closest one may come, perhaps, is noting how the derivative work of Ernst's successors shows signs of competence on the technical level while yet lacking the inspirational energy that vitalizes Ernstian collage. These people rarely give even a hint of the Ernstian mood.[4] This, surely, is because they do not share the spirit in which Ernst worked. Their activity is worthy of mention here for just one reason. It confirms that technique alone does not suffice to give meaning to the surrealist collage. With them, the effect we witness is somewhat like that produced when a person has been taught to imitate the sounds of a foreign language but never fully grasps the significance of the words he mimics.

Those who have practiced collage successfully in the spirit of surrealism have been reticent about their ambitions. Ernst's well-known remarks on collage offer a commentary, rather than a plan of operations, acknowledging the essential mystery of surrealist collage, the impossibility of reducing it to a formula. Ernst's words sound quite vague when they describe collage as "something like the alchemy of the visual image." Imprecise though it may appear to be, this phrase was deemed worth reproducing under the entry "Collage" in the 1938 *Dictionnaire abrégé du surréalisme,* where it had something to tell readers. The central characteristic of surrealist collage is that it finds an analogy better in alchemy—the transmutation of base metals and the search for the alkahest—than in chemistry, which studies the laws regulating the combination of elements.

For the surrealist, collage finds meaning to the extent that it is capable of opposing the compartmentalization of thoughts, emotions, and actions by which the reasoning mind comes to terms with ambient reality, feels at ease with it. Collage serves surrealism best by illustrating the viability and the vitality of an integrative principle that overthrows the barriers erected by reason, education, habit, and experience. Where pictorial collage rewards surrealists, its results do not cast the spectator adrift in chaos but entice him forward into a world where he must rely on imagination for guidance that common sense patently cannot provide. Imagination comes into play under solicitation from collage just

as Breton contended that it must: to give us an idea of what *can* be. Thus, the change undergone by the elements assembled in surrealist collage is closer to what we associate with alchemy than with chemistry. No laws can be traced that govern the interaction of constituent elements, permitting the collagist either to calculate or to predict the effect their proximity will have. Instead, surrealist collage supports André Breton's argument in *Les Pas perdus* that the true significance of a created work is not the one its creator believes he or she is giving but "that which it is liable to take in relation to what surrounds it" (p. 16).

If collage is not an art in the surrealists' estimation, then it is certainly no science either. Its practice no more demands respect for rules than it is aimed at defining any. Whereas graphic *cadavres exquis* escape the formal regulation without which the coherence of verbal ones would be jeopardized, collages are even more free from control. The disposition of elements that will find a place in the completed picture is not restricted, either by some paper-folding ritual or by a need to link contributions from several players involved in the same pictorial experiment. A surrealist collagist will not benefit, in the end, from witnessing surprising confrontations following upon participation in the company of several other individuals but, rather, is able to observe the progress of his or her picture from start to finish. The surrealist collagist is in the position to advance—if necessary by trial and error—in full awareness of what he is doing, toward a final satisfying image.

The difference between pictorial *cadavre exquis* and collage does not deserve to be noticed so that the one method of image-making can be placed higher or acknowledged as more reliable than the other. What matters is that the first technique is used to penetrate the surreal from one direction while the second permits approach from another. Although distinct from one another, these two methods are complementary means of pursuing the very same goal.

This said, one perplexing question remains. At the center of the contrast between application of the *cadavre exquis* method and collage-making is the difference between ignorance (the state in which, while making a contribution, each player of *le cadavre exquis* voluntary remains, vis à vis the other participants) and awareness (the state in which the collagist works while drawing upon material available for his use). If illuminating juxtapositions grow out of the ignorance shared by players of *le cadavre exquis,* is no penalty levied against a surrealist collagist searching for comparable illumination by way of a technique that does not have ignorance as a prerequisite? To anyone inclined to anticipate that a high penalty must be paid, Ernst has a reply in his *Au delà de la*

František Dryse, *Get in, Please!* (1980), collage.

peinture. Here collage is described as having the irrational as its "most noble conquest."

The irrational, to surrealists, is no more predicated on the foreseeable (the anticipated) than is the unknown on the known. The surrealist collagist is motivated by the hope of achieving not simply more than can be projected but something *other* than he or she is able to anticipate. He or she finds the deconstructive process (by which visible reality is deprived of its stability and recognizable unity) to be the prelude to a constructive procedure having no predictable outcome. Resistance to reason and to the view that the world about us is and must continue to be rationally explicable opens the surrealist's mind to the marvelous. Without preconceived ideas about the effect that collage will produce, surrealists look to the marvelous to intervene, obliging the so-called real to yield to the surreal.

Given the admiration felt by surrealists of the first generation for the poetry of Arthur Rimbaud and their enthusiasm for what Rimbaud had

called "the alchemy of the word," it is tempting to interpret Ernst's phrase about the alchemy of the visual image as designed to assert the extension, through collage, of the magic power of verbal language to the visual field. While this possibility cannot be discounted, we nevertheless must grant that Ernst had more in mind than simply affirming the painter's right to as much respect as the word poet. Pierre Mabille makes this clear when he likens the self to an alembic, adding the words: "Bursting forth from this mysterious furnace of alchemy, the flares of desire (most violent impulses, eruptions of flames), needs, appetites and also disgust, refusal."[5] Although many years separate Ernst's definition of collage from Mabille's *Le Merveilleux* (in which, by the way, we find among numerous others a quotation from Rimbaud's *Les Illuminations*), one may link Ernst's ideas with Mabille's on the plane where collage has the greatest significance for surrealists. This is the level at which the image born of collage provides evidence of the alchemical procedure of self-discovery through self-revelation. Here, according to Mabille, "the Marvelous expresses the need to go beyond imposed limits" (p. 68). However, as Mabille insists, the marvelous is less "the extreme tension of being than the conjunction of desire and external reality. It is, at a precise moment, the disturbing instant when the world gives us its agreement" (p. 69)—the moment caught in a successful surrealist collage, or, as Mabille describes it elsewhere, the hour that "marks the consent of things to the will of man."[6]

When a surrealist practices collage, it is always with contempt for the art of imitation. In fact, collage is invariably a means of breaking with that art. Its appeal for surrealists lies in the opportunity it affords the practitioner to go beyond limitations within which experience confines our idea of what is to be accepted as real. Skepticism about the stability of reality and about the finality of the real prompts the surrealist collagist to embark on a rearrangement of elements furnished by pictorial records of the known. The purpose is to capture something of the unknown, something caught in a snare constructed from bits and pieces of the familiar. Assaulted by the scissors, these bits and pieces are usually recognizable for what they used to be; only long enough, though, to make us realize that they are not at present what we took them for. They have become elements in transition, moving out of their past identity toward a new one. The latter emerges only as we examine each vestige of familiar reality in the magic relationship that—thanks to the collage method—it now bears to others torn like itself from the context of the commonplace.

The fabrication of collage is an activity fitting perfectly with the surrealists' disrespectful treatment of "a world that some call reality." This

is because reality appears to surrealists the way we hear it described in Mabille's *Le Merveilleux:* "only incessant discovery; a mystery reborn indefinitely which the imagination, armed with calculation and precision instruments, shows us different from what our senses perceived at first contact; a universe about which it is permissible to wonder if it is not entirely other than we conceive it habitually" (p. 17). Hence, collage has a special merit in the surrealists' eyes. It is a process through which the instruments of scissors and paste are deliberately used to reorder and to juxtapose features of reality as "we conceive it habitually." It uses those features to project an imaginative view of the real. Now what *can* be is no longer confined to what apparently *is,* but still grows out of it. Hence, Mabille's explanatory comment, "This is to say that for some of us, faithful to the thinking of Heraclitus, oneiric, imaginative, poetic activity is not a gratuitous game, a futile amusement of the idle dilettante and aesthete, it corresponds for us to the dangerous zones where energy is transmuted into tangible reality" (p. 72). It goes without saying that Mabille stresses, "We consider the artist's message as a prophetic prefiguration, a step forward into the unknown."

Ernst made no secret of his belief that the irrational is the great benefit enjoyed by the collagist. Nowhere did he state, however, that this benefit is actually guaranteed anyone implementing the collage method. Collage appears before us in a false light if we imagine the calculation to which Mabille alludes capable of bringing about, with scientific precision, whatever results surrealists might desire. Although the surrealist's mind is open to the marvelous, it does not follow that the marvelous is, or even might be, at his beck and call. Calculation does not assure the surrealist collagist full success at every attempt. Success, anyway, can never be projected with confidence; it can be measured only retrospectively, once attained.

The one thing shared by all surrealists who have turned to making collages is a determination to effect a rupture with habitual views of reality. The form to be taken by protest against commonplace reality has no fixed outline. Indeed, protest takes shape only as the surrealist image develops. It does not assume definitive form until the collagist's arrangement of pictorial elements has provoked imaginative speculation in defiance of the norms of customary thinking that correspond to everyday experience.

Anything helping make inroads into the unknown marks a step forward in surrealism. In contrast, an effort to progress in any other direction brings no advance in which surrealists see merit. It may even appear to be a retrograde step from their standpoint. Thus, a collage designed to put together a likeness of something already known (a hu-

man face, shall we say)—however unexpected the materials from which it is assembled, however cleverly they are put together—fails to meet the essential function of collage, surrealists believe. Meanwhile, a surrealist collagist's success in removing his picture from the context of everyday reality is to be judged less from the amount of interference for which he has been responsible than from the effect of his intervention in undermining habitual reality.

Anne Ethuin, *collage revêtu*, (1978), overlaid collage.
Photo Marcel Lannoy.

Dating from 1943 and originating in a photograph taken at a track meet, a collage by Jindřich Heisler shows a competitor breasting the tape at the end of a footrace, while others trail behind. The winner's right leg has been replaced by a coiled spring presumably extending from his bare foot to his hip, concealed under his running shorts.

Reaction to a collage such as this takes us through two stages. First comes—as with Collier's modification of the scene painted by Munkácsy—a shock, more of amusement than of anything else, in which we are conscious mainly of the picture's violation of familiar reality. This, we say, is a spectacle separated by absurdity from the realm of the real.

Some whimsical thoughts may intrude also. Where is the winner's sense of fair play? If winning is the point of participating in sports, how far does one have to be willing to go in order to win? Then follows something else as, looking more closely, we notice the expression on the face of the competitor who will place second. It betrays neither surprise nor resentment at what is happening ahead of him. As for two spectators or officials we see in the picture, neither of them seems the least excited. The one in the background stands with his arms folded—no gesture of protest here. Closer to us, the other reclines comfortably on the grass, resting his weight on one elbow.

The revelation of Heisler's picture—its surrealist content, taking us well beyond amusement at the unaccustomed or the odd—strikes us when we realize that no one visible in it shares the emotions we feel. No one contests the inevitable outcome of the race or questions how it will come about, how, for instance, the starter could have let one participant begin with such an advantage over the others. Matter-of-fact acceptance of the incredible by everyone involved in Heisler's collage removes the image we see from the reality known to us all. We find ourselves observing another world where no conflict is discernible between the *given* of an unexceptionable sports photograph and the marvelous, released by the collagist's intervention. When we ask, then, how collage may take on the quality of prophetic prefiguration for a surrealist, one way to answer is suggested by Mabille's *Le Merveilleux*, which refers to being "transported to a world cut to the size of our desires" (p. 20). At the magic hour when the marvelous manifests itself, we enter the world where surrealists expect to experience release from the frustrations of everyday living, the universe of which collage can speak with assurance.

Discussing pictorial collage in the *Dictionnaire général du surréalisme et de ses environs*, Edouard Jaguer seems bent on persuading his readers that a radical difference exists between the Ernstian collage, the type of collage picture deriving from Ernst's practice of utilizing old engravings, textbook and catalog illustrations, as well as pictures torn from popular romances, and those collages—made after 1950, he specifies—incorporating photographic elements. Peter Kral (from whose ideas, one suspects, Jaguer's take inspiration) refers to the first as collage "in its traditional form," when suggesting that surrealist collage based on photographic material breaks with tradition in something more than its use of nongraphic elements.[7]

One could give Kral's argument serious attention if it were not posited almost exclusively on evidence culled from the work of his compatriots,

surrealist collagists in Czechoslovakia, from whose practice he generalizes far too freely. Still, however skeptical we may feel about the opinion shared by Jaguer and Kral (who affirms that collages derived from photographic elements prove that collage-makers have diminished faith in the marvelous, since 1950), it challenges us to examine how photographic and graphic collages compare, in meeting the requirements of surrealism.

In the form first explored by Ernst, surrealist collage favors mixing pictorial matter borrowed from disparate graphic sources. All the material utilized belongs to the realm of representational art, offering interpretations of people, incidents, or scenes, re-creations of situations or activities, pictures of scientific instruments, tools, machinery, and so forth. Ernst drew from preference upon graphic material of such a nature that it always had a point of reference outside the picture (narrative text, mythological scene, historical event, or whatever), antedating and accounting for the artist's attempt at graphic transposition. Any collage put together from source material of this sort comes before its audience as a representation also, or at least the public's inclination is to view it as such. For this reason, the surrealist collagist working with graphic materials must accept certain consequences that follow upon his choice of materials. It does not mean, of course, that he remains at the mercy of the graphics he is using. After all, Ernst was able to turn to surrealism's advantage the epic inflation of some of the pictorial elements he had elected to incorporate into his collage images. Nevertheless, first contact leads viewers to suppose they are facing a representational picture.

It is here that Ernstian collage breaks new ground. The type of graphic collage pioneered by Ernst does not take its full effect so long as the spectator merely itemizes its constituent parts or examines how they have been brought together. The whole effect broadens our perspective on surrealism, as the representational features used combine to set a trap. The latter is sprung the moment Ernst's audience realizes that his collages address themselves to the viewer's imagination without coincidentally invoking a reference point outside the frame of the picture, in the world around us. The wonder of the graphic collage, in Ernst's hands, is that it is still representational yet does not refer to mundane reality. It reveals a self-sufficient universe to which the artist permits us access. Here is a world that exists before our eyes, though outside the limits one would expect to see imposed by the clearly referential character of the easily identifiable constituent elements it calls into service.

Described with extreme simplicity, Ernst's method may be said to encourage our progress from one question, *why*, to another, *why not*. His

adaptation of identifiable materials, all well enough known from other contexts, brings to mind so many conflicting reference points at once that, clashing with one another in the rational mind, they finally cancel out and disappear. In their place they leave a vacuum. The latter will be filled, especially if the spectator is a surrealist, less by memories of the known than by stimulating anticipation of the as yet unknown animated by the viewer's imagination. Contrary responses, irreconcilable in reason, extend an invitation to imaginative activity that reason is unable to curb.

In one respect, the parallel with photographic collage is very close. This is because the question, *why*, as we normally ask it, does not arise in the surrealist mind. The same is true of the riposte, *why not*. Surrealists refuse to acknowledge the customary obligation to evaluate experience and to monitor mental projection in terms formulated or approved by reason. Where one or another of these common interrogative formulas arises in surrealist consciousness, the basis on which a response takes shape is never laid down by reason but by desire. It is not the reasonableness of the forthcoming answer that appeals to surrealists. Rather, adherents to surrealism look to desire to shed light on what the artist brings before his public. They are particularly attentive when made aware of the influence of a desire that remained unvoiced until brought out by the verbal or pictorial image an artist has to offer.

Embarking on the investigative journey, inward-looking surrealist collagists leave behind the heavy baggage of reason, assured that they will progress faster and farther while equipped with a curiosity fired by desire. The assumptions on which they set out to make collages are likely to strike the skeptical observer as vague. From where surrealists take their stand, however, being unable to define desire ahead of its manifestation in the collage image is no disadvantage at all. In fact, it authenticates that image, granting it a significance which surrealists believe raises imagery from the level of "art" and "literature" to the plane of revelation where they reserve to themselves the right of judgment which they deny critics.

In spite of this, collagists who build on a photograph—and this means using the photo as a frame, so to speak, not simply as one of a number of possible sources from which contributory pictorial elements are to be drawn—have a point of departure somewhat different from Ernst's. True, each is at liberty to start with a photograph that violates rules of perspective, for example, or one that, by way of exaggeration originating in camera angle or lens manipulation, modifies visible reality in some fashion. However, Heisler indicated through the use of a snapshot or press photograph taken at a track meet that beginning with the excep-

tional, with something which past experience recommends that we approach with caution, is by no means a prerequisite for collages based on photographic material. Indeed, the example left us by Heisler gives the impression that the contrary may well be the case and that the imaginative release occasioned by surrealist photocollage may be related to the banality of the material out of which it has grown.

Without going so far as to treat Heisler's collage as a model comparable in its influence among surrealists with Ernst's graphic collages, one can infer from the Heisler example a noteworthy feature setting it at some distance from the Ernstian type. The basic element in Heisler's collage—quite literally its point of departure—is a photographic record, documentary in character. Thus, Heisler's source material bears comparison with the illustrative matter taken from medical textbooks more often by Ernst's successors, it is true, than by Ernst himself.

The documentary nature of a photograph like the one Heisler chose establishes a zero point of banality from which the modifying effect produced by collage may be measured. Like the press photograph, the snapshot owes its value to its status as a document having at least some historical interest. The terms on which it belongs to history are easy to comprehend. The photo shows what any spectator could have expected to see, had he or she been in the photographer's place at the precise moment when the camera shutter was activated. It does not matter whether these terms betray naïveté in people who deem them applicable. The important thing is not whether these terms really do underlie a criterion that is unquestionable. To the collagist, the distinguishing feature of documentary photographs is the following. They pass into circulation and are accepted as unimpeachable evidence of what *is* or—just as important—of what individuals who have not shared the photographer's viewpoint suppose *must be.* Thus, intervention by the surrealist collagist brings disruption to evidence defined within time and space, which delimit the scope of the photograph as a reliable objective document. The time and space concepts permitting the viewer to "make sense" of a press photograph so confine it that imagination has no part to play in his reception of and reaction to the visible. Hence, the role of collage, as surrealists envisage it, is to redeem the scene, to release it to subjective imagination by withdrawing it from dependence on historical circumstance—the spatial as well as the temporal—in this fashion severing its contacts with history.

The difference between graphic and photographic sources for collage stems from the fact that photography is bounded by history while graphics may draw inspiration from literature or the nonfactual. It is a difference that explains how graphic collage progresses toward its goal

Karol Baron, *And What Now?* (1975), collage-book.

(disturbance of its audience's preconceptions) by blending and amalgamating pictorial elements normally kept apart in the rational mind. Photocollage takes its effect in another way.

The photocollage breaks with documentation of historical events by superimposing on them disconcerting extraneous elements. Originating in differing temporal and spatial contexts, each element changes the documentary significance of the picture. Essential to this process is that what we have occasion to see still looks to be a photograph of something we would have been able to observe if standing in the photographer's place at the opportune moment. In other words, whereas the graphic collage lets us see what might be, the photocollage claims attention as a record of what *is*, even when it shows us something patently unacceptable to common sense.

Of course, given the nature of photography, it does not take viewers long to uncover proof of the manipulative intervention for which the collagist is responsible. They discover very soon, for instance, that the sprinter in Heisler's photocollage has undergone an operation by someone other than a surgeon. All the same, in the brief moment when the

eye notices the spring replacing the runner's leg, while the reasoning mind is too startled either to dismiss or to accept what the eye sees, the spectator's sense of wonder takes over so that the photocollage appears as photographic documentation of the marvelous.

It is commonly acknowledged among surrealists that Ernst immediately brought graphic collage to perfection, leaving no room for later experimentation that might be expected to improve upon his accomplishment. The best surrealists can hope for is to produce fruitful variations such as those offered, for instance, by Ludwig Zeller. One attraction of photocollage is the possibility for surrealist collagists to make a contribution without either competing with Ernst or having the quality of their work judged by comparison with his. The frame of action for the surrealist photocollagist allows the chance to bring something to surrealism in an area where the Ernstian collage has not set an example that it would be foolish to hope to surpass and pointless for surrealists to attempt to imitate.

The surrealist photocollagist is no mere observer of reality, curious about its anomalies, perhaps, yet at all times thoroughly respectful of its boundaries and well content to work within them. He or she is an activist, a subversive determined to remove those same boundaries, or at all events to push them back a little. The aim is to bring before an audience sights that, even in its exotic aspects, objective reality cannot show. In this regard, his or her work complements that of the collagist employing graphic material.

Kral's article in *Phases* characterizes the authenticity of collage as "an abusive use, within an original 'discourse,' of elements borrowed from other discourses." Here collage is described as lying "in the conflict between the original and new ('shifted') meanings of those elements" (p. 98). From the point of view shared by surrealists, though, whatever is abusive to common sense, and to the kind of comprehension that commonsensical discourse is designed to offer, actually works to redirect discourse. Surrealists see conflict as present, therefore, only so long as rational preconceptions hold out against the irrational which Max Ernst sought through graphic collage and Heisler was to find in photocollage.

The differences between graphic and photographic surrealist collage are inherent in the materials utilized. The common element linking them, meanwhile, is the subversive spirit in which surrealism mounts a frontal attack on the reality principle. This is why no barriers oppose employment of graphic matter as well as photographic elements within

one and the same collage, like Collier's version of Milton's work habits, for example.

One feature common to surrealist photocollage and graphic collage is that both are characterized, usually, by formal cohesiveness. Neither, though, is intended to impress its audience by eliciting aesthetic response. The imposition of cohesiveness is anything but an acknowledgment of or concession to the demands of art. It assists in making collage an aggressive gesture, typical of the surrealists' militant resistance to the status quo.

Unity of form within the collage opposes rational logic and concurrently asserts the logic of the extrarational. It denies the reasoning mind an opportunity to protest that the constituent parts of a surrealist collage fail to come together closely enough to "say" anything coherently. It plays an important part in making collages communicate the unsayable, so that in their own way they "speak surrealist." Hence, surrealists turn to collage sure of its capacity to articulate a statement about the nature of reality inspired by an imaginative perception of an interrelationship between its visible aspects which projects a poetic sense of the real, unhampered by the prosaically familiar ordering known to everyone from experience.

An essential element in collage is utilization of prefabricated materials. These are pictorial elements that preexisted the act of conflation. In surrealism, graphic and photographic material is called upon to serve a purpose very different from the one that brought them into being. The surrealist collage exists to change the significance of the materials from which it creates a new entity. And so the presence of the recognizable never encourages complacency about the permanence of everyday reality. Nor is it allowed to release in its public only nostalgia for the bygone times to which belongs so much of the material on which Ernst liked to draw.

When he experiments with collage, the surrealist's intention is not to borrow elements from graphic and photographic sources merely so as to deprive them of all meaning. His goal is to invest what he has chosen with a new significance altogether, one that grows out of unprecedented amalgamation and juxtaposition. The surrealist collage leads its source materials through two stages—declassification and reclassification—but does so simultaneously. For each of these processes to take effect, the elements assembled by collage have to remain identifiable, still recognizable for what they were. Only under these conditions can the wonder of transformation impress itself on the spectator's imagination, as declassified pictorial evidence is submitted to reclassification.

Without in any way diminishing the value of the contribution made by collagists to the pursuit of surrealist ideals, one may speak of collage not so much as creation but as subversion achieved through diversion of materials which no spectator has difficulty tracing to their origin. The spirit in which the recognizable is turned away from its familiar function (that is, from the function appearing normal to the general public) is the same as that in which, on one page of his *L'Amour fou*, André Breton affirmed, "The greatest weakness of contemporary thought seems to me to reside in the extravagant overestimation of the known in relation to what remains to be known." The direction taken by the surrealist collagist is therefore parallel to that followed by Marcel Mariën in *L'Imitation du cinéma*, a 1959 film in which we are invited to witness, as Mariën himself puts it, "the embezzlement of familiar objects."[8]

The procedure depends for its success on the presence of two active ingredients. The element of familiarity is necessary to initiate the process. It sets things moving, even when at first recognizable features in the collage give the spectator the lulling impression that the stability of the familiar is going to be respected in the surrealist collage image. Recognition is transformed into a force operating ironically to help undermine stability and put things in motion. Movement becomes irresistible. It accompanies displacement of the so-called real, facilitating the latter's replacement by the surreal, as the second ingredient, the collagist's manipulation of familiar objects, now takes effect. A process that the reasoning mind would consider misapplication of familiar materials has no negative connotations here. To surrealists it ceases to appear reprehensible, once observed to be less misappropriation of what we thought belonged exclusively to reality than its reapplication—not a loss to reality, then, but a gain benefiting the surrealists' heightened perception of the real, surreality.

Through collage, advance from the real to the surreal illustrates in pictorial terms the conquest of banal reality by exciting surreality. Hence, it exemplifies the progression that everyone committed to surrealism devotes his or her energies to demonstrating and in relation to which all surrealists measure the integrity of the artist and the potency of art. The criterion serving by way of collage to bring mental release from the limitations of rational projection may vary, of course. Amusement may prove to be no less productive a reaction than dread or horror, in jolting the mind out of the rut of habitual thinking and expectation.

Something the rational mind would condemn as a crime obeys a law still unwritten. This law surrealists feel sure will break, in the end, with a commonsense system of cause and effect which they cannot accept

and refuse to countenance. Thus, as Mariën uses it, the word *embezzlement* takes on ironic force, invoking the sort of conventional judgment to which Mariën and surrealism's collagists are opposed. In this regard, embezzlement violates the pact governing acceptance of some things and demanding rejection of others, the pact separating the familiar from the unfamiliar.

The French word employed by Mariën—*détournement*—indicates how embezzlement of familiar objects is to be effected. In collage a change, characterized by Ernst as alchemical, is produced as the familiar is turned away (*détourné*) from the role that has rendered it familiar to us. Graphic and photographic elements have not ceased to be familiar because incorporated into a surrealist collage. It is simply that their role therein is no longer the one to which we are accustomed. Separation from the function that customary use assigns them has made them look alien, sometimes even hostile in appearance. They are not confined any more by function to a prescribed place in our lives. All the same, still present, they continue to demand attention. A vital change has occurred. They now exist autonomously—not for whatever service practical utility imposes but for themselves. Turning them away from one role has left them free to assume another. Only continued faith in the laws of habitual usage, surrealists would argue, can lead us to condemn the transformation they have undergone as a criminal act of embezzlement.

Examination of the substantive *embezzlement* from another perspective assists us in measuring the breadth of the surrealist undertaking. Whether or not society judges embezzlement of familiar objects to be a misappropriative act, that procedure indicates something of note. The surrealist's appropriative gesture is the contrary of submissive respect for the familiar. It demonstrates how the familiar can be brought into the surrealist scheme of things. To surrealist collagists, certainly, appropriation of familiar objects would seem to be quite pointless and would appear no more than a futile gesture of defiance if they did not believe in the possibility of penetrating to the unknown by way of the known, if they were not convinced that the real can open up a pathway to the surreal.

In surrealist collage, transcendence of the limits set by past experience and prior acquaintanceship for reality—our awareness and acceptance of it—is the prized consequence of juxtaposing graphic and photographic elements. Juxtaposition is valued as bringing purification of the dross of utilitarianism in an alchemical transformation of the accustomed into the unwonted. Alchemical sublimation occurs with magic effect where the speculative act of collage causes the real, fertilized by the marvelous, to bear fruit in the surreal.

9

THE LANGUAGE OF DESIRE

There is something pleasing about the quip that represents French romantic poets as believing they had discovered "the principle of perpetual emotion." It sounds apt because we have no trouble agreeing that, however broad a range is offered by romantic literature in France, its diverse forms present variations originating in feeling. This is to say that we have no serious difficulty tracing romantic writing—and hardly more, when it comes to romantic painting—to one common source, emotion. We recognize within which framework the romantic finds his creative being, just as we locate the wavelength on which romanticism sends its message to the world outside and expects an answer. As a consequence, we respond to romanticism most freely and enthusiastically while reacting to its emotional appeal. When enthusiasm for romantic writing begins to wane, it is usually because inclination or ability to respond emotionally has started to decline.

Nobody has coined a phrase that appears fully successful in classifying surrealist effort and accomplishment exhaustively. This fact on its own tells us something important about the surrealists, who have never tried to establish a firm underlying principle by which literature and art can find momentum, even temporarily. Because the motivating force of surrealist creative energy has nothing to do with promoting the ambitions of a literary or artistic school, many people are bewildered, unable to track down a central purpose behind surrealist endeavor. Yet such a common purpose can be seen to exist. It grants many of the products of surrealism indisputable unity. A considerable number of surrealism's adherents are more aware of what holds them together than were the

romantics. For the link that binds numerous apparently dissimilar forms of surrealist creative expression is desire. Whereas the romantics communicated through emotion, the surrealists often speak the language of desire.

A statement such as the last one has the appeal of glibness. It encourages anyone listening to ignore or gloss over a question which it reduces to essentials bare enough to excuse us from attending to its complexities. These do not take on a definite outline, in fact, until we ask what, exactly, it means to a surrealist to talk of desire and to speak its language. Essentially, desire raises two problems. We need to know how certain surrealists understand the word *desire*, and we have to establish also how, through use of desire, they aim to speak a special language.

It is only natural that, as disciples of Sigmund Freud, surrealists should look upon the attainment of desire as, in its most direct form, a process of wish fulfillment. Thanks to Freud, they realize how desire in man may find outlet in roundabout ways, indirection being imposed by inhibiting obstacles that impede forthright expression. From the beginning, this discovery helped give prominence to one of the most distinctive features of surrealist theorizing about desire, the conviction that desire admitted and consciously articulated —the equivalent of the common currency of emotion, during the period of romanticism—can only be, in the age of surrealism, desire still incomplete. From this premise follows many surrealists' devotion to desire unvoiced and unacknowledged yet surfacing during the creative act, which thus assumes the character of an investigative procedure of the first order.

Some of the best surrealist works are not creations devised as tributes to desire. They serve, instead, as the medium through which desire demands attention and takes definition. It is for this reason, and not just out of a determination to shock or offend, that surrealists often depart from the norms of good taste, propriety, and aesthetic acceptability. Conducting themselves in that fashion, they lose the attention of individuals whose interest in surrealism runs no deeper than passing curiosity. These people react most easily with a feeling of shock or by taking offense. Hence, they complain that surrealism becomes boring or is a hollow joke, when they no longer are shocked and positive response to desire has never been triggered in their sensibility.

With romanticism, the common ground of emotion on which the artist meets his or her public is, so to speak, open ground. With surrealism, we face something profoundly different. The desire supplying this or that artist with an audience is rarely identified, accurately pin-

pointed, in advance of the creative act. Far more frequently, surrealists are attentive to a form of desire that takes shape, becoming gradually recognizable, only as the creative gesture uncovers it or brings it into focus. This fact does not lead every surrealist to preoccupation with unacknowledged desire, normally considered unavowable, with presenting the socially or morally inadmissible. The freedom surrealists are anxious to grant desire in all its manifestations does cause them to regard expressing desire of the "shameful" kind as quite permissible. All the same, the scope of their efforts would be restricted indeed, if they allowed desires nurtured in private, but yet fully recognized, to provide the sole substance of art. Frequently, surrealism attempts to break new ground, taking its audience into areas not explored before,

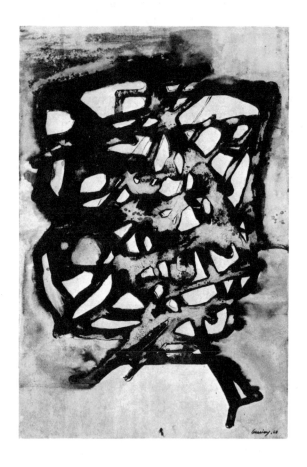

Mário Cesariny, *Head* (1968), aquamoto.

by stimulating the artist to pursue desires still not knowingly entertained.

In whatever form, surrealist poetry is not meant to prove how the blind may try to lead the blind. It demonstrates that the investigative act of creation may bring illumination to both the artist and the individual whom the work addresses in the language of desire. Two published statements clarify this point. The first is by Alberto Giacometti, who declared, during the period when he kept company with the surrealists:

> I can speak only indirectly of my sculptures and hope to say only partially what has motivated them.
> For years, I have brought into being only sculptures that offered themselves to my mind complete, I have limited myself to reproducing them in space without changing a thing, without asking myself what they could mean (I had only to modify a part or try to adjust a dimension to be completely lost and for the whole object to be destroyed). . . . The attempts I have made sometimes at conscious realization of a picture or even of a sculpture have always failed.[1]

The second is by Man Ray. The occasion is a discussion of photography:

> Can one in fact imagine a more imperative coming together of two people than discovery of a common desire? From the first gesture of a child pointing to an object and giving it a name, but with what intense significance, to the developed mind creating an image that moves us to the deepest level of our unconscious by its strangeness and its reality, the awakening of a desire is always the first step toward participation and experience.
> Every effect prompted by desire must also rest on an automatic or subconscious energy that helps in its realization. Of this energy we possess unlimited reserves; all that is needed is the wish to reach down into ourselves, eliminating all feeling of restraint and propriety . . . the creator concerning himself with human values allows the unconscious forces to filter through, colored by his own personality which is only the universal desire of man and brings to light motives and instincts long repressed which are, after all, a basis for brotherhood and confidence.[2]

Giacometti indicates without any ambiguity that the artist must be led to a destination he does not foresee reaching, showing that, in fact, he can be diverted from his route when interjecting his own estimate of where he is headed. But it is Man Ray who begins to reveal how we outsiders may expect to travel along with certain of the surrealist artists, so that they neither outstrip us nor leave us disinclined to accompany them. In addition, Man Ray singles out an essential characteristic of surrealist activity in the creative field. He leaves no room for doubt in those of us willing to admit his sincerity regarding surrealism's capacity

to draw strength from unlimited reserves of energy lying deeper in man than emotion does, at a level where "unconscious forces" are active. Only by finding means to tap these forces (of which they can know in advance neither the nature nor the full power) may artists speak not merely for themselves but, surrealists assert, for all mankind.

As in romanticism, so in surrealism the truly creative artist is viewed as enjoying the privilege and right of productive communication with others. But surrealists argue that the means of communicating must take us beyond emotion, through liberative imagination. In the way that the romantic would entrust himself to feelings—well content, incidentally, to find that only a very few were up to sharing with him the benefits of doing so—the surrealist often abandons himself to desire. More exactly, he awaits the revelation of desires that send their roots deeper into his being than needs he is conscious of experiencing.

Understanding what lies behind the Giacometti statement cited above calls for consideration of a phenomenon of poetic significance for surrealists, the kind of beauty André Breton termed *"convulsive."*

Discussing the characteristics distinguishing convulsive beauty, Breton remarked on one occasion:

> Such beauty can emanate only from the poignant feeling of something revealed, from the full certainty obtained through the irruption of a solution which, by reason of its very nature, could not come to us by ordinary logical paths. It is a matter in such cases, in fact, of a solution always surprising, of a solution certainly rigorously appropriate and yet very superior to what is needed. The image as produced in automatic writing has always constituted a perfect example of this. Likewise, I have been able to desire to see a very special object constructed, corresponding to some poetic fancy. I foresaw this object more or less, in its matter and its form. Now, it has happened that I have come upon it, unique no doubt among other man-made objects. Obviously this was it, even though it differed in every regard from my expectations. One might have said that, in its extreme simplicity, . . . it made me ashamed of the elementary nature of those expectations. The fact remains that pleasure here is a function of the very dissimilarity existing between the object wished for and the *find*. The find, whether it be artistic, scientific, philosophical or as shabbily utilitarian as you like, in my eyes takes away any beauty that is not the find itself. In it alone do we have the opportunity to recognize the marvelous precipitate of desire. It alone has the power to enlarge the universe, in part to reject its opacity, to reveal to us the universe's capacity for extraordinary concealment, proportionate to the innumerable needs of the spirit.[3]

This key pronouncement on convulsive beauty distinguishes the sense of beauty—and its manifestation in the world about us—from aesthetic value judgments. Unless we grasp that central idea, we cannot penetrate

the surrealists' motives in exploring the field of art instead of concentrating exclusively on pressing social and ethical issues.

With particular stress, Breton relates beauty (awareness of its presence, that is) to revelation. His displacement of man's sense of beauty denotes a revolutionary concept of the beautiful which rules out discussion of all traditional aesthetic norms. Coincidentally, beauty in its convulsive form discredits procedures by which aesthetic needs have been met in the past. No less significant is that, as Breton speaks of it, revelation is differentiated from uncertainty, or the merely tentative. It stands as proof, which the French surrealist leader himself relates to a solution neither foreseen nor knowingly sought but which breaks in upon consciousness unannounced. Noteworthy, here, is Breton's insistence on the antilogical, and so unpredictable sources of revelation. Antilogical techniques are to be implemented in order to bring out a solution that will do more than meet preestablished need. In this respect, therefore—and now we face a second noteworthy point—the revealed solution is itself revelatory. It brings to light more than the artist was aware of wanting to know. Hence, it defines desire beyond the point to which the artist is alert to need.

Now these remarks enlighten us upon the magic of the *find*. In locating or creating an object we have not sought knowingly, not planned, runs Breton's argument, we may achieve realization of a desire never consciously acknowledged and entertained. Thus, we take a step beyond the "object wished for" into a domain beyond conscious desire. Breton does not seek to distinguish between subconscious desires and unconscious ones. Instead, he limits himself to bidding readers note how, to the extent that a *find* exceeds expectations and even goes beyond hope, it epitomizes convulsive beauty, filling its magic role as "marvelous precipitate of desire."

In Breton's text, the adjective *always surprising (excédente)* and the substantive *dissimilarity (dissemblance)* emphasize the folly of supposing that convulsive beauty lies within the scope of conscious projection. For Breton, the convulsive element is that which distinguishes beauty situated beyond anticipation. That is why he looks upon the beauty of the *find* as residing in its exemplary nature. As a "marvelous precipitate," the *find* puts the surrealist in touch with desire. It does so more excitingly than could ever be the case if he were to restrict himself to aiming to satisfy needs he could define in advance and set himself as targets during the creative process.

In this sense, the *find* strips beauty from everything contrived and, in addition, enlarges the individual's awareness of the universe by reducing its "opacity." Clairvoyance, therefore, is the discovery that the phys-

Found object. Photo furnished by Ian Breakwell, London.

ical world can respond to the innumerable needs of the spirit, needs as yet unnumbered because they still have not been revealed by some illuminating *find*.

In *L'Amour fou* we read of an incident dating from 1934. At a time

when Giacometti was experiencing trouble completing the facial features of a sculpture in progress, he and Breton happened to visit a flea market which the latter frequented. There they came across a half-mask of metal for which they could not guess the purpose, unless it might be a German fencing mask. After a brief hesitation, Giacometti—by no means the habitual collector of strange objects that Breton was—returned to the stall and bought the mask, encouraged by Breton who, feeling no impulse to own it himself, was pleased to see his friend acquire it. Reflection imposed the conclusion that the mask was in some way *"embraced"* between the *Head* reproduced in the fifth number of *Minotaure* (May 1934)—Giacometti's most recent work—and the face, which, thanks to this *find*, the sculptor was now able to model, so completing his *Feminine Personage* (or *The Invisible Object*, as it has come to be known), reproduced with the mask in *L'Amour fou*.

The relevant section of his 1937 volume having appeared with illustrations under the title "Equation de l'objet trouvé" (Equation of the Found Object) in a special number of the Belgian magazine *Documents* called "Intervention surréaliste" (June 1934), Breton received a letter from the poet Joë Bousquet identifying the mask as a baleful object. According to Bousquet, it was one of the masks he had been ordered to distribute to the soldiers under his command during the Great War, the night before many of his company had been killed in an attack in the Argonne during which he himself had been paralyzed for life by a bullet in the spinal column.

The foundation of the surrealist theory of chance is rejection of the accidental. In surrealism, the accidental is ousted by the necessary. Thus, Pierre Mabille's account of the circumstances under which one surrealist painter, Oscar Dominguez, happened to cause another, Victor Brauner, to lose an eye[4] removes the incident from the frame of banal though shocking accident by tracing premonitory evidence present in Brauner's painting as many as six years before. Brauner himself confided later, "I was caught up in an adventure of nonresponsibility"[5]—an adventure, we notice, not an unfortunate combination of circumstances. Brauner's statement does not ask us to accept that loss of an eye fulfilled his subconscious or unconscious desire. Still, receiving a blow from a glass thrown at someone else completed a process announced in his pictorial imagery, and in a fashion no more explicable to the reasoning mind than the perfectly geometrical disposition of the fragments of glass shown by radiography to be lodged in his eye; no less fascinating as a demonstration of the marvelous operation of chance, either.

Discussing "the language of stones" in one of the later surrealist mag-

azines, Breton implies that he is among "those who consider that nothing of what surrounds them can be in vain, can fail to concern them from some angle."[6] While most people never notice stones at all, Breton belongs with individuals who are transformed by stones into "something like inverted astrologers" (p. 63) and who therefore come to feel "the necessity of a *quest*, daily more exacting," which we may guess increases their awareness of the world. Thus, Breton's passion for seeking out curiously shaped pebbles and stones reflects the state of being "prey to searching" (p. 64). It is "as though it had something to do with our destiny," he remarks. "We are given over entirely to desire and solicitations thanks only to which, in our eyes, the object required is going to manage to be dignified." Why? Because between the object and us, "as though by osmosis, a series of mysterious exchanges are going to be effected in a rush, by way of analogy."

In 1956, reports Breton, who more than a decade earlier had hunted agates during his honeymoon on the Gaspé Peninsula, he unexpectedly came across some along a French river. As he put it, the discovery gave him "the perfect illusion of treading the ground of *earthly paradise.*" Most people would regard such a discovery as purely accidental and accordingly would dismiss Breton's reaction to it as ridiculously exaggerated. But the surrealist's attitude is fundamentally different, as Breton made clear when affirming, "one finds that for which one experiences, in depth, the need" (p. 68) and going on to declare, "The search for stones possessing this singular allusive power, provided this search is passionate, determines the rapid passage of those enjoying it into a *second state,* the essential characteristic of which is *extra-lucidity.*"

Breton's keen interest in stones lends itself to skeptical interpretation as a mere quirk of temperament, unworthy of notice and surely uninformative. All the same, taken with what he has to tell about the value of the *find,* his curiosity over stones is fully in keeping with the surrealist position. Furthermore, it brings into clearer focus the relation he perceived between the *find* and desire.

According to Breton, *extra-lucidity* promotes "a magic causality, presupposing the necessity for the intervention of natural factors having no logical relationship with what is at issue, in this way baffling and confounding our thinking habits but not being any the less of a force to subjugate our minds" (p. 68). When the mind, normally under reason's restraint, is subjugated by desire instead, surrealists contend, then the surreal manifests itself. Hence, Breton's assurance: "Stones . . . continue to speak to those willing to hear them. To each they speak a language made to order; through what he knows they instruct him in what he aspires to know" (p. 69).

Jean Cazaux has noted that in surrealism the opposition between surreality and reality rests on "what is arbitrarily limiting, apparently necessary or definitive about the latter."[7] Thus, he has glimpsed one central fact. Surrealism has not declared war on reality, but it insists that the surreal is in radical conflict with a certain sense of reality opposing or appearing to frustrate desire. Hence, surreality can be understood as reality infused with desire, the medium through which the real lends itself to communicating desire.

The pivot on which the real and the surreal find equilibrium is the human sensibility, consciousness or, as Mabille called it, the spirit. Mabille explained himself as follows. If it is possible to compare the spirit to a mirror, then its silvering is "the red flow of desire." He added, "In this strange apparatus, in any case, the alteration of images, far from being gratuitous, marks the first phase in the transformation of the universe."[8] Subsequently, Mabille (who was to assemble an anthology called *Le Miroir du merveilleux*, published in 1962, after his death) observed in *Le Merveilleux*, written in Mexico City in August 1944, "But the Marvelous is less still extreme tension of the being than the conjunction of desire and outer reality."[9]

To many a surrealist, the remarkable thing about objective chance is that it can be seen to operate beneficently, especially where, precipitating desire, it reveals itself excitingly through the *find*. In *L'Amour fou* Breton gives an account of certain concrete discoveries he has made (one of them the very morning Giacometti found his mask, in the same flea market), describing and interpreting found objects that compelled him to grant them attention even when he was at a loss to account for their fascination. Reading this section of his book, we may draw broad inferences. The found object is to be regarded as no more than a token, presented by ambient reality, of the role *finds* are capable of playing, so long as we admit their significance as harbingers of desire. Hence, we lose sight of Breton's reasons for detailing several *finds*, if we neglect one important aspect of his preoccupation with them.

It is surely of interest that, although Breton speaks insistently of *la trouvaille*, the find, in *L'Amour fou* he never once alludes directly to the role of *le trouveur*, the finder. In all that he says on the subject of chance discovery, he places emphasis on chance without pointing out that the beneficence of chance would be wasted on anyone disinclined or unable for some reason to be its beneficiary. *L'Amour fou* does not give the role of human responsiveness the stress it will receive later in "Langue des pierres." All the same, Breton's whole argument, like the examples adduced in *L'Amour fou* to support it, presupposes receptivity and takes it

for granted in the person to whom chance brings revelation by way of desire. Certainly, we cannot prove Breton guilty of more than an oversight. For it is evident from his discussion of automatic writing in the 1924 manifesto that he looked upon chance as benefiting only those prepared to respond positively and gratefully, after entering a state of eager receptivity.

According to Breton's view, some discovery that our humdrum lives have not prepared us to make constitutes a *find* important enough to command attention, when providing a glimpse of the immanent universe of desire concealed behind the facade of the everyday world. Obviously, Breton looks upon the found object as typifying that universe, but not as the only sign that conceivably may reach us from the zone over which desire reigns supreme. Hence, his assertion that the magic released by automatic writing is a perfect example of a found solution going beyond conscious need. Hence, too, his fidelity to the automatic principle as essential to the active pursuit of goals attainable by surrealist artists.

Without constituting the be-all and end-all of surrealism that numerous observers presume it to be, automatism is a vital feature of the surrealist creative approach. Automatism offers a practical solution to the problem facing any surrealist artist who has asked how to acquire a method for defining desire, if not actually for encompassing it, where desire unconfined is desire undefined. In its pictorial, sculptural, and verbal forms, automatism provides a means to make possible the pursuit of a goal taking on definition only as the created work moves forward. The central advantage of automatism, in other words, lies here. It releases the creative act from limiting predefinition that, in the opinion of the surrealists, would cramp the artistic gesture. So far as the public is concerned, they are freed of respect for technique per se. They are at liberty, now, to judge the artist less on his skill in applying consecrated literary or pictorial methods, in utilizing a given form, than for the revelation of desire to which his work offers testimony.

In a positive sense, discussion of the language of surrealism makes us witness possession of the artist by desire, letting us observe how his relationship to desire imposes special demands on the expressive modes at his disposal. "Man," we are informed in the first manifesto, "proposes and disposes. It rests entirely with him whether he belongs wholly to himself, that is to say, maintains in a state of anarchy the every day more formidable gang of his desires. Poetry teaches him this. It carries with it the perfect compensation for the miseries we endure" (p. 31). Breton's statement lays the cornerstone of surrealist theory with

respect to the relationship poetry must bear to desire. It shows that possession by desire is, to the surrealist, self-possession through self-discovery. It makes clear that the latter is not predicated on mastery of one's desires. On the contrary, self-discovery presupposes willingness to allow desires to exist as anarchic forces, a gang (*bande*, in Breton's text) no less outside society's laws than the anarchist *bande à Bonnot*, whose violent activities terrorized Paris and its suburbs for six months during 1912–1913 and obviously impressed Breton, as it did Louis Aragon. The interesting difference is that, whereas his story "Lorsque tout est fini" (1922) suggests that, to Aragon, the significance of anarchy remained political and hence social, for Breton it was to continue to be poetic.[10]

Anything short of the most scrupulous dedication to the task of self-discovery, whether or not through identification of desire, can lead to radical contradiction with surrealism's highest principles. It leaves the door open upon imitation and reduces implementation of surrealist techniques to their routine application for parodic purposes at best. At worst, it turns the artist into a charlatan, whose conduct surely will do surrealism's name more harm than good.

A notable aspect of convulsive beauty accounts for the reputation automatism earned very rapidly among members of the original surrealist group in France. From the beginning, surrealism taught that beauty eludes those who keep to the paths of familiar logic. On the other hand, beauty could be sought with more success by those ready and equipped to entrust themselves to the logic of unreason. The fundamental error outsiders often make, when looking over the description of the technique of automatic writing furnished in the 1924 *Manifeste du surréalisme*, is to view its author as inclined to condone or actually to advocate verbal incoherence. Breton made no secret of Freud's influence upon his thinking during the period when he had lost confidence in the French poetic tradition. In fact, he stressed this, with some pride, in his first manifesto. All the same, that basic text rests on a belief Breton evidently considered it superfluous to put into words.

In the mid-1920s, surrealism did not represent itself as proving Freudian theory, which, in any case, could not have found validation from a nonscientific standpoint. Nor did the surrealists ever seek to apply for therapeutic purposes some literary variation on Freudian free association. They were eager to follow the example set by *Les Champs magnétiques* because, like Breton and Soupault, they came to look upon automatism as a means of revitalizing poetic expression and hence of rejuvenating poetry. And, if they were like Breton, they did so in the

conviction that breaking down the barrier separating the conscious from everything lying deeper in the personality would bring them into closer harmony with desire.

The distinguishing mark of the *find* seems to be that its attraction results from a fortuitous encounter with something one had no expectation of meeting. From the viewpoint adopted in *L'Amour fou*, that encounter involves much more than simple accident, however. After all, the revelation precipitated by the *find* is the gift of beneficent chance, of *le hasard objectif*, in which surrealists place abounding faith.

On 12 December 1933, Breton and Paul Eluard reported in the third and fourth issues of *Minotaure* results of an inquiry focused on the following questions: "Could you say which has been the capital encounter of your life? To what point did this encounter give you, does it give you the impression of being fortuitous? necessary?" Disappointed with many of the responses that had come in, Breton and Eluard explained why: "We had intended it situate the debate . . . at the very heart of that hesitation taking possession of the mind when it seeks to define 'chance'" (p. 102). Their own conclusion was that chance "would seem to be the materialization of external necessity making its way in human unconsciousness (to try boldly to interpret and reconcile Engels and Freud on this point)." In short, they questioned whether one can speak of chance without relating its expression to desire realized. This, without a doubt, is why in *L'Amour fou* the idea of the "apparent gratuitousness" of the *find* is admitted only as an indication of "our temporary incomprehension." Breton's mind establishes a logical connection between the adjectives *apparente* and *provisoire* just as it links the nouns *gratuité* and *incompréhension*. Once incomprehension has been acknowledged to be temporary and as having yielded to understanding, then the *find* is judged gratuitous in appearance only. Indeed, viewed in relation to desire, the *find* is not gratuitous at all, but necessary.

During the 1930s, Breton turned repeatedly to the theme of chance and desire. How else are we to account for his willingness to countenance critical paranoia and his quite uncharacteristic patience with its promoter, Salvador Dalí? Eluard, too, gave his attention almost exclusively to desire, to surrealist desire, that is, not to the commonplace variety that later would induce him, in 1946, to name one of his postsurrealist verse collections *Le dur désir de durer* (The Tough Desire to Endure). If we examine surrealist automatic writing from the perspective that inspired Eluard's *L'Amour la poésie* (1929) and Breton's *L'Amour fou*, we come closer to understanding an important point. To surrealists, the image released by verbal automatism has far less value as a literary creation than as proof of the privilege enjoyed by desire to borrow from

the universe about us in order to externalize itself and bring itself to our attention. When we look on notable word images obtained by automatic writing as so many *finds* (and surrealists were doing this before Breton elevated the substantive *trouvaille* to a position of eminence in his vocabulary), we can perceive one thing clearly. In the eyes of those who have written them down (called, significantly, in the first *Manifeste* "modest *recording machines*" [p. 42]), such images testify to the *"catalyzing* role" of the *find*, as Breton refers to it in *L'Amour fou* (p. 47).

The unifying function of desire in surrealism cannot be ignored by anyone grasping the connection between roles assumed in a wide range of media by surrealist artists, all of whom consider that the activity of creation may entail, in the creator, passivity of a singularly productive kind. Surely one of the strongest and most durable links between Jean Arp and the surrealists (whom he called his "friends" and with whom he never declined to exhibit) was Arp's role as a spectator at the burgeoning of form. Similarly, in *Beyond Painting*, Max Ernst spoke of himself as "attending" or "being present at" the birth of some of his works, as though he were engaged in midwifery, not art. Ernst's attitude assists us in dealing with one of the fallacies that has delayed appreciation of surrealism, engendering misunderstanding and even fostering antagonism. It is the common assumption that language is, to use Breton's pejorative term, the "medium of immediate exchange."

Surrealism has never preached a doctrine calling for deliberate infusion of difficulty into discourse, presumably heightened in poetic content to the degree that it has become less comprehensible. As a result, Breton's article (15 October 1936), in *Minotaure* setting up "Le Merveilleux contre le mystère," took issue with Stéphane Mallarmé for what its author, who, a few lines before, had derided "the elementary exchange function" of language, dubbed a "puerile" concern to introduce obscurity into his poems.[11] The surrealist's art is not an art of voluntary addition, or of subtraction, for that matter. Surrealists do not deny art's communicability, do not pronounce its message unassimilable. Rather, they question the benefit of communicating by means permitting evaluation according to standards that invariably relate comprehension to rational assimilation. The rational becomes the surrealist's enemy to the extent that he shares with his fellows the conviction that anything refusing to accede without resistance to the demands of reason contributes to enticing the mind, by way of imagination, beyond range of the commonplace. The goal has not become the unreasonable so much as the extrarational, not the unreal but the surreal.

In *L'Amour fou* Breton alludes to "the pressing, disconcerting irration-

ality of certain events" (p. 59) such as are recounted in his text. These manifestations of chance—often rendered concrete, like Giacometti's mask, in unexpected but revealing *finds*—clearly mean much to Breton because of his firm belief that it is essential not to *"let the pathways of desire become overgrown"* (p. 38). More than this, such manifestations further our understanding of the part that automatism can play in surrealism.

The importance surrealists have always attached to automatism has nothing to do with the erroneous assumption that it is sure to raise the artist above criticism, placing him comfortably beyond reproach or out of reach of appreciation, even. The first surrealist manifesto argued that automatism promotes poetry. Hence, the liberative automatic gesture would be worthless, poetically sterile, if it did not free the artist to some purpose. Often the surrealist's aim is to cast off restraints—aesthetic, social, ethical, and even moral ones—so as to sharpen awareness of desires which those same restraints have forbidden him to identify and to acknowledge. In other words, freedom *from* takes on meaning to surrealists only when it can place the artist in the position of realizing he at last enjoys the rewarding advantages of freedom *for* something previously hidden from sight. Thus, automatism can be a practical and efficient means for helping keep the pathways of desire from becoming overgrown. Among surrealists, therefore, interest in automatism does not originate in the assurance that it provides a sure guarantee of anything at all. In fact, the surrealist may regard it as a vitally important technique applied with a success in which he certainly may take pride, only when it assists him in keeping the channels of desire open, not just for himself alone but also for those to whom he speaks through his works.

At the end of his 1924 manifesto Breton refused to prophesy which forms surrealism would take in the future. He cared not at all, he announced, to witness the arrival of surrealist stereotypes, with the risk of their earning consecration of the sort that, in his view, had drained established literary modes of poetic substance. Wherever confrontation occurs between form and content, surrealists demand that resolution consistently favor the latter. Hence, this basic rule of their practice: form must be validated by the content it captures and conveys, not vice versa. The moment a method appears in danger of no longer helping clear undergrowth from the pathways of desire, it has lost its usefulness and therefore its meaning.

We see now how automatism relates to a central principle of productive surrealist action. Surrealism posits an ideal state that no participant

in the movement regards as beyond reach. Incapacity to understand (the way one grasps the meaning of an informational statement) is not debilitating or confining for the poet, but the route to illuminating response. The surrealist ambition is to effect extrarational communication between himself as word poet and his readers, between himself as pictorial artist or sculptor and those seeing his work. However, this is far from inviting or requiring the creative artist to confuse incoherence with truth, gibberish with poetry. Indeed, here is one of the critical problems of creative action for surrealists. Whether he phrases it formally or not, each of them must address an acutely important question: how to communicate beyond the limitations of reason and yet on the near side of the unintelligible. He does not seek to effect the breakdown of communication. He wants to place it on a footing where rational objection is powerless to curtail imaginative play.

One of the most solid bases for intercourse between artists and public, surrealists demonstrate, is provided by desire. And this does not merely condone wish projection of the "if only" kind. More important, it sanctions reliance on the common bond of obscure desire brought to light for the artist and for his audience by the creative gesture in which surrealism encourages trust. Obscurantism of the sort condemned in Mallarmé's verse is unproductive, surrealists are persuaded, because it situates poetic pleasure (sexualized in Mallarmé's calculatedly ambiguous term *jouissance*) on the level of cerebration. Hence, the contrived mystery of French Symbolism is to be replaced by the marvelous, which removes emission and reception of the poetic message from the plane on which Mallarmé aimed to command attention and respect, locating poetry far more frequently at the level of desire.

Characteristically, surrealist expression evades reason's supervision. Therefore, denied the availability of habitual modes of reception, many people are likely to find themselves facing special difficulties in dealing with surrealist works, in reacting to them with something other than hostility born of bewilderment and attendant resentment. Among surrealists, the problem of earning acceptance for material that evades rational assimilation becomes critical. It is all the more pressing because, opposing the elitism of the romantics, who arrogantly addressed themselves, like Stendhal, to "the happy few," the surrealists follow Lautréamont's lead in believing poetry "must be made by all. Not by one." Yet surrealism takes its stand at a dangerous point where language (however narrowly or broadly one interprets the word) is used in scornful disregard of custom, which bases communication on the reasonably

acceptable. There is, after all, a considerable distance between someone who speaks to his readers of "rosy finger'd dawn" and Breton, telling *his*, "On the bridge the she-cat-headed dew was rocking."

Implied in all forms of surrealist language—though more transparently in some than in others—is a revolutionary communicative gesture, activating a response mechanism destined to break with convention no less boldly than the surrealist creative act itself. Breton referred to this when confessing that he was in no hurry to understand himself. Neither he, though, nor those who joined him, nor again those who came later to surrealism can be accused of preferring ignorance to understanding. The surrealist attitude develops out of two axioms consigned to the *Manifeste du surréalisme*. One affirms, "The intractable mania consisting of reducing the unknown to the known, to the classifiable, puts minds to sleep" (p. 21). The other asserts, "Imagination alone gives me an account of what *can be*" (p. 17). Breton and his associates began by placing what *can be* above what supposedly *is*, not simply out of determination to turn their backs on the real but because they saw reality as expandable to surreality, which, by the way, surrealists never cease to identify with what *will be*.

Without granting attention to a frame of mind common among participants in surrealist activity, we miss the essential movement giving vitality to surrealism as a cognitive process. Reason is eliminated, dismissed as an unreliable guide. Within the scope of scientific thinking, Breton argued, reason may allow us to progress up to a certain point, in explaining, for example, why Mexican beans appear to jump. But from the outset, Breton protested that reason does not take us far enough, does not satisfy our deepest desires, which he viewed as grounded in imagination. This is why, seeing beans jump for the first time, he opposed cutting one open until time had been set aside for imaginative reflection on the possible cause of their strange behavior. After all, surrealism encourages its devotees to concentrate less on how life is than on how it could be. Next to the imagined explanation for the antics of Mexican jumping beans, the explanation revealed when a bean is sectioned may well look dissatisfying to some individuals, even though it reassures others. The disappointment felt by those who are dissatisfied with an explanation grounded in reason is comparable to that felt by someone for whom Cinderella's glass slipper has always been an object of wonder and who learns that the translator of Perrault's version of the well-known fairytale mistook *vair* for its homonym *verre*, thus reading "glass" where "spotted ermine" was required. Only Freudians are going to be pleased at such news.

In the minds of a number of surrealists, including Breton, there is no conflict between the idea of poetry as the pursuit of beauty and that of poetry as fulfillment of desire. This is because, from the moment when surrealism achieved autonomy, poetic effort was associated with revelation. The source of the underlying optimism of surrealism and of the energy that was to keep surrealism active can be traced to the surrealists' confident anticipation of finding the unanticipated, to the excitement felt at probing the unknown, frequently in the light of desire. Already in his 1924 manifesto Breton was affirming with pride, "The fact remains that an arrow now points the way . . . and that attaining the true goal no longer depends on anything but the endurance of the traveler" (p. 32). Little by little, Breton forecast, the "traveler" "becomes aware of the limitless expanses in which his desires manifest themselves" (p. 53).

One arrives at a very accurate perception of surrealism as an exciting state of mind through consideration of the role desire plays in the surrealist experience. However, one can expect to deal successfully with desire, as it infuses so many surrealist-inspired works, only when aware that, before it is anything else, the state of mind known as surrealism is a state of receptivity sensitive to suggestions readily released by desire.

One of Breton's most revealing statements on desire comes from his book *Nadja*: "I have always wished to an incredible degree to meet at night, in a wood, a beautiful nude woman, or rather, such a wish not signifying anything, once expressed, I regret to an incredible degree not having met her" (p. 46). Whereas it is a simple matter to relate to the romantic tradition the first half of Breton's sentence (that part in which he formulates a conscious wish), it is the second half that gives his words distinction. It is indisputably surrealist in origin. A wish expressed, surrealism teaches, is already a wish compromised, first by thought and then by language. Therefore, it is no more than a regret. Still, Breton confided in *Nadja* far more than the belief that experience generally falls short of desire. He proclaimed his devotion to desires that words cannot confine because they remain outside articulation. Thus, he brought into focus the predicament shared by all surrealists who entrust themselves to desire, grateful to let it lead them where it will. The problem resides in attempting to embrace in language any kind of desire that loses its luster the moment it is subject to the restrictions of language. Consequently, the main thrust of surrealist thinking is and must be directed to bringing about reconciliation of desire and language, without sacrificing the former to the latter.

Even though not openly stated, implied here is one of the tenets of

surrealist faith: the conviction that unvoiced desire common to the artist and to his audience has the capacity to inspire a language adapted to its undistorted expression. On this hypothesis rests one of the surrealists' articles of faith. Surrealists agree in believing that an artist must find for himself a pathway to desire. However, close behind, the reader or spectator travels that path also, eager to enjoy the same discoveries and fully equipped to respond to them.

Very often, the bond between the surrealist artist and the audience with whom he communicates cannot be perceived. Nor can we see how close are the links between them, until the surrealist position with regard to desire is acknowledged. Surrealists share confidence in the ability of desire to bring about communication between the creator and his public, even where accepted modes of communication appear suspect. Much that is typical of surrealist expression, in fact, grows out of suspicion of the expressive means handed down by commonly respected modes of literature and art. Where suspicion has preceded creative expression, the characteristics of surrealism emerge as at once doubt and the dissipation of doubt, often transcended in a language that desire has made its own, that of surrealist objects, for example.

10
THE LANGUAGE OF OBJECTS

In 1936 André Breton had occasion to comment on what he saw fit to term "a crisis of the object." He attached so much importance to this topic that, against strict logic, he eventually incorporated his remarks in his book on surrealism and painting, next to his preface to a 1936 exhibition of surrealist objects and a brief 1942 note on the *poème-objet,* of which he himself was a leading practitioner.

In a sense, of course, *Le Surréalisme et la peinture* treats every worthwhile painted canvas as a kind of object. On the second page, Breton likens a picture to a window, which he admits to approaching so as to see *"what it looks out upon."* All the same, having already ranked visual images above auditory ones, in both clarity and rigor, he leaves readers wondering at his willingness to include material on surrealist objects among his essays on painters. Seeking to comprehend his motives could lead us very easily to misapply the word *object,* which then might lose definition. As a result, the surrealist object might de denied an existence separate from surrealist painting. In fact, the object would be stripped of the autonomy it must be recognized as enjoying, if one hopes to reach a fuller understanding of its significance as a mode of surrealist language, independent of graphic art.

This said, we must acknowledge that, taken on their own, Breton's observations about the poetic object—specifically, about the object in surrealism—cannot be faulted. Not for a moment does Breton lose sight of the contribution objects are capable of making to the exploration of surreality. Indeed, the excitement he voiced in 1936 simply confirmed his rapidly developing perception that objects have an indispensable

and irreplaceable role to play in surrealism's battle with mundane reality.

In classic accounts of surrealist experience made prior to 1936, objects already figure prominently enough to betray, among surrealists, enlightening awareness of their mysterious side and of their stimulating presence among us. We recall without difficulty the pages on the glove and on billboard advertising for Mazda light bulbs in Breton's *Nadja* (1928) as well as the sights in display windows of the Passage de l'Opéra, described in Louis Aragon's *Le Paysan de Paris* (1926), not to mention the Cadum Baby in Robert Desnos's *La Liberté ou l'Amour!* (1927). Nevertheless, Breton's 1936 discussion, "Crise de l'objet" (Crisis of the Object), prepares its readers to grasp how the object may take an even more active part, on surrealism's side, in resisting the commonplace. While he appears to approach his topic obliquely, we discover soon enough that this is only to make his point with greater emphasis.

Breton's "Crise de l'objet" is concentrated on the confluence of scientific thought and poetic and artistic ideas, illustrated by reference to two key dates in nineteenth-century French literary history, 1830 and 1870. The purpose of Breton's summary remarks is to bring out, in the year 1830, "the necessity for the fusion of the mind and the tangible world," in short, we read in *Le Surréalisme et la peinture*, "a call for the marvelous" (p. 275). As for 1870, that year is associated with "a *contradiction surmounted*" so as to "provoke total upheaval of the sensibility." The result, says Breton, was "rout of all rational habits, eclipse of good and evil, distinct reservations about the *cogito*," and, furthermore, "discovery of the everyday marvelous." In both cases, then, Breton's summation stresses the marvelous as present in everyday life.

Specifically, Breton ends up connecting the mathematical concept of "generalized geometry" (linked in his text with the year 1870) and a need, attributed to artists of the period, to break down the barriers keeping "the already seen" apart from "the visible," separating what is experienced from what *can* be experienced. In other words, his attention is concentrated on a common structure which he ascribed to modern scientific and artistic thought. He defines it as follows: "The real, too long confused with the given, . . . is cracked in all directions by the possible and tends henceforth only to be one with it" (p. 276). The steps of Breton's argument are revealingly clear. They lead him away from the reality of the outer world—known to us all—in the direction of the possible. There he expects the real to be rescued from the commonplace through welcome intervention by the marvelous. In Bretonian perspective, therefore, both science and the creative arts undergo a significant

evolution of thought, marked by the imprint of the subversive force of the marvelous.

All that is still needed at this point is for someone to testify, in surrealism's behalf, to the defeat of late-nineteenth-century Positivism. Michel Carrouges obligingly does so when recalling that, for him (and, we may add, surely for others also), surrealism stood for "the revelation of the presence and power of the marvelous, destruction of the Positivist concept of the world."[1] The collapse of Positivism paves the way for surrealism, along the route followed by invigorating doubt. It is an essential prerequisite for development of a sensitivity to objects that will be characteristic of Breton and his surrealist companions. Hence, it sets the stage on which objects will act out a role inconceivable against the background of Positivist thought, which no surrealist could fail to regard as completely depressing and stultifying.

The surrealists' fascination with objects—whether it be with *finds*, with modified everyday objects, or with assemblages—is an outgrowth of their trust in the marvelous as proving reality capable of opening up a path to surreality. In surrealism, the marvelous is viewed, at the same time, as disrupting accepted reality and as a precious catalyst by which the real can be induced to precipitate the surreal. Not for nothing did Paul Eluard speak in his *Donner à voir* of the "physics of poetry."

In the context of the argument outlined in the "Crise de l'objet," the surrealist object is accepted as a concrete presence, of course. More to the point, it is a token of the operation of "thought that has broken with millennial thinking." Addressing us in a language of its own, the object conveys "a thought no longer reductive, but indefinitely inductive and extensive" (p. 277). Breton does not go on to suggest that only material things can communicate the kind of thought to which surrealists listen. All the same, he treats thought as "enamored of its own movement only." Moreover, he sees it as subject to "an unprecedented *will to objectification*," to which poetic objects correspond. At this stage, his presentation draws a fruitful analogy between the poetic object and the mathematical object. Neither, Breton insists, holds artistic meaning for the person who has made it. Even though each may satisfy certain aesthetic demands, it would be an error, we are assured, to appreciate the one or the other from the standpoint of art.

Mathematicians surely would never dispute that Breton's remarks apply to their objects. For this reason, the parallel with surrealist objects established in his essay takes on special importance. It provides the groundwork for a theory of the object to which his friends and associates gladly subscribe.

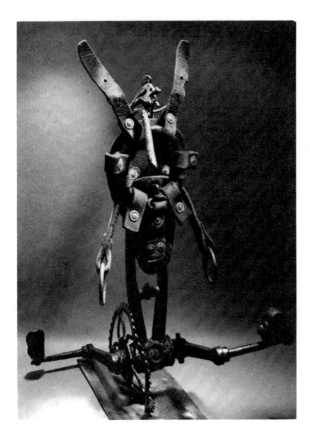

Jean-Louis Bédouin, *The Shaman* (1972), object. Photo Pierre Bérenger.

"Let language take concrete form!" was Eluard's advice in "Physique de la poésie" (p. 74), where he spoke of the "virtual object" as being born of the "real object" to become real in its turn (p. 76). "Physique de la poésie" antedated "Crise de l'objet." Yet Eluard was not the only surrealist to make a suggestion of that nature. Nor, for that matter, was he the first. As early as 1924 Breton had proposed making and circulating objects revealed to us in dreams. Looking back a dozen years later, he insisted that he had recommended granting such things objective existence more as a means than as an end. Just like those devised by mathematicians, in other words, surrealist objects were never to be decorative, but always functional. Thus evaluating one of them—that is, responding positively to it—does not invite the spectator to pass judgment, along the way, on its aesthetic appeal or lack thereof. Evaluation

places him under the strict obligation to measure its success in assuming a role prescribed by surrealist thought.

Aiming to educate his audience, Breton stressed in "Crise de l'objet" what the object is not, and must not be. He intended to redirect attention in a manner that would eliminate distractions that, otherwise, would obscure the purpose from which surrealist objects—including oneiric ones, which he terms "veritable solidified desires" (p. 277)—take meaning and power. It is permissible, surely, to say that, even when proposing the manufacture of objects modeled on things glimpsed in dreams, Breton was less concerned with the mechanics of fabrication (with solving, for instance, the technical problems of how to make such things) than with a movement continuing to be of primary importance to the vitality of surrealism. This is the dynamic movement from thought to action, the "passage," as he called it, from dream activity to reality—the realization of a dream. While surrealism was still young, the *will to do* counted for as much as actually attempting to do, so long as it affirmed protest against the depressingly static appearance of objective reality.

Naturally, the surrealists were not to go on being satisfied with imaginative projection only. They could not be content forever with a sort of pleasant daydream leaving them comfortably assured that, if they chose, they would be able to produce concrete objects having no traceable precedent in the world about them. A marked change of emphasis occurred roughly at the time when *La Révolution surréaliste* was replaced by *Le Surréalisme au service de la Révolution*. Around 1930, at all events, a much more thorough discussion was initiated on the theoretical plane, accompanied by more active and enthusiastic pursuit of unexpected anomalies in the physical universe and, concurrently, by vigorous experimentation with object-making, conducted in a mood of optimism. This is the activity of which Breton takes note in his 1936 text, which summarizes the surrealist attitude by reviewing achievements and bringing expectations into focus.

The essay on the crisis of the object is particularly enlightening in the way it explains the surrealist object's existence. Taken together, the proliferation of surrealist objects during the 1930s and, perhaps even more, the volume of theoretical discussion surrounding their manufacture distinctly suggest something Breton seems inclined to contradict. In "Crise de l'objet" Breton's point of departure is not the eagerness displayed by fellow surrealists to explore the world of objects, as they had begun (well in advance of 1930) to investigate that of verbal poetry and painting. Indeed, his argument is that the surge of activity evident after that date bears witness to the very same *"will to objectification"* finding him

responsive in 1924. This indicates that he regards the impetus to make surrealist objects as arising from the poetic impulse itself more than as originating in the individual whose efforts finally give that same impulse both form and substance. It is as though the object were seeking to materialize itself, instead of affording the fabricator an opportunity to achieve his or her ambition to bring something new before the public.

It sounds as though Breton is splitting hairs, when declaring that the *"will to objectification"* expresses itself no less through the "object with symbolic function" (defined by Salvador Dalí in 1931) than through those reflecting the activity of dreaming, for which Breton himself had called seven years before. In reality, though, the emphasis given "Crise de l'objet" is crucial. It aims at ensuring the continued purity of surrealist inspiration in things that, because the constructive process necessary for their realization precludes the spontaneity characteristic of automatic writing or drawing, are susceptible to distortion and even degradation in passing from mental representation to objective realization.

On the practical level, this means that the controlling principle of creative action—from which completed objects result—will focus on the passage from the world of imaginative projection into that of physical reality. Aesthetic concerns are at odds with that principle. For when one follows Breton's injunction to seek surprise for itself, *"unconditionally,"* there remains neither time nor place for the pursuit of beauty. Nevertheless, Breton's demand for surprise (made in connection with verbal poetry, not apropos of manufactured objects raised to significance by surrealism) does require some clarification.

Where object-making comes under examination, it is a costly error to infer that surrealists calculate surprise effects quite systematically, as though able to do so accurately while working diligently to catch their audience off guard. Although it would be naive to rule out fully deliberated intent in every single instance, assuming it to be necessarily a factor on each occasion makes nonsense of surrealism, as expressed in the language of objects.

This is the true nature of surrealist activity—the reason why one does not become a surrealist simply by edict or election or again as a consequence of mere whim, and certainly not by earnest endeavor. The surrealist touches off surprise when he arrives at a degree of receptivity bringing unforeseen revelations. Before these welcome discoveries can release surprise in anyone else, they first must have surprised the artist himself. Therefore, seeking after surprise, as Breton refers to the procedure, means attaining a state of mind in which surprise is not only

possible but—given the prejudicial nature of rational thinking in which we have been trained—virtually inevitable.

Early on, experience taught surrealists that, generally speaking, automatism is a successful means of entering that state and, hence, of releasing liberative surprises in the imagination. However, pure automatism rarely, if at all, underlies the procedure by which surrealist objects come into being. Making a poetic object, surrealists quickly learned, is not an activity that can draw upon automatic techniques with guaranteed profit. When one actually is soliciting surprise, some conscious effort has to be admitted. This is, most often, an effort directed at removing an obstacle that, in the world of commonplace things, intervenes between us and a sense of the marvelous.

As children, we are continually confronted with the marvelous residing in objects to which we react without reservation, fascinated by a strangeness we find occasionally frightening. But growing up separates us from wonder. Acquaintance with the practical utility of everyday things broadens our understanding of the function that assures an object a place in human life. Wonder at the spectacle of tangible reality diminishes as our awareness of the functionality of things increases. Where puzzlement concerning an object still subsists, we feel confident it will yield before long to comprehension—to appreciation, then, of this or that manufactured object's role in our lives—as soon as we have been enlightened as to the practical use reserved for something still unfamiliar.

The surrealist object comes into existence to renew our ties with the marvelous. It elicits wonder by way of surprise, in defiance of the utilitarian. It presents itself to the public as both a protest and an affirmation. Through it, the surrealist protests against "the depressing repetition" of objects surrounding us in daily life. Like Breton, he or she finds such things depressing, in that they commit us to regarding as illusory "anything that could *be* outside of themselves" (p. 279).

Breton and those who share his viewpoint may be accused of ingratitude toward the useful things lying within reach. Nevertheless, Breton's position leads him to charge that we use them "rather from habit than necessity." True, his line of reasoning is more than a little suspect. All the same, it clarifies his attitude considerably. It intimates that utilitarianism demeans an object and deprives it of the possibility of eliciting wonder, of being the repository of the marvelous, because, when we look at it and approach it, we see only the purpose to which it is meant to be put. Hence, Breton's assertion that the objects displayed within the framework of a May 1936 exhibition—these included, by the way,

mathematical objects (one of them is reproduced full-page in the definitive edition of *Le Surréalisme et la peinture*), *finds*, and ready-made objects no less than interpreted ones—were of a nature to *"raise the interdict"* having such depressing consequences. According to Breton, such objects responded to a pressing need to "fortify the means of defense" against invasion by practical utility. Speaking of these and similarly subversive objects brought Breton to a declaration echoing the lines in which, in the course of his first surrealist manifesto, he cited Pierre Reverdy with approbation and respect: "Poets and artists meet with men of science at the center of those 'force fields' created by the imagination through the bringing together [*rapprochement*] of different images."

A visitor looking at the May 1936 exhibit, Breton's catalog essay in hand, might not have escaped some confusion, all the same. *Finds* can hardly be said to contribute to defense against practical utility simply because they have been found, rather than purchased or received as gifts. No found object with an immediately recognizable purpose would hold any surrealist's attention even for a moment. Moreover, those to which a purpose could be attributed, after a brief examination, would be discarded quickly. Breton implied this when reporting, in *Nadja*, how he would search the flea market for "those objects one finds nowhere else, obsolete, fragmented, unusable, almost incomprehensible, in a word, perverse in the sense in which I understand and love it" (p. 49). Found objects capable of stimulating a surrealist's interest are those that meet the criterion of perversity sketched in Breton's 1928 volume.

There may appear to be some inner contradiction in Breton's remarks and in the attitude underlying them. For it is agreed, generally, that our sense of the reasonable is shaped by the utilitarian principle, which coincidentally fixes the norms of acceptability. People can accept any object, however strange it looks to them, provided they manage to persuade themselves it has found its way into existence in answer to a practical need, justifying to the reasoning mind the appearance of an unfamiliar object in the world about us. Meanwhile, the existence (and, by extension, the creation) of anything for which no practical use can be traced, or even supposed, appears to invite only skepticism. Into this category fall the objects of surrealism. These patently deny the public an opportunity to use them in one way or another, as we should expect to use a thing for which a purpose is prescribed, can be established, or at least presumed. Being useless by commonly admitted standards, surrealist objects may be expected to surrender the right to exist, or, more exactly, forfeit that right.

In spite of all this, Breton embarks in "Crise de l'objet" on a compari-

son between mathematical objects and the apparently useless objects of surrealism. He implies that the second are as functional as the first. For this reason, his attempt to place mathematical and surrealist objects on the same footing sounds more opportunistic than truly convincing, even though it is not easy to say, initially, where he believes the advantage in doing so lies, for surrealism. Of central importance, then, is the accurate interpretation of functionality within the frame of Breton's argument.

One can hardly posit that Breton introduces mathematics into his discussion so as to give an air of seriousness and respectability to certain forms of poetry and art produced since the last quarter of the nineteenth century. The fact he wishes to highlight is this. Poetic and artistic investigation of the sort particularly interesting to him has something noteworthy in common with that of science. His intent, therefore, is to show how the orientation of poetry and art, within the framework of surrealism, is similar to modes of thought from which modern physics, for example, takes impetus.

The *faculté de rapprochement* emphasized in "Crise de l'objet" permits surrealists to "rise above considerations of the manifest life of the object," which is usually taken as marking its boundaries, its limitations. As a result, the object turns into "an uninterrupted succession of *latencies* which are not peculiar to it and call for its transformation." As a result, the value conventionally ascribed to the thing under consideration disappears behind its "representational value." The surrealist object, meanwhile, concretely evidences preference for "latent reality" over visible reality, for the virtual over the manifest, which encourages stress upon the object's "evocative power."

Recalling Gaston Bachelard's assertion that one will find more in "the real that is hidden" than in "the immediately given," Breton claims justification for the surrealist attitude, which tends to "provoke a *total revolution of the object*" (p. 280). "Perturbation" and "deformation" are to be sought in the realm of things, so long as they provide us with objects derived from the tangible world about us, but managing all the same to differ from familiar things "by simple *mutation of role.*"

Even at its most elementary stage, the change of role granted an everyday object is significant in surrealism. It accounts for the strong appeal exercised by surrealist objects over the minds of those who find it impossible to ignore them. Resistance, under whatever circumstances, by an object to an assignable utilitarian purpose (one, that is, judged acceptable by reason) violates our sense of practicality. When this happens, imaginative speculation is at liberty to take over. Such is the case whether we are looking at something created by the hand of a surrealist,

or at some strange natural object—a *find*—brought to our attention by chance, or again by something commonplace, unpredictably modified by an accident (like a fire that, by extreme heat, twists out of shape and partially melts an office typewriter, for instance).

We are guilty of no distortion of surrealist ideas when making some distinction between a surrealist object and a surrealist painting. If, according to Breton's dictum, a painted canvas merits attention for *"what it looks out upon,"* an object draws its poetic value more often from what it enables us to look in upon. This does not mean, of course, that a surrealist picture and object are somewhat contradictory expressions of surrealism. On the contrary, Breton himself ruled out the idea of conflict between them when, at the beginning of *Le Surréalisme et la peinture*, he described Pablo Picasso as working from "a *purely inner model*" (p. 4). All the same, one fact does merit emphasis. Even though a surrealist object stands before us as a concrete external presence, appreciating and enjoying it as surrealists do require us to look through it into ourselves. More than a protest and an affirmation, therefore, the object solicits a response from which we learn how it is possible to broaden, beyond the realm of verbal language, a question asked in Breton's *Introduction au discours sur le peu de réalité:* "Does not the mediocrity of the universe depend essentially on our power of enunciation?"[2]

A man-made object truly contributes to surrealism when it demonstrates a power of enunciation unfettered by the mediocrity of the physical world customarily termed reality. The surrealist object articulates a point of view, attesting publicly to a position exemplary of a consistent and revealing attitude. The real, as it is commonly known, exercises no restraint over the latter. For the surrealist attitude acknowledges and submits to none of the restrictions enforced by "what is" at the expense of "what can be." Instead, it expresses faith in the capacity reserved for what surely *can be* to usurp the place presently occupied by what apparently *is*. It challenges the restrictions and controls which appear to give permanence and stability to what passes for real. In this respect, the surrealists' attitude to the world about us supports with something more convincing than mere rhetoric Breton's assertion that surrealism "is what *will be*."

When they fill the role that is theirs above all, surrealist objects stand as markers, as signposts pointing ahead into a world where—so surrealists believe—what currently *is* must give way to what *can be*. For this reason, contemplation of one of these creations helps uncover the fallacy of representing all surrealist creative activity as escapist in nature. Making a surrealist object is a gesture that externalizes dissatisfaction with

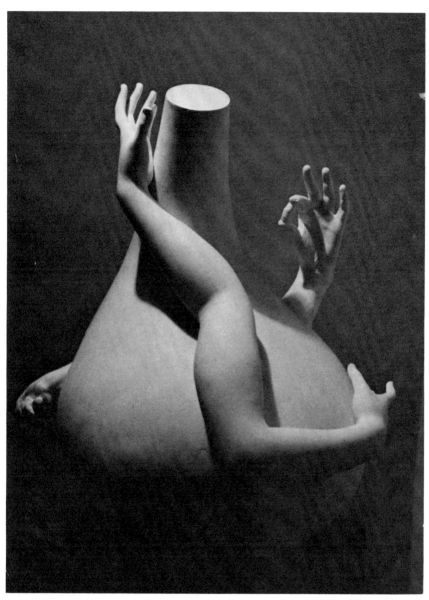

Kurt Seligmann, *Will o' the Wisp* (1937), plaster object. Photo Maywald.

ambient reality in a manner not to be ignored. Therefore, it becomes an act of aggression (sometimes violent, sometimes quite brutal) directed

against the acceptable, the generally approved. For this reason, it lends itself to interpretation as evidence of antisocial feeling or thought. Yet nothing, really, could be further from the truth. To understand this, we have to grasp the fundamental fact that surrealism's ambition is not simply to turn its back once and for all on ambient reality. Confronting the everyday world, it aims to upgrade our sense of the real. It undertakes to sharpen our awareness of things attuned to inner aspirations that assume the greatest importance in surrealism.

The ambiguity often presented by surrealist objects comes from the fact that they appear to have originated in familiar reality, yet finally to have departed (whether amusingly or alarmingly) from the known, taking the direction of the previously unknown. Such an object is *Le Déjeuner en fourrure*, exhibited by Meret Oppenheim in the 1936 show *Fantastic Art, Dada, Surrealism*, at New York's Museum of Modern Art. The famous fur-covered spoon, cup, and saucer illustrate an axiom laid down in the first number of *La Révolution surréaliste* in 1924: "Any discovery changing the nature, the destination of an object or a phenomenon constitutes a surrealist fact."

It seems natural to associate the nature of an object with its destination. This is why strangeness in an unfamiliar piece of machinery or gadget dissipates, once we are apprised of the purpose for which it has been designed. When, though, something we normally identify with a useful purpose presents an aspect (like the fur coating of *Le Déjeuner en fourrure*) sure to conflict in some manner with agreed purpose, it no longer occupies its customary place in our lives. What is its use, now? Where does it belong? How do we deal with it? Unable to answer these questions as it was able to do before the object underwent modification, reason has to concede victory to the inexplicable. In the case of *Le Déjeuner en fourrure*, then, we perceive that Oppenheim has followed the advice offered by Noël Arnaud when he called for making things "intercessors between the inexpressible and us."

The concept of the inexpressible marks the limitations of our powers of expression, their inadequacies and deficiencies. However, when a surrealist confronts the inexpressible, it is not to resign himself to failure, by any means. Breton's *Second Manifeste du surréalisme* acknowledges that speaking of expression means, "to begin with," speaking of words. Yet he and his fellow surrealists do not consider themselves condemned to frustration. In surrealism, the creation of objects represents an effort to circumvent the obstacle of inexpressibility. Thus, the language of objects supplements that of words, sometimes even compensating for the latter's deficiencies.

In some cases, surely, it is the aggressive solidity of a surrealist assemblage incorporating wood or metal (or both), in short, its *permanence*, that impresses it upon our attention. In others, though—one thinks of the paper sculptures of Wilhelm Freddie, for instance—the fragility of the construction grants it special appeal. Just as a number of the earliest collages have deteriorated under the effect of passing time (some, inspired by Dada, having been made out of ephemeral materials deliberately selected for their impermanence), so the Freddie paper objects are liable to curl and sag in unpredictable ways. What will happen, in time, to a 1955 paper sculpture called *Petting Party*? Will it change enough for a more appropriate title to suggest itself? This question brings to the fore the surrealist practice of titling objects.

We notice that in many instances no title at all is provided, the artist being content with the noncommittal label "object." Now the spectator is thrown back on his or her own imaginative resources, left to give whatever name seems most fitting. Where a title originates with the object's creator, it is very often—as was so frequently the case, too, with Arp's sculptures and Ernst's paintings—an interpretation, at which the artist himself arrives only after the work is complete, when he has had the opportunity to review at leisure the thing he has made. Either way, the title is applicable only so far as someone has found it appropriate. It must be this way, when we are dealing with objects separated by modification from past association and use or assembled out of elements borrowed from known reality by an artist intent on breaking down its barriers or on probing its potential for bringing surreality to light. Nomination does not domesticate the surrealist object so much as it represents an attempt to adjust to it, to indicate the relationship one feels to it.

While the assemblage tests the surrealist possibilities of physical reality—its pliability under pressure from desire—the name it brings to mind reflects an effort to carry the inquiry forward into verbal language. The title that has suggested itself (whether to the artist himself or to one of his audience) is an approximation, very often less than fully satisfying because it does not exhaust the significance assumed by the object with which it is linked. This fact is enough in itself to indicate that the language peculiar to surrealist objects is no mere substitute for words, and so readily translated into verbal language. Where words prove inadequate to the task of communicating precisely what a surrealist construction suggests, experimentation with the language of objects is much more than a means of passing time for surrealists who happen to lack talent for writing or painting. It often leads where words cannot follow

with unerring accuracy. Indeed, the value of certain of the objects of surrealism can be weighed best when verbal language is least successful in transcribing what they have to say.

Before an object with a prescribed role in daily life known to everyone can be turned to the purposes of surrealism, it must be submitted to a modification capable of rendering it unsuitable for its normal use. It is not the surrealist's duty, at this stage, to project or foresee some new function to be assumed by the object he has modified. His contribution is limited to taking something out of its assigned place in the everyday world. Once he has done this—by releasing in the spectator a feeling of revulsion at the thought of drinking out of a cup coated inside and out with fur or perhaps by releasing feelings of an entirely different nature at the prospect of sitting on an ivy-covered chair like Wolfgang Paalen's *La Housse* (1936)—the object is free to exist and to be seen for itself, outside the limits of the utilitarian. Disturbing to the reasoning mind, as much as to our idea of an order ruled by common sense, the object is imaginatively provocative. No longer confined to an explicable role, it presents a challenge reason cannot meet. Only imagination can deal with it now, that same imagination which alone, declared Breton in his *Manifeste du surréalisme*, gives him "an account of what *can be*."

Behind the surrealists' faith in imagination lies contempt for the stasis of the familiar and, at the same time, curiosity about an ever-changing world of possibilities. So the function of the surrealist object is to terminate a confinement imposed on things by their usefulness. It asserts the rights of imagination while resisting those claimed by reason. The modified object is, then, the product of a liberative gesture having essentially the same meaning as the one that produces a surrealist object without analogy or compare in the world of physical things to which we are accustomed.

Modifying a familiar object in the spirit of surrealism entails looking in two directions at once. It means looking back to the previously known (the object originally borrowed from reality) and forward to the unexpected and unanticipated. Looking back, however, is not a nostalgic act by any means. All it does, really, is provide a measure by which progress into the unfamiliar can be gauged. Previously reliable norms come to mind at this point, but only to grant us the occasion to perceive how they fail to apply in the world of the surreal. Basically, the same is true of a constructed surrealist object that does not grow out of something already well known to us. Its constituent parts remain identifiable, since the artist has utilized things that have come to hand. They are "legible," so to speak. But interpreting the object as an entity requires us to face the consequences of being unable to "read" its parts in conjunction with

one another and to make sense of them by doing so. Hence, the surrealist constructed object, a product of imaginative play, is more than the sum of its parts.

Resulting from the *rapprochement* of parts no one would expect to see brought together and having no justification that reason can find tolerable, a constructed surrealist object appears gratuitous indeed. Therefore, it is more or less irritating to the spectator. Observing such a creation, we witness expansion of the definition of poetic communication as understood by surrealists. We note that poetry is not attained solely within the frame of verbal language. In addition, we realize that the *rapprochement* exemplified in the surrealist word poem and the one facing us as we contemplate a surrealist construction are more than complementary. They are mutually enlightening.

There is no profit in an attempt to promote one kind of *rapprochement* over the other. Nor, for that matter, is anything to be gained from the discovery that a person who believes he or she can detect a close parallel between the two forms of *rapprochement* in question must be deluded. The important thing is that, in whatever form it takes, *rapprochement* has the function of disorienting the reasoning mind, of sowing disquiet and even alarm, where complacency has reigned. Moreover, the supposedly negative role of *rapprochement* is counterbalanced by a positive one that contributes to furthering the cause of surrealism. To the surrealist—fundamentally different in this respect from the Dadaist—iconoclasm is valid only when breaking down is a prelude to building anew, on a foundation other than that of habitual reality.

The ultimate goal of surrealist experimentation with *rapprochement* in its varied forms may be described as tending to give expression to the inexpressible. Its general technique—the method by which it reaches out to embrace the inexpressible in communicable form—tends toward assimilation of the unassimilable. In one regard, this procedure consists in bringing together elements that our acquaintance with nature or our sense of practical necessity has not prepared us to find in proximity. A surrealist assemblage is a concrete presence called into being neither to imitate some aspect of the known nor to serve a purpose that may be judged practical. All the same, only a crude distinction can separate a surrealist object from those approved by society on the basis of utility. Essential to surrealist activity in image-making is revision of ideas about what is useful, change in the justificative principle that condones manufacture and retention of one sort of object while treating another kind with suspicion or ridicule.

We have to acknowledge at the source of the impulse in which surrealist objects originate a protest against utilitarianism arising out of de-

votion to needs far more compelling, in the surrealists' estimation, than those which impose unresisting submission to practical necessity. The needs that matter to a surrealist dictate respect for the imagination and especially for the revelation it is capable of bringing, in fruitful conjunction with desire.

The surrealists' open contempt for the useful complements the scorn for the work ethic expressed by Breton in *Nadja*. Both may sound like mere snobbery, a latter-day romantic protest against the way of life approved by society. Both, in fact, point to something of much deeper significance. This is the surrealists' conviction that release from the pressures generated by conformism, with consequent acceptance of social values fostered by conformity opens the mind to imaginative flights bringing rewards that evade measurement by society's norms.

Attempting to define surrealist objects, Marcel Jean has called them "singular landmarks in a universe which is not that of everyday life but which is, however, connected to it by the fine strong threads of desire."[3] It would have been closer to the truth to describe the threads of desire as drawing the surrealist object away from everyday life, or at least from the accustomed spectacle of reality. The desire infusing surrealist objects detaches them from the mundane. Thus, they are invested with a quality impenetrable to reason, yet able to arouse response in a spectator whose imagination has not capitulated to rationality.

Everything depends on the direction in which the threads of desire tug at the object and on the manner in which desire speaks to us through what the artist has to show. When Dalí proposed in 1930 making objects of erotic significance, "in other words, objects destined to procure, by indirect means, a particular sexual emotion," he set uncharacteristically narrow limits on the potential of surrealist poetic objects. This was because he recommended creating things devised to stimulate the imagination in a way specified in advance. Far more typical of the objects of surrealism are those in which procurement of no identifiable response in the public has been foreseen by the artist during the creative act.

So far as the surrealist assemblage investigates the unknown without regard for the requirements set by practical utility, the procedure from which it results resembles that of automatic writing. In each case, the value surrealists ascribe to investigative action is linked with its demonstrated success in bringing to light the unexpected, the revealingly unpredictable. In each case, also, the technical means called into service have no intrinsic interest, being prized by the surrealists only for the discoveries they make possible. Hence, it is of no moment that the pro-

cedure of verbal automatism follows a very regular pattern, while methods can be endlessly varied by which an object is modified to surrealist purpose or put together out of materials garnered from familiar reality. In surrealism, the results justify the means which, of themselves, authenticate nothing. Attention to aesthetic concerns would slow down, perhaps even stem, the free flow of automatic writing, inhibiting the manifestation of precious *rapprochements de mots*. In like fashion, those same concerns would delay, even redirect, the inquiry to which a surrealist dedicates himself when assembling a poetic object: the essential characteristic of surrealist assemblage is freedom. Surrealist objects are free not only from social, moral, and ethical values, as well as from associative limitations, but also from any preoccupation liable to force the creative gesture in a direction other than the one in which desire has led the artist.

More often than not, the key to the operation producing surrealist objects is chance, the element that combines the components brought together in a surrealist construction. Reason finds this element quite mysterious, inexplicable at times. But while rational thinking is inclined to relegate chance and its expression to the realm of the accidental, the surrealist mind accepts it as a truly illuminating reflection of the marvelous.

The excitement felt by a surrealist at the spectacle of chance in operation is an outgrowth of his faith in the benevolence of *le hasard*. Surrealists go beyond regarding chance as sympathetic to the individual's desire. They look upon it as the agent no doubt best able to bring his desire to light. This is why the particularly reassuring quality attributed to chance, in surrealism, lifts it well above the random, the haphazard. Chance is seen as reconciling surrealist man and the external world from which he feels alienated most of the time. It is viewed as uniquely capable of bringing human desire to fruition. And so the surrealist object commands attention when proclaiming, in a language all its own, the harmonious union of inner need and outer reality.

The object is uniquely equipped to impress that union upon the attention of its audience. There are exceptions, surely—for example, Joseph Cornell's boxes allow us only to peep at a universe of desire kept remote from us, cut off by a wall of glass. By and large, however, surrealist objects stand within our reach. Sometimes we can walk around them; always one can touch them. Their special virtue, then, is that they implicitly issue the invitation openly expressed by Marcel Duchamp when he designed a three-dimensional cover for the catalog of an international surrealist exhibition, *Le Surréalisme en 1947*. On the front, he pasted a pink foam-rubber breast (a "ready-made" borrowed from a pair

of "falsies"), projecting from an irregularly shaped black velvet ground. On the back, he placed a blue-bordered label with the words *"Prière de toucher"* (Please Touch), arranged in three lines.

Duchamp knew very well what he was doing. Touching can externalize the violation of a taboo. In this instance, violation is typified by the realization of erotic desire, reduced to an elementary level. Thus, disinclination or refusal to touch (which would require an individual handling *Le Surréalisme en 1947* to proceed very carefully indeed) is no less enlightening than eagerness to do so. Without great subtlety, Duchamp's cover-object simplifies the relationship surrealist objects establish with those approaching them. The impulse to touch may be quite uninhibited in some, or it may be complicated by conflicting responses in others. Yet it demonstrates that, through assemblage, surrealism is able to set up a relationship to objects on the basis of contact of a sort neither words nor pictures can emulate. Whether we decline to touch it or do so without hesitation, the object in surrealism demands that we come to terms with it as a physical presence, even when we find ourselves incapable of putting into words our motivation in reacting as we do. As a matter of fact, reaction in the absence of reflection may well give an individual the occasion for a discovery about himself that he could never have made but for his encounter with a particular object.

The perversity to which Breton was always sensitive in *finds* lies in their capacity to provoke comparable response, no more subject to rationalization, at times, no more compelling, surely, and, hence, equally illuminating. The Wonderland the surrealist explores with pleasure is like Alice's, in some ways. Things advance to greet him, with the silent command "Touch me," no less imperious than the "DRINK ME" beautifully printed in large letters on a little bottle ("which certainly was not here before"), without which Alice would never have shrunk to "the right size for going through the little door into that lovely garden" where her adventures begin in earnest.

11

THE VISUAL LANGUAGE OF FILM

Few statements by André Breton lend themselves so easily to misinterpretation as his remark in "Comme dans un bois," "There is a way of going to the cinema as others go to church."[1] Taken on their own, these words have an appealing lapidary quality. Replaced in Breton's essay, they lead nowhere in a manner that, guiding our reading authoritatively, promises to forestall error. One finds it easy to conclude that Breton meant to liken the movie-goer to the communicant, bringing to attendance at film programs not only love but also faith and hope. Yet this apparently unexceptionable supposition has a grave disadvantage. It fails to take into consideration an essential characteristic of the surrealist's sensibility, without which the attraction of cinema would be severely restricted and he or she would not be able to participate fully in "the only *absolutely modern* mystery" of film.

It may sound an exaggeration to say that the fascination of cinema to a surrealist originates in the spectator more than in some intrinsic feature of the movie he or she admires. All the same, we need to redress the balance, in order to understand one important fact. Very often, the language of cinema is, in surrealist context, the language a surrealist is capable of hearing, rather than the language a film actually speaks. It is, in short, a measure of surrealist receptivity more than a sign of the specifically surrealist nature of the film medium.

This is something that Breton appears to have neglected to impress upon his readers. "Comme dans un bois" concluded with an admission of disappointment that sounds like a complaint. Yet, when noting that cinema had not managed by mid-century to live up to its promise, Bre-

ton did not take into account one basic factor. The promise to which he referred has never been volunteered by film. Nor has it ever been extorted from cinema. Surrealism in the movies has remained, therefore, especially pure at the level of potential. In other words, surrealists have read surrealism into film more often than cinema has spoken the language of surrealism.

This is far from being a negative feature of the situation. Characteristically, the surrealist's dialogue with the movies is like a phone conversation in which we hear only one speaker. The latter voices his utterances with such assurance that we have no inkling of disagreement, no intimation of disharmony. This is because we are witnesses to the absorption of a film into surrealist consciousness, which accepts or disregards, approves or disapproves, modifies or transforms entirely on subjective, essentially selfish grounds. The other speaker's remarks can only be inferred from what we hear said. Moreover, it is not simply a matter of drawing irrecusable inferences about the unknown, on the unimpeachable evidence of the known. At all times, we have to remember that the surrealist's evidence is weighted, openly biased in favor of special concerns. At moments, those concerns bend the facts, not be-

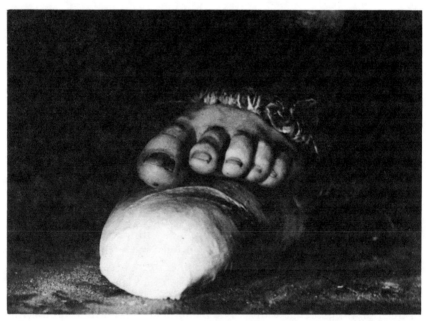

Wilhelm Freddie, still from *Eaten Horizons* (1950).

196 Languages of Surrealism

cause surrealists practice distortion willfully, dishonestly, or even out of carelessness, but because it is natural to the process of assimilation resulting from the give-and-take of contact on surrealist terms. The nature of the response conditions cinematic language, then, thanks to the overriding demands of surrealist audition. In these circumstances, a presumably fundamental question, *why speak,* takes second place to another, *why listen.*

How often do we find that Ado Kyrou, the most vocal of surrealist commentators on film, recalls in movies he has seen details of plot and dialogue that simply are not present? Whenever this happens, the version he has to offer brings the motion picture under discussion closer to surrealist ideals, enriching its surrealist content. Enrichment, on these occasions, presumably is the outcome of the writer's conviction that he has seen and heard what he eagerly wished to see and hear or, after the event, wishes to have seen and heard.

We gain nothing by impugning Kyrou's integrity as a critic. No more than any other surrealist does he aspire to the rank of objective observer. Thus, we are in danger of losing track of essentials, if we do not recognize that the errors present in Kyrou's remarks about film are a token of his devotion to the surrealist perspective, not an ill-disguised sign of determination to misrepresent or falsify. Without too much exaggeration it could be said that surrealism in film is in the eye of the beholder, and in his ear also.

On occasion, Kyrou's recollections of movies that we, too, have seen strike us as introducing variations for which no acceptable justification or excuse can be adduced. At other moments, though, modifications that come with recall are enlightening indications of how a surrealist sees and hears and, hence, of the surrealist possibilities of cinematic language. We find here proof that there exists a margin between intention and achieved effect in which film sometimes speaks very persuasively indeed to surrealists in its audience. Very often, in fact, this margin is for them the only redeeming feature of commercial cinema. In any event, it keeps surrealists attentive and ever hopeful, despite the disappointment that the vast majority of commercial movies inevitably brings them.

Up to a point, it appears fair to say that surrealists take surrealism into the movie house with them. Still, they would receive small return on their investment of time were cinema not capable of speaking to them in ways to which they are eagerly attentive.

What interests us primarily here is not the kind of film that takes as its subject matter behavior all surrealists are predisposed to condone or approve—a movie that deliberately incites rebellion against the ethical,

political, social, or religious values underlying bourgeois society, for instance. On the level of plot alone, cinema offers substance no different, after all, from what is to be found in theater or in documentary and fictional writing. To arrive at an accurate impression of the dialogue between cinema and surrealism we must attend to aspects of film not always embraced by considerations focused on story line. This is not to suggest that movies speak to a surrealist only in defiance of their assigned themes. It is true nevertheless that surrealists frequently respond to secondary details, for example, to an atmosphere or tonality that successfully saves them from being disheartened by features of a motion picture meant to ensure its commercial viability.

To a degree that it would be foolish to ignore, surrealists' affection for old serials, for potboilers, and for backlot Hollywood productions is a token of their distaste for the artistic pretensions of the film industry. All the same, their admiration for film material commonly judged to be at best second-rate is not indicative solely of opposition to aestheticism in every form. It points also to their capacity to enjoy cinema at a level where directorial control is relaxed or ineffectual, both in creating certain effects and, more important, in eliminating or avoiding others. Breton, we recall, remarked when voicing reservations about realist fiction in his first *Manifesto* that surrealists become interested in Stendhal's fictional characters only at the moment when their creator loses control over them. The created work's ability to escape conscious supervision is frequently the key to surrealist response to cinema.

We cannot even begin to talk about the surrealist language of film without noting the significant fact that surrealists have never joined in the dialogue in which critics address themselves to the syntax and grammar of cinema. Two factors have encouraged the surrealists to abstain from participating in a discussion that has provided more than one critic with his reputation and his livelihood. The surrealists' refusal to entertain the applicability of aesthetic criteria to creative activity of any sort is a more obvious factor than their profound disinterest in the film language on which critics discourse and their devotion, instead, to the language of films grasped and interpreted in ways imposed by surrealist principles, not by others authorizing the jargon of commentators for whom they have nothing but scorn. Thus, it is easy enough to ridicule the surrealists for being, apparently, totally ignorant of the discussion going on around them and to conclude, in consequence, that their sense of cinema is remarkably unsophisticated, not to say primitive. It is far more difficult, though, for an outsider who sits in condescending judgment to acknowledge that the surrealists' reaction to the movies,

their idea of film as expressive language, is an outgrowth of their concern with communication originating less in preoccupation with grammar and syntax than with finding means to attain the realm of the surreal and to report findings made there.

It is entirely consistent with their attitude that the surrealists have made no attempt to advocate improvement of the cinema, to help better it in some way or other. Benjamin Fondane's preface to his *Trois Scénarii* of 1928 gave the keynote for all surrealist commentary on filmmaking, declaring, "It is not, consequently, to correct the cinema, to make it better (*let it not become an art;* that is all we ask of it) that we propose in our turn this mortar destined to ruin a certain form of the cinema in people's minds, to bring another into the world." Significantly, Fondane—whatever his later reservations about surrealism—was one of those who dated the decline of the movies from the introduction of sound film.[2]

Among the most important aspects of the surrealists' approach to cinema is their belief that, where it *"speaks surrealist"*—to borrow Breton's phrase—film sometimes achieves its purest accent when doing so involuntarily. This does not mean that voluntary language and surrealist effect are invariably incompatible, in cinema. It does point up one essential fact, though. Surrealism cannot be regimented. Its manifestation through cinema is not a sign that a filmmaker has mastered an appropriate language and is in full command of its articulation. Rather, it indicates that surrealism possesses the ability to reach out to a film audience independently of the conscious purpose this or that movie director has in view. We should be in error if we infer that the director can employ the language of surrealism only against his will and unknowingly. It would be no less a mistake to assume that one has exhausted the question of surrealist language in film, after giving careful attention to the work of certain individuals—Luis Buñuel at the head of the list—whose surrealist sensibility has marked their cinematic practice indelibly.

The line separating valid from invalid, authentic from inauthentic, acceptable from spurious is a fragile one, where surrealism in the cinema is concerned. One has only to review the unconvincing sequences devised by Salvador Dalí for Alfred Hitchcock's *Spellbound* to realize one thing. Assemblage of supposedly typical surrealist imagery is no guarantee of total command in the use of surrealist cinematic language. In fact, Dalí's contrived footage unintentionally issues a warning. It leaves us wondering whether the language of surrealism, in the movies, does not necessarily elude anyone who, having the vocabulary at his disposal, is unable to arrange words into sentences because he imagines

himself master of syntactical laws that exist only in his mind, and, hence, fail to lead to productive communication with the surrealist sensibility.

At the same time, the surrealist's repeatedly demonstrated ability to derive pleasure and reward from films directed by individuals who know or care nothing about surrealism is revealing. It suggests that, given the outlook assuring him admission to the surrealist camp, cinema excites him in a very special way. Its fascination lies in letting him hear more than what he sees may appear to warrant, something of which the nonsurrealist might even question the presence.

A number of spokesmen for surrealism—the best known among them, surely, being Kyrou and Jacques B. Brunius—have insisted upon film's capacity to express surrealism indirectly, even inadvertently. No one, though, has stated the case for involuntary surrealism in cinema more boldly than Nora Mitrani, in a brief article written for the special surrealism number of L'Age du Cinéma.

Mitrani's text reflects her faith in film's continued capacity to serve as a vehicle for surrealism. In addition, it argues for surrealism's ability to reach expression through cinema. Mitrani not only gives an instance of the unexpected apparition of surrealism but also infers conditions under which the surreal can invade the screen. She does not actually attempt a blueprint for surrealist action in the movies. Nonetheless, she does outline reasons for believing cinema fully capable of speaking surrealist, under circumstances that she is glad to specify.

Among factors to be considered when film's potential for surrealist expression comes under examination is the pervasive effect of censorship in commercialism. More particularly, it is the oppressive nature of censorship helping to curtail surrealism, that is, censorship's origin in bourgeois values, to which the surrealists are radically and violently opposed. Except sometimes in the privileged domain of film comedy (and, even there, usually within the magic limits of old silent short subjects), there is little or no chance of surrealism being permitted free rein. Commercial cinema has never ceased to be subject to strict controls meant to perpetuate respect for a world to which, because they are unable to breathe its atmosphere, all surrealists are deeply hostile.

In published remarks about his career in the cinema industry, Buñuel emphasized more than once the intrusive and unwelcome presence of the film censor standing between him and desired effects. He stressed how often he found it necessary to hoodwink that guardian of public decency, to circumvent the obstacle of censorship in order to say things through movies to which surrealists are sure to be especially respon-

sive. Mitrani views the example she has elected to cite as differing in essence from any she might have taken from Buñuel's *oeuvre*. She borrows from "an otherwise mediocre film," *One Way Street*, made by Hugo Fregonese, whose work surrealists have no reason to admire the way they respect Buñuel's. It is, then, the exceptional, unpredictable character of the passage over which she pauses (one sequence only, she makes clear, not the whole movie, as Kyrou manages to persuade himself) that leads Mitrani to see special value in it.

Taking up the theme of "Intention and Surprise," Mitrani recalls how *One Way Street* shows a character, played by James Mason, lying stretched out in a hammock at siesta time in a small Mexican village. A brown-skinned girl, *"fish in hand,"* approaches, lifts the hat shading his face, and passes the fish two or three times under the sleeper's nose: "Mason awakes, leaps on the temptress, but he is so clumsy that he falls and pulls her down with him. The spectator is left to guess the outcome, as if he has already felt the clammy touch of the fish between his hands."[3]

Mitrani praises this scene (and not Fregonese for making it, we notice), which she says avoids Hollywood's "puritanical censorship." She asserts that "its insolence and freshness" place it "beyond the level of compromise between bourgeois virtue and pornography," which she judges to be the level attained by most commercial films made around 1950. So far so good. Mitrani has made a telling point that all surrealists—devoted to an unrelenting struggle against the hypocritical compromise which, in their estimation, comes between surrealism and cinema—are convinced must be made. However, she goes further still. She acknowledges that the symbolism of the interlude may strike some people as "too obvious and too Germanic," and even that Fregonese may appear to have "conformed to the taste the public has for *risqué* situations." Nevertheless, she proceeds to assure readers that a movie director "is not always the master of his intentions that he would like to be." What does she infer, then? "It is very rare in even the most deliberate film for at least one of its sequences not to break free and, unknowingly, to reveal an intense reality." The deduction Mitrani goes on to make is worth attention. Upon it rests something Kyrou's *Le Surréalisme au cinéma* terms "a glimpse of what surrealist criticism could be."[4]

Observing that "this sequence is not entirely announced by the previous one," just as it "remains without finality in the general architecture of the film," Mitrani contrasts what Fregonese has shown with the "more common, more tasteful" spectacle of a young girl strolling, flower in hand. Then she comments, "but if the flower should become a fish this leads to a sudden disorientation and scandal for the spectator."

Between Mason and his "demon" the relationship is carnal, she affirms, "burning and icy at the same time, free from sentimental ambiguity, the fish, a small piece of cold, still flesh, becoming the very symbol of this purity."

Whether or not we accept Mitrani's strangely reticent interpretation of the symbolism of the fish, we must grant that the sequence isolated in *One Way Street* "profits from such forcefulness of meaning" because it is at the same time "unforeseeable and shocking." We may even admit—though perhaps reluctantly—that this passage would have been excluded, as Mitrani believes, from a "supposedly perfect film" because it "smacks of incoherence or vagabondage of the imagination," inimical to well-constructed movies that consistently offend surrealists by their "excess of rationalism." In short, we succeed in following Mitrani's line of reasoning up to this stage, because we grasp where it leads and why.

The crux of Mitrani's argument comes to light in an involved sentence focused on surprise: "Yet if one is surprised it is only within an intellectual anticipation already accessory to one's surprise, and not on the poetic plane where the authentic image arises, negative and upsetting in the first place, because it has to be, because appearances falter and fall apart when subterranean life reaches their level." Here, though, more questions are raised than answered. Ignoring them, Mitrani goes on to express satisfaction at seeing film characters from time to time "live according to *their* will, obeying *their* imagination more than the director's intelligence." Thus, her essay in "surrealist criticism" takes a leap beyond logical deduction. The key to her interpretation is the judgment that Fregonese is either a director "endowed with an imagination 'surprising' to him" or, alternatively, "not completely master of the situation" because "his logical intelligence occasionally fails him."

There is no way to escape the conclusion that Mitrani displays singular naïveté. Indeed, from what she writes we learn far more about the way she herself looks at cinema than about the movie she has undertaken to discuss. It is simply indefensible to contend that the woman advancing toward the hammock in *One Way Street* holds a fish in defiance of the director's wishes. It is equally indefensible to imagine Fregonese would fail to recognize the sexual symbolism of the fish or of the use to which one of his characters puts it. After all, a fish is not too subtle a symbol for Russ Meyer to borrow, also, in an exploitation film in which, during a seductive dance, the heroine drops one down her bodice between impressively ample bare breasts. Still, the tenor of Mitrani's argument merits consideration, despite the weakness of the evidence adduced to back it up. In fact, her claim that cinematic poetry has the power to break down more barriers than a movie director may

knowingly seek to overthrow finds strong support in a scene occurring in a motion picture she herself did not live to see.

When Benjamin in Mike Nichols's *The Graduate* rescues his girlfriend from the church in which she is being married, he defends himself with a large crucifix against guests whom he finally shuts inside by jamming the church door. Questioned about his hero's conduct, Nichols admitted, "The crucifix is in the book [the novel on which he based his movie]. And I think it's very reasonably in the book because what the hell are you going to grab in a church if you're going to beat off people? You can't grab a priest."[5] True, reason *can* be limiting, but need not be—as Marty Feldman has demonstrated in *The Last Remake of Beau Geste* by having a blind legionnaire (officer material, according to his sergeant) unwittingly fell others around him on the dance floor, while wielding his partner (Digby Geste, played by Feldman) like a club. What is most interesting about Nichols's explanation is that it is so apologetic, attempting to explain away Benjamin's conduct on purely practical grounds: "We had a technical problem. How's he going to keep all those hundreds of people from stopping him? Well, he's got to jam something in the door. What has he got in his hands? He's got the crucifix. Well, hey, why doesn't he just use it? (pp. 286–87). Technical considerations and reasonable deduction are offered as excuses leading to Nichols's confession: "Now, here's the point that should be made about all this. I suppose I must take the responsibility for all this Christ nonsense. Because if it's capable of being interpreted that way, I've got to take it. But it came about through a series of practical decisions and it crossed none of our minds."

In one way, it is thoroughly disappointing to hear Nichols so weakly defensive—not only about what his interviewer clumsily terms "those Christ symbols" but, far more significantly for us, about having Benjamin use the crucifix in a manner surrealists can only applaud. In another way, though, the director's fervent disclaimer is enlightening. It allows readers to acknowledge the pure surrealism of the scene at the church in *The Graduate* as unpremeditated, the remarkable, unforeseen by-product of rational logic, that basic tool of the unimaginative, anti-surrealist mind.

It is obvious that the censor found Nichols's argument totally persuasive. Benjamin's gesture has been allowed to stand as a logical outcome of the situation in which the young graduate must fight for and defend the girl he loves. The censor was momentarily blinded, then, unable to see what surrealists perceive at once: a potently scandalous cinematic image that places a symbol of Christianity—"the foul christian symbol,"

another Benjamin once called it[6]—at the service of physical not divine love, turned now against the church-supported bourgeois ideal of the sanctity of marriage.

In the films mentioned, Fregonese and Nichols have one thing in common. Neither convinces us he has any intention at all of competing with Robert Desnos, praised in the *Manifeste du surréalisme* as an exceptional individual who *"speaks surrealist* at will" (p. 44). Nothing is further from these directors' thoughts than conducting their audience into the world of the surreal which, as like as not, they presume to be a world of oddity taken to extremes. Thus, our interest in *One Way Street* and in *The Graduate* lies as much in seeing the men who made them, although faithful to "the real world," stumble upon the surreal, as much as in the moments of cinematic surrealist imagery these movies happen to offer. If Fregonese and Nichols enter surrealism, it is, so to speak, by the backdoor and while seeking access to somewhere quite different. To put it more positively, and more accurately too, it is not they who approach surrealism, but the surreal that explodes without warning in their film universe, where it is unforeseen, comes without premeditation, and passes without recognition by the filmmaker himself.

The impression encouraged by *The Graduate* in particular is one with which no surrealist would quarrel. Surrealists are convinced that surrealism is an eruptive force. Although persistently resisted by society, it cannot be denied forever, they feel sure. Eventually, and perhaps when least expected (Benjamin's energetic act of revolt fires the imagination, in part, because it is out of character), surrealism asserts itself, demanding satisfaction of desires that the rules and habits of everyday living repress. Hence, the optimism of Breton's axiom, "Surrealism is what will be." From it derives, among other things precious to surrealists, confidence in cinema as the projection of desire fulfilled, as an assertion of human aspiration in disregard of obstacles modern society contrives to place in its way.

By the ethico-moral code of the surrealists, Benjamin's moment of rebellion appears exemplary. His conduct at the church lends itself to favorable evaluation in light of principles anyone having some knowledge of surrealism may identify. It is not difficult to understand why for a moment in *The Graduate* a young man personifies the surrealist protagonist posture vis à vis society's consecrated values, just as the servant girls do throughout Nico Papatakis's factually based movie *Les Abysses*. It is no less easy to see why the couple in Claude Lelouch's *Un Homme et une femme* represents attitudes that fill the surrealists with loathing. Even so, there is a difference worth noting between the climactic scene in Nichols's movie and in Lelouch's. *Un Homme et une femme* vigorously

affirms an antisurrealist position (so, incidentally, earning the approval of the Roman Catholic Church) no less by way of its dialogue than through what it shows. This means that, respecting the distinction surrealists feel it essential to make between cinema and theater, Lelouch's message of conventional morality is conveyed dramatically, not cinematically.

The sight of Benjamin laying about him with a crucifix offers a purely cinematic statement. It illustrates that the movies are supremely capable of speaking surrealist in the language of visual images. It suggests how something shown on film can exercise an imaginatively stimulating appeal that words may not be able to embrace or even to attain. In some of the most stimulating instances, the usual effect of the film as a mirror held up to familiar reality is short-circuited, so that mundane reality is transcended. This result is not necessarily obtained through exploration of dream imagery as the province of evasion. On the contrary, the surrealist charge is often of greater explosive force when the filmic image assembles elements that, in themselves and viewed separately, are perfectly banal. Brought together, though, they carry us beyond contemplation of drab reality into a zone where the surreal illuminates life.

The surreal encroaches upon the real where the cinematic image violates preconceptions that, being commonly entertained, lend an air of permanence to familiar reality as we commonly refer to it. Shaking the real to its foundations, surreality does not work exclusively to overthrow everyday reality but rather to expand our awareness and our grasp on the real. In certain circumstances, this process is linked unmistakably with violation of social and moral taboos that surrealists condemn as insufferably limiting in their effect. Such taboos confine thought, feeling, and action, the surrealist contends, to the disadvantage of desire, placing the individual's needs second to society's demands. Thus, when a cinematic image challenges, rejects, or defies taboos, it takes on positive meaning in relation to surrealist revolt.

Where moral taboos are in question, we have no problem appreciating the nature and significance of the disruptive potential of cinematic language, as surrealists perceive it. Of course, understanding is one thing and agreement with the moral position shared by surrealists is another thing altogether. All the same, comprehension is not difficult, even when approval is withheld. The sight of the young college graduate swinging his crucifix has a directness that does not require extended commentary. For this reason, it is scarcely typical of involuntary surrealist cinematic imagery. The situation can be far different, though, where the surrealist language of film defies mental attitudes we are not conscious of defending or of taking for granted.

What are we seeing at a given moment in a film? Usually, the answer to this question is predicated on our response to another: Why are we being shown what we see? This is to say that normally we look to the second answer to dispose of any uncertainty or uneasiness the first may have released in us. However, a movie may lead in the direction of surrealism by withholding a clear reply to our second question, thus making it all the more troublesome to answer the first in a manner satisfying to common sense. The apparent gratuitousness of what is being shown detaches a filmed image from a frame of reference that would control its evocative appeal by giving it comprehensible direction and purpose. Now the gratuitous becomes the gateway to the marvelous, domain of the surreal.

Cinema is capable of *"speaking surrealist"* very impressively indeed when it offers imagery that eludes exact definition, resisting attempts at thorough explication. In other words, some of the best surrealist images to find their way accidentally onto film defy translation, cannot be rendered fully and accurately in the language of words overseen by rational thought.

One kind of disturbing imagery offered in commercial films is typified in two brief sequences from the second part of *The Last House*, made by Mario Bava, for whom Kyrou has expressed admiration both in *Le Surréalisme au cinema* and in *Amour-Erotisme et cinéma*. The first sequence has a nude female bather climbing up out of a lake onto a dock. The titillating aspect of the scene momentarily appears intensified when a man's hand, fingers extended, slides along the surface of the water to touch the young woman's bare midriff. We are reminded of Kyrou's words, "The hand, object of terror for woman, possessing a life of its own and guiding man toward 'evil,' is, since *Les Mains d'Orlac* [Robert Wiene's *Orlacs Hände*], one of the common themes of cinema."[7] At once, however, we discover, as the woman screams, that the hand belongs to a floating dead man. He is one of numerous corpses encountered in a movie that will culminate in parricide. In defiance of the biblical injunction to honor father and mother, two small children, whose mother and father have succeeded in killing just about everyone else in the movie, will blow their parents to bits with a shotgun before going off to play in the woods.

Only one of the murder victims in Bava's film do we meet twice. The second time we come upon the man seen earlier floating in the lake, he has been pulled aboard a fisherman's rowboat, where he lies on his back, a live squid spreading itself over his bare face.

Erotically focused, the first encounter links with the second. Both

bring life into confrontation with death in images that illustrate the violability of exposed human flesh. In each case, the impact of terror (to which surrealists never fail to react positively in the cinema) sharpens response on an exclusively visual level. The absence of verbal commentary helps free the image to speak to the individual sensibility in a variety of ways. This is why audience reaction is not uniform. Those who feel nothing more than alarm or revulsion can hardly appreciate how, unconfined by words, the cinematic image elicits from a few others a response that transforms the spectacle of the real into a glimpse of the surreal. To surrealists *The Last House* brings more than the heart-quickening stimulation characteristic of films of terror (a better phrase than "horror film" for the genre to which this movie belongs). Surrealists may find in it, perhaps, proof of the existence of "a certain point of the mind from which life and death, real and imaginary, past and future, communicable and uncommunicable cease to be perceived in contradiction." If they do, then they realize more fully why, in his *Second Manifeste du surréalisme* (p. 154) Breton traced surrealist activity to the hope of determining that point. "The notion of a supreme point," as Michel Carrouges has emphasized, "is the fundamental cornerstone of surrealist cosmology."[8]

Not every surrealist viewing Bava's film will interpret the two passages cited here in exactly the same way. Still, the surrealists' reading of a basic text of surrealist theory may provide some of them, at least, with a point of reference permitting identification of a source for the appeal to which they have responded. Admission of this possibility, in even one or two instances, by no means carries with it the supposition that Bava, too, is acquainted with the second surrealist manifesto and has been moved by his reading to try to capture the supreme point by cinematic means. The fascination of the movies is that they can evidence surrealist effects for which no cause is to be determined or even presumed in the filmmaker's mind.

Whatever enables Bava to earn surrealists' approval without seeking it and even without knowing he has gained it, one cannot say it proves words to be an unfortunate impediment to involuntarily achieved surrealist expression. Words do not invariably reduce the surrealist potential of the visible in film. In fact, a shock of surprise, Nora Mitrani would have noted with pleasure, gives a totally unexpected dimension to an otherwise dull scene in one "adult" movie during which three giggling naked young women suggestively peel and eat bananas while, voice over, we hear a man reading from, of all things, a play that surrealists

revere, Alfred Jarry's *Ubu Roi*. For present purposes, even so, it is visual effect that concerns us as a productive means for instilling awareness of the surreal, for releasing it from beneath the surface of reality.

The series of essays in which Breton began to discuss the relationship between surrealism and painting opened in 1925 with a declaration of principle—"The eye exists in an untamed state." Upon that principle was to rest a concept fundamental to his *Le Surréalisme et la peinture*, first published in 1928. From it derives, at the same time, a sense of cinema, treated as an exploratory tool capable of facilitating advance into the world of the surreal. As is confirmed by their misgivings at the advent of sound film, when movies come under examination surrealists place their confidence in visual images above all. They concentrate upon cinema's demonstrated ability to show more than everyday reality routinely brings before us. In doing so, they clearly associate film's liberative virtue with its propensity to attract the eye "untamed," that is, untrammeled by rational thinking in its reaction to visual stimuli.

The essential characteristic of stimulus and surrealist response in the film medium is the absence of imposed or accepted regulation. In the surrealist spectator, openness to numerous stimuli permits imaginative release to take more directions than it would be possible to police or control in any fashion. The surrealist, then, is equipped to discover imaginatively stimulating material where other people find no more than the occasion to ridicule the filmmaker's efforts or to feel irritation at them.

The surrealist's dialogue with film can be sustained, on some occasions, through concentration on elements obviously belonging to the movie, that is, growing out of its director's intentions. At other times, it breaks concentration. The spectator's attention is diverted, sent off in directions the filmmaker has no wish to see followed, no interest in inviting his audience to take. The result, now, is speculative embroidery which, without realizing it, the director has provided the surrealist imagination with the chance to undertake. We see what can happen in an "adult" film showing three scenes featuring the same secondary character. These sequences are logically connected, tracing events chronologically over a period of a few days. In each instance, the man we are watching sits at a desk in his office talking over the phone. On the second occasion, he wears a surgical dressing that covers most of his forehead. It was absent in the first scene, goes unexplained in the second, and will have disappeared by the third day, when one can detect neither scab nor scar on the flesh it concealed.

Evidently, the film in question was made hastily and with the kind of

cynical indifference to professional standards that marked the sexploitation branch of the film industry before competition became keener. Spectators who feel the need to understand what happened between the shooting of the first, second, and third scene will not be at a loss for an answer. But they will end up demonstrating nothing more interesting than their own devotion to rational explanations for which surrealists have no patience. Meanwhile, there is another way of viewing the results of directorial negligence, as we see it betrayed here. Belgian surrealist Marcel Mariën points to it when, among individuals assigned specific tasks during the filming of a movie, he singles out the script girl, dubbing her "a veritable Cerberus" whose duty consists in supervising the smallest detail during the shooting schedule: "That an actor moving from one room to another appears with a different necktie or his face black with bruises he did not have in the previous shot, imagine the to-do. That would be the end of the world!"[9] But to the surrealists, breaking the illusion of reality, shattering the verisimilitude of film narrative by undermining its unity, this is not at all a sign of failure. On the contrary, far from lamenting "the end of the world," they relish the intervention of the unaccountable, delighting in the inexplicable interruption of routine. They agree with Mariën, when he declares, "In fact, it would be precisely opening wide the door upon that liberty from which by every means attempts are made to warrant the mind's freedom."

Everything centers here on the word *freedom* and the acceptation it is given. Rationalist-minded people, Mariën emphasizes, maintain that the mind has to be free of doubt and confusion. Surrealists take the opposite view. They defend the position that only when doubt and confusion leave reason uncertain of itself can the mind be free to function with the imaginative creativeness that faithfully attunes thought to the surreal.

Generally speaking, at the source of any movie-goer's reaction to a script girl's mistake lies his willingness to measure cinematographic imagery against the world around him or, in contrast, his eagerness to see the demands of that world set aside, ignored. To the surrealist, a movie that scrupulously respects the boundaries of familiar reality is not just dreary and a waste of time. It is, more seriously, evidence of an opportunity lost through misapplication of techniques peculiar to the film medium. In contrast, a motion picture that, for whatever reason, by whatever accident, slips the confinement imposed by common conceptions of what is termed *real* now enters a protest against so-called reality, thus affirming the immanence of surreality. Hence, a movie that

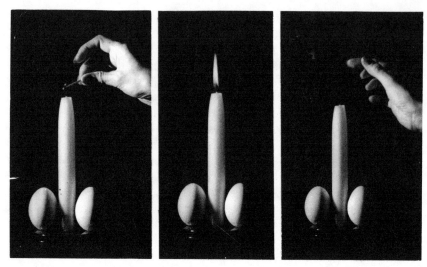

Marcel Mariën, sequence from *Imitation of the Cinema* (1959). Photo Léo Dohmen.

speaks to us of surreality, even inadvertently, uses a vocabulary of special import to the surrealist. It puts us in mind of Breton's remark about "a certain number of works, poetic and otherwise," that "have value essentially because of the power they possess to appeal to a faculty *other* than intelligence. Beauty demands to be enjoyed before being understood and entertains with clarity only very distant and secondary relationships." Beauty, then, does not rebel against elucidation so much as tolerate it "*a posteriori* and as though outside itself."[10]

In a film poor enough to be beneath contempt to any normal spectator, the appearance and disappearance of a surgical dressing catches the eye but serves no purpose explained by the exigencies of plot. Yet, even though this may seem to entail relegating the surrealists to the ranks of the abnormal, what we see here exemplifies surrealism, proves its capacity for "opening certain doors that rationalist thought flattered itself it had condemned for good and all."[11]

An absurdly small detail, not introduced purposely and surely resulting from a moment of inattention, detaches what we are watching from the context of everyday experience and helps us grasp more firmly the significance behind Breton's love for "everything that, breaking at random the thread of discursive thought, takes off suddenly like a rocket illuminating a life of relationships fruitful in a different way."[12] Granting that the rocket soon falls to the ground, Breton nevertheless claimed

that we need no more than its flash to "measure on their dismal scale the exchange values that are proposed today."

In a very important sense, surrealism's major, irreplaceable role is to discredit exchange values commonly accepted in modern western society. Actively and persistently, it seeks to replace these with others that will revitalize exchange between men. The surrealist believes implicitly that acceptance of his values together with conduct dictated by them will force prosaic existence to give way to poetry, upon which rational objection will be incapable of infringing.

The surrealists' approach to cinema is to be examined in light of the central ambition outlined above. It is an offshoot of their pursuit of poetry as an attitude toward reality, as a means of responding positively rather than negatively to the world in which we find ourselves. The peculiarity of that approach lies in making the surrealist's dialogue with film a tug-of-war between the intentional and the unintentional. On the one side, we observe repeatedly that commercialism in the movies produces moments of significance to the surrealist's imagination only by accident. On the other side, surrealists openly acknowledge, as Breton did in an essay taken up in his *Point du jour* (1934), that, "in the final analysis, everything depends on our power of voluntary hallucination." The effect produced inadvertently by the filmmaker captures the imagination of spectators in whom hallucination is not a momentary condition or a permanent debility but a power exercised voluntarily and with purpose.

It is reasonable to say that surrealism has a better chance of being released involuntarily in a film spared the strict control of skillful direction. Experience has persuaded surrealists that they have every justification for regarding artistically successful movies as antithetical to surrealism in cinema. A certain number of shining examples come to mind—among them Henry Hathaway's *Peter Ibbetson*—that conflict with this view. However, these are not sufficiently numerous to undermine a basic argument of surrealist subjective movie criticism. Even commercial films that do find favor among surrealists often benefit from a degree of accommodation, sometimes quite flagrantly generous—Kyrou's refusal to admit the religious aspect of an admired film, John Cromwell's *The Enchanted Cottage*, for instance. Moreover, when a commercial director blunders into surrealism, he scarcely does so to the complete satisfaction of surrealists in his audience.

Eleven contributors to the surrealism number of *L'Age du Cinéma* (including Robert Benayoun and Kyrou, who later made films of their own)

did more than declare their admiration for *Shanghai Gesture*, made almost a decade earlier. They replied to questions intended to elicit "irrational enlargement" of Josef von Sternberg's movie. One sample question, with accompanying answers (from individuals identified only by their initials), indicates something it would be most unfair to ignore. Even a commercial motion picture of uncontested greatness, by surrealist standards, does not *"speak surrealist"* as explicitly as it might:

> *What ought to happen when Mother Gin-Sling comes down to the gaming room after the revolver shot?*
> Fire breaks out in a mountain hut (JLB). Loaded revolvers are passed around (RB). Mother Gin-Sling masturbates ferociously over the suicide's corpse (GG). Boris's revolver appears on the pan of a set of scales (which one does not see) (GL). A lion drops from the ceiling onto the gaming table (BR). Everyone drips and melts like candles (AS). The gaming table becomes a diamond worn by Ouspenskaya in her youth (MZ).

It is clear that following most of these suggestions would have resulted in separating von Sternberg's film very efficiently indeed from the stage play from which it was adapted (dismissed in Kyrou's *Amour-Erotisme et cinéma* as "horribly melodramatic" [p. 224]). More than this, introducing some of the effects proposed would lead to serious interruption of narrative sequence, if not render subsequent resumption of the plot unlikely. Thus, surrealists' devotion to cinema's image-making capacity would take precedence over everything else. Indeed, its priority over other considerations would allow the irrational (more precisely, the antirational) to invade the movie, leaving room for nothing else.

> *At what point should a snowfall take place?*
> It should happen upside down, from bottom to top, at the moment when the women are hoisted up in their cages (RB). At the moment when Omar uncovers Poppy's shoulder (AK). During the final long shot, but the snow melts immediately (GL). During Poppy's jealous outburst to Omar about the powder puff (JS). As Dixie waits for food (AS). When the black swan breaks its two black eggs (T). When Omar pulls Poppy's shoulder strap down (MZ).

Presenting these answers, Jean Schuster comments, "Snow must fall when eroticism becomes manifest (RB, AK, JS, MZ). Note the clearly symbolic 'inversion' by Benayoun, which considerably reinforces the eroticism of the sequence." The things emphasized by Schuster are not all that deserve to be noted. Just like the game on which it was based,[13] the activity detailed in *L'Age du Cinéma* takes the form of "experimental research" into the possibilities for "embellishing," not life at a remote time in history, on this occasion, or the city of Paris, but a created work,

a movie by a director whom surrealists hold in high esteem. We find in *L'Age du Cinéma* more than a tribute to a film considered by surrealists to be among von Sternberg's major achievements.[14] The answers characterized by Schuster as "spontaneous, if not completely automatic" are generated, for the most part, by sequences present in *Shanghai Gesture*. They treat these passages as springboards for development of a special kind.

Von Sternberg has shown himself capable of exciting the surrealists' imagination by displaying half-naked women in cages, for example, or having Dr. Omar play with the shoulder strap of Poppy's dress.[15] All the same, the recommendations set down in *L'Age du Cinéma* imply that he has not gone far enough. Looking them over, we notice they share one feature of particular interest. Beyond question, if followed, any of these suggestions would enrich the surrealist content of *Shanghai Gesture*, and each would do so by cinematic means, techniques peculiar to the medium of cinematography. The answers reported by Schuster indicate that the surrealism of *Shanghai Gesture* is not confined by limitations that weigh upon the film medium but by the limits von Sternberg set on the free exercise of imaginative play. These limitations are to be traced to the mind of the movie's director, who feels obliged to answer, ultimately, to "reason," "common sense," or whatever one chooses to term the demands of credibility, as formulated by reference to lived experience. However great surrealists consider him to be, von Sternberg was a man who accepted as his last assignment directing John Wayne in *Jet Pilot*, produced by Howard Hughes and released fully seven years after its completion in 1950.

Obviously, implementing Georges Goldfayn's proposal would have made *Shanghai Gesture* a film ahead of its time. Still, the main issue has little to do with the foreseeable prohibitions of the censor at the time when *Shanghai Gesture* was made in 1941. The obstacle to full attainment of surrealism in this film has less to do with external factors like fear of censorship and even respect for narrative continuity than with the absence of inner drive. Whatever his qualities as a movie director, von Sternberg could never claim, as Buñuel could after *Las Hurdes*, that he had made *Shanghai Gesture* because he had "a surrealist way of looking at things."[16]

It is indicative of the strength and, at the same time, of the weakness of *Shanghai Gesture* that the reflections it induced in 1950 among members of the surrealist circle in Paris had as much to do with things the film omits as with what it includes. Questions like the following are designed not only to embellish the movie but also to enlarge its scope

as an expression of surrealism. The idea was to imagine it as less involuntarily surrealist—in short, to modify it radically as an exercise in filmmaking:

> When is a river seen in the film? To whose dream does Maria Ouspenskaya belong, and what is this dream? How does Omar exist outside the film? What should the door opened by Omar at the beginning of the film reveal? Between whom or what should a chance encounter take place on the gaming table?

This last question in particular indicates the kind of surrealist thinking that underlies these inquiries. It makes a pointed reference to one of the seminal word images from which surrealist poetic inquiry takes impetus, the famous line, "Beautiful as the chance encounter on a dissecting table of a sewing machine and an umbrella," in the fourth canto of the Comte de Lautréamont's *Les Chants de Maldoror*. It openly challenges respondents to impose a surrealist frame of reference on their speculation in the medium of film. In so doing, it sets a poetic criterion by which von Sternberg's movie is to be assessed. And this prepares us for another question, *"What don't we see?"*

Asking what a motion picture does not show may sound so broad a question as to sacrifice vital meaning and prompt endless complaints. The briefest summary of these—amounting to a description of what *Shanghai Gesture* is not and cannot be—could leave readers wondering over the choice of such a question. Indecision yields, however, to realization that this might well be the most important question of all.

Although short, the answers supplied reveal the spirit in which the individuals polled responded.

> The scene deep in the forest, even though it is the one that determines all the others (JLB). The death of Mother Gin-Sling, who ultimately lets herself be swallowed by the dragon (AK). The flight of swallows and the swimming of sea-cucumbers above and below the sea, far from Shanghai, over which Poppy's plane returns behind time (GL). The sea (BR). The Forest of Dunsinane (MZ).

These replies look like a strange, perplexing mixture. Jean-Louis Bédouin's response calls for a sequence for which dramatic relevance is claimed. Kyrou's similarly demands an addition to the plot, an addition of a supernatural nature, however. Two responses, Bernard Roger's and especially Michel Zimbacca's, with its Shakespearean reference, sound boldly irrelevant, while Gérard Legrand's seems truly committed to the cause of the irrational. We look in vain for uniformity among these answers, which follow no observable pattern. Beneath the surface, though, all of them are interconnected. They indicate that each respondent has interpreted the question facing him as an invitation—not to

say what the film lacks, exactly, but what he himself feels the desire to see in *Shanghai Gesture*.

In no instance would it have taxed von Sternberg's ingenuity as a director or strained cinematographic means beyond tolerance to implement the suggestions implied in this list of things not seen in *Shanghai Gesture*. Not one of the respondents, we observe, treats answering Schuster's laconic question as a chance to make proposals for pushing back the technical boundaries of film, to improve upon cinema. Each obviously had a narrower ambition altogether, indicative of the faith and hope surrealists bring into the movie house. Meanwhile, in only one case does it seem—and just a moment's thought reminds us that appearances can be deceptive—that an individual (Bédouin) misses something in von Sternberg's adaptation that would have explained *Shanghai Gesture* more fully. Expanded comprehension is patently not the common goal. Instead, mystery, the inexplicable, and the marvelous are the ingredients that respondents would like to see present in greater measure and in total disregard of fuller explanation, more factual detail, or greater plausibility.

Introducing any of the elements recommended surely would contribute to bringing von Sternberg's movie closer to surrealism. Results to which surrealists attach special meaning would be obtained by stressing cinema's ability to show rather than by profiting from what it is capable of telling through means shared with theater. Obviously, the emphasis common to all replies noted by Schuster is consistent with the fact that his question focused explicitly on the visual element in film. However, so as to appreciate what is significant, we need to observe that the position taken by surrealists collaborating on *L'Age du Cinéma* is exactly that of their elders a quarter of a century before.

During the 1920s, surrealists turned to film to show them something that everyday existence denies us. Their main spokesman in France could look back to an earlier date still. During his 1914–1918 wartime military service, Breton, in the company of Jacques Vaché, would sample all the film programs currently playing in the provincial town where he was stationed. Vaché and he would leave their seats at the first twinge of boredom, heading for the next movie house without bothering to ascertain the name of the last motion picture or the next one. Breton's comment in "Comme dans un bois" is of capital importance: "A few hours on Sunday sufficed to exhaust all that Nantes had to offer: the important thing is that we would come out 'charged' for a few days; without there having been anything deliberate between us in this, qualitative judgments were excluded."

It does not take Breton long to contradict himself in "Comme dans un

bois." Referring to cinema, he remarks a few lines later, "I think what we valued most in it, to the point of taking no interest in anything else, was its *power to disorient.*" In the company of a man who, he was to acknowledge later, helped revolutionize his idea of poetry, as opposed to literature, Breton may never have attempted to judge the quality of films according to a preestablished scale. Nevertheless, the value he and Vaché placed in cinema's *pouvoir de dépaysement* led them to evaluate movies according to criteria stressing mental and emotional disorientation. These same criteria were to provide the basis for a surrealist sense of cinema, a key in fact to comprehension of surrealist cinematic language.

12

SOUND IN SURREALIST CINEMA

The role falling to sound in surrealist cinema raises special problems. These may be traced without difficulty to the earliest days of surrealist activity in France, and even beyond. They began to take firm shape when the advent of talkies caused more than a few participants in surrealism to question the continued viability of film as a truly poetic medium, once sound had become a regular feature of cinematic expression.

The surrealists in Paris were faced with the discovery that—as they saw it, in any case—sound in film presented movie directors with an invitation to debase cinema by equating it with theater. The availability from 1927 onward of technical means to turn movies into filmed theatrical presentations made it seem likely that future developments in cinema would be controlled, not to say entirely dictated, by ambitions rightfully belonging to the stage. As a result, it looked as though the wonderful freedom Georges Méliès, for example, had brought to film-making was endangered. Cinema would be sacrificed, presumably, to the pursuit of goals shared by playwrights and stage directors, instead of being allowed to go on contributing to extension of the public's acquaintance with the marvelous.[1]

To a number of André Breton's companions, though not to all of them, this seemed especially regrettable, quite alarming even. They feared that, ultimately, if not at once, cinematic imagery—the special kind of image-making only movies could offer—would be domesticated. It appeared to a number of surrealist observers that domestication threatened to be a more or less unavoidable consequence of the explicative

function of the spoken word in sound film. Hence, the danger facing cinema was even more serious than the risk of sinking to the level of filmed stage plays. Even if the poetry of the visual image were not disrupted beyond hope of redemption by intrusive language, one sad conclusion seemed inescapable. Reduction of poetic intensity, of the kind to which surrealists are especially sensitive, looked inevitable as soon as films began to talk to audiences who, previously, had been required to watch, not listen. In movies communicating with their audiences largely on the plane of dialogue, the visual imagery of film risked becoming an accessory feature, no more than an adjunct to narrative. Where it might occur, conflict between the auditory and the visual seemed most likely to be resolved in a fashion granting indisputable victory to words over pictures.

Such a conflict would be insignificant to the majority of moviegoers, seeking amusement, not enlightenment. Moreover, it was not a conflict in which filmmakers in France or anywhere else could be expected to take sides deliberately against the visual. To movie directors and to their public, sound and cinematic imagery were elements contributing to the film experience. Attention to words did not mean necessarily impoverishing images. Yet, in the main, it was the surrealists' responsiveness to the visual and their fear of the limiting effect of the verbal on the poetic liberation of which they believed cinema capable that persuaded some of them to anticipate the very worst. They presupposed—or at least the more hasty among them did—that introducing sound into film would mark a retrograde step. In their opinion, it would be no less harmful to the medium than the self-conscious manipulation they perceived as marring the work of certain movie directors intent on transforming cinema into an art form. Of course, these surrealists detected enough evidence that apparently confirmed their misgivings, promising to bear out their doleful predictions. At the same time, though, there was proof that sound need not always work against film poetry.

Even before the arrival of the talkies, there had been indications that verbal language need not have an exclusively explicative or dryly informational function in movies. Indeed, one caption—famous among surrealists who had seen F. W. Murnau's *Nosferatu, eine Symphonie des Grauens* (1922)—demonstrated beyond dispute that words could enrich the poetic content of cinema by adding to what film was capable of showing: "On the other side of the bridge, the phantoms came to meet him." As Robert Desnos noted, while praising *Nosferatu* in the newspaper *Le Soir* on 21 May 1927, "Everything was sacrificed to poetry and nothing to art" in Murnau's silent film. No less attentive than Desnos to the links binding cinema to "the solemn elements of disquiet," other

surrealists ought to have appreciated in greater numbers that *hearing* the intriguing caption they had read with excitement surely would not have weakened the impression made on them by *Nosferatu*. On the contrary, it would have proved sound to be a potentially fruitful disquieting element. All that was required was realization of the capability of sound for advancing surrealist purposes. Yet, from the moment when they began to fear sound might reduce the potency of cinematic imagery, surrealists by and large found themselves defending a distinctive concept of film. This encouraged an approach to movies as expressing a *vision*—that is, a way of looking—consistent with surrealism, no matter how unfashionable it might be among film critics.

In the long run, nothing appears to lend support less ambiguously than surrealism has done to the proposition that cinema is primarily and perhaps essentially a visual experience.

Of course, the first movies to enthuse the surrealist in Europe belonged, as indeed did the founding of the surrealist movement, to the presound era in cinema. Thus, the admiration felt and voiced in surrealist circles did not denote conscious preference for silent over sound films; there simply was no choice open to spectators at that time. Still, the kind of pleasure and imaginative stimulation surrealists found in early movies conditioned their idea of cinema, their approach to it, and their expectations of a medium owing its appeal largely to one indisputable fact: silent films command attention on the visual level, whether the tale told is comic or tragic, humorous or horrifying.

It was natural that the cinematographic poems published by future surrealist Philippe Soupault in 1918 should ignore sound almost ten years before it became available to moviemakers. The same has to be said of Desnos's scenario "Minuit à quatroze heures," subtitled "essay in the modern marvelous," which appeared in *Les Cahiers du Mois* during 1925, only months after Breton published the first surrealist manifesto. However, dates do not tell the whole story.

In Paris, Man Ray may have had no option but to make his *Retour à la raison* (1923) and *Emak Bakia* (1927) without sound. But his silent *L'Etoile de mer* (1928) and *Le Mystère du Château de Dés* (1929) both postdate the invention of sound film. So does *L'Espace d'une pensée* (1928), made in Brussels by René Magritte and Paul Nougé. This movie has been destroyed, but other, more elaborate surrealist experiments with silent film survive.

Elucidating Germaine Dulac's studied imagery in *La Coquille et le clergyman* (1927) is a continual challenge to the mind through the eye, even though in some respects this movie does betray the surrealist scenario by Antonin Artaud on which it is based. Anyone who has even a nod-

ding acquaintance with surrealist cinema, meanwhile, feels sure he knows how to interpret the lurid sight of the sliced eyeball in the opening silent sequence of Luis Buñuel's *Un Chien andalou* (1928). More recently, according to its director, Paulo Antonio Paranaguá, the award-winning Brazilian surrealist movie entitled *Nadja* (1966) in homage to André Breton (who died only four months after its completion) represents "an attempt to learn to familiarize oneself with a language distinct from words." In his *Nadja*, filmed images are not part of a process of transmitting ideas but, Paranaguá has said, "an experiment that involves the spectator, that forces him to make himself part of what he is seeing."[2]

Unrealized surrealist projects in cinema, meanwhile, here and there present suggestions that appear to accord perfectly with the stereotyped view of surrealist peculiarity and incongruity: the singing tramcar in Henri Storck's scenario "La Rue" (published 1951) or the smokestack emitting steam to the faint sound of Couperin, in the same author's "Am-ster-dam" (1952) which ends expressing anguish "through a single muted note quietly introduced and then progressively amplified until it is as loud as we can bear." All the same, filmscripts by surrealists generally follow the pattern we are accustomed to find in the best-known movies of surrealist inspiration.

In his "La Révolte du boucher," first published in 1930, Artaud sought "maximum legibility" for elements already characteristic of his script "La Coquille et la clergyman": "Eroticism, cruelty, taste for blood, search for violence, obsession with the horrible, dissolution of moral values, social hypocrisy, lies, false witness, sadism, perversity." Convinced that cinema is "a superhuman eye," Artaud had no intention of using captions—as Desnos had put it in *Paris-Journal* on 13 April 1923—"like the commentaries of a dominie below a fine poem." Setting down words to be spoken in his film, he enclosed them in little boxes on the printed page, like titles on a silent screen. Thus he treated "La Révolte du boucher" (The Butcher's Revolt) as a talkie only to the extent that "the words pronounced in it are so placed as to make the images rebound." The declaration Artaud made at the end of a prefatory note to "La Révolte du boucher" insists that "it is the eye that finally pulls together and underscores the residue of all movements" confronting the hypothetical spectator.

We have no difficulty understanding the nostalgia expressed by Joseph Cornell, whose mysterious boxes have found their way into numerous surrealist exhibitions: "Among the barren wastes of the talking films there occasionally occur passages to remind one again of the profound and suggestive power of the silent film to evoke an ideal world of

beauty, to release unsuspected floods of music from the gaze of a human countenance in its prison of silver light." Nor is it hard to comprehend his gratitude to Hedy Lamarr, "the enchanted wanderer, who again speaks the poetic and evocative language of the silent film, if only in whispers at times, beside the empty roar of the soundtrack," to which Cornell opposes the "world of expressive silence."[3] If, then, we turn for a moment to films on which surrealism has exerted no direct influence, we discover the chances good, here and there, from time to time, that the eye will satisfy the surrealists' taste for the marvelous. Not infrequently, sight liberates in surrealists the wonder they believe cinema is especially suited to releasing in its audience. One has only to glimpse in one of the *Frankenstein* series an incongruous giant glove (worthy indeed of mention in Breton's *Nadja*)—presumably a shop or tavern sign—which hangs high above the pavement at the corner of a street down which a golem walks hand in hand with an innocent child, to sense what kind of rewards movies can offer the surrealist by way of details not essential to plot.

In contrast, surrealists have virtually no opportunity to respond to sounds of a comparably gratuitous nature. There is little likelihood of background noise being permitted to enter a film in which its unplanned presence could divert attention from dialogue or interrupt plot development. Control of sound has proved to be, consistently, far more rigorous than supervision of visual elements in the commercial cinema. Instances of truly accidental intrusion of extraneous sound upon a motion picture, surrealist or any other, remain very rare.

Of all filmmakers Norman McLaren has come closest, no doubt, to automatism—not only in declining to let premeditation dictate the progress of his animated films, but also in the way he has employed sound, on occasion. By scratching the film surface, he has demonstrated that one can obtain results neither foreseen nor regulated. So impressed is one surrealist with these that he asks whether McLaren's scraper is not the bladeless knife without a handle (imagined by Georg Christoph Lichtenberg at the end of the eighteenth century) that occupies an honored place among projected surrealist objects.[4]

The pleasure surrealists have derived from listening to some of McLaren's soundtracks is exceptional indeed. They have to admit that whatever one hears in commercial films has been either introduced by design or permitted by directorial edict to survive in the edited version. Because sound is an element that helps authenticate the realism of most films, only very infrequently does one have the opportunity to notice sound contradicting what we are meant to believe. At the beginning of David Lean's *The Bridge on the River Kwai*, the measured tread of the

soldiers signals an unforeseen inexplicable weakness in the British career officer whose sense of discipline (fundamental to British colonialism) we are supposed to consider above reproach. The officer does not know, presumably, what every lance corporal knows—that marching troops must break step when crossing a bridge. Here realism is violated in error, but without the admixture of surrealism. We come close to the latter only when the soundtrack plays John Philip Souza's "Colonel Bogey" and the director's fellow countrymen find themselves singing, under their breath, the vulgar words that go, popularly, with the tune in the United Kingdom, though not in the United States, "Ballocks! And the *same* to you!" Here, though, we touch on a feature of sound that we shall need to approach circumspectly, and by way of other considerations.

To maintain perspective, we must take into account a contributing factor having a strong influence over surrealism's manifestation through film. The cost of making a sound movie was prohibitive from the first. It seems to have had a longer-lasting effect on surrealist filmmaking than the anxiety worrying some participants in the surrealist movement who feared the invention of sound must surely mark the demise of cinema.

We look in the wrong direction when imagining surrealists to be either shortsighted or obstinate. As early as his article on music and subtitles in *Paris-Journal* (13 April 1923), Desnos acknowledged, "All means are good that give good films." He added on the same occasion, "it is in the spirit rather than in an accessory technique that purity ought to be sought." Still, when later Buñuel was invited to select background music for a sound-added version of *Un Chien andalou*, he scarcely seems to have grasped the opportunity with enthusiasm. His choice fell on a passage from *Tristan und Isolde*, for no better reason than that the title of Wagner's music took his fancy. The simple—and, as it happens, profoundly inaccurate—deduction appears to be that, in Buñuel, we face a surrealist filmmaker whose treatment of sound does no more than prove he has no ear for music. Buñuel's repeated assurances that he is impressed by silence, that he detests music in films, and that music is a "parasitical element," a "sort of trickery"—all this seems to point straight to a dead end.[5]

Yet if we *listen* while we watch the reissued *Un Chien andalou*, once past the surprise of hearing music in a film we know to have been made without it, we become aware of something noteworthy. The very blandness of the background music (to employ that tendentious, misleading term) functions ironically, with respect to the film's violent visual im-

agery. The same is true of the use made of Brahms's Fourth Symphony throughout Buñuel's *Las Hurdes* (1932). In that film, the horrifying sights the movie offers contrast with the monotone affected by the commentator, imparting information with businesslike detachment. Buñuel is already advancing along the road where, in the late 1950s, we shall hear him advising the French New Wave directors to beware of music, because "one ends up betraying the image." From the outset, Buñuel's objections were directed against introducing music as accompaniment to filmed imagery in a way that "underlines" or "punctuates" it. In other words, he opposed using music to support or second the image.[6]

If reinforcing imagery in this fashion is to be regarded as undermining cinematic images, then are we not brought up against a disturbing paradox in Buñuel's theory about music for film? Should this seem indeed the case, we have only to recall a late episode in his *L'Age d'Or* (1930). Here a tortured thirteen-year-old girl is put to death by a reincarnation of the Marquis de Sade's monstrous Duke of Blangis. The duke, Buñuel's scenario insists, is "evidently Jesus Christ," with whom, indeed, we have no trouble associating the actor's flowing robes, bearded face, and general mien. The murder takes place, fortunately, off camera, to the hideous accompaniment of a paso doble. Musical sounds, we gather, can make a significant contribution to the impact of the cinematic image by way of contrast, not confirmation. This result may come about when associations that an audience readily makes with the musical element in a film clash with the emotion solicited by the things seen on-screen. In the movies of Buñuel, no doubt the best-known instance occurs during the orgy sequence from *Viridiana* (1961). While it is passing before our horrified or lustful eyes, we hear the Halleluia Chorus from Handel's *Messiah*.

Use of such a musical selection may appear more than a little facile, as it did to an American who once protested to me about it, on the grounds that the music is hackneyed. I am in no position to say how trite the Halleluia Chorus sounds to a Spanish audience. Nevertheless, thinking over the implied criticism that it is borrowed to cheap effect in *Viridiana*, for my next showing of Buñuel's film I had my students agree beforehand that we would rise, as tradition demands, while the chorus was playing. I took care, however, not to forewarn a brace of colleagues who would be attending the screening. Left sitting in a roomful of people—male and female—all on their feet, the two men, as they admitted later, began to feel uncomfortable. Meanwhile, if—like a certain Prince of Wales—the rest of us were standing out of respect for musical genius, we were getting in the bargain a better view of the action. And did not our tribute to Handel look, coincidentally, like a salute to the triumph

of anarchy and indulgence of the passions over order, sexual continence, and the call of the convent? One thing is sure: Buñuel can never be accused of banality.

The contrastive effect of Wagner's music in *Un Chien andalou* may be termed an unforeseen bonus, the fortunate consequence of accident—of beneficent chance, as surrealists refer to it. In this sense, it is comparable to the effect of the fortuitous arrangement of the beggars at a dining table, which suggested to Luis Buñuel, making *Viridiana*, a parallel with Leonardo da Vinci's painting *The Last Supper*. Accident is hardly a factor, though, in the role assumed by the paso doble in *L'Age d'Or*. There it increases the visual impact of the concluding scene, creating an effect repeated in Stanley Kubrick's *A Clockwork Orange*, which has its central character kicking a senior citizen to the well-marked rhythm of "Singin' in the Rain." The same effect is borrowed in a Czech short subject that incorporates a German newsreel showing inmates in a concentration camp whom we watch shambling by to the tune of "Blue Skies," complete with sugary vocal.

At the close of *L'Age d'Or*, music clearly does not serve to mitigate the brutality of things shown and implied. Instead, it stirs us out of unprotesting acceptance of what we see, sharpening visual impressions by auditory methods that defy the spectator to accept the visual passively. This means that, when introducing the distinctive musical rhythm of the paso doble, Buñuel makes a statement dispensing with words. He passes judgment as much on his audience as on a film character who does not speak but recalls, concurrently, the historical figure of Jesus and one of Sade's most terrifying literary creations, the leader of the debauchees assembled in *Les 120 Journées de Sodome*.

As *L'Age d'Or* approaches its end we face a simple equation: the Duke of Blangis = Jesus Christ. The latter's injunction, "Suffer little children to come unto me," is unvoiced but nevertheless takes on horrifying force in Buñuel's movie. We are confronted with an equation implying not the salvation of the world but a dance of death set to a stimulating Spanish dance tempo that quickens the heartbeat while a young girl has time to scream no more than once before she dies. As a result, then, the facility of the visual equation does not remain in our memory so much as the intensity infused by sound into a sequence which ends before the final fade-out comes, in complete silence.

The provocative aspect of the famous scene in *L'Age d'Or* follows obviously upon design, not accident. It eliminates any possibility of spontaneity such as gives special character to certain forms of pictorial and verbal surrealist images, those based in the practice of automatism,

notably. In other words, it brings us face-to-face with deliberate intent and with the part reserved for intentionality in surrealist filmmaking.

One cannot take up the question of sound in surrealist films without accepting that it owes its presence to the director's determination to turn it to advantage. This basic fact brings into focus a matter of central importance. What kind of advantage, we may ask, does the surrealist filmmaker look to sound to ensure? Is it, perhaps, the kind that a soundtrack can offer any movie director devoted to providing a faithful reflection of the world about him or, alternatively, wanting to capture an impression of some exotic ambience? In their *L'Invention du monde* (1952), Jean-Louis Bédouin and Michel Zimbacca utilize native music (Australian aborigine and Iroquois Indian chants, Voodoo tom-toms, Bahian drums) as well as music from Japan, Mexico, and Bali. This sort of auditory evidence appears to indicate we are dealing with a documentary film. The effect it seems likely to give is undercut, however, by the film's commentary.

Before we proceed any further, it is as well to pause for a moment over the word *commentary*. Its familiarity is likely to lead us quickly astray.

Buñuel begins *L'Age d'Or* with a section on scorpions, modeled after movie documentaries. It is accompanied by the kind of characterless music popular in the documentary mode. However, no voice makes itself heard on the soundtrack at this stage. Instead, the sort of information that verbal commentary usually conveys is flashed on the screen in caption form: "The scorpion is a genus of Arachnida that lives generally under rocks." The ironically didactic strain can escape no one. Obviously, Buñuel prefers to put the spoken word to uses more interesting than mere instruction. Meanwhile, reading the commentary he himself wrote for *Las Hurdes*, French surrealist Pierre Unik maintains an uninflected tone when reporting, "The monks live like hermits surrounded by a few domestics." As he speaks the camera lingers over a nubile young girl. These two apparently divergent examples cast suspicion on assumptions that usually underlie the role of verbal commentary in film.

Taking up the question of sound in film documentaries, surrealist Jacques B. Brunius remarks on the ineptitude generally displayed in documentaries dating from the 1930s. It is as though he wants to explain Buñuel's use of the captions in *L'Age d'Or* when he observes, apropos of commentary, "Most of the time it taught you nothing useful that a subtitle could not have told you effectively."[7] All that needs to be added to Brunius's remarks is this. Buñuel's comments on scorpions also show documentary commentary to be fundamentally pointless, by surrealists' standards.

Words that follow along behind the cinematic image are redundant, Brunius argues. If they happen to anticipate what the film has to show, on the other hand, their effect may be to eliminate the surprise that images are capable of provoking. Having a shot of an appetizing girl coincide with the noncommittal word *domestics*, Buñuel reversed the traditional relationship of commentary to image. He demonstrated that the camera can add meaning to what movie audiences hear. Even so, it was left to Brunius to explore more fully the relationship, in film, between image and sound (both music and the spoken word). He did so through his editing of documentary movies. Convinced that a limitless field opens up before anyone willing to use words, images, sounds, and music concurrently, Brunius reports in *En Marge du cinéma français*, "It seemed to me possible that a simple sound could set off a train of ideas and images—another time an image would suggest a word or a phrase, while elsewhere the words inevitably would call up a visual image, either illustrating or completing it—finally that music could often serve as a rhythmic mold for certain passages without commentary" (pp. 129–30).

Brunius's words are echoed by Paranaguá. More than three decades after Brunius began working in film, shooting *Nadja* committed Paranaguá to exploring symbolism. He therefore found himself obliged to give careful attention to editing and framing. For this reason, his "experiment in language," as he called it, became at the same time an "experiment in rhythm and stylistic unity," underscored by utilization of Vivaldi's music, chosen to stress the film's rhythm.

We can see, now, that Brunius has not simply brought us back again to Buñuel's use of the paso doble in *L'Age d'Or*. He indicates also that commentary—the spoken word, essentially—must find a place in the movement of the film rather than command notice as something added primarily to bolster filmed images and to give them a force they would lack if left to themselves. Thus, for instance, it is perfectly legitimate to reverse the customary order of assimilation and response and to regard the shot of the attractive girl in *Las Hurdes* as a fitting visual comment on the verbal reference to domestics, hinting that the monks service those who serve them. The central point, therefore, is the following. Beginning with his editing of Jean Renoir's 1936 film, *La Vie est à nous*, and a documentary he himself codirected with Jean Tarride in 1937, *Records 37* (for which he wrote the spoken text), Brunius's experiments in film deposed the spoken word from its presumed position of superiority over the cinematic image and at the same time eradicated the superficiality and redundancy he criticized in conventional commentary (a term he himself abhorred, by the way). "The main thing," he

declared, "was that image and sound should really be *complementary*, even at the cost of a certain separation between them."

We shall need to investigate in a moment the feasibility of separating image and sound. First, though, we ought to take account of a film where Brunius's adjective *complementary* applies quite as one would expect it to. Doing so brings us back to *L'Invention du monde* (The Invention of the World).

Instead of the kind of material one anticipates finding in a travelogue, we hear in *L'Invention du monde* words written by surrealist poet Benjamin Péret. Péret's text was not conceived as a traditional commentary intended to instruct audiences on exotic matters. Instead, it illustrates something Bédouin has emphasized, "The film was conceived as a poem in pictures and it was the analogies discovered between the pictures [*images*] that entirely dictated the montage and the very articulation of the sequences." Bédouin has insisted too that Péret's words are "in reality a sort of long poem that becomes comprehensible really only when accompanied by the image."[8] Hence, while experiencing this movie, the spectator is not expected to rely on the spoken word to elucidate the pictures but must do the very opposite. It is Bédouin's belief that *L'Invention du monde* has the merit of manifesting the relationship between surrealist thought and the way so-called uncivilized or primitive peoples look at the world. So, we may conclude, it is the visual evidence of native artifacts following one another across the screen that illuminates what Péret has to say. For this reason, the most significant passages in Péret's text are not those conveying information, however elegantly:

> Fixing in stone the prey he covets, the animal he wishes to tame, man affirms his power.
> But to model nature according to his desires he first has to exorcise it.

What really counts, here, is the poetic interplay set up between words and visual images:

> My crest is a double crenelated rainbow traversed by lightning. . . .
> Eyes take flight with the image that has risen out of matter, as the flower blossoms so that its seed may fall to germinate, grow, flower, fall, germinate, grow, flower, fall, germinate, grow, flower. . . .

According to a statement published by Bédouin and Zimbacca in the magazine *L'Age du Cinéma*,

> *L'Invention du monde* admits, as its basic hypothesis, the perenniality in the human mind of associations that permit us, as soon as poetic consciousness is awakened by one of them, to embrace by analogy all the

others, and to be carried right away to the source of mythical thought. . . . Under these conditions, only the poetic influx can open these forms and symbols, considered as so many clusters of meanings closed in upon themselves. Only this can bring forth their multiple prolongations to organize them at last into a responsive chain reaction.

There lies the significance of Péret's contribution. A press release for *L'Invention du monde* asserts,

Benjamin Péret here gives us back through his text the poetic images of primitive conception, founded on analogy, and at the same time delineates the sense and origins of the objects presented.

Lending a voice to certain of them, Benjamin Péret has been inspired by their significance in rites in which they personified spirits and forces, thus expressing the dramatic side of the scenario.

Consequently, when the movie was completed, "trusting in the power of expression and evocation of the elements presented," Zimbacca came to believe that *L'Invention du monde* "will appeal to the spectator's unconscious as much as to his faculties of logical sequence, the film being situated on the plane of poetry."

As we have observed it to this point, the surrealists' treatment of sound repeatedly denies spoken language its justificative and arbitrative roles with respect to cinematic visual imagery. This does not entail, necessarily, reduction of the status of words. Yet it does mean that a change has come over the contribution made by the spoken language in film. Surely spoken language is the most significant factor, many people would have thought, in the experience of movie audiences since the arrival of talkies. But it is not considered among surrealists to be the major advantage of talking films. The explicative function of verbal communication is regarded as anything but critical to surrealist expression through film. In fact, surrealists look upon speech in movies as lending itself, under normal conditions of use, to severely restricting cinema, by making film no more than a mirror image of mundane reality. At the same time, though, surrealist filmmakers realize there are ways of liberating words from their traditional role. They are not interested in incoherent jumbling, by any means. They want instead to employ words to make the kind of sense to which the surrealist imagination can respond outside the limits of conventional discourse grounded in commonplace exchange. Absorption of the spoken word in an overall effect, obtained no less by what is shown than by what is said—this procedure lays the foundation for using verbal language as merely one contributing element instead of as the dominant feature of the communicative act of filmmaking.

Naturally, we do not have to accept without question everything its

directors say about *L'Invention du monde*, especially about how it *works*. What is important, essentially, is the intention behind their use of the contributing element of sound to fill out a scenario not written down, Bédouin once took care to emphasize, but entirely *drawn*.[9] The significant considerations are the movie's central theme, described in the synopsis as "Man transforms and re-creates what he chooses to represent," and the revealing complementary observation in Péret's text, "I am going to contemplate the other face of the world."

Surrealism challenges a common supposition that movies are most successful when they reflect familiar reality. In *L'Invention du monde*, the familiar does not supply the norms by which cinematic images are to be assessed. On the contrary, devotion to contemplating "the other face of the world" shows us a world "invented." Mundane reality is altered by creative imagination. Everyday phenomena are transformed, their routine function transcended in the operation of a magical interpretation of life's essential forces. For this very reason, one is tempted to isolate *L'Invention du monde*, to look upon it as a movie rendered exceptional by the peculiar nature of subject matter imposing special qualities which induced Bédouin and Zimbacca to spend two years making the film. Still, it does not follow that the unique nature of the material filmed in museums on two continents limits words and music to a role from which nothing can be learned about their place in surrealist cinema.

The principle relegating film commentary as an explanatory accompaniment backing up filmed imagery is challenged and found wanting in *L'Invention du monde*. The same may be said of *Jabberwocky*, made in Czechoslovakia in 1971 by surrealist Jan Švankmajer.

The only verbal element in Švankmajer's film, in which the music by K. Liska is noteworthy, comes at the very beginning. It consists exclusively of Lewis Carroll's poem "Jabberwocky," recited by a young girl or a prepubescent boy. The enigmatic character of the poem taken from *Through the Looking-Glass* is well known. In Carroll's text, conventional comprehensible language surrenders to bold, provocative portmanteau words, phonetic and semantic inventions that have found their way into the dictionary like *galumphing* (coined from *gallop* and *triumph*) and *chortle* (defined in the *Oxford English Dictionary* as a blend of *chuckle* and *snort*).

If we pause for a moment to look over the explanation furnished in an 1855 issue of Carroll's private so-called periodical *Misch-Masch* (where the first stanza of "Jabberwocky" originally appeared), we cannot but notice that it offers glosses likely to increase wonder, instead of liberating us from it. The *tove*, we learn, was a species of badger having smooth

white hair, long hind legs, and short horns like a stag. It lived chiefly on cheese, Carroll informs us. The *borogrove,* on the other hand, is an extinct kind of parrot: "They had no wings, beaks turned up, and made their nests under sun-dials: lived on veal." The *rath,* a species of land turtle, whose forelegs turned out so that it walked on its knees, lived on swallows and oysters. Given this mock scientific information ("The scorpion is a genus of Arachnida that lives generally under rocks"), let us consider the images passing by, while we hear the poem recited in Švankmajer's movie.

As the word *tove* is heard, a Biedermeier wardrobe fills the screen. Its doors open suddenly, revealing nothing inside. The admonition "Beware the Jabberwock, my son!" accompanies the spectacle of the wardrobe, now outdoors, zigzagging among the leafless trees of an orchard in winter. While another warning is being delivered—"Beware the Jubjub bird, and shun / The frumious Bandersnatch!"—the wardrobe charges the camera lens, moves offscreen from right to left, rides in once more from the right, and stops in the center, filling the screen again. A little later, as the poem tells of the Jabberwock coming "whiffling through the tulgey wood," the camera pauses above the wardrobe. Now a gallon jar of homemade fermenting wine begins to grow up from one of the wooden boards forming the top of the wardrobe, "blossoms," as Péret would say, "so that its seed may fall to germinate, grow, flower." Buttons, not berries, bob around inside. Immediately, another jar begins to grow, this one containing seashells. As yet another jar of button wine presents itself, together with a large jar of "homemade chestnut wine," we hear the verse, "And burbled as it came." Švankmajer treats us to a mini-documentary (with antitraditional, irrational commentary) on the making of button wine.

A letter from Carroll to a child-friend (perhaps one of those little girls he used to photograph nude—with mama's consent, of course) reports, "If you take the three verbs 'bleat,' 'murmur,' and 'warble,' and select the bits I have underlined, it certainly *makes* 'burble'; though I am afraid I can't distinctly remember having made it in that way." He could not explain, either, we recall, what a "tulgey wood" is. Meanwhile, in Švankmajer's film, words do not account for pictures any more than pictures explain words. Unrelated on the plane of commonsense relationship, they come together in a surprising combination to which only imagination has the privilege of furnishing a key.

The most memorable sequence in Švankmajer's *Jabberwocky* is the one during which we hear music, but no words. Three dolls sit at a table, each with a smaller doll on her lap. This is no Mad Hatter's Tea Party, however, but a meal during which the diners feed on tiny dismembered

dolls, just as the man and woman in Paranaguá's *Nadja* eat their children. With a spoon, one of the dolls at table pursues an elusive morsel around her dish. Swallowing a tasty mouthful, another closes her eyes blissfully. The largest diner delicately spoons small limbs and torsos into the mouth of the baby doll on her lap. And the music goes on with imperturbable sweetness.

At this point in *Jabberwocky*, music departs from the role it usually is called upon to play in motion pictures where it functions simply to provide suitable reinforcement of the mood generated by plot development or filmic imagery. Here music offers no clue that assists us in coming to terms with the scene before us. It denies us a feeling of confidence about the correct way to interpret what we see. Because it encourages neither alarm nor distaste, it fails to refer us to norms of conduct by which we are accustomed to judge what is reasonable and what is proper. It solicits no emotional reaction provoking either the horror or the disgust our eyes inform us we ought to be experiencing. The disparity between what we witness and its musical accompaniment results in discordance, not harmony. In short, music only *appears* to play a negative role. It leaves us alert to all that is disconcerting in the sight we witness, while still urging acceptance on the auditory plane of things usually considered unacceptable: dolls "playing house" the way their owners often do, thoroughly enjoying a meal that film animation persuades us to acknowledge as being cannibalistic.

Response to auditory impressions conflicts sharply with reaction to visual perception. Švankmajer refuses to let sight and sound complement one another in the traditional way that reduces music in film to a background sound one hears but to which one does not listen. Music has ceased to be a means of minimizing the distraction caused by the whirring of the projector. It is not, either, a conditioning agent, helping captivate audiences for whom a documentary is simply a short subject filling out a movie program. While dolls regale themselves on other dolls less fortunate than they (we see some of the unfortunate cooking in saucepans on top of a stove), music takes on a challengingly subversive quality.

The *"power to disorient"* admired in cinema by Breton and its power to "disquiet," attractive to Desnos, do not find their origin here in visual effect exclusively. Nor, for that matter, do they result from the intervention of sound alone. They have their source, on this occasion, in the mind's inability to reconcile music and visual image within the frame of accepted social usage, according to the moral and ethical values that the habits of social conduct enjoin us all to respect. Thus, the contrast between visual alarm and auditory reassurance, in place of the harmony

one is accustomed to find between sight and sound, gives Jan Švankmajer's sequence its impact.

A celebrated scene in *L'Age d'Or* impresses upon us the surprising presence of a cow in the heroine's bed-chamber, by way of the jangling bell suspended around the animal's neck. When the camera cuts to the hero, who is being led away down a street by plainclothes policemen, the sound of the cowbell is still audible. Like the dog barking at the prisoner, the sound of the bell offers a perceptible tie with the previous scene. It also links up with the next, during which we continue to hear the bell, the baying of hounds (developed, apparently, from the barking of the dog in the street), and, in addition, the sound of wind blowing. Up to a point, a logical progression seems discernible here. The presence of the cow explains the clanging of the bell, which establishes a firm connection between the woman and her lover. When the noise of barking carries over, while the camera returns to the bedroom, a sound effect the ear has registered as a movie cliché (the clamor of a baying pack, in eager pursuit of its quarry) lays a stepping-stone to a more surprising effect: Buñuel creates an unprecedented association between the sound of wind and liberation.

All this, though, represents some simplification in the interest of commonsense order. Proceeding more carefully, we notice that at no time does sound truly serve the cause of realism. Hearing a cowbell is no excuse, reason informs us, for having a cow lie in anyone's bed. Furthermore, the heroine is startled by the sound made by a dog too far away for her to hear, especially while lost in an onanist daydream (suggested by her action of buffing her fingernails). Buñuel's audience, meanwhile, still hear the cowbell during the street scene some distance away, just as they did earlier in the house. And the wind audible indoors (where it ruffles the woman's hair) emanates not from outside but from the mirror in front of which she is sitting. The symbolism of hounds in full cry may seem heavy-handed enough to surrender its meaning quickly. But it is overshadowed, in any case, by the humor of Buñuel's pun on *vache*, which the continuous sound of the bell invites us to understand in both its meanings, as (formally) "cow" and (colloquially) "cop."

Taking another glance at *Las Hurdes*, we see something else worth noting. Hearing the word *domestiques*, Pierre Unik's compatriots readily substitute for it the informal equivalent, *bonnes à tout faire*, prompted to do so when Buñuel lets his camera lens caress a young girl. The important thing is that the phrase *bonne à tout faire* (more suggestive in French than its translation—"maid of all work"—gives us to understand) is

never articulated. It does not need to be for the movie's audience to draw the inference intended.

We encounter a comparable effect in *L'Age d'Or*. Here the identification of bovine creatures with policemen is established by purely visual means, backed up by sound effects. It rests, really, on associations released by a word never actually heard in the film. The connection, clear enough to a French-speaking public, is lost on those unversed in *argot*. Such spectators are likely to find themselves bewildered by what they are shown, because they do not grasp the double meaning of *vache*. This is a word no one else hears, either, of course. However, it is critical to full participation in the visual associative process generated by the film's imagery.

Something interestingly similar occurs—just as intentionally, it seems fair to suppose—in a purely commercial vehicle, *The Bridge on the River Kwai*.

At first, it may seem a little puzzling that Lean should choose to have a column of British and Commonwealth prisoners arrive to the rhythm of an American march, at the beginning of his movie. Of course, we cannot discount the imperative need to appeal to the American market, which explains the presence of William Holden, who at least seems less out of place in this film than Steve McQueen does in *The Great Escape*. All the same, we finally discover an explanation beyond the pressing considerations of commercialism for Lean's use of "Colonel Bogey." It lies in the contemptuous abusive vulgarity it brings to mind without ever rendering audible. His devotion to "the maintenance of good order and military discipline"—to quote *King's Rules and Regulations*, which imposes on this man his narrow vision and special form of lunacy—leads the S.B.O. (not an unfamiliar variation on S.O.B., but Senior British Officer) to collaborate with his Japanese captors.

A less familiar example will illustrate more fully what is at issue here. It is provided by a short subject made in Czechoslovakia by Ludvik Šváb, during 1971. Called *L'Autre Chien*, it has a beginning that looks very familiar indeed to devotees of surrealist cinema. A man standing at a window looks out at a full moon, soon traversed by a narrow cloud appearing to cut it in half. Šváb makes no effort to conceal that he is engaged in what he terms "a kind of cinematographic reinterpretation" of *Un Chien andalou* (*L'Autre Chien* means, after all, *The Other Dog*). His reinterpretation entails disconcerting modification, however. Before watching the cloud move across the moon—just as Buñuel did, playing a character stropping his razor in *Un Chien andalou*—the man in *L'Autre Chien* looks down at the window sill. Here lies a tray bearing a plate

with two fried eggs. After the cloud has drifted by, still looking up, the man is seen absentmindedly playing with a knife, tapping its edge against his lower lip. The camera next concentrates attention on the dinner plate. A knife and fork enter the frame. The knife cuts through an egg, one half of which the fork raises toward the camera lens. We now see the man eating the half egg from the fork. Then the camera pans down from his mouth to his throat as he swallows. Dissolve. The film is over.

As described here, on the basis of the scenario, *L'Autre Chien* seems tedious, pointless even, an antifilm, perhaps, taking its effect (if one may go so far as to speak of its achieving any effect) from anticlimax. This seems to be the case because only people familiar with colloquial Czech can understand what lies behind the limited action of Šváb's movie. Everyone else needs guidance. To them the filmmaker explains, "My version's central—and only—gag is simple, and works well so far as an initiated audience is concerned." The uninitiated, meanwhile, cannot appreciate the film's sight gag because they are unable to recognize how, as Šváb puts it, this silent film is "rooted in linguistics."[10]

It is common among Czechs to say a full moon "shines like a fish eye." A related metaphor refers to a fried egg as a cow's eye. One has but to remember how a calf's eye was substituted for the woman's, when the close-up of the eye slashed by Buñuel's razor early in *Un Chien andalou* was filmed, to be able to follow the associative verbal sequence upon which Šváb relies to make his point comprehensible: "So the beauty which in the original version was destined to become a victim of brutal destruction in the act of ultimate freedom is here by means of a linguistic transformation made *edible,* and its consummation [sic] becomes the bleary act of an everyday pleasure. Yesterday's pathetic becomes today's trivial. Either aggression will be sarcastic or will not be at all." Significantly, Šváb's concluding sentence is cast in the framework of Breton's last one-sentence paragraph in *Nadja:* "Beauty will be CONVULSIVE or will not be at all." The end of Paranaguá's "Manifesto for a Violent Cinema" follows, we notice, the same word pattern: "Cinema will be violent or will not be at all."[11]

Watching *L'Autre Chien* may lead very easily to entirely wrong conclusions about its place in surrealism, about the things it has to tell us regarding the role of sound in surrealist cinema. The total absence of sound may foster the supposition that Ludvik Šváb made his little movie the way he did because the expense of adding sound would have been too burdensome. However, no sooner has that idea taken form than it has to be dismissed as unacceptable because quite inapplicable.

Ludvik Šváb, sequence
from *The Other Dog* (1971).

Sound in Surrealist Cinema 235

Other surrealist films in which we hear no sound do not really suffer for lack of it. They succeed in communicating a view of the world—a *vision surréaliste*—that sacrifices nothing important to all-embracing silence. In fact, the absence of dialogue or background noise encourages viewers to concentrate on sight, in a manner that helps them appreciate for themselves why the silent screen was so fascinating to many of the first surrealists. On the other hand, one cannot project *L'Autre Chien* after *Un Chien andalou* without observing clear differences. Beyond considerations of quality, judged on a plane where Šváb had no ambition to compete with Buñuel, these differences originate in a common source. Only if we recognize the following do we arrive at an understanding of what *L'Autre Chien* was meant to do, thus participating on a level where Šváb's unpretentious movie finds its meaning and value.

Buñuel did not need words in *Un Chien andalou*. He could reach the audience to whom he addressed himself with titles (which, incidentally, play havoc with our sense of chronological sequence), with facial expressions, and with revealing gestures, sometimes quite exaggerated.[12] In contrast, Šváb has no audience at all unless some of those who watch his film can supply the verbal phrases that underlie the visual imagery of *L'Autre Chien*, while yet remaining inaudible.

The most noteworthy feature of *L'Autre Chien* is that the all-important clue to its visual imagery is hidden in suppressed language. As others have done before him, Šváb makes clear that any form of explicit commentary whatsoever, any verbalized interpretation of visual elements assembled in a film, must be considered superfluous. In addition, he goes further than Brunius, further, too, than Buñuel, at least in one respect. In the most direct fashion imaginable, Šváb challenges us to note that we are in no position to estimate the importance of words in surrealist cinema unless we give attention to the presence, by implication, association, or suggestion, of certain words other than those to which the director asks us to listen.

Are we guilty of extending too far an inquiry into the surrealist function of sound when we reflect on the contribution made by silence, that is, by sound deliberately suppressed? It hardly seems that we are guilty when we consider how well-suppressed words can serve the purposes of surrealism. Indeed, surrealism in the movies brings to mind a remark by Paul Eluard. Discussing verbal poetry in his *Donner à voir*, Eluard affirms, "Poems always have big white margins, big margins of silence in which ardent memory is consumed to create anew a delirium with no past. Their principal quality is not to evoke, but to inspire" (p. 74). True, it may sound paradoxical to cite this statement of principle in connection with the surrealist potential of sound in film. Yet it is no less

appropriate to refer to Eluard's words, when cinema holds our attention, than it is for him to use them in the course of a discussion entitled "The Physics of Poetry." Their applicability to the film medium cannot be contested once the surrealist point of view has been acknowledged as exercising a profound influence on the manner in which movies may act on the spectator's sensibility.

For Eluard, the physics of poetry is a reaction in which the audience's role can never be totally passive. This is no less true of the movie audience than of a poet's readership, because surrealist film involves spectators in completing the poetic image. On some occasions, playing their part entails listening in the margin of silence left by the filmmaker. We are reminded of Eluard's assertion that one sees what one wants "only with closed eyes" (p. 76). He might have added that one hears what one wants, sometimes, only where silence reigns. Just as he argues that the reader of a poem "necessarily illustrates it," so, too, he might have identified a person really participating in the surrealist film experience as not merely watching but as similarly—and no less necessarily—illustrating it in such a way that the world "is illumined."

Šváb's juggling with linguistics as the pivot of *L'Autre Chien* may not impress all who see his film as either successful or even worth the effort. Some viewers are sure to feel that contrivance strains effect and that, in this one-joke movie, the joke falls flat. However, *L'Autre Chien* merits attention. In the name of surrealism, it reduces to the simplest practical terms a demonstration of cinema's ability to solicit response by bidding its audience attend to a margin of silence where they can answer the call of the surreal. Šváb's experiment is an enlightening one; it proves how readily, where sound is silenced, the visual may evoke words. In showing how film may tell through what it shows, his movie does more than hint at the surrealist potential of cinema's visual language.

How are we to listen? If we do so with the limited ambition to comprehend, we may as well not listen at all to the poem incorporated in Švankmajer's *Jabberwocky*; we will not *hear* the wind rushing out of the mirror in *L'Age d'Or*; a cowbell will bring to our minds the Swiss Alps, not the urban environment where cops prowl. Surrealist cinema may not always be as overtly violent as Paranaguá would wish. However, surrealists never cease to treat film as an initiative medium, one in which sound has a major role to play.

13
CONCLUSION

Surrealist creative endeavor presents enough variety to bewilder even the most careful and open-minded observer looking for discernible unity in the material surrealists offer through the art media in which they speak to us. On the surface, certain common elements present themselves in results that appear perhaps strange, outlandish, or even bizarre. Yet, whichever adjective sounds to an outsider most appropriate for describing what surrealists appear to want to tell and show, there is a grave disadvantage in applying it indiscriminately on the supposition that it provides an accurate measure of surrealist effect. We are left with the impression that all one must do, to be able to track surrealism down efficiently and without delay, is look for the strange, the outlandish, the bizarre, or indeed the weird. From this idea it is no more than a dangerously short step to the inference that surrealism finds its origins and reaches full scope in technique. From there our conclusion must be that surrealism can be defined perfectly adequately within a technical frame.

Of course, technique does play a part in surrealist creativity. All the same, technical considerations are far from the only ones that should matter to somebody hoping to understand surrealism through the behavior of the artists it encourages. The motivating force of their undertaking comes between all who engage in surrealist activity and individuals whose artistic objectives are more easily grasped because they center on an aesthetic.

Advocates of surrealism hold in contempt all rules growing out of aesthetic intentions. Because of this, many commentators persuade themselves that surrealists acknowledge and demand compliance with

no regulatory principles of any significance. Thus, it is easy for some to infer that surrealism expresses its adherents' determination to relax all controls. In fact, it seems to many people outside the surrealist camp that the attraction surrealism has held for numerous artists, often of remarkably dissimilar talents, lies no deeper and is no more meaningful than the authority each of these individualists thinks he has found among the surrealists for simply going his own way.

Surrealists apparently need have no regard for guiding principles such as those that have organized and given direction to well-known and respected "schools" of art and literature. It looks as if surrealism recruits, in the main, persons to whom discipline of a normally productive nature is as intolerable as any other. These are artists, it would appear, whose creative instincts are so diverse as to leave them inclined to seek and enjoy affiliation only with a "school" which refrains from attempting to channel or orient creative action—which is, in short, no school at all.

Conflicting with the estimate of the surrealists as an anarchical group bringing together a loosely knit band of individuals, each quite independent, is plentiful evidence that surrealism's defenders are capable of treating dissidents sternly, even with brutal harshness. Moreover, when they have expelled and subsequently attacked or ridiculed one or another of their number, it has been on the basis of principle more than of personal antagonism. The history of the surrealist movement has shown that more serious and more exacting demands have been made on its participants than the majority of outsiders appreciate.

Objective examination of surrealism, and of the conduct it inspires in men and women associated with it, brings to light certain tensions underlying creative activity by members of the surrealist circle. Generally speaking, tensions result from the interplay of two forces. Surrealism permits the individual freedom to tackle as he or she sees fit the problems it sets. It calls for resistance to the distraction offered by other matters traditionally important to artists, whatever their field happens to be. Of these matters, barred from consideration and attention in the context of surrealism, pursuit of beauty through art is surely the most prominent, the one surrealists appear most bold in ignoring. However, there is a more subtle temptation still than that of creating beauty, which all surrealists deem just as insidious in its effects and no less pernicious. This is egotism.

In his first manifesto André Breton insisted that he had no faith in a surrealist stereotype. It was not that he felt it would be premature to project one as early as October 1924. Rather, he was opposed from the first to the establishment of a pattern of surrealist creative action which

could be applied routinely, confidently, and therefore *without risk*. He sensed, evidently, that the temptation of egotism would undermine the work of anyone who, however fruitfully he or she had contributed to surrealism theretofore, began relying on previous achievements, returning to use over again methods that had already proven efficient, content now to repeat past successes and to exploit these—just as Salvador Dalí ended up doing.

Breton's suspicions are clarified in a remark made years later by a former surrealist, Nicolas Calas: "Communications hold our interest either for *what* is said or for *how* it is said, either for the *value* of the information contained or for the *attractiveness* of the presentation."[1] Essential to active participation in surrealism is the belief that communication is valuable above all for *what* it says. However, a surrealist who falls victim to egotism tends to stress more and more *how* he communicates. Emphasizing the attractiveness of presentation over content, he gradually abandons the surrealist position. Even if he does so only implicitly, he finds himself confirming Calas's argument that "the *attractiveness* of the presentation" is "the artistic component of the communication." So an individual wanders away from the surrealist camp in search of "art," which now means more to him than the surreal. Having become a technician more than a surrealist, by comparison with former associates he has transformed himself into a "false artist," defined by Calas as "one who exhibits his showmanship (mannerisms), and attempts to compensate [*sic*] the lack of insight by adding superfluous decorations." He has forgotten one of the first lessons of surrealism, now that he has ceased to acknowledge that the artist "should achieve that state of grace in which one overcomes the vain satisfaction of solving purely aesthetic problems" (p. 15).

Surrealists not only scorn compromise with aestheticism; they actually fear it. For them, a state of grace cannot be attained except by artists who turn their backs resolutely on aesthetic problems and solutions. Aesthetics and surrealist art remain mutually exclusive. For this reason, disaster must attend any effort to classify surrealism as a "mode" that can be adopted from choice, for whatever motive, only to be rejected the moment boredom sets in or when a more beguiling "approach" presents itself. One does not become a surrealist out of mere curiosity, because blessed with the gift of mimicry, or again with the ability to follow prescribed methods, to apply certain techniques, or to utilize ordained devices of one sort or another.

Devotion to aestheticism makes artists cognizant of and attentive to criteria established in advance of the creative gesture. It can hamper progress in surrealism and perhaps even bring it to a stop, possibly

obliging the artist to fall back a pace when he or she should concentrate on moving forward. Given the peculiar nature of surrealism, the heavy demands it makes, and the limitations it imposes, creative action cannot be adjusted so as to cause it to respect a fashion or to apply a formula. On the contrary, creative vitality would be sacrificed any time a surrealist felt content to aim no higher than imitation of predecessors or contemporaries. Louis Aragon's image of the surreal as located on the horizon line, consequently as retreating before anyone advancing toward it, has never lost its pertinence. It has not ceased to highlight the dynamism of surrealism and to support Breton's view that surrealism is "what *will be*."

As surrealists see it, aestheticism sets a trap into which artists must not let themselves fall so long as they wish to avoid the crippling confinement of fixed forms, rules, and regulations. From the surrealist standpoint, the latter appear restrictive because they have been designed for one purpose only: to foster certain *effects*, subject to evaluation according to standards that do nothing to help bring us closer to the goals of surrealism. The distinction their aspirations require surrealists to draw between literature and poetry, for example, dismisses traditional customs governing the use of language in verse, shall we say. It marks a liberative assertion in which the seeds of surrealist poetry are sown. Literature is seen as hedging expression within restrictive formal limits. As for poetry, in the surrealists' estimation, it can overthrow barriers of all kinds. It is an affirmation which, before anything else, assures freedom of inspiration—no less in painting and cinema than in the written text or the surrealist object.

In the absence of a clearly definable aesthetic purpose, the significance of surrealist activity is at first hard to identify, doubly so for anyone who imagines that, even though surrealists do not confess publicly to aesthetic ambitions, however vaguely formulated, they must have some, really. The majority of commentators experience difficulty comprehending that it is in the nature of surrealism to demand something other than attention to aesthetic matters. As a result, many observers cannot grasp the advisability of studying less the techniques of surrealism per se than the languages in which surrealists address their audience.

The surrealists have not been content with scoffing at the earnest pursuit of beauty. Their practice as poets, painters, filmmakers—and also when reading poems, looking at pictures, watching movies, or contemplating surrealist objects—has demonstrated over and over again that traditional aesthetic concerns are inimical to surrealism. Surrealists are prompted to creative action by their conviction that seeking conventional beauty—to which Breton, in his *Nadja*, opposed *"convulsive"*

beauty—leads an artist, whatever his medium, along paths where there is little likelihood of his making discoveries to which they attach any value at all. In the course of an early essay on Francis Picabia, reprinted in *Les Pas perdus*, Breton openly condemned both "the long-established predilection for fixed forms in literary matters" and "the dogma of 'composition' in painting." On the same occasion he argued that it is at the price of "constant renewal," having to do in particular with "the means used," that the artist can avoid becoming "prisoner to a genre which he has or has not created" (pp. 162–63). Because of the standpoint they share, surrealists are bound to be dubious about the benefits of form. They are dedicated, instead, to seeking illumination through content.

Responding to an inquiry conducted by the newspaper *Le Figaro*, Breton (who had yet to publish his first surrealist manifesto) remarked in a text later reprinted in *Les Pas perdus* that poetry would hold no interest for him if he did not expect it to suggest "a particular solution to the problem of our lives" (p. 138). Soon after, he revealed himself to be eager to obey what he called in "Entrée des médiums" the "magic dictation" of automatic writing (p. 150) and its "precious confidence" (p. 151). He and the first recruits to surrealism felt confident that one may obey "without fear of going astray." In other words, it became clear very

Chas Krider, *Cosmetic Cosmos* (1980), photograph.

early that surrealists were to be preoccupied with content that increases knowledge, whether through words or pictures or by way of some other expressive mode.

The ambition surrealists were to take with them into the creative field may sound quite laudable. Even so, it does not stand out in clear enough definition, yet, for us to be able to estimate the scope of its consequences for artistic expression. To progress further, we must be attentive when Breton praises Picabia in *Les Pas perdus* and notes that, for the first time, a painting becomes "a source of mystery," adding, "with this art without a model, neither decorative nor symbolic, Picabia no doubt has just arrived at the highest scale of creation" (p. 165). In a public lecture delivered 17 November 1922 at the Ateneo in Barcelona, Breton spoke of an exhibition of Picabia's drawings due to open the very next day: "Here, we are not dealing, either, with painting, or even with poetry or the philosophy of painting, but with a few of the inner landscapes of a man who left a long time ago for the pole of himself" (p. 195). As reprinted in *Les Pas perdus*, Breton's statement leads to a somewhat quaintly phrased climax. Its meaning is plain enough all the same. In Picabia's art, the absence of a model borrowed from the outside world prepares spectators to survey landscapes painted from "the *purely inner model*" of which we read in *Le Surréalisme et la peinture*. The absence of symbolic or decorative intent permits concentration on a journey for which the self is the polestar.

The emphasis giving direction to surrealist creative action betrays two preoccupations above all. The first of these is crystallized in the following question: how to gain access to content that will advance surrealism's ambitions by extending knowledge beyond the boundaries set by rational projection. With this question goes another: how to communicate knowledge of the kind in which surrealists are interested. An answer to the first question began taking shape when Breton and Philippe Soupault experimented with automatic writing, when Joan Miró and André Masson tapped the potential of graphic automatism. As for the second, phrasing it suffices in itself to draw attention to something of importance. Surrealists approach verbal poetry, painting, cinema, and so forth in a spirit of inquiry, asking how each medium may become a language for surrealism.

We cannot broaden our understanding of the things a surrealist attempts to accomplish (or ends up achieving, for that matter) unless we realize how his or her interpretation of the word *language* expands its meaning. Our estimate of surrealism must fall short if we persist in interpreting its languages as communicative means exclusively. We miss essentials so long as we try to gauge what surrealists try to do and in

fact manage to accomplish, without investigating how a surrealist's language can do more than merely share with its audience something he or she has discovered and decided to make public. What role does language play in actually promoting discovery? How does it function, not just as a vehicle for conveying the artist's findings but also as an instrument that can make certain findings possible?

To the surrealists the value of the word *language* is functional, not decorative. Seeking to master a language involves acquiring a communicative mode suitable for sharing discoveries to which surrealism grants weight and, more than this, for making new discoveries possible. Surrealist inquiry is directed toward one end in particular. The surrealists' use of various forms of investigation is dictated by a common objective, transformation of each and every medium of artistic expression into a cognitive instrument. Hence, the success of each surrealist language is to be judged according to its efficiency as a means for expanding knowledge.

If there is a guiding principle on which the surrealist must address the task before him, it can only be this. No established regulations offer any guarantee of success or of progress out of familiar reality into the realm of the surreal. Imitation, meanwhile, however genuine the admiration it betokens for one's predecessors, is nothing more than—to borrow the phrase with which Breton once recorded his own feelings of disappointment with Dada—"a means of sitting down." Imitation is as close to complacency as the self-kleptomania against which Breton railed. In its place, surrealism demands self-renewal, which we are to believe eludes any artist no longer dedicated to self-exploration.

Because none exists, no generally applicable rules can be followed confidently by artists nervous about losing their way or hoping to avoid being led astray. Exploring the communicative possibilities of their respective languages, each surrealist must test a medium's revelatory capabilities, must judge its potential for bringing knowledge out of what it lets him see. Hence, his obligation is to measure the liberative capacity of his chosen expressive mode according to its ability to extend self-knowledge, first in its creator and then in an audience.

Surrealism does not simply teach that a step already taken need not be taken again. It asserts vigorously that a tendency in the artist to repeat what is behind actually takes that individual backward. In addition, it leaves the artist open to the risk of losing his or her way, so that moving ahead once more becomes especially difficult. Retracing one's steps is seen as tantamount to ignoring the unknown and succumbing to dull preoccupation with the known. Looking back to the past and the

gains made so far precludes, surrealists are convinced, advance into the unknown which lies ahead.

Development of a surrealist language would be quite a meaningless and fruitless project unless posited on trust that the unknown can be induced to yield up its secrets, that advance out of the familiar into the unfamiliar is feasible and—so long as a serviceable language can be found—in fact likely. The optimism keeping surrealism alive has its wellspring here.

Opposition to aestheticism is unyielding among surrealists. All the same, it has nothing to do with failure to recognize or to appreciate beauty. Opposition follows, instead, from the surrealists' conviction that searching for beauty by traditional methods diverts attention from the central purpose of art and, indeed, may impede attainment of viable artistic ends. These ends are always identified in the surrealists' mind with the active pursuit of knowledge. Surrealists find this pursuit too pressing a concern to leave them time or inclination to indulge a taste for familiar beauty in art. It is not that they are incorrigible philistines, their sensibilities too numb to let them appreciate the kind of beauty that holds cultivated people's attention. Nor again does the search for knowledge merely oust the beautiful or turn surrealists away from its contemplation. In surrealism, pursuit of knowledge takes on the significance that beauty holds for individuals who locate the goal of art in aesthetics. Breton made this clear when asserting that beauty must be "convulsive"—disruptive of inherited values and fashioned by criteria revolutionary in nature and surrealist in origin.

What place is there for surprise in the context of surrealist thought and of the activity inspired by surrealist thinking? Following up this question reveals that Breton was disinclined to lay down conditions under which surprise would be acceptable. He would not specify, either, under which conditions it would be decidedly unwelcome. Still, underlying his demand for surprise, sought "unconditionally" and "for itself," is the presumption (fundamental to the attitude behind that requirement) that pursuit of surprise will benefit surrealism materially. Thus, in Breton's mind there appears to have been a contradiction between his proposal that surprise be sought for itself, unconditionally, and his repeated assurances that he himself was dedicated to reaching only goals consistent with surrealist ambitions. Actually, Breton saw no contradiction, by any means; nor has any surrealist coming after him done so. To be exact, in surrealism contradiction was resolved from the start by faith in the beneficence of chance. Surrealists have remained persuaded that chance has the power to meet human need, even in someone unaware

Juhani Linnovaara, *Rain Still Life* (1975), acrylic on canvas.

of the nature of his or her own needs and therefore surprised to find what these prove to be.

Obviously, the word *need* lends itself to a broad range of interpretations. Nevertheless, in the surrealist's mouth, under pressure from aspirations common to members of the surrealist circle, it tends to narrow considerably in scope. Of the meanings for *need* recognized among surrealists, one in particular comes into focus as we notice how the surrealists view chance as most beneficent when it helps bring about inexplicable (*"convulsive"*) surprises, in this way shedding light on things reason cannot satisfactorily interpret or classify. The kind of surprise to which surrealists look customarily for illumination accords naturally with their wish to see knowledge expand in directions where reason is not equipped to monitor discoveries or assess their importance, where it even opposes attributing them any perceptible value at all.

The knowledge that really counts for surrealists not only evades analysis and evaluation, once gained, but also eludes advance projection, so

taking the artist beyond conscious need. This is not knowledge such as one can purposefully seek to acquire, then, but knowledge that the rational mind is incapable of deliberately aiming to gather. Acquisition of what surrealists need to know cannot be subject to advance regulation, especially when—as is often the case in surrealism—a need does not take on full definition and dimension until it has been satisfied. Exploratory surrealist practice must serve to open the door on the presently unknown. And the unknown, of course, includes things we do not know that we do not know.

Everything helping give surrealism its appeal for those who participate in it can be traced to the one assumption that ignorance fills a positive role, not a negative, retarding one. In surrealism, ignorance is anything but a token of sloth, of comfortable acceptance of the status quo. It fosters experimentation with means that are prized because they can uncover more than is known to be concealed. The fascination of the surrealist quest is that, by the route of surprise, it leads beyond the anticipated. The inexhaustible potential of the known to extend its territory at the expense of the unknown increases surrealism's vitality.

On balance, it is not the communicative function of language but its investigative capability that gives language the value it holds for surrealists. Language, then, is not merely an instrument to be employed skillfully for the dissemination of knowledge possessed by the artist. It is a means for attaining wider perspectives and deeper insights.

Surrealists who let themselves be distracted by concern for the communicability of their materials are sure to rate lower, among their fellows, than those who give themselves over to capturing revelations without pausing to wonder how they are going to share with others whatever will be discovered. This is not to say that surrealists are hostile to their public or that they remain totally indifferent to the reception given their work. They never waver in their trust in surrealism's message of mental and emotional emancipation. They continue to be confident that surrealism will find its audience. At the same time, they are suspicious of any inclination in the artist to adjust—out of consideration for reader or viewer—the revelations that surrealism induces them to prize. They feel sure that adjustment can result only in distortion of the surrealist program.

Breton may not have recognized immediately the necessity for giving discovery precedence over communication. Even so, his celebrated aphorism, "Language has been given man so that he can make surrealist use of it," would have commanded less respect among surrealists if it could not be read as entitling surrealists to set greatest store by the exploratory function of language. Sidestepping the question of the ori-

gin of language, Breton concentrated on the use to which it should be put. The role of language, he concluded, was to be exclusively surrealist. Thus, anyone using it in contradiction with surrealism's demands must be guilty of misapplying it. The uncompromising requirements drawn up in the name of surrealism and the severity with which surrealists were to condemn all who departed from or ignored Breton's premise have their source here. It is here that surrealists find justification for attacking everyone whose concept of language is at variance with their own.

Surrealism grants unity of aim and significance to diverse expressive modes. Each qualifies as a language of surrealism to the degree that it measures up to demands that surrealists consider important enough to make. Even where external evidence of unification appears lacking, the languages of surrealism are marked by an organic unity that comes to light as one perceives the essential meaning of surrealist thought. When that happens, the stridency of certain claims voiced by surrealism's spokesmen, the harshness of their criticism of literary or pictorial artists who disagree with them, and their obstinate refusal to compromise cease to be the most memorable features of surrealist practice and can be perceived as secondary to a purpose of deep significance.

Surrealists are persuaded that they have every reason for mistrusting artists who aim no further than displaying their expertise. Technical competence signifies to surrealists that such individuals have reached a plateau and that each has managed to consolidate a position there. Safe and sure of themselves, these artists feel little or no inducement to push on farther still. In fact, the exercise of skills each already has at his or her disposal and can use without hesitancy discourages the attempt to do more than he or she has proved capable of doing. It helps convince the artist that he or she might lose more than would be gained by seeking to rise to a higher plateau or even accepting the idea that one exists. Having an individual "style," a "manner," confines an artist within limits largely of his or her own making, surrealists believe. Being in such a position would not simply make surrealists restive but would lead them to question their roles as creative artists.

Critics who suppose that circumstances in the end forced Breton to admit the inadequacy of automatic writing as a literary technique misunderstand the situation in which his poetic aspirations place any surrealist. Automatic writing was never proposed or accepted by the surrealists as a literary device. It was a language taken up as a tool for poetic investigation. When, as tools do, it began to lose its cutting edge, leaving no expectation of rendering it serviceable again, Breton did not try to conceal the fact.

The surrealists' distrust of prescribed techniques, regulatory principles, aesthetic constants, and fixed parameters for creative activity is not a sign of unintelligent prejudice. Nor is their failure to meet all or any of the conditions and criteria respected by other artists merely a token of ineptitude or a consequence of blindness or insensitivity. Turning away from well-worn traditional routes, the surrealists strike out on their own, assured that only by doing so can they fulfill their obligations. In pursuit of the aims they have before them, they must work at all times with the knowledge that, in surrealism, art is a means, not an end to be kept in sight. Hence, the languages of art are simply methods on which surrealists rely to bring them through to revelations that will demonstrate art's ability to transcend conventional purposes and become a gateway to the surreal.

Because surrealists avail themselves of familiar frames of artistic expression, even when they modify these radically for their own use, it seems to many an observer permissible to judge surrealism by standards usually applicable when art forms are brought under scrutiny. It is easy enough for critics to infer that a surrealist aspires to be a painter of sorts or a poet of sorts and to conclude that he or she falls short of success, managing to be neither a painter nor a poet of the best sort. Yet surrealists often come closest to their goal—they pursue it, anyway, with greatest tenacity—when the results they obtain do not measure up against established critical values. The languages of surrealism may not always ring true in the ear of the nonsurrealist. But it is when skeptical critics have most trouble listening that surrealists display the possibilities of their language best. It is then that each speaks his or her language most fluently and finds the most appropriate medium for expressing surrealism.

NOTES

NOTES TO CHAPTER 1: INTRODUCTION

1. André Breton, *Manifestes du surréalisme* (Paris: Jean-Jacques Pauvert [1962]), p. 183.

2. Tristan Tzara, "Essai sur la situation de la poésie," *Le Surréalisme au service de la Révolution* 4 (December 1931): 15. Further references cited in the text.

3. Paul Eluard, *Donner à voir* (Paris: Gallimard, 1939), pp. 79–80.

4. Breton, "Distances," in his *Les Pas perdus* (Paris: Gallimard, 1924), p. 174. Further references cited in the text.

5. Alain Jouffroy, "Post-face" to his *Aube à l'antipode* (Paris: Le Soleil Noir, 1966), p. 120. Further references cited in the text.

6. See the catalog *Surrealist Intrusion in the Enchanters' Domain* (New York: D'Arcy Galleries, 1961), p. 79.

7. See the letter from Breton to Jean Gaulmier, cited in Gaulmier's edition of *Ode à Charles Fourier* (Paris: Klincksiek, 1961), pp. 7–8.

8. Breton, "Entretien avec Madeleine Chapsal," in his *Perspective cavalière* (Paris: Gallimard, 1970), p. 206.

9. Jean Schuster, "A l'ordre de la nuit, au desordre du jour," *L'Archibras* 1 (April 1967): 4.

NOTES TO CHAPTER 2: SURREALIST IMAGE-MAKING

1. André Breton and Jean Schuster, "Art poétique," *BIEF: jonction surrealiste* 7 (1 June 1959): no pagination.

2. Quoted in James Thrall Soby, *Yves Tanguy* (New York: The Museum of Modern Art, 1955), p. 17.

3. Breton, *La Clé des champs* (Paris: Les Editions du Sagittaire, 1953), p. 112. Further references cited in the text.

4. Ibid, p. 10.

5. Max Ernst, "Comment on force l'inspiration (Extraits du 'Traité de la peinture surrealiste')," *Le Surréalisme au service de la Révolution* 6 (15 May 1933), as cited in Ernst, "Inspiration to Order," *Beyond Painting* (New York: Wittenborn, Schultz, 1948).

6. See André Masson, *Entretiens avec Georges Charbonnier* (Paris: Julliard, 1958). Text of a radio series broadcast between October and December 1957.

7. Breton's uncertainty about the adaptability of painting to surrealism's demands, at the time he wrote his manifesto, is evidenced in the list of painters cited: Uccello, Seurat, Gustave Moreau, Matisse, Derain, Picasso ("by far the most pure"), Klee, Man Ray, Max Ernst, and, "so close to us," Masson. See *Manifestes du surréalisme* (Paris: Jean-Jacques Pauvert [1962]), p. 42.

NOTES TO CHAPTER 3: GRAMMAR, PROSODY, AND FRENCH SURREALIST POETRY

1. André Breton, "Caractères de l'évolution moderne et ce qui en participe" (Text of a lecture delivered at the Ateneo, Barcelona, 17 November 1922), 210.
2. J.-K. Huysmans, Preface to the 1903 edition of his *A Rebours*. See Lucien Descaves, ed., *Œuvres complètes de J.-K. Huysmans*, vol. VIII (Paris: Crès, 1928–34), p. VI.
3. After all, Soupault wrote an "epitaph" for Aragon, as he did for André Breton, Arthur Cravan, Paul Eluard, and Théodore Fraenkel (but not for Benjamin Péret). In it he predicted optimistically, "You will make poems throughout Eternity."
4. Translations are not provided for extracts selected only as illustrations of rhythmic structures and syntactical constructions reminiscent of those found in nineteenth-century French verse.
5. Incidentally, Rosey would fall into an unmistakably traditional declamatory style when reading his own poems, as would Breton (though to a lesser degree). Notation of this fact is not intended to imply that their manner of recitation detracted from the poetic content of their work. The very opposite was true. Still, the contrast is sharp when we hear a younger surrealist poet, Jehan Mayoux (born 1904), read in accordance with his theory that one must recite poetry as though it were prose and sharper still when we listen to an even younger surrealist, Robert Benayoun (born 1926).
6. This is the sole text by which Jean Arp is represented in successive editions of Breton's *Anthologie de l'Humour noir*, between 1940 and 1966.
7. Originally published in Mexico City under the imprint Poésie et Révolution, Benjamin Péret, *Le Déshonneur des poétes* was reprinted with *La Parole est à Peret* (Paris: Jean-Jacques Pauvert, 1965), p. 82.
8. See Breton, *Manifeste du surréalisme* (Paris: Jean-Jacques Pauvert [1962]), p. 41, for a list of literary figures from the past, in whom Breton detects surrealist qualities.
9. In *Nadja* (Paris: Gallimard, [1963], p. 9), Breton speaks of revealing to himself "what among all the others I have come into this world to do." No more disgraceful betrayal of the surrealist's sense of destiny could be imagined than Richard Howard's translation of this phrase in the American edition of *Nadja* (New York: Grove Press, 1960), p. 13, as "what I alone have been put on this earth to do."

NOTES TO CHAPTER 4: JEAN-PIERRE DUPREY

1. André Breton, *Anthologie de l'Humour noir* (Paris: Jean-Jacques Pauvert, 1966), definitive edition, "Paratonnerre," pp. 11–22.
2. Alain Jouffroy, "A Jean-Pierre Duprey le suprême inconnu," *Phases* 5–6 (January 1960): 37.
3. Jean-Pierre Duprey, "C'était à la je ne sais quoi...," *Edda* 2 (March 1959), no pagination.
4. André Breton, "Lettre-preface," in Jean-Pierre Duprey, *Derrière son double* (Paris: Le Soleil noir, 1950), p. 16.
5. Benjamin Péret, "La Pensée est UNE et indivisible," *VVV* 4 (February 1944): 9.

6. Discussion of Duprey's writings in relation to theater will be found in J. H. Matthews, *Theatre in Dada and Surrealism* (Syracuse, N.Y.: Syracuse University Press, 1974), pp. 213–31.

7. Extracts from Duprey's *Spectreuses* (1949) were published in the *Almanach surrealiste du demi-siècle*, a special issue of *La Nef* 63–64 (March-April 1950): 115–24. They were illustrated by Max Ernst. The five Ernst drawings were gathered on one page when *Spectreuses* was printed in its entirety after *Derrière son double*.

8. Jean-Pierre Duprey, *La Forêt sacrilège* (Paris: Le Soleil noir, 1970), p. 30.

NOTES TO CHAPTER 5: ANDRÉ BRETON AND JOAN MIRÓ

1. André Breton, *Yves Tanguy*, trans. Bravig Imbs (New York: Pierre Matisse Editions, 1946), designed by Marcel Duchamp.

2. The same holds true, of course, for inferior surrealist poets, despite Edward Germain's efforts to make a case for David Gascoyne's "The Very Image," a poem dedicated to René Magritte, in his "Four Surrealist Images," *Visible Language* 8, 4 (Autumn 1974): 319–32.

3. Claude Tarnaud, *Braises pour E. F. Granell* (Paris & New York: Editions Phases, 1964).

4. Anna Balakian goes further: "After writing free verse for more than thirty years, Breton arrives in *Constellations* to [sic] the prose stanza, reminiscent not of Baudelaire's poems in prose, nor of Reverdy's, but of Rimbaud's *Les Illuminations* in its compactness and concrete ellipsis." See Anna Balakian, "From *Poisson soluble* to *Constellations*: Breton's Trajectory for Surrealism," *TCL* 21, 1 (February 1975): 53. The purpose of what follows here is not to deny the sensitivity displayed in Anna Balakian's perceptive analysis of image patterns in Breton's texts, but to consider the latter in conjunction with the graphic works from which their author drew inspiration. Breton, it should be noted, first published a selection of his *proses parallèles* as "Constellations," with the explanatory footnote, "Sur sept gouaches de Joan Miro (1940–41) et sous leurs titres." They appeared without the relevant graphics in *Le Surrealisme, même* 5 (Spring 1959): 4–7.

5. Man Ray and Paul Eluard, *Les Mains libres* (Paris: Jeanne Bucher, [1937]); Hans Bellmer and Paul Eluard, *Les Jeux de la poupée* (Paris: Editions Premières, 1949).

6. Vincent Bounoure and Jorge Camacho, *Talismans* (Paris: Editions surrealistes [1967]). Cf. the *prière d'insérer* by José Pierre: "Playing dice with the hypothetical portrait of woman, Vincent Bounoure and Jorge Camacho, in common accord, adjective their blazon."

7. In an essay called *"Constellations* de Joan Miró," *L'Œil* 48 (December 1958), Breton spoke of "the twenty-two gouaches as a whole," reiterating, "Twenty-two times in all—the magic number."

8. See Jean Ferry, *Une Etude sur Raymond Roussel* (Paris: Arcanes, 1953), p. 29. Breton's preface is reproduced as "Fronton-virage" in his *La Clé des champs* (1953), where the error goes uncorrected.

9. Michel Beaujour, "André Breton et la transparence," in Breton, *Arcane 17* enté *d'Ajours* (Paris: 10/18 [1965]), p. 163–64.

10. Jacques Dupin, *Joan Miró: Life and Work* (London: Thames and Hudson, 1962), p. 356.

11. See Legrand's prefatory note to the *proses parallèles* in Breton, *Poésie et autre* (Paris: Le Club du Meilleur Livre, 1960), p. 333.

12. René Alleau, ed., *Dictionnaire des Jeux* (Paris: Tchou, editeur, 1964), s. v. "tarots."

13. Quoted by James Johnson Sweeney, "Joan Miró: Comment and Interview," *Partisan Review* 2 (February 1948): 210–11.

14. Breton, *"Les Chants de Maldoror* par le comte de Lautréamont," in his *Les Pas perdus* (Paris: Gallimard, 1924), p. 80. The optimistic idea of being led links up with

that of *La Clé des champs* (Paris: Les Editions du Sagittaire, 1953), the title of a collection of essays by Breton, issued with jacket illustration by Miro.

15. Remark recorded by Georges Duthuit in "Où allez-vous Miro?" *Cahiers d'Art* 9, 8–10 (1936): 261.

16. In notes on *Constellations* appearing in his *Breton* (Paris: Gallimard, 1970), Philippe Audoin asserts, "The point of departure appears to have been provided, as the case may be, either by the title of the plate or by one of its graphic elements, or again by its general tonality" (p. 224). Audoin does not specify, however, whether these remarks owe anything to information furnished by Breton or Miró.

17. An oil on canvas bearing the title *L'Echelle de l'évasion* (The Escape Ladder) dates from December 1939. Apropos of the ladder motif, Miró confided in Sweeney, "In the first years it was a plastic form frequently appearing because it was so close to me—a familiar shape in 'The Farm.' In later years, particularly during the war, while I was on Majorca, it came to symbolize 'escape,' an essentially plastic form at first—it became poetic later. Or plastic first, then nostalgic at the time of painting 'The Farm,' finally symbolic" (See James Johnson Sweeney "Joan Miro: Comment and Interview," *Partisan Review* 2 [February 1948]: p. 209).

18. Benjamin Péret, "Du fond de la forêt," *Le Surrealisme, même* 2 (Spring 1957): 109.

19. As quoted by Alan Milburn, "Some Modern Spanish Painters," in Nigel Glendinning, ed., *Studies in Modern Spanish Literature and Art* (London: Tamesis, 1972), p. 111.

20. In *BIEF: jonction surréaliste* 7 (1 June 1959), no pagination.

NOTES TO CHAPTER 6: SURREALISM'S "UNDERLYING AMBITION"

1. For text, see André Breton, "Situation surréaliste de l'objet" in his *Manifeste du surréalisme* (Paris: Jean-Jacques Pauvert [1962]), p. 311.

2. William York Tindall, *Forces in Modern British Literature 1885–1956* (New York: Vintage Books, 1958), p. 238. Tindall's incapacity to judge surrealism led him to pronounce Eluard "the best poet of the group" (p. 235). On Davies's *Petron* see J. H. Matthews, "Surrealism and England," *CLS*, I, 1 (1964): 55–72.

3. Assembling in 1928 a succession of articles on surréalism and painting originally published in the first French surrealist magazine *La Révolution surréaliste*, *Le Surréalisme et la peinture* was published in several expanded editions by Gallimard in Paris until 1965. Further references cited in the text.

4. Edward Germain, "Four Surrealist Images," *Visible Language* 8, 4 (Autumn 1974): 321. Germain gives an inaccurate page reference to the unreliable translation of Breton's manifestoes by Richard Seaver and Helen R. Lane, published by the University of Michigan Press in 1967. Rendition of the word *rapprochement* (borrowed by Breton from Pierre Reverdy) as "juxtaposition" is not Germain's fault, however.

5. Dylan Thomas, "On the Marriage of a Virgin," *Collected Poems 1934–1952* (London: Dent, 1952), p. 127; Germain identifies Moore's line as coming from "Poem about England." His fanciful reference is to "*View*, III (October 1943)." The third series of *View* ran between April and December 1943. Nos. 2 and 3 are not dated by month.

6. Breton, *Anthologie de l'Humour nòir* (Paris: Jean-Jacques Pauvert, 1966), p. 402.

7. Thomas's radio play is set in a village with an almost plausible sounding Welsh name, Llareggub—which is nothing other than the vulgarity "bugger all" written backward.

8. Breton, *Yves Tanguy*, trans. Bravig Imbs (New York: Pierre Matisse Editions, 1946), p. 11.

9. Spike Milligan, "The Dreaded Batter Pudding Hurler (of Bexhill-on-Sea)," in *The Goon Show Scripts* (London: The Woburn Press, 1972), p. 28. Two studies of the surrealist content of Milligan's scripts have appeared: Jacques B. Brunius, "The Goon Show," *Le Surrealisme, même* 2 (Spring 1957): 86–88; J. H. Matthews, "The Goon Show: it all depends on where you're standing," *Surrealist TransformaCtion* 6 (1973): 14–24, also

taken up in his *Toward the Poetics of Surréalism* (Syracuse, N.Y.: Syracuse University Press, 1976), pp. 189–205.

10. Breton, "Silence d'or" in his *La Clé des champs* (Paris: Les Editions du Sagittaire, 1953), p. 78. Further references cited in the text.

11. It was apropos of Pablo Picasso that, in his very first essay on surrealism and painting, *La Révolution surréaliste* 4 (15 July 1925): 27–28, Breton rejected art based on imitation in favor of art referring to *"a purely inner model."* Cf. *Le Surréalisme et la peinture* (Paris: Gallimard, 1965), p. 4.

12. For the purposes of the present discussion the function of the preposition in surrealist writing has been examined exclusively in the work of Breton. See J. H. Matthews, *Benjamin Péret* (Boston: Twayne, 1975), for the use made by Péret of prepositions (pp. 89–102), conjunctions (pp. 77–84), and verbs (pp. 103–19).

NOTES TO CHAPTER 7: *LE CADAVRE EXQUIS*

1. Isidore Ducasse, Comte de Lautréamont, *Poésies*, première édition commentée par Georges Goldfayn et Gérard Legrand (Paris: Le Terrain Vague, [1960] 1962). This edition was delayed two years in press.

2. Tristan Tzara, "Recette du 'cadavre exquis' écrit," in the catalog *Le Cadavre exquis: son exaltation* (Milan: Galleria Schwarz, n.d.), p. 18.

3. Simone Collinet, "Les Cadavres exquis," in *Le Cadavre exquis: son exaltation*, pp. 30–31.

4. Tzara, "Recette du 'cadavre exquis' dessiné," in *Le Cadavre exquis: son exaltation*, p. 24.

5. Jindřich Chalupecký, "Le Cadavre exquis à Prague," in *Le Cadavre exquis: son exaltation*, p. 42.

6. Marcel Duhamel, "Le Cadavre exquis," in *Le Cadavre exquis: son exaltation*, p. 32.

7. René Alleau, ed., *Dictionnaire des Jeux* (Paris: Tchou, editeur, 1964), s.v. "jeux surréalistes," p. 478. Further references cited in the text.

8. André Masson, "D'où viens-tu cadavre exquis? Un des jeux (sérieux) des surréalistes," in *Le Cadavre exquis: son exaltation*, p. 28.

9. See J. H. Matthews, *The Imagery of Surrealism* (Syracuse, N.Y.: Syracuse University Press, 1977), pp. 145–46.

NOTES TO CHAPTER 8: COLLAGE

1. See the entry "Collage (dans le domaine litteraire)," contributed by Henri Béhar to Adam Biro and René Passeron, eds., *Dictionnaire général du surréalism et de ses environs* (Fribourg: Office du Livre, 1982), pp. 97–98, and Renée Riese Hubert, "The Fabulous Fictions of Two Surrealist Artists: Giorgio de Chirico and Max Ernst," *New Literary History* 5 (1972–1973), especially p. 165.

2. The canvases in question are discussed in J. H. Matthews, *Eight Painters: The Surrealist Context* (Syracuse, N.Y.: Syracuse University Press, 1982), pp. 15–21.

3. Jacques B. Brunius, "Rencontres fortuites et concertées," in the catalog *E. L. T. Mesens, 125 Collages et Objets* (Knokke-le-Zoute: July-August 1963).

4. See, for instance, Jacques Carelman, *Saroka la géante* (Paris: Le Terrain Vague, 1965) and Luis Garcia-Abrines, *Asi sueña el profeta en sus palabras* (Saragossa: Coleccion Orejudin, 6 [1966]).

5. Pierre Mabille, *Le Merveilleux*, written in Mexico, August 1944 (Paris: Les editions des Quatre Vents, 1946), p. 11. Further references cited in the text.

6. Mabille, *Le Miroir du merveilleux* (Paris: Les Editions de Minuit, 1962), p. 18.

7. Kral's phrase occurs in the course of his remarks, in the *Dictionnaire général du surréalisme et de ses environs*, concerning Aube Elleouët, Breton's daughter. Jaguer's remarks appear in the heading "Collage (dans le domaine plastique)," pp. 98–99, of the

same publication. It is evident that Jaguer argues from the position taken by Kral in an article called "L'Age du... collage, suite et fin," published in *Phases* 5, 2d series (November 1975): 98–116. Further references cited in the text.

8. André Breton, *L'Amour fou* (Paris: Gallimard, 1937), p. 61; Marcel Mariën, "L'Esprit avant l'escalier," *Les Lèvres Nues* (Summer 1960), special number on *L'Imitation du cinéma*.

NOTES TO CHAPTER 9: THE LANGUAGE OF DESIRE

1. See *Minotaure* 3–4 (18 December 1933): 46.
2. Man Ray, "L'Age de la lumière," *Minotaure* 3–4: 1.
3. André Breton, *L'Amour fou* (Paris: Gallimard, 1937) pp. 20–22. These lines come from the opening section of Breton's book, originally published as "La beaute sera convulsive" in *Minotaure* 5 (12 May 1934). Further references cited in the text.
4. Pierre Mabille, "L'Œil du peintre," *Minotaure* 12–13 (12 May 1939): 53–56.
5. Quoted by Alain Jouffroy in his *Brauner* (Paris: Le Musée de Poche, 1959), p. 32.
6. Breton, "Langue des pierres," *Le Surréalisme, même* 3 (Autumn 1957): 62–64. Further references cited in the text.
7. Jean Cazaux, "Révolte et docilité dans l'invention poétique surréaliste," *Minotaure* 11 (15 May 1938): 28.
8. Pierre Mabille, "Miroirs," *Minotaure* 11: 66.
9. Pierre Mabille, *Le Merveilleux* (Paris: Les Editions des Quatre Vents, 1946), p. 69.
10. See Louis Aragon, *Le Libertinage* (Paris: Editions de la Nouvelle Revue Française, 1924). *Le Libertinage* appeared six and a half months before the *Manifeste du surréalisme*.
11. Breton, "Le Merveilleux contre le mystére" reappears in his *La Clé des champs* (Paris: Les Editions du Sagittaire, 1953). The passage in question occurs on pp. 11–12.

NOTES TO CHAPTER 10: THE LANGUAGE OF OBJECTS

1. Michel Carrouges, response to Gilbert Ganne's inquiry, "Qu'as-tu fait de ta jeunesse?" *Arts* 560 (21–27 March 1956): 8.
2. André Breton. *Introduction au discours sur le peu de réalité* (Paris: Gallimard, 1927), p. 31.
3. Marcel Jean, *Histoire de la peinture surréaliste* (Paris: Editions du Seuil, 1959), p. 227.

NOTES TO CHAPTER 11: THE VISUAL LANGUAGE OF FILM

1. André Breton, "Comme dans un bois," written for the special surrealism issue entitled *L'Age du cinéma* (August-November 1951), reprinted in his *La Clé des champs* (Paris: Les Editions du Sagittaire, 1953).
2. Benjamin Fondane, "Du Muet au parlant: grandeur et décadence du cinéma," *Bifur* 5 (1930): 37–50.
3. Nora Mitrani, "Intention and Surprise," in Paul Hammond, ed., *The Shadow and its Shadow: Surrealist Writings on Cinema* (London: British Film Institute, 1978), pp. 96–97. Originally published in *L'Age du Cinéma* 4–5 (August–November 1951): 50.
4. Ado Kyrou, *Le Surréalisme au cinéma*, rev. ed. (Paris: Le Terrain Vague, 1961), p. 278.
5. See Joseph Gelmis, *The Film Director as Superstar* (Garden City, N.Y.: Doubleday, 1970), p. 286. Further references cited in the text.

6. Benjamin Péret, "Du Fond de la forêt," *Le Surréalisme, même* 2 (Spring 1957): 106.

7. Kyrou, *Amour-Erotisme et cinéma*, rev. ed. (Paris: Eric Losfeld, 1966), p. 131.

8. Michel Carrouges, *André Breton et les données fondamentales du surréalisme* (Paris: Gallimard, 1950), p. 20.

9. Marcel Mariën, "Un Autre Cinéma," *Les Lèvres Nues* 7 (December 1955): 11.

10. Breton, "Fronton-virage," introduction to Jean Ferry, *Une Etude sur Raymond Roussel* (Paris: Arcanes, 1953), p. 14.

11. Breton, "Devant le rideau," in his *La Clé des champs* (Paris: Les Editions du Sagittaire, 1953), pp. 88–89.

12. Breton, "Signe ascendant," in his *La Clé des champs*, p. 112.

13. See "Recherches expérimentales," in the last issue of *Le Surréalism au service de la Révolution* (May 1933): 10–24.

14. This is different from the text drawn up by the Romanian surrealists in praise of Mario Soldati's film *Malombra* in 1947, reprinted, also, in *L'Age du cinéma*.

15. Omar's gesture of slipping the strap down off Poppy's shoulder and up again, for the pleasure of slipping it down once more, is acclaimed enthusiastically in Kyrou's *Le Surréalisme au cinéma* as a "supreme refinement of eroticism" and as "proof of potential mad love." It was as an example of mad love paralleled only by Buñuel's *L'Age d'Or* that Breton had praised *Peter Ibbetson* in his *L'Amour fou* (Paris: Gallimard, 1937). See the chapter on Hathaway's movie in J. H. Matthews, *Surrealism and American Feature Films* (Boston: Twayne, 1979), pp. 81–98.

16. See Jacques Doniol-Valcroze and André Bazin, "Entretiens avec Luis Buñuel," *Cahiers du cinéma* 36 (June 1954).

NOTES TO CHAPTER 12: SOUND IN SURREALIST CINEMA

1. See surrealist Paul Hammond's book entitled *Marvellous Méliès* (London: Gordon Fraser, 1973).

2. Paulo Antonio Paranaguá, "*Nadja*, numero ordinal," *A Phala* 1 (August 1967): 134.

3. Joseph Cornell, "'Enchanted Wanderer.' Excerpt from a Journey Album for Hedy Lamarr," *View* (December 1941-January 1942): 3.

4. Robert Benayoun, *Le Dessin animé après Walt Disney* (Paris: Jean-Jacques Pauvert, 1961), p. 24.

5. Luis Buñuel, interviews in *Cahiers du Cinéma*, June 1954 and in *Arts*, July 1955.

6. Buñuel, interviews in *Arts*, July 1955 and in *Le Monde*, 16 December 1959.

7. Jacques B. Brunius, *En Marge du cinéma français* (Paris: Arcanes, 1954), p. 129. Further references cited in the text.

8. Letters from Jean-Louis Bédouin to the author, 26 April and 27 May 1963.

9. Letter from Bédouin to the author, 26 April 1963.

10. Information supplied by Ludvik Šváb.

11. Paranaguá, "Manifesto por um cinema violento," *A Phala* 1 (August 1967): 32. The manifesto is dated 18 July 1966.

12. This notation is not to be read as disparaging. As is clear from the scenario by Buñuel and Salvador Dalí—which Buñuel followed quite faithfully, when shooting the movie—*Un Chien andalou* was meant to parody the conventional pantomine of passion characteristic of silent-movie drama. In fact, its surface resemblance, here and there, to popular cinema is one of the false leads that makes comprehension of *Un Chien andalou* impossible by familiar standards.

NOTES TO CHAPTER 13: CONCLUSION

1. Nicolas Calas, *Art in the Age of Risk* (New York: Dutton, 1968), p. 9. Further references cited in the text.

INDEX

Dulac, Germaine, *Coquille et le clergyman, La*, 219
Dupin, Jacques, 81, 83
Duprey, Jean-Pierre, 13, 58–78; *Aube à l'antipode,*14; *Derrière son double*, 60–77; *Fin et la manière, La*, 72; *Forêt sacrilège, La*, 62, 73; *Spectreuses*, 72, 78
dur désir de durer, Le. See Eluard, Paul

Eaten Horizons. See Freddie, Wilhelm
Ecart absolu, L', 85
Eléphant Célèbes, L'. See Ernst, Max
Eluard, Paul, 23, 25–26, 30, 34, 87, 100, 103, 105, 122, 149, 154–55; *Amour la poésie, L'*, 129, 170; *Donner à voir*, 6, 14, 24, 79–80, 113, 119–20, 123, 179–80, 236; *dur désir de durer, Le*, 170; and Breton, André, *Dictionnaire abrégé du surréalisme*, 122–23, 137, 142, 149
Emak Baki. See Ray, Man
Enchanted Cottage, The. See Cromwell, John
Ernst, Max, 4, 21, 26–27, 34, 59, 79, 103, 116, 141–43, 157, 189; *Airplane Gobbling Garden*, 28; *Au delà de la peinture*, 144–47, 171; *2 Enfants sont menacés par un rossignol*, 142; *Eléphant Célèbes, L'*, 142; *Femme 100 têtes, La*, 66, 142; *Histoire naturelle*, 33; *Oedipus Rex*, 142; *Pietá ou la Révolution la nuit*, 142; *Rêve d'une petite fille qui voulut entrer au Carmel*, 142; *Semaine de bonté, Une*, 142
Espace d'une pensée, L'. See Magritte, René, and Nougé, Paul
Ethuin, Anne, 148
Etoile de mer, L'. See Ray, Man
Etude sur Raymond Roussel. See Ferry, Jean

Faune noir, Le. See Vitrac, Roger
Fauvism, 39
Feldman, Marty, *Last Remake of Beau Geste, The*, 203
Femme 100 têtes, La. See Ernst, Max
Ferry, Jean, *Etude sur Raymond Roussel, Une*, 82
Figaro, Le, 242
Fin et la manière, La. See Duprey, Jean-Pierre
Fini, Leonor, 79
Flaubert, Gustave, 62
Fondane, Benjamin, *Trois Scénarii*, 199
Ford, Gordon Onslow, 125; *Transparent Woman, The*, 39
Forêt sacrilège, La. See Duprey, Jean-Pierre
Frances, Esteban, 34, 125

Freddie, Wilhelm, *Eaten Horizons*, 196; *Petting Party*, 189
Fregonese, Hugo, *One Way Street*, 201–202, 204
Freud, Sigmund, 159, 169

Georgia. See Soupault, Philippe
Germain, Edward, 106–108, 114
Get in, Please! See Dryse, Frantisék
Giacometti, Alberto, 161–62, 165, 167, 172
Goldfayn, Georges, 119, 213
Graduate, The. See Nichols, Mike
Grande Gaîté, La. See Aragon, Louis
Grand Jeu, Le. See Péret, Benjamin
Grands Bardes gallois, Les. See Markale, Jean
Granell, E. F., 80

Hathaway, Henry, *Peter Ibbetson*, 211
Hayter, Stanley William, 79
Hebdomeros. See de Chirico, Giorgio
Heisler, Jindřich, 148–49, 150–54
Histoire naturelle. See Ernst, Max
Hitchcock, Alfred, *Spellbound*, 199
Homme et une femme, Un. See Lelouch, Claude
Honneur des poètes, L', 55
Housse, La. See Paalen, Wolfgang
Hugnet, Georges, *Petite Anthologie poétique du surréalisme*, 47
Hugo, Valentine, 79
Hugo, Victor, 44, 57, 72
Hunting of the Snark, The. See Carroll, Lewis
Hurdes, Las. See Buñuel, Luis
Huysmans, J.-K., *A vau l'eau*, 40

Illuminations, Les. See Rimbaud, Arthur
Imitation du cinéma, L'. See Mariën, Marcel
I'm Waiting for You [Expecting You]. See Tanguy, Yves
Introduction au discours sur le peu de réalité. See Breton, André
Invention du monde, L'. See Bédouin, Jean-Louis, and Zimbacca, Michel

Jabberwocky, See Švankmajer, Jan
Jaguer, Edouard, 73, 149
Jarry, Alfred, *Amour absolu, L'*, 62–63; *Dragonne, La*, 62; *Ubu Roi*, 207–208
Jean, Marcel, 192
Jennings, Humphrey, 79
Je sublime. See Péret, Benjamin
Jet Pilot. See Sternberg, Josef von
Jouffroy, Alain, 60
Journal d'un Poète. See Vigny, Alfred de